Pastoral and Monumental

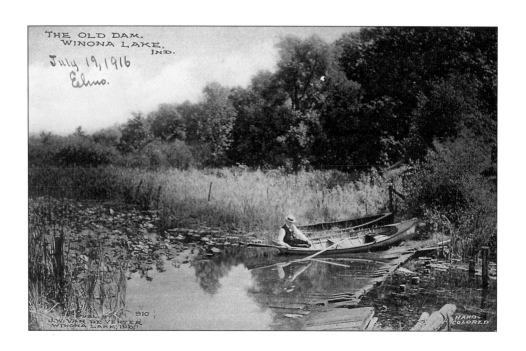

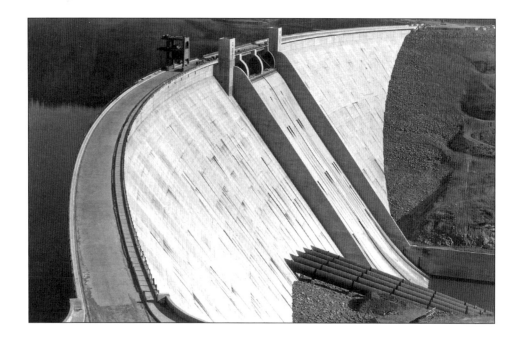

PASTORAL & MONUMENTAL

Dams, Postcards, and the American Landscape

DONALD C. JACKSON

UNIVERSITY OF PITTSBURGH PRESS

Published by the University of Pittsburgh Press, Pittsburgh, Pa., 15260

Copyright © 2013, University of Pittsburgh Press

All rights reserved

Manufactured in the United States of America

Printed on acid-free paper

10 9 8 7 6 5 4 3 2 1

Library of Congress Cataloging-in-Publication Data

Jackson, Donald C. (Donald Conrad), 1953–
 Pastoral and monumental : dams, postcards, and the American landscape / Donald C.
Jackson.
 pages cm
 Includes bibliographical references and index.
 ISBN 978-0-8229-4426-3 (hardcover : alk. paper)
 1. Dams—United States—Pictorial works. 2. Postcards—United States. 3. Dams in art.
4. Landscape photography. I. Title.
 TC556.J33 2013
 627'.80973—dc23 2013003770

To Jessie Tufts and Clifton Jackson

CONTENTS

ACKNOWLEDGMENTS

Over the past thirty years I have interacted with hundreds of antique postcard dealers and ephemera merchants to gather the images in this book. But in other respects the creation of *Pastoral and Monumental* constituted a solitary endeavor involving little direct collaboration with colleagues or friends. That caveat aside, some specific acknowledgements are in order. First, I thank Carol for her commentary on the manuscript and her patience in allowing thousands of "dam postcards" and related memorabilia to clutter our shared world. Thanks also to Murray G. Murphey for his willingness to support both my work in American studies and my desire to study the material culture of dams, to Ellis Turner for helping spur my initial interest in postcards, collectibles, and photographica, and to Paul Barclay for sharing with me his enthusiasm for postcards as valued components of culture and cultural history. Eric Luhrs of Lafayette College's Skillman Library deserves special mention for his helpful guidance on digital scanning techniques and protocols. The Lafayette College Academic Research Committee generously supported this project, and the assistance of student Excel Scholar Elizabeth Tutschek during the early stages of the book is gratefully acknowledged. I also appreciate the forbearance of my colleagues at Lafayette, who all too often experience conversations suddenly veering off into discussions involving dams, water, and the history of postcards and graphic imagery. In addition, the history department secretaries Kathy Anckaitus and Tammy Yeakel provided welcome camaraderie and efficient logistical support as the project evolved.

The anonymous readers of the manuscript for the University of Pittsburgh Press contributed valuable insights and suggestions; this is a much better book because of their commentary. Last but not least, thanks to Ann Walston and Alex Wolfe of the University of Pittsburgh Press and especially to Cynthia Miller for her patience and support in bringing the project to completion.

This book contains postcards illustrating hundreds of dams and water projects covering almost all fifty of the United States. Despite this coverage, the

author appreciates that views of many dams were excluded simply because of space limitations. If one of your favorite (or perhaps least favorite) dams, or a hydraulic engineering project you consider to be of particular importance, failed to make the cut, I apologize. An effort was made to present a wide variety of images, but, as the author is well aware, a vast multitude of engaging photographs and postcard views were necessarily left on the cutting room floor. All images reproduced in this book are from the author's collection. For more information, see the author's website, www.damhistory.com.

Pastoral and Monumental

PASTORAL AND MONUMENTAL

When someone invokes the word *technology*, what first leaps to mind? Most likely the Internet, ever-smarter phones, or a maelstrom of gigabyte-driven social media. But what about the physical world that sustains us, and the role played by hydraulic technology in defining how human cultures interact with the environment? People today may struggle to imagine life without instant e-connections of all sorts. But imagine a world without fresh water as close as the nearest faucet or fountain; or a world of devastating droughts alternating with disastrous floods. Water control was integral to the growth of the world's first irrigation-based civilizations, and now, centuries later, it is no less important to modern society. Computers and electronics may dominate popular conceptions of technology, but it is of no small consequence if we lose track of how dependent we are on water and its place in our lives. And in the pantheon of water control technologies, nothing is more important than dams.

Dams make water available in ways far different than nature otherwise provides. Small wood and stone weirs cut across meandering streams, diverting flow to pastoral gristmills. Massive concrete piles hold back the flow of rushing rivers, fostering the growth of monumental cities. While the scale of dam building can encompass structures from a few to several hundred feet in height, an overarching principle transcends variation in size and scope. Above all, dams are built to change the water regime of nature to serve human desire. Irrigation of arid tracts to make the desert bloom; reservoirs to impound mountain streams and

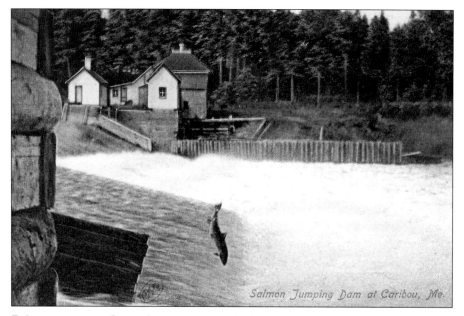

Salmon Jumping Dam at Caribou, Me.

Fish versus power. Soon after arriving on the New England shores, British colonists experienced the deleterious effect of dam building on fish migration. By the mid-eighteenth century some farmers sought the removal of mill dams to sustain fish runs, but the growing economic value of waterpower limited the political potency of these anti-dam protests. This postcard from Caribou, Maine, circa 1910, poignantly illustrates how dams could disrupt the life cycle of spawning salmon.

feed metropolitan aqueducts; hydroelectric power plants connecting to multi-state regional power grids; huge lakes where people find recreation in swimming, boating, and fishing. These things and more are provided by blocking stream flow and transforming the world's water resources to meet a perceived human need. In this, dams comprise an elemental technology mediating our interaction with the natural world.

As dams proliferated across the world's landscape through the twentieth century, an understanding took hold—first among cultural elites and later more broadly—that the transformations they brought were hardly an unmitigated good. The obliteration of river basin ecologies and the inundation of culturally significant landscapes assumed greater recognition as dams and reservoirs grew in size and number. Appreciation of the environmental costs incurred by dams did not suddenly erupt, instead it gradually gained standing as ever larger projects were built and more streams and verdant river valleys disappeared under rising waters. Today, the deleterious effects of dams are perhaps most dramatically represented by the destruction of spawning fish populations, by the devastation of wetlands and other sensitive riverine ecologies, and by the displacement of people from homes and homelands to make way for expansive reservoirs. Over

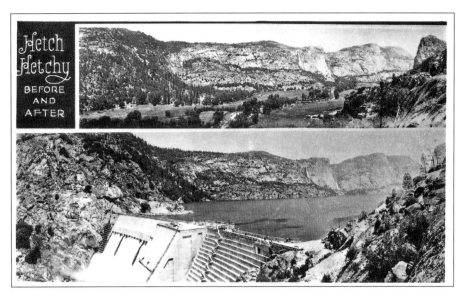

San Francisco's plans to flood Hetch Hetchy Valley in Yosemite National Park ignited a nationwide movement to stop construction of a major dam. The initiative to save the valley came to naught when, after a decade of controversy, Congress and President Woodrow Wilson authorized the dam in 1913. This postcard from the mid-1920s, contrasts the undisturbed valley with the reservoir impounded by the partially built O'Shaughnessy Dam.

the last forty years the depiction of dams as primarily a destructive technology has, in large part, come to dominate public discourse about water control technology and its place in modern society. But this is a relatively recent phenomenon, and, as strange as it may seem to some modern-day observers, in the not so distant past dams were commonly perceived, promoted, and appreciated as a way to improve—and even beautify—the environment.

At the beginning of the twentieth century people were not oblivious to the ecological consequences of dam building. Many understood how dams blocked fish migration, and, as illustrated in chapter 7, more than a few fish ladders were built to provide upstream passage for spawning salmon and other species.[1] Similarly, San Francisco's plans to inundate Hetch Hetchy Valley in Yosemite National Park for a municipal water supply reservoir instigated a controversy of national scope in the years prior to 1913. Today the damming of Hetch Hetchy holds great importance to many people as a symbol of the (seemingly) unmitigated evil inflicted by large-scale dam construction. Nonetheless, one hundred years ago the issues surrounding San Francisco's Hetch Hetchy project were, within America's nascent environmental community and the nation as a whole, quite nuanced. In fact, many members of the Sierra Club in California actually supported construction of a dam at Hetch Hetchy, forcing the opposition to create a new organization (the Society for the Preservation of National Parks) to

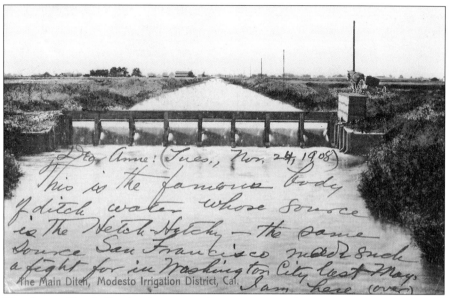

The dam at Hetch Hetchy does more than capture the flow of the Toulumne River for municipal use in San Francisco. It also furnishes water for the agricultural communities of Turlock and Modesto in California's Central Valley. Written in 1908, the inscription on this view of the Modesto Irrigation District's Main Ditch connects the scene to congressional hearings on the proposed Hetch Hetchy Dam, attesting to how postcards fostered cultural narratives about dams and their place in American life.

carry on the fight. Even at Hetch Hetchy, the flooding of a beautiful mountain valley engendered reactions among early environmentalists that were not nearly so clear-cut as we might imagine today.[2]

The various associations that dams engender—both positive and negative—are evident in the broad-based cultural narratives that people share with one another in the course of their daily lives. These narratives, which incorporate visual images as well as speech and text, derive from no single storyteller or auteur and are crafted by people of widely diverse backgrounds and social standing. Reflecting a variety of social, political, and economic perspectives, they encompass shared authorships and, at times, may express ambiguity in the stories they tell. But despite such open-endedness, cultural narratives hold meaning and social significance. In the case of dams, they reflect the values of a society that both uses natural resources to serve human purposes and, at the same time, has come to appreciate the social value of free-flowing rivers and natural landscapes. An essential goal of this book is to illustrate how such cultural narratives involving dams (or paraphrasings of such narratives) build upon and help define visual imagery—specifically that presented in picture postcards—produced, distributed, mailed, and consumed in America during the early and mid-twentieth century.

At first blush, postcards might seem too transitory or ephemeral to be worthy of academic interest or historical analysis. After all, in today's world postcards are widely perceived as throwaway souvenirs, mere vehicles for simple, banal messages expressing "wish you were here!" or some other briefly phrased sentiment of marginal long-term consequence. And the images on modern-day cards are usually rather predictable scenes of major landmarks (e.g., the Washington Monument, Golden Gate Bridge, the Liberty Bell, Hoover Dam), iconic regional views (e.g., fall foliage in rural Vermont, cactus and armadillos in the desert Southwest), or generic "greeting" cards divorced from any particular locale. In such a context, is it reasonable to ask of postcards: How important can such cultural detritus be? Yes, the question is reasonable; but the value of postcards as a source for historical inquiry is nonetheless clear and convincing.

Exchanging Local Views

To a contemporary eye, what is most remarkable about postcards from the early twentieth century—and what has largely vanished from America's collective memory—is the astonishing variety of "local views" printed for cities, towns, villages, and hamlets from Maine to California and every state in between. Distributed through small retail shops, drugstores, merchant houses, and dry goods emporiums, these local views depict streetscapes, buildings (of all conceivable types, including churches, schools, fraternal lodges, post offices, theaters, and

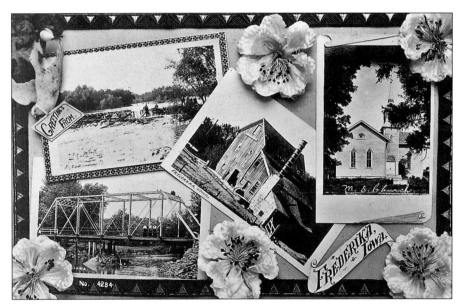

A "multi-view" postcard of Frederika, Iowa, a small town on the Wapsipinicon River, postmarked May 22, 1909. Here, a local dam (on the left with the inset Greetings From) is conjoined with other local landmarks, including a truss bridge, a mill, and a church. The ornate floral design bespeaks a sense of local pride in the featured scenes and structures.

Multi-view cards featuring local scenes were popular in small towns across the United States. Here a card sent from Brownwood to Goldthwaite, Texas, in August 1907 highlights a local dam that (although not mentioned on the card) extends across the evocatively named Pecan Bayou.

After the First World War, the variety of local views recorded in postcards began to diminish, but the multi-view card found new life in "big letter" cards. The O of this card from 1935 features a view of the Columbus, Ohio, municipal water supply dam completed across the Scioto River in 1908.

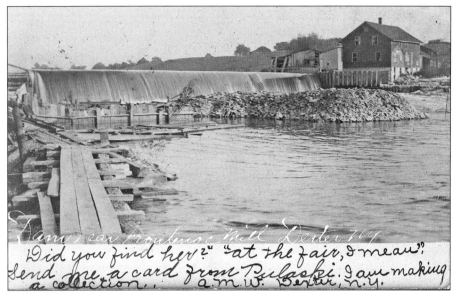

The message on this view of Dexter, New York, postmarked December 12, 1905, makes cryptic reference to some presumed romantic liaison. But it also documents the phenomena of postcard collecting: "Send me a card from Pulaski. I am making a collection."

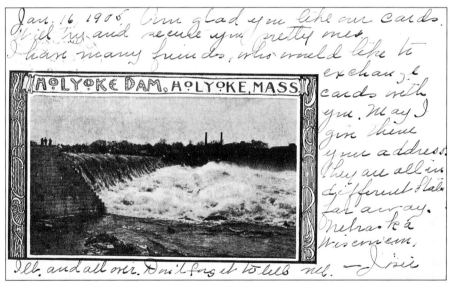

People seeking to exchange postcards often fashioned informal networks, as reflected in this card sent to Brooklyn, New York, from Holyoke, Massachusetts, in 1905: "Am glad you like our cards. Will try and send you pretty ones. I have many friends who would like to exchange cards with you. May I give them your address? They are all in different states far away. Nebraska, Wisconsin, Ill., and all over. Don't forget to tell me."

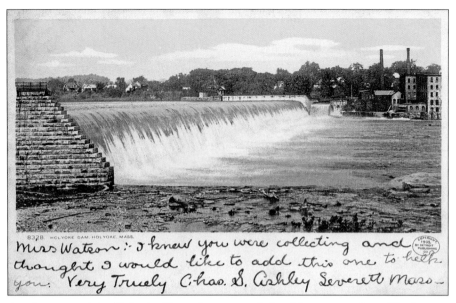

Another view of the Holyoke Dam, this one mailed in May 1906, where Charles of Leverett, Massachusetts (a small town about fifteen miles north of Holyoke), provides a card to Miss Watson in the nearby village of Moores Center: "I knew you were collecting and thought I would like to add this one to help you." Courtship was a part of postcard culture, with the collection and exchange of cards offering an entrée into the private world of a prospective companion (or perhaps a life partner).

hotels, fire engine companies, factories, mills and commercial establishments, parks, memorial statues, farm landscapes, bridges, water towers, dams, and much more. Certainly some of these cards focus on sites that we would not consider surprising: a city hall, a town square, or perhaps a historic house where George Washington reputedly slept or supped. But others portray scenes that likely would never interest contemporary postcard manufacturers nor attract attention from modern-day consumers seeking out cards for friends, loved ones, or passing acquaintances. In this latter category, local views of small-scale rural dams, as well as of more monumental structures tied to large-scale water control systems, were frequently published as part of informal postcards series documenting a community, town, city, or region.

 Born of a fortuitous melding of photographic and printing technology with an increasingly sophisticated postal and transportation system, the picture postcard first flourished in late nineteenth-century Europe. As discussed in chapter 2, during the early twentieth century (from about 1905 through the advent of the First World War a decade later) postcards gained a prominence in the American public mind that is difficult to appreciate a century later. This prominence is reflected in Postal Service tabulations, which record more than 667 million penny postcards passing through the postal system during 1907 (penny postcards were so named because postage for delivery to any destination in the United States

was one cent; postcards sent to foreign countries and domestic letter envelopes required two cents postage). By 1910, the number of postcards mailed had risen to almost 1 billion.[3] Significantly, these numbers reflect only cards that were individually mailed. As evidenced by more than a few of the postcards reproduced in this book, many others were purchased, saved, exchanged, and/or distributed beyond the purview of the Postal Service (in addition, many were also included in sealed packages sent through the post office). Postcards represented no small enterprise engaging the interest of but a few devotees. It was a huge business with postage fees for the approximately 1 billion cards sent in 1910 approaching $10 million. And this was at a time when the entire annual budget of the federal government was less than $700 million. Big business indeed, and one driven by the public's fascination with postcards as a medium of personal and cultural communication.

During the golden age of postcards a great multitude of Americans across the social spectrum purposefully collected and exchanged picture postcards, which were then arranged and exhibited in albums. Frequently, these albums were positioned in drawing rooms and parlors for perusal by guests and loved ones. Many cards were sent not to convey a written message per se ("Martha and I arrived in Duluth. Having a fine time. Please write soon") but instead were simply inscribed "Here's one for your collection" or "Please send me views of your town." Postcards constituted an inexpensive means of conveying visual information about the world (and most specifically about people's very local world) to others. In this way, they created the phrasing and syntax of visual narratives involving the physical landscape.

The value of postcards in library collections has been described as offering "innumerable glimpses of what folks believe are visual keys to people, places and things. They are the popular culture pennants which celebrate the ordinary and sometimes even the exceptional and the spectacular."[4] Or, in the words of the historian Norman Stevens: "a collection of postcards may represent the best set of images available of the architecture of one type of building, an historic event, or a city or town. Postcards offer a window into the world as it was viewed by the society of its time. . . . Above all, because they were produced as items for mass consumption and often not with an apparent conscious or literary purpose, postcards are a true reflection of the societies in which they were produced."[5] Leaving aside the supposition that there might ever be any single "true reflection" of a society, Stevens's observation that postcards present a "window into the world as it was viewed by the society of its time" nonetheless represents a useful and important insight. Postcard distribution was not confined to any particular region, and an infatuation with postcards extended to people throughout the nation. Communities in the Northeast and the Midwest appear better represented than those in the Southeast and mountain West in terms of the number

and variety of local views produced during the golden age, but this distribution pattern generally reflects population densities in early twentieth-century America and does not obviate the fact that interest in picture postcards represented a truly national phenomena.

In recent years, a plethora of illustrated books on towns, cities, and urban neighborhoods have appeared that draw from postcards to document the visual character of a community. Sometimes these books make no overt reference to their reliance upon postcards as essential source material (although anyone familiar with the design and graphic motifs associated with antique postcards can readily identify them), while other times they are directly acknowledged as a "Postcard History of My Town U.S.A."[6] Often devoid of description, and even general narrative text, these types of postcard histories can offer wonderful insight into the physical character and evolution of a community. But they do little to analyze how the images relate to a broader sense of culture or to how postcards intertwined with the life of American society. Often times, they are simply compendiums of images, assembled to be viewed as a visual list. Other books of a similar ilk, but focused a particular type of scene or building type, also present postcard images in essentially a list format; they are not focused on a particular town or region, but they adopt a comparable methodology in terms of organization and presentation.[7]

This book offers something different than these more traditional types of postcard histories. *Pastoral and Monumental* is distinctive because of how postcards are considered within a broader cultural analysis not confined to a single region or locale nor limited to a simple listing of visual images. Thus, it considers the business of postcard production and distribution, the myriad ways that people used and collected postcards, and the evolution of postcards as a social and cultural medium through the first half of the twentieth century. But just as importantly, the subject of dams as a feature of America's technologically driven political economy is kept front and center. As presented here, dam postcards are more than relics and souvenirs of an antiquarian past, they offer an entrée into understanding how Americans have used hydraulic technology to transform the environment and serve broad-based human desires. And they provide a basis for understanding how many citizens of the late twentieth century eventually came to see dams as ill-advised intrusions into ecologically sensitive river valleys.

Images and Subjectivity

Postcards are not sui generis and were preceded in important ways by cabinet views and stereo views (sometimes called stereopticons or stereographs) produced and sold by the tens of thousands in the mid- and late nineteenth century. In the twentieth century, the personal snapshot photograph (first popularized by Kodak cameras in the late 1880s) gradually grew in popularity and, on a more commer-

cial level, were joined by teletype (or "wire") photographs used by newspapers and magazines to document events of the day. While this book utilizes postcards as the primary source for dam images, these other photographic formats are drawn upon at various times to flesh out and enhance the visual record of dams and their place within the American landscape.

Recently, photographs and postcards have attracted the attention of scholars interested in the history of empire and the ways that Western European, American, and Japanese culture used photographs as a means for extending the power of colonial regimes. Drawing upon the ideas of modern cultural theorists, these analyses of photographs and postcards highlight the ways that visual images could be used in the service of economic and political repression, as they emphasized notions of savagery and seeming backwardness in the portrayal of non-Western peoples as the Other. It is undeniable that the late nineteenth and early twentieth centuries represented a time when ideas of race and racial inferiority held broad-based currency in American and European social thinking. Recent books such as *Delivering Views: Distant Cultures in Early Postcards* and *Anthropology and Photography, 1860–1920* have done much to document the racial undertones that inculcated the production, distribution, and visual consumption of images of non-Western peoples. Just as importantly, such analyses have highlighted the ways in which photography constitutes something much more than a simple indexing of the physical world.[8]

Photographs, and printed images derived from them, are never strictly objective in their depictions. To some degree they are always subjective, simply because decisions need to be made by people (subjects) in determining where cameras will be pointed, what lenses will be used, when shutters will click, when (and how many) prints of an image will be made, and who will have access to these images. Viewed in such a context, *Pastoral and Monumental* certainly does not present an abstract and fully objective visual rendering of dam history writ large. It is a story that the author has assembled and ordered by selecting a discrete subset of images drawn from a universe of billions of possible views created during a period of more than fifty years. Out of this multitude, dams and water control structures and scenes are likely featured on perhaps hundreds of thousands of postcards, and this book features but a few hundred images. Thus it is fair to wonder: What can such an undeniably limited sampling offer in terms of meaningful analysis of dams and their place on America's physical and cultural landscape? The answer can be derived from the very images themselves and from the effort made to explicate what information these images might contain and why this information is worth caring about. In essence, dam postcards comprise a telling thread in a complex narrative tapestry about America's cultural and environmental landscape that people shared with—and expressed to—one another. And the author has conceived a narrative of his own by presenting a select group of images arranged to help tell a story that he believes worth telling.

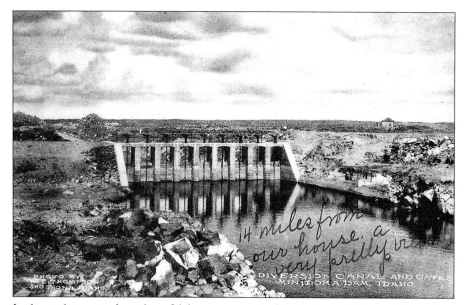

In the arid terrain of southern Idaho, water control technology held special meaning to local settlers. The handwritten message adorning this card, circa 1910, reveals that a seemingly bleak scene of the diversion dam and canal near Minidoka was—to at least one person—a "very pretty view" located "14 miles from our house."

Does that mean that this book is subjective history? Yes. Does that necessarily detract from the value or significance of what it has to say? No. Every history book constitutes a winnowing of facts and data in order to justify an argument or insight that an author seeks to express. The value of a book lies in the logic and creativity that is brought to bear in the selection and presentation of evidence to support the author's thesis. And this process is always subjective, no matter how blandly unremarkable or "objective" the text may appear. To people who believe that dams wreak environmental havoc and possess little redeeming value for enlightened societies, this book may appear to comprise a blasphemous apologia for dam builders of the past. But should someone hold such a view, they would miss a key point of the book and misinterpret why so much time was expended in its creation. Indeed, the author does believe that dams can provide useful and valuable service to humankind, but he also recognizes that they can cause enormous damage to cultural landscapes and ecological systems. The aim of this book is to show the multitude of ways in which dams interacted with and intertwined in people's lives and to show how dams were often perceived as appropriate (the temptation is to say "natural") parts of community and regional environments. By using visual images imprinted on antique postcards as a stepping stone—not an end in itself—the hope is that readers gain perspective both on the reasons dams were built and on how people have incorporated dams (whether consciously or not) into an understanding of the world around them.[9]

Dam Pretty

Over decades spent looking at and collecting vintage dam postcards, the author has been impressed that he has never come across a card with a message such as, "Can you believe they made a postcard of *THIS* scene?" No matter how unremarkable or mundane a particular view of a dam might seem, there is scant evidence that people reacted with incredulity or astonishment to the fact that the scene would appear on a postcard. Certainly there are times in which people would play off the word *dam* and make a naughty reference to a "dam pretty place" or some grammatical variation on this theme. And by the 1920s, card manufacturers would at times sell scenes festooned with mildly provocative inscriptions like "Isn't this dam pretty." But never have I come across a card inscribed by either the publisher or correspondent with the missive, "Isn't this dam ugly."

Taken as a whole, it appears that postcards of dams were accorded a respect and value commensurate with scenes of other physical representations of America's cultural environment (such as bridges, courthouses, libraries, churches, and city halls). Although modern-day observers might find it remarkable (or at least

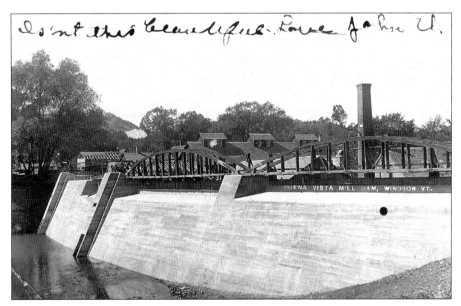

A concrete dam is not something that people in the twenty-first century readily think of as "beautiful," but that might reflect more of our own culture than some universal truth. Here, John U. inscribes the Buena Vista Mill Dam in Windsor, Vermont, with the missive "Is'nt this beautiful." We can all make our own artistic judgment regarding this mass of concrete, but John (without evident sarcasm) perceived it as beautiful and used a postcard to share the news. An anomaly? Perhaps. Or perhaps simply a reminder that what we consider to be mundane and unattractive is specific to our own time and culture.

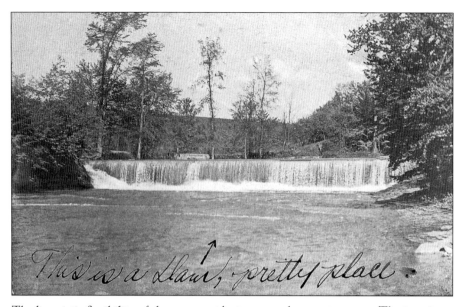

The linguistic flexibility of dam was not lost on people a century ago. The inscription "This is a Dam, pretty place" plays off that ambiguity in a naughty, yet socially acceptable, way. This real photo postcard captures a scene along Cattaraugus Creek in Western New York State.

odd) that a local dam comprised the subject of a postcard, such a perspective was not commonly shared by the American citizenry in the early part of the twentieth century. In the final analysis, the author has come to believe that postcards published through the first half of the twentieth century generally present dams in a seemingly positivistic light for a simple reason: that is how most people viewed them. Dam postcards were manufactured, sold, inscribed, mailed, and collected in large numbers because, without derision, people recognized the scenes, landscapes, and subjects they captured to constitute an integral part of their world.[10]

Photographs, Postcards, and Mystery

On the surface, photographs represent objective "reality," or at least this is how they are commonly perceived. But upon reflection it is clear that photographs—and by extension picture postcards—comprise artifacts that, while establishing a visual record of "how things really were," also serve to raise questions about the scenes captured by the camera that the photographs by themselves cannot answer. In her book *On Photography* the cultural critic Susan Sontag acknowledges that "photographs are valued because they give information. They tell one what is there; they make an inventory." But she further observes that a photograph "confers on each moment the character of a mystery. Any photograph has multiple meanings; indeed, to see something in the form of a photograph is to encounter a

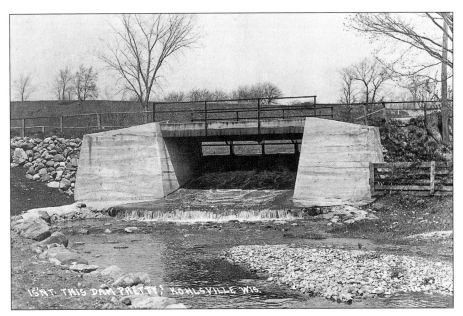

Postcard companies constantly sought new ways to market their product, prompting a manufacturer in the Midwest to publish a series of rural dam views featuring the caption: "Is'nt this Dam Pretty." The scene in this Kohlsville, Wisconsin, view, postmarked 1918, seems so undistinguished to the modern eye that it is not hard to imagine that the caption was used a bit tongue-in-cheek. Of course, it could have been phrased as "dam awful" or "dam ugly." But the manufacturer characterized the scene as "dam pretty" and that in itself says something about perceived public norms.

potential object of fascination. The ultimate wisdom of the photographic image is to say 'There is the surface. Now think—or rather feel, intuit—what is beyond it, what the reality must be like if it looks this way.' Photographs, which cannot themselves explain anything, are inexhaustible invitations to deduction, speculation, and fantasy."[11]

Sontag is not alone in calling attention to the mysteries presented by photographic images. In his recent book *Believing Is Seeing: Observations on the Mysteries of Photography* the documentary filmmaker and historian of visual media Errol Morris directly addresses the issue in analyzing a series of famous and provocative images involving war and politics. The particular images Morris focuses on may differ in subject from those discussed in *Pastoral and Monumental*, but, referring to his book as a "collection of mystery stories," he makes a point universal to all photographs and to all attempts to glean knowledge from them: "imagine finding a trunk in an attic filled with photographs. With each photograph we are thrown into an investigation. Who are these people? Why was their photo taken? What were they thinking? What can they tell us about ourselves? What can we learn about the photographer and his motivations? Each of these questions can lead us

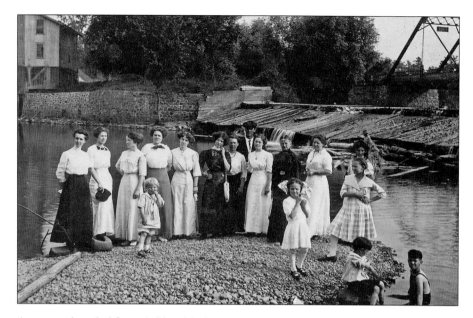

A postcard mailed from Ashley, Michigan, in July 1912 poses many mysteries. Why are these women and children (and one man) grouped together in front of a seemingly unremarkable wooden dam? Is it a view recording a particularly low stage of river water during a drought? Is the dam incidental to the view? Is there any special reason why this particular group is gathered in front of this particular dam for an informal portrait? The main written message on the reverse offers scant insight into the significance of the grouping, but a note in the margin cryptically requests "tell them all I said hello." This may refer to the group in the photograph. Or maybe not. But if so, then how did the correspondent ("Daisy") get a copy of the postcard to send? The mysteries are only compounded.

on a circuitous and winding path. An excursion into the labyrinth of the past and into the fabric of reality."[12] With picture postcards, a multitude of questions arise that expand upon Morris's musings. Why did the photographer take this view and why did he or she decide it was worth printing or manufacturing as a post-card? Why did the local drugstore or dry goods emporium chose to stock (or commission the production of) a particular scene? Why did someone chose to buy a particular card and then use it to send a particular message to a particular person? Why did they purchase a card, not mail it, and keep it for themselves? How did someone react after receiving a particular card with a particular message? Why are some cards immediately discarded and others kept as keepsakes? And was it mere serendipity that a particular view was thrown in a drawer, later swept in a box and stored in a musty attic, and then, only by happenstance, un-earthed decades later in a garage sale cleanout precipitated by the death of the recipient's granddaughter? All good questions and all difficult if not impossible to answer from a distance of almost a century by someone who bought the card

This formally posed photograph was clearly not taken on a whim, but why was a dam near Plymouth, Pennsylvania, chosen as backdrop for a group portrait? The card was never sent through the postal system, but notations on the back reveal the location and that the assembled party includes two families related to "Martha and Mrs. Morgan." The card was considered a family heirloom of sorts, with everyone identified—including Rex the dog. But questions involving the relationship between the two families remain. And what significance did the dam hold in their lives?

at a flea market, from a dealer at an "ephemera/collectibles" show, or from an Internet auction site.

The cultural value, and often the intrigue and mystery, of picture postcards is enhanced because they frequently appear with messages from the sender or inscriptions later written to describe the scene, identify people, or otherwise explicate a perceived significance of the view. Sometimes written messages on mailed postcards clearly relate to the image shown. At other times messages seem to bear no relation to the nominal "subject" that appears in the view. With dam postcards the questions regarding why a particular person might have used a particular card to communicate with a particular correspondent appear even more provocative because—to the modern eye—dams seem unlikely subjects for celebration or commemoration in a postcard view. Was the postcard featuring a dam scene specifically and consciously chosen by the sender? Or did it just happen to be hastily grabbed from a rack of local views and used without much thought given to the particular scene? Good questions and not always easy or possible to answer.

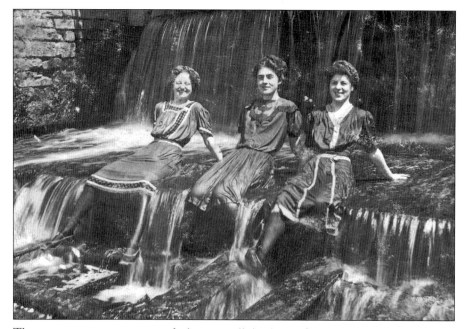

Three young women ca. 1910 frolic in a mill dam's overflow. The location is unknown (the postcard was never sent and there are no inscriptions). We're left with some intriguing questions: Who are the women, who took the photograph, why was it printed as a postcard, and why are they wearing shoes?

In light of the myriad questions arising from the postcard genre, consider a set of early twentieth-century dam scenes that, in one way or another, also feature groups of women. Such a pairing of women and dams is not particularly obvious or expected—dam building and water control engineering are fields historically dominated by men—which makes these views all the more captivating. For the collective standing aside a drought-parched stream bed presumably near Ashley, Michigan (identified by a postmark), it may be that the presence of a dam in the scene was accidental. But it seems strange that such a utilitarian backdrop was selected for an informal, yet certainly not random, group photo. In contrast, for the grouping posed in front of a dam on Wissahickon Creek near Philadelphia (so identified in a written note on the back), the presence of a dam was hardly accidental. The dam setting was consciously chosen and the stepped downstream face used to considerable artistic effect. But what, if any, larger significance did the dam have in their lives? The final view in this impromptu collection of "women and dams" is presented on an unmailed, uninscribed view that offers no evidence as to where three young women reveled in the overflow of a mill dam; here the intriguing mysteries may lie not so much in location or identity but rather in who took the photograph and who was the intended audience when printed as a postcard.

With photographs all is not mystery of course—even for views devoid of

descriptive inscriptions, messages, or postmarks—and Morris is mindful that "photographs preserve information. They record data. They present evidence." There is a physical reality that underlies the images and information recorded in photographs, and, above all, this is what makes them so engaging as historical artifacts. That said, the limits of our understanding need be recognized once we set out to interpret the information that, with the click of a shutter, light sensitive chemicals etched into photographic plates and negatives. And these mysteries only multiply when the medium of postcards enters the historical equation and we confront yet more layers of uncertainty. So, should all of this mystery and uncertainty preclude us from even attempting to analyze what meaning might be held within picture postcards of bygone days? No, that would be too harsh, for if held to such a standard, a wide swath of historical documentation would fall short. Instead we should embrace photographs and picture postcards not as some idealized arbiter of truth but as a source of information that enhances our knowledge of the past.[13] In the words of the photograph curator Roy Flukinger of the University of Texas, Morris's collaborator, "historical photographs may give you the possibility of new facts, and may give you the chance to ask new questions. The thing I like about photographs is that they offer me a different sort of visual, and hopefully, therefore, emotional experience of what I'm looking at, that words can't do, or that words can only do part of."[14]

Pastoral and Monumental Dams

There are many ways to categorize dams. They can be grouped according to use (irrigation, power, municipal use). They can also be categorized by design (gravity, thin arch, buttress) or by construction material (wood, earthen or rock fill, stone masonry, concrete). In a broader context, they can also be connected to two idealized themes: the pastoral and the monumental.

The first of these themes encompasses relatively small-scale structures that seem to blend into—or at least visually complement—the natural environment. Pastoral dams clearly involve a manipulation of the environment to serve a human purpose, but, like the agrarian development they foster, they appear to meld into their physical setting in ways that do not detract from surrounding flora and fauna. In contrast, monumental dams project bold physical statements attesting to the avowed power of humankind to dominate nature. Some small mill dams appear so prosaic as to almost disappear into the riparian landscape; conversely, it is difficult to envisage some large dams, such as Shasta Dam in Northern California, as anything other than bold artifacts symbolizing the dominance of technology over nature. Dams formed out of wood and uncoursed stone are most easily understood within a pastoral context. In contrast, dams built using concrete are more readily associated with "engineering" rather than "craftsmanship," an attribute imbuing them with less pastoral qualities because they do not blend as easily into a local terrain of wood and stone. Taken further, it is also possi-

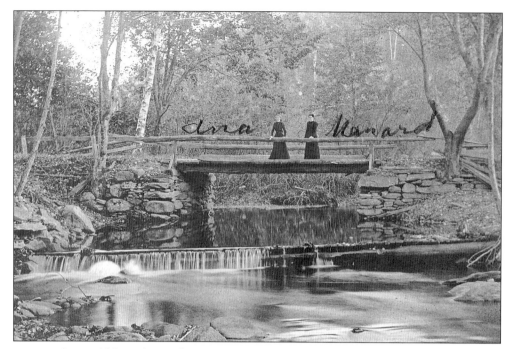

Ana and Manard gaze down upon a small dam in the tranquil environs of Montague, Massachusetts. The card was mailed in 1924, but the scene possesses a timeless quality, harkening back to a pastoral, preindustrial past.

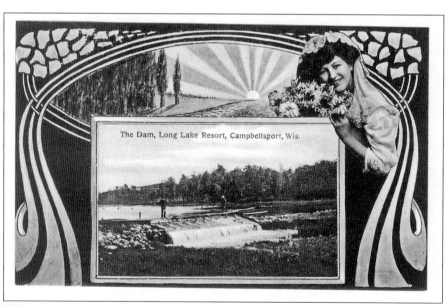

The Dam, Long Lake Resort, Campbellsport, Wis.

While the art nouveau framing of the Long Lake Dam in Campbellsport, Wisconsin, was a bit unusual, it reinforces the pastoral character of what otherwise might appear to be a prosaic timber crib dam.

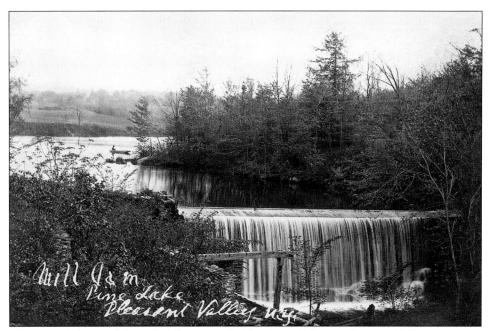

The size of the pond (Pine Lake) impounded by the mill dam in Pleasant Valley,
New York, is quite substantial, bespeaking a significant commercial purpose. But
the serene setting in the southern Adirondack Mountains, replete with a small
fishing boat, speaks not so much of bustling industry but rather of a world where
humans and nature coexist in peaceful harmony.

ble to connect pastoral dams to small-scale, artisan-based traditions ingrained
within rural, preindustrial forms of technological development.

 The idea of pastoralism and its place in American culture has long been a
subject of cultural criticism and literary analysis. In his landmark book *The Machine in the Garden: Technology and the Pastoral Ideal in America*, Leo Marx takes pains
to contrast a popular form of pastoralism (that he terms "sentimental") with a
more intellectualized pastoralism (termed "complex") that he associates with fa-
mous American authors such as Thoreau, Melville, and Faulkner. While the at-
tributes of this latter form of pastoralism can come across as rather rarified, and
not particularly germane in terms of this book's distinction between pastoral
and monumental dams, Marx makes an important observation in noting how
"the pastoral ideal has been used to define the meaning of America ever since
the age of discovery, and it has not yet lost its hold upon the native imagination."
He also draws upon allusions to ancient Rome and the poet Virgil in describing
how "in the pastoral economy nature supplies most of the herdsman's needs and,
even better, nature does virtually all of the work." In this, Marx offers insight
into the ways that pastoral mill dams were appreciated from colonial times into
the twentieth century as technological constructs that transformed the natural
environment in the service of human desire.[15]

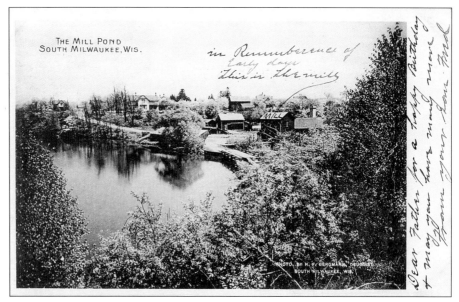

The millpond in South Milwaukee, Wisconsin, almost looks like a natural lake, but the grouping of nearby buildings point to a more practical purpose. Mailed in March 1910, Fred used the card to send birthday greetings to his father in Buckeye, Ohio. Note how the MILL is personalized with an arrow and the inscription "in remembrance of early days."

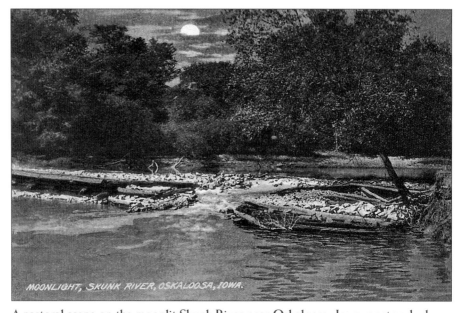

A pastoral scene on the moonlit Skunk River near Oskaloosa, Iowa, postmarked October 1911, featuring the remains of an early mill dam. Timber crib technology was simple yet effective, making use of locally available wood and stone to divert a stream. Of equal importance, labor to construct such a dam could be readily drawn from the local agricultural community.

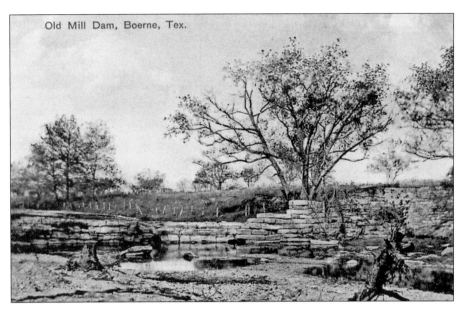

Old Mill Dam, Boerne, Tex.

Located about twenty miles northwest of San Antonio, the mill dam in Boerne, Texas, was built using locally quarried rock and exemplifies the pastoral ideal in a southwestern setting. While the parts of the dam near the abutments stand out as human-made constructs, the center section of the overflow dam blends into the riverine environment and is not easy to distinguish from a natural rock ledge.

Massive monumental dams are also understood as artifacts that transform nature to serve a human purpose. But rather than call forth images of an Edenic landscape populated by herdsmen, peaceful grazing sheep, and small rural mills, monumental dams are better seen as representing and symbolizing the industrialized societies that achieved global prominence in the nineteenth and twentieth centuries. In using the word *monumental* to refer to attributes of such large-scale dams, the author has drawn upon a concern held by many early twentieth-century engineers that the nonspecialist public should visually perceive dams as objects of stability and safety. This concern was enunciated in 1909 by Frederick H. Newell, the first chief engineer and director of the United States Reclamation Service, when he advised America's civil engineering community that "plans for the construction of storage works, while they must be prepared with regard to reasonable economy, must be [undertaken] to being not merely safe but looking safe. People must not merely be told that they are substantial, but when the plain citizen visits the works he must see for himself that there is every indication of the permanency and stability of a great storage dam."[16]

Oftentimes, scholars use the term *sublime* in describing large technological constructs that stand in counterpoise to the pastoral technologies that predated the onset of the Industrial Revolution. And, in using this term, it is specifically with the intent to convey a sense of the "terror" (as well as fascination) that

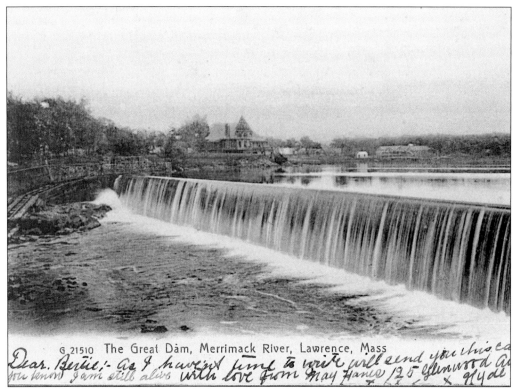

G 21510 The Great Dam, Merrimack River, Lawrence, Mass

Dear Bertie;- As I haven't time to write will send you this ca you know I am still alive with love from May Hance 125 Glenwood Av ×914 ll

Upon completion in 1848, the Great Stone Dam across the Merrimack River in Lawrence, Massachusetts, represented one of the great engineering feats of mid-nineteenth-century America. The 32-feet-high, 943-feet-long masonry structure would not have attracted much attention if built in the twentieth century. But at the time of construction it stood as a tremendous monument affirming America's rapid industrial growth.

(Opposite, top) Masonry and concrete dams are well suited to the monumental ideal, but large-scale embankment dams can also project a dominating visual presence. Completed by the U.S. Reclamation Service in 1911, the Belle Fourche Dam in western South Dakota would have been too expensive to build using a concrete or masonry gravity design. This postcard nicely illustrates the massive, monumental character of large embankment dams, but the caption exaggerates the length of the main structure; it is actually only a little more than a mile long.

(Opposite, bottom) Built as part of New York City's Catskill Aqueduct system, Ashokan Dam stands as a paragon of the monumental dam. Completed in 1915 and rising two hundred feet above its deepest foundations, the massive masonry structure (also known as Olive Bridge Dam) helped establish a visual standard by which, consciously or not, other large-scale storage dams in America were implicitly compared. The New England engineer John R. Freeman—a prominent advocate of massive gravity dams—served as consulting engineer for its design and construction.

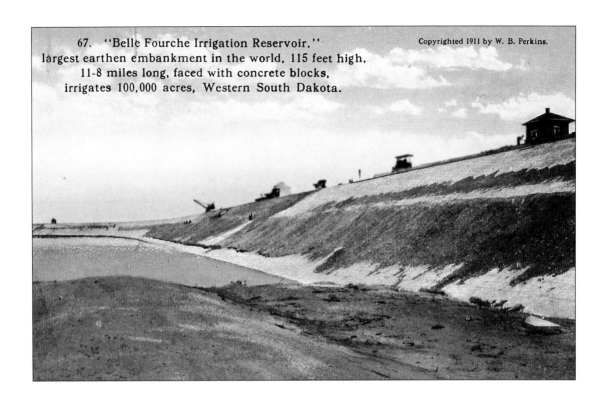

67. "Belle Fourche Irrigation Reservoir."
largest earthen embankment in the world, 115 feet high,
11-8 miles long, faced with concrete blocks,
irrigates 100,000 acres, Western South Dakota.

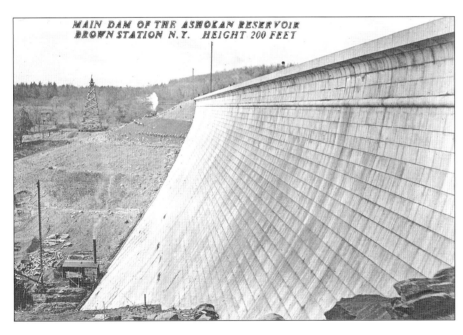

MAIN DAM OF THE ASHOKAN RESERVOIR
BROWN STATION N.Y. HEIGHT 200 FEET

PASTORAL
AND
MONUMENTAL

Authorized in 1902, the U.S. Reclamation Service provided federal support for irrigation in the western United States. Director Frederick Newell embraced a monumental ideal for many of the Service's early dams, including the visually imposing Pathfinder Dam near Caspar, Wyoming, completed in 1909. This view shows the upstream face with the reservoir mostly empty.

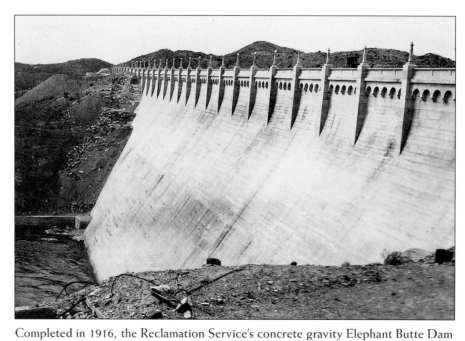

Completed in 1916, the Reclamation Service's concrete gravity Elephant Butte Dam across the Rio Grande in southern New Mexico exemplifies the agency's desire to create civic monuments that would—it was hoped—inspire public confidence.

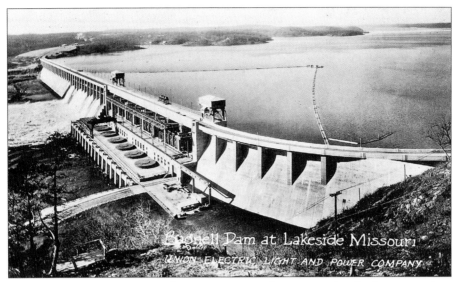

Prior to the 1930s monumental concrete gravity dams were often built as part of investor-financed hydroelectric power projects. The Boston-based engineering firm Stone & Webster was one of the leaders in designing and building dams for private companies; Bagnell Dam, completed in 1931 in the northern foothills of Missouri's Ozark Mountains, stands as one of their most prominent projects. Built for the Union Electric Light and Power Company, the Bagnell Dam symbolizes the efficacy of private companies in supplying the nation's power needs.

observers experienced when physically confronting the technology in question.[17] While some people may wish to characterize large-scale dams as sublime, the author of this book has chosen to use the word *monumental* precisely because of the ways that engineers like Newell specifically sought to implement massive designs that—he hoped—would not provoke feelings of terror but, in fact, would allay public fears and inspire public confidence.

The prominent and influential engineer John R. Freeman extended Newell's concerns and, a few years later, made a point of alluding to the "psychology" of dam design when promoting the construction of massive structures that he proclaimed would "inspire public confidence."[18] For Freeman, monumentality was most notably associated with masonry and concrete gravity dams, and he sought to denigrate buttress dam designs (such as that used for the Big Bear Valley Dam in Southern California in 1911) on grounds that their less massive visual appearance necessarily made them less desirable for large public works projects. The author finds Freeman's emphasis on the importance of visual appearance and "psychology" in dam design to be historically significant and worthy of recognition, especially because Freeman served as president of the American Society of Civil Engineers in the early 1920s, and, as a proud graduate of the Massachusetts Institute of Technology, he also championed the importance of university training for engineers. Make no mistake, Freeman was no gadfly operating at

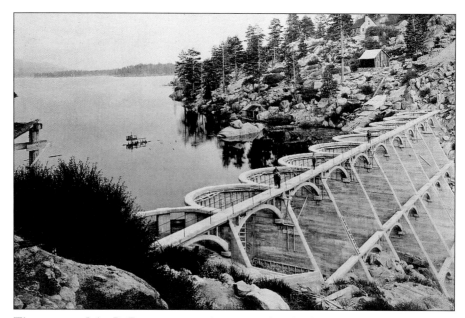

The engineer John R. Freeman strongly criticized multiple arch buttress dams—such as the Big Bear Dam, built in 1910–1911 in Southern California by the engineer John S. Eastwood—as being "lace curtain" structures in which "the psychology of these airy arches" extending between the buttresses was "not well suited to inspire public confidence." If monumentality is to be equated solely with a solid downstream façade, then, in Freeman's view, buttress dams will necessarily be found wanting.

the fringes of the civil engineering fraternity. He occupied a central place in the world of hydraulic engineering and, in his capacity as a prominent consulting engineer, exerted great influence on the practice of early twentieth-century American dam building.[19]

In highlighting Freeman's invocation of visually based "psychology" as an appropriate criteria for assessing the suitability of dam designs, the author does not believe that notions of monumentality are necessarily constrained by Freeman's proscription tying it to massive embankments or to masonry and concrete gravity designs. While massive dams are perhaps more readily amenable to the monumental ideal, large flat-slab and multiple arch buttress dams are not anathema to the concept. For example, the four-thousand-feet-long Grand River Dam, built in northeastern Oklahoma in the 1930s, shows how multiple arch dams could be imbued with a sense of monumentality. While buttress dams present facades quite different from those of traditional gravity dams advocated by Freeman, they can offer a distinctive sense of monumentality and civic achievement that transcends mere bulk and mass. Of more general import, Freeman's identification of visual appearance, and public perception, as a factor in dam design has proven of lasting significance, even as it has dropped from the overt conscious-

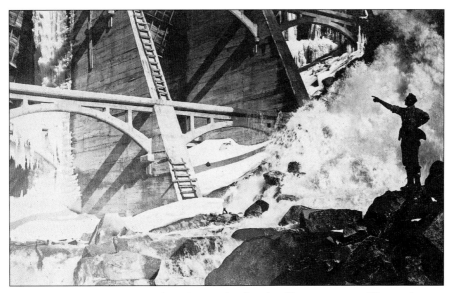

Big Bear Dam's downstream face during the floods of January 1916. This real photo postcard illustrates the graceful design of Eastwood's strut-tie beam arches. But this structural feature is what John Freeman criticized as "airy arches" that would not inspire "public confidence."

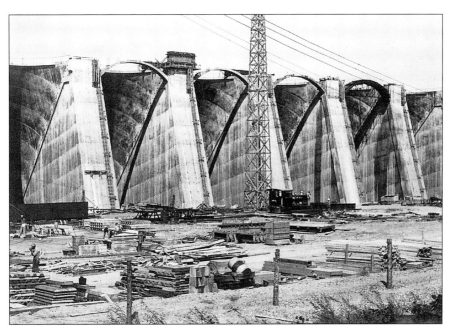

Freeman was an influential engineer and his "lace curtain" critique had a telling effect. In 1924 the European-trained engineer Fred Noetzli proposed the construction of "hollow buttress" multiple arch dams that, while they would not necessarily use any less concrete, presented a more massive appearance than "lace curtain" designs like those used at Big Bear. This view shows how Noetzli's concept was adopted for the Grand River Dam in the 1930s.

ness of both dam engineers and the public at large. Monumentality in large-scale dams is no accident but has long held a place in dam design protocols.

Pastoral and Monumental Conjoined

While the pastoral and the monumental represent two ideals, most dams exist somewhere on a continuum between the two extremes. For example, beaver-built dams formed from branches and brush laboriously extracted from nature's wood-lots represent a special and distinctive form of pastoral dam, a structure devoid of human labor but that nonetheless transforms the balance of nature in dramatic ways.[20] Within the riverine landscape, beaver dams can stand as true monuments, monuments not to human ingenuity but to a more primal creative energy. Humans can identify with the persistent labor and skill underlying the beaver's accomplishment and thus perceive them as something significantly more than simple pastoral relics of nature. References to beavers as "nature's engineers" abound. Conversely, human engineers often adopt beavers as a symbolic mascot or icon to publicly herald their work on projects of great size and complexity.[21]

As evidence of the regard that beaver dams were accorded by engineers, the 1911 edition of Edward Wegmann's landmark treatise *The Design and Construction of Dams* includes special notice of beaver dam technology. Specifically, Wegmann quotes the famed conservationist Enos Mills's description of how beavers undertake the task of dam building:

> A few worked singly, but most of them were in groups. All worked quietly and with apparent deliberation so that it was a busy scene. "To work like a beaver!" What a stirring exhibition of beaver industry and forethought I viewed from my boulder pile! At times upward of forty of them were in sight. Though there was general cooperation, yet each one appeared to do his part without orders or direction. Time and again a group of workers completed a task and without pause silently moved off to begin another. . . . It produced a strange feeling to see so many workers doing so many kinds of things effectively and automatically.[22]

A beaver captured on film in the wild. Beavers can be enormously determined in gnawing down trees, building dams, and impounding streams, all for the purpose of protecting access to their mid-pond lodges.

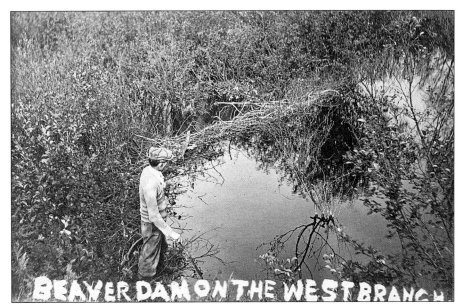

A typical beaver dam across West Branch at an unidentified location, probably in the northeast United States. The pastoral ideal of dam building is well illustrated in this modestly sized structure that (despite its nonhuman origins) uses locally available materials to alter the riverine environment in ecologically significant ways.

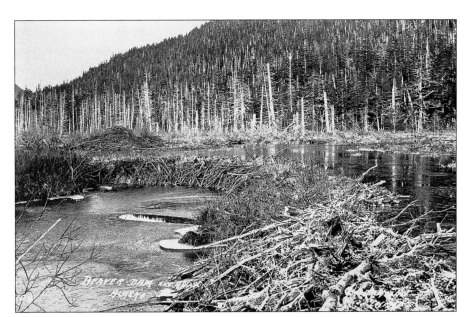

A mammoth beaver dam located in Alaska dating to the 1920s. Beavers can work together in large groups to construct wood and brush dams that—in their own way—achieve a measure of monumentality. Note the size of the beaver lodge in the center-left background. Human dam builders have admired the energy, resourcefulness, and skill that beavers bring to their work, seeing in them a natural counterpart to their own efforts to transform river basins.

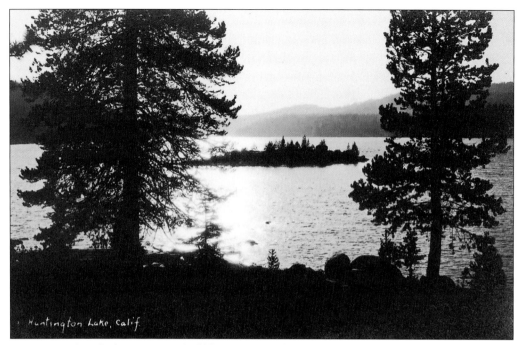

Huntington Lake, Calif.

A real photo postcard of Huntington Lake, circa 1930, lending credence to the claim that "nature must have designed this spot to cradle a lake." Of course the lake in question is actually a hydroelectric power reservoir seven thousand feet above sea level, but it is easy to appreciate how the public could perceive the lake as a fortuitous melding of nature and artifice on a grand, yet pastoral, scale.

The complex interrelationship between the pastoral and monumental is not limited to beaver dams. For example, consider a description from the 1920s of Huntington Lake, a hydroelectric power reservoir high in California's Sierra Nevada east of Fresno: "Nature must have designed this spot to cradle a lake . . . and waited patiently for the men of wide vision and vast resources to wall up the narrow outlets with their titanic buttresses of steel and concrete . . . and the beautiful lake, following the contours of the mountains, not only serves the useful purposes of industry but has added to this wonderland a new jewel glowing in its pine-fringed setting."[23] The rhetorical flourish of this description could be dismissed as little more than the musings of an enthusiastic copywriter paid to promote a mountain lake tourist resort. Yet many people who came to visit this reservoir possessed little interest in the fact that it was not a natural lake. They experienced it as simply a feature—a very attractive and inviting feature—of the mountain landscape. Of course, the dam (actually three discrete dams) and the artificial reservoir it impounds exist first and foremost as productive components of California's electric power grid. Nonetheless, the reservoir has achieved a cultural status within the public mind that transcends utilitarian issues of kilowatt hours. The dams responsible for Lake Huntington comprise a part of the

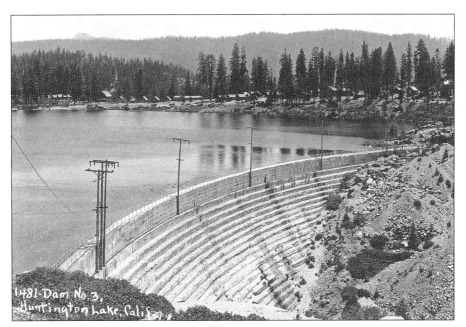

1481-Dam No. 3,
Huntington Lake, Calif.

Dam No. 3 at Huntington Lake, circa 1930. While the monumental character of this concrete curved gravity dam would seem to belie the notion that the reservoir is in anyway "natural," the vacation cabins in the background attest to how the lake was becoming a place where people could retreat from the hurly-burly of urban California. Of course, such hurly-burly is exactly what hydroelectricity produced by the reservoir helped to create.

landscape that is integrated into—and in the eyes of the public not so distinct from—the natural terrain. While the reservoir may have assumed a "natural" quality, this by no means meant that public visitors thought it should be left unused by humans. By the 1940s Huntington Lake had become a destination for mountain recreation, a place to enjoy a new, almost oxymoronic, form of "pastoral pastime": motorized boating and water skiing at seven thousand feet above sea level.

Huntington Lake was hardly the first construct of hydraulic engineering that elicited pronouncements of how humankind (or "man") had completed or extended nature in some logical and beneficial way. For example, in her book *The Artificial River* Carol Sheriff describes how rhetoric celebrating the planning and completion of the Erie Canal in the early nineteenth century often drew upon such imagery.[24] What is noteworthy is not the singular importance of Huntington Lake in creating a landscape that environmental historians such as William Cronon have characterized as "second nature," rather its significance resides more in highlighting how twentieth-century dams could be, in the public mind, readily seen as straddling the worlds of both the pastoral and monumental.[25]

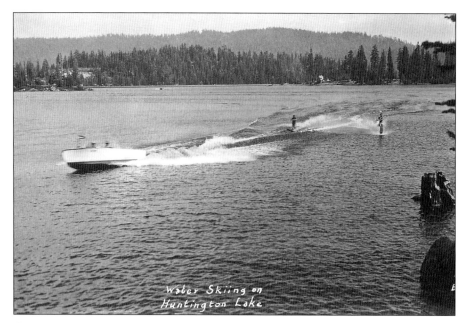

Water Skiing on Huntington Lake

Once large reservoirs are in place, people can use them in unanticipated ways. Here, the placid waters of Huntington Lake are transformed into a playground for motorized water sports in the 1940s. By the mid-twentieth century, "recreational" use of reservoirs was eagerly embraced by a large segment of the American public seemingly little interested in seeking out places for pastoral reflection.

Finally, in reconciling the themes of pastoral and monumental, consider the South Fork Dam built above Johnstown, Pennsylvania, in the mid-nineteenth century. Originally designed to store water for the Pennsylvania Canal and later used to impound a lake controlled by wealthy Pittsburgh businessmen seeking a bucolic vacation retreat high in the Allegheny Mountains, the South Fork Dam collapsed in late May 1889 after heavy rains overtopped the earthen structure.[26] The resulting deluge killed at least 2,200 people as the raging torrent ripped through Johnstown and other communities below the dam. The Johnstown Flood undoubtedly constituted a disaster of monumental proportions, and, more than 120 years later, it still resonates as one of America's greatest tragedies. But examine a postcard view produced after the flood that featured one of but a few known photos of the dam taken before its destruction. It would be difficult to envisage a more pastoral scene; nonetheless the tremendous destruction attending the dam's collapse stands as one of the most horrible disasters in American history.

(Opposite, bottom) The frightful power of the flood that struck Johnstown in 1889 is captured in this scene of urban carnage. Twenty years later, the disaster still held public interest, spurring production of numerous postcards.

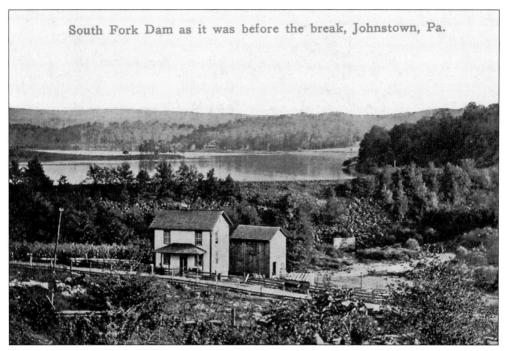

South Fork Dam as it was before the break, Johnstown, Pa.

The South Fork Dam in western Pennsylvania printed as a postcard twenty years after its collapse on May 31, 1889. The serene setting for the earth embankment dam evokes a pastoral landscape where both humans and nature are easily accommodated. But when rising storm waters overtopped the dam the embankment eroded, unleashing a torrent of almost five billion gallons upon Johnstown and the Conemaugh River Valley. The destruction reached monumental proportions (over 2,200 people died), galvanizing the nation and highlighting the horrors that could accompany the transformation of nature on a massive scale.

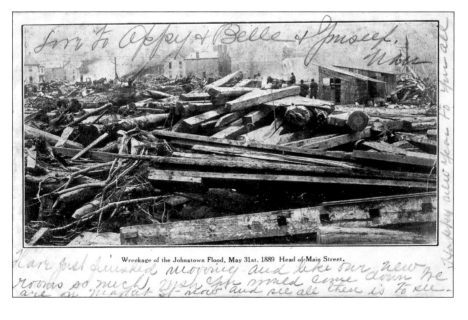

Wreckage of the Johnstown Flood, May 31st, 1889 Head of Main Street.

The dichotomy inherent within the appearance and eventual fate of the South Fork Dam—simultaneously *both* pastoral and monumental—brings to the forefront the complexity that dams hold within contemporary society. The ideals of pastoral and monumental posited in this book are not meant to constitute a rigid construct in which particular dams must be either-or. Rather, they are offered as a way for readers to think about dams and about the way that people have integrated, both consciously and otherwise, an awareness of dam technology into their lives.

Dams and Landscape

This book has two basic goals. One is to convey to a modern audience an understanding of how dams were used by people in the nineteenth and twentieth centuries to do things that they considered of value. The second is to explore how people's relationship to, appreciation for, and concern about dams is reflected in images and messages presented on postcards and related photographica. To achieve the first goal, this book offers a wide-ranging chapter illustrating how people used dams for logging, navigation, milling and factory production, irrigation, municipal water supply, flood control, hydroelectric power, and recreation. To address the second goal, the book offers a chapter on the history of postcards and their place in American culture, as well as chapters on dam design and construction techniques and on dam disasters. A separate chapter examines how massive monumental dams assumed special cultural significance during President Franklin Roosevelt's New Deal of the 1930s; this is followed by a chapter highlighting myriad environmental issues that, by the latter part of the twentieth century, engendered widespread public concern. In conclusion, I consider the ways that both dam building and the status of postcards in American culture changed in the latter half of the twentieth century.

Traditional forms of text and written exposition are not ignored in *Pastoral and Monumental*. Nonetheless, the analytic focus is on the images themselves and on the way that these images are embedded in the cultural construct of postcards, a construct that includes how people used them in the joy, sorrow, business, and routine of their public and private lives. The notion of landscape referenced in the book's subtitle thus encompasses both the *physical* landscape that dams transformed as well as the *cultural* landscape that dams inhabited in the minds of people who built, relied upon, observed, and at times despised them. In this, postcards serve as an entrée into the minds of the American people, offering a way to enhance understanding of water control technology's place in the cultural and socioeconomic life of the nation.

POSTCARD CULTURE

Picture postcards seemed to arrive with great suddenness in early twentieth-century America, but they only flourished because of cultural and technological innovations brought to fruition in the prior century. First and foremost, the U.S. Postal Service created an expansive network allowing for rapid, reliable, and modestly priced mail delivery. By the mid-nineteenth century this fostered—in the phrasing of the historian David Henkin—a distinctive "postal culture" engaging Americans across both the geographic and the socioeconomic landscape.[1] In addition, the cultural phenomena of picture postcards depended upon the commercial exploitation of photography and upon inexpensive printing techniques allowing images (both black and white and color) to be manufactured in mass quantities. At the start of the twentieth century, synergistic interaction among a vibrant postal system, a rapidly evolving photographic and printing industry, and a population fascinated by visual images germinated a postcard culture that, on a scale unimaginable just a few years before, quickly captivated America.

Nineteenth-Century Postal Culture

After breaking free from Britain in 1783, national leaders understood the value of a communication system that could tie together the former colonies.[2] The U.S. Constitution authorized Congress "to establish Post Offices and Post Roads," and, acting on this enumerated power, Congress created a federal post office. As the nation expanded westward, the proliferation of post offices and post roads proved

astonishing; by 1830 the system covered the entire region east of the Mississippi River, encompassing 72,000 miles of post roads and 4,500 post offices. Communication by mail quickly became an essential component of the national experience, and, although high postage rates did not encourage private letter correspondence, the distribution of newspapers and printed journals thrived.[3]

The early U.S. mail system operated quite differently than what we now take as the norm. For example, during the first part of the nineteenth century, the recipient, not the sender, paid the postage. In addition, postal rates initially depended upon the distance a letter traveled. Over time, rates and policy largely set in the 1790s came to be seen as onerous, and the public clamored for reform.[4] Change began in 1845 when Congress instituted a "flat rate" postage structure where letter delivery for distances less than 1,500 miles required five cent postage (for greater distances, ten cents). By 1851, a flat rate of three cents for delivery up to 3,000 miles was allowed for prepaid letters. In concert with flat rates, starting in 1847 Congress authorized prepayment of postage using "postage stamps" affixed directly to letters. By 1856 both prepayment and postage stamps were compulsory.[5]

These midcentury changes marked a major transformation of the mail system and its place in American life. Previously, the high cost of postage had discouraged the less advantaged to make much use of the Postal Service. But as flat rates took hold, and as family and personal networks extended over ever greater distances (the California Gold Rush of 1849 did much to stimulate transcontinental communication), the Postal Service became an essential part of life, cutting across class and culture.[6] No longer was letter writing a privilege and practice of the well-to-do. Now Americans of all backgrounds and means sought to maintain correspondence—and relationships—with people both near and far. A new postal culture took root, one where "a critical mass of Americans began reorganizing their perceptions of time, space, and community around the existence of the post."[7] As a postal agent of the 1850s dramatically trumpeted, "imagine a town without a post office! A community without letters! 'Friends, Romans, countrymen, lovers' particularly the lovers, cut off from correspondence, bereft of newspapers, buried alive from the light of intelligence, and the busy stir of the world! What an appalling picture!"[8]

During the Civil War the importance and pervasiveness of postal culture did not abate, and in fact it expanded, as millions of men were mobilized and billeted far from home. The U.S. Postal Service provided invaluable service in connecting soldiers to their families, further ingraining "the post" into the life of the nation. Once the war ended, systemic growth continued as railroad transport became fully integrated into the Postal Service.[9] By 1864 special railway post office (RPO) cars were in operation, allowing letters to be sorted and postmarked as they rolled down the track.[10] Now, in the space of a few hours, letters could travel hundreds of miles with replies received in a matter of a few

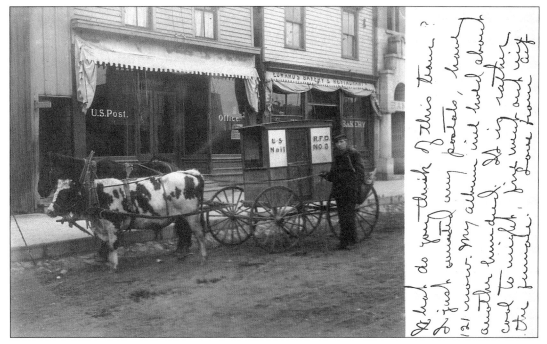

A view of rural free delivery wagon No. 3 in Weyweaga, Wisconsin, postmarked May 20, 1906. The teaming of a horse and a cow may have been unusual, but RFD wagons were ubiquitous features of small town and rural life when the postcard craze swept the nation. Note that the message is primarily about postcard collecting: "I just curated my postcard collection, have 121 now. My album will hold about another hundred."

days, maybe less. Yes, the telegraph (first connecting Washington, D.C., with Baltimore in 1844) was faster, but it was far more expensive and, for the typical American family, remained a rarely used medium throughout the nineteenth century.[11] In contrast, letter writing had become an egalitarian pursuit, inculcating almost every level of American society.

Never static, America's postal culture gradually evolved away from a system where people received mail by going to a community post office. While home delivery was practiced in a few cities as early as the 1820s, in the antebellum era carriers only rarely brought mail directly to a business or domicile. Change came in 1863 when Congress explicitly authorized urban home delivery, but for many years delivery via carrier was nominally restricted to cities with populations exceeding fifty thousand. Home delivery in towns with populations of ten thousand (even less if the postmaster general agreed) was sanctioned in 1887 and, starting in 1896, rural free delivery (RFD) for farmers came to select parts of the United States. In 1902 RFD became available nationwide and, just as the postcard craze was poised to explode, RFD routes brought the last bastion of rural Americans into regular contact with the national Postal Service.[12]

R. D. HAWLEY'S
TRADE PRICE LIST
New Crop Turnip Seeds.

June 22, 1875.

Early White Flat Strap Leaf, per lb.,		40c.
Purple Top Strap Leaf,	"	40c.
Large White Globe,	"	40c.
Long White, or Cow Horn,	"	40c.
New Sweet Yellow Globe,	"	50c.
Yellow Stone,	"	50c.
Yellow Aberdeen,	"	50c.
Yellow Russia,	"	50c.
Sweet German, or Rock,	"	60c.
Shamrock Ruta Baga,	"	35c.
American Ruta Baga,	"	50c.

5c. per lb. less on orders for 25 lbs. or over.

New Crop Timothy and Red Top Seed received in August and September.

Seed and Agricultural Warehouse,
492 and 498 Main St.,
HARTFORD, CONN.

(Above) A government issued U.S. Postal Card sent from Hartford, Connecticut, in June 1875.

(Left) Reverse of the card above, showing how R. D. Hawley kept prospective customers posted on turnip seed prices. Hawley bought prestamped blank cards from the post office and then printed his price list on the back.

It was within the rapidly evolving post–Civil War Postal Service that government-sponsored postcards entered the epistolary milieu. Nothing in the early nineteenth century precluded someone from sending a simple flat card through the postal system so long as they paid the same postage required for a regular letter. In fact, an 1861 patent for such a "mailing card" was issued to John Carlton of Philadelphia. After Carlton transferred his patent to John Lipman, it was explicitly marketed as Lipman's Postal Card, for use in commercial advertising.[13] Perceiving a potential market for short messages sent absent an envelope, in 1873 Congress allowed the Post Service to manufacture and sell prestamped United States Postal Cards. These cards could be sent through the mail system to any domestic address at a flat rate of a single penny—hence the ubiquitous term *penny postcard*. The side of the card with the printed stamp was for the recipient's address, while the reverse was reserved for a written message or printed missive.

The simple, inexpensive means of communication provided by government-sponsored postal cards immediately found an audience: over sixty-four million were issued in 1873, and growth continued as the new century approached.[14] Use was by no means restricted to personal communication with businesses quickly embracing postal cards as a way to reach both long-standing and potential customers. Buying cards in bulk, commercial firms would print advertisements or notices on the message side. By the 1870s and 1880s, penny postcards occupied an important place in American life, but they had yet to spark a social frenzy with people avidly buying, collecting, and exchanging views on a massive scale. The advent of a postcard craze—and all the commercial and cultural possibilities it engendered—needed to await developments in the worlds of photography and graphic printing.

The Business of Photography

The formal invention of photography is generally dated to 1839, when Louis Daguerre publicly demonstrated his ability to fix visual images on copper plates (creating what came to be known as daguerreotypes). Fox Talbot soon followed with a calotype process that created "negative" renderings of a scene and the technology of photography embarked upon an intense evolution that has yet to abate. Like Polaroid instant snapshots of the mid-twentieth century, daguerreotypes were unique in the sense that they existed only as a single positive image. The images were fixed upon a thin sheet of copper, and daguerreotypes were prized by many people for personal portraits because of their rich, clear tones. In the latter 1840s daguerreotypes achieved significant commercial success and drove the growth of photography as a business.[15] Cheaper processes analogous to Daguerre's technique were later developed for iron plates; this relatively inexpensive ferrotype technology (commonly called tintype, although tin was rarely used in their production) continued to be used through the late nineteenth century. However, by

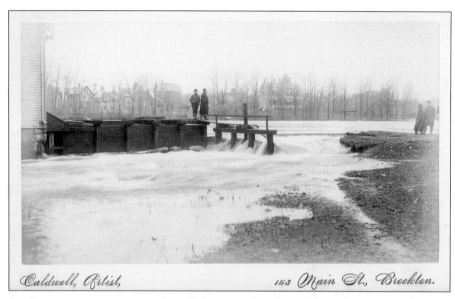

Caldwell, Artist, *143 Main St., Brockton.*

A cabinet view, circa 1880, of a mill dam near Brockton, Massachusetts, on the verge of washing out. Mounted on a stiff paperboard, the image was printed by the local photographer and artist Caldwell, doing business at 143 Main Street.

the 1850s, daguerreotype and related technologies began to fade in commercial importance because, unlike Talbot's colotype process and the later ambrotype technology, they were not amenable to the creation of photographic negatives and multiple prints of the same image.[16]

Early photography, which depended upon long exposure times to fix images, was largely confined to indoor studios. But interest in documenting outdoor scenes and the physical landscape came quickly as photographers expanded the commercial possibilities of the trade. With the diffusion of the wet plate collodion process in the 1850s, it became possible to capture—and distribute to a fascinated public—visual images of the expansive world of cities, towns, farms, forests, or essentially any well-lit place accessible to photographers and their (still) bulky equipment.

In the 1850s the business of photography experienced explosive growth. Images of all types attracted public interest, and this, in turn, spurred production of evermore images to meet a voracious market demand. Compared to what became possible a few decades later, photography in the mid-nineteenth century was cumbersome and time consuming, but technological innovation was driven by widespread public demand for views of the world both near and far. Starting in the 1850s and continuing through the remainder of the century, views for public sale were printed on attractive rigid boards designed for display in homes or offices. Generically referred to as cabinet cards (or cabinet views), such views were similar in format to many portraits of individuals (carte d'visite) or of families that were commissioned directly from a local commercial photographer. But

Cabinet view of the concrete curved gravity Bulls Run Dam near Portland, Oregon, circa 1895. This "great dam" represented a major civic undertaking by the City of Portland to provide an abundant, healthy water supply. The monumental character of the enterprise was enhanced by Ransomes' Patent Concrete Finish, which mimicked the appearance of stone masonry construction.

Stamp on reverse of the Bulls Run Dam view, advertising that it was taken by W. B. James at 226 Burnside Street. Available for commercial sale, the Bulls Run Dam view is identified as "No. 90" with duplicates printed "at any time."

the subject matter of cabinet views could extend far beyond studio and family settings and encompass any buildings, structures, and landscapes accessible to a photographer; as the years went by, and equipment became less bulky, the range of subjects and images available for purchase expanded commensurately.[17]

In terms of widespread commercial appeal, stereo views (sometimes more formally referred to as stereographs) constituted one of the most popular photographic formats available after entering the marketplace in the 1850s. Stereo views were created by placing two cameras adjacent to one another, their lenses separated by only a few inches. Thus, two similar—but not identical—images could be used to record a scene and then be printed side by side on a rigid rectangular card. Because the two images were recorded from slightly

Cabinet view of an ornately dressed women gazing at small overflow dam. While the photograph provides no clue as to where or by whom it was taken, the embossed border reflects the image's importance. Likely this was not printed for commercial sale but was intended for a specific customer.

different locations the resulting stereo view could foster the illusion of three-dimensional depth. The earliest stereo views date to the 1850s, and the format quickly proved a big seller; in the following decades, they were frequently distributed in "series" covering a city, town, or region. The idea behind this marketing strategy was clear: photographers and publishers hoped that people would seek out more than individual views and instead purchase entire collections.[18]

Dams were frequently included as a part of stereo view series for the simple reason that they constituted significant structures within a community. And when a dam-related disaster struck, photographers would sense a market opportunity and rush to record the scene in stereo views. For example, when the Williamsburg Dam in western Massachusetts collapsed in May 1874 and killed more than one hundred people, several photographers rushed to the scene. Within days they had published a multitude of stereo views documenting the flood's destruction for distribution to a national audience. But even absent such tragedy, dams were commonly recorded in stereo views because photographers considered them to be subjects of interest to their customers.

In retrospect, stereo views undoubtedly comprised an important commercial precedent for the picture postcard industry of the early twentieth century. As with postcards, stereo views were produced in response to the desires of a public willing to spend money for the pleasure that came from looking at, owning, and

NO. 380 Fairmount Dam, Phila.

POPULAR SERIES. AMERICAN VIEWS.

(Top) A stereo view, circa 1870, of the Fairmount Dam and Waterworks in Philadelphia. Upon completion in the 1820s, the Fairmount Waterworks was celebrated throughout America as a major civic monument.

(Bottom) The collapse of the Williamsburg Dam on May 16, 1874, killed more than 130 people. Commercial photographers quickly flocked to the Mill River Valley to document the devastation. This stereo view by George Ireland focuses on the remains of the mill dam in the village of Leeds, about fifteen miles downstream from the failed storage dam (see chapter 4).

The Series to which this Card belongs is *underlined*.

No. 12 S. Bartlett's House
 Williamsburg, Mass

PUBLISHED BY

J. A. FRENCH, Keene, N. H.

10 BRIDGMAN'S BLOCK,

Portrait and Landscape Photographer,

WHOLESALE AND RETAIL DEALER IN

STEREOSCOPIC VIEWS.

General Catalogue furnished on application. Descriptive List of 100 Gems for the Stereoscope, representing Childhood Scenes, with a choice lot of Landscape, Floral and a few of a novel character. The above subjects can be had Plain or in Colors.
N. B.—Residences, Landscapes, Family Groups, Interiors, Wreaths, Crosses and Funeral Flowers made to order.

No. of Subjects.		No. of Subjects
Westmoreland.	36	Potter's Grove. 12
Fitzwilliam.	18	Lake Pleasant. 12
Harrisville.	24	Worcester, Mass. 50
Winchester.	36	Clinton, Mass. 50
Marlborough.	36	Barre, Vt. 18
Hanover.	29	Snow Scenes. 36
Keene.	100	Flowers. 48
Troy.	36	Claremont. 64
Nelson.	24	Royalston, Mass. 50
Swanzey.	18	Fitchburg, " 18
Hinsdale.	48	Sugar Scenes. 12
Chesterfield.	50	Keene Quarries. 30
"Spofford Lake" and Prospect House.		Charlestown. 44
Bellows Falls.	50	Surry. 12
Monadnock Mt.	72	Jaffrey. 12
American Select.	48	Mill River Val. 46
Public Garden.	12	Gems, colored. 125
Boston.		Miscellaneous. 1320
Mt. Auburn.	12	Dublin. 24
Navy Yard.	12	Gilsum. 24

J. A. French of Keene, New Hampshire, carried on an expansive stereo view business documenting New England landmarks and scenes—including the Mill River dam disaster. In creating a commercial market for local views, stereo view publishers established an important precedent for the picture postcard industry.

sharing images of the world. But (aside from creating an illusion of visual depth) stereo views differed from postcards in two significant ways. First, stereo views were generally more expensive than postcards. Prices for stereo view cards in the nineteenth century could reach as high as twenty-five cents per card (if purchasing a series, the price per card dropped). In contrast, postcards in the early twentieth century commanded a retail price of a penny or two a card (some premium cards might cost a nickel or more). In a world where an annual salary of five hundred dollars represented a very good wage, the difference between a few pennies and twenty-five cents was hardly insignificant.

Second, while both stereo views and postcards were sought out and amassed in privately held collections, only postcards were designed to be sent through the mail. Postcard collectors frequently traded and exchanged views with their fellow collectors, and they did so on a scale that dwarfed comparable activity by stereo view collectors. And postcards allowed for a vast, informal system of information and image exchange as people other than collectors communicated messages to one another in the normal course of their lives. Stereo views did not disappear as cultural artifacts after the advent of picture postcards, but—compared to their earlier status—after the beginning of the twentieth century they occupied a limited niche in the marketplace of photographic images.[19]

Early Souvenir and Private Mailing Cards

During the nineteenth century, American correspondents were not forbidden to send simple, unsealed cards through the Postal Service. However, because the cost of sending such cards was the same as sending a letter in a sealed envelope, the practice held little allure. This changed in 1873 when Congress allowed the Postal Service to sell cards with a prepaid postage of one cent. Now it was possible for

The Columbian Exposition of 1893 in Chicago inspired numerous "souvenir cards" featuring colorful lithographs printed on U.S. Postal Cards. The Columbian Exposition is often credited as introducing Americans to picture postcards.

people or businesses to purchase cards and print messages or images on them. But the picture postcard industry was not sparked simply by a change in postage rate policy, it also required changes in how easily and cheaply images could be imprinted on cards.

High-quality image reproduction had become possible in the early nineteenth century as lithographic printing techniques began to flourish. By mid-century, lithography spawned a greeting card industry that—in ways we would find recognizable in terms of modern colorized greeting cards—provided a way for people to commemorate birthdays, holidays, weddings, and anniversaries.[20] But chromolithography (as it was often termed in this era) produced images that, while not outlandishly expensive, served a relatively select market of well-to-do consumers. Eventually technological innovation allowed for more modestly priced lithographic imagery, and by the twentieth century European printing companies had found ways to bring manufacturing costs down to a point where postcard-sized images could be economically produced in large batches. German companies proved particularly adept in developing the technology, and, prior to the outbreak of the First World War in 1914, companies in Leipzig, Dresden, Berlin, and elsewhere in Europe played a central role in the international postcard industry.

In concert with chromolithography other less costly methods of printing graphic images entered the marketplace during the latter nineteenth century

Europe led the way in creating a postcard culture of visual communication. This multi-view card, postmarked February 1901 and sent from Cairo to Lexington, Massachusetts, shows the Aswan Dam under construction in southern Egypt. This structure (as opposed to the New Aswan Dam built by Soviet engineers in the 1960s) was the product of British engineering. But notice (on the left margin) that the card is of German manufacture, "A. Gianny & Co. L. Feist, Mainz."

and provided new ways to disseminate pictures to a mass audience. The most common of such images depended upon the halftone process in which black-and-white images are recorded as a field of black dots and in which variation in the sizes of these dots create shade and light, mimicking the composition of the original image. Halftone images were cheap to print (they were a staple of mass-produced tabloid newspapers), but they lacked the depth and detail of either photographs or lithographs. Nonetheless, the proliferation of halftone technology encouraged entrepreneurs to enter the printing business as the postcard craze took hold in the early twentieth century. By 1900, there also existed a widespread network of local and regional photographers who, having found commercial success in meeting demand for cabinet views and stereo views, were well positioned to print and sell real photo postcards (RPPCs) for local markets. Just as importantly, these professional photographers also provided the original images that far-distant printing and manufacturing companies could use as a basis for postcard production.

As it turned out, European manufacturers led the way in exploiting opportunities presented by the congruence of widespread photography, inexpensive

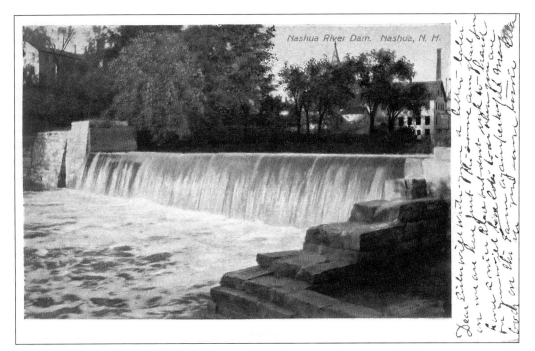

Nashua River Dam, Nashua, N. H.

Black-and-white photographs and halftone prints were important components of
the early postcard industry. But inexpensive, high-quality color printing proved a
significant spur to the trade, and European printers led the way in this technology.
Manufactured in Germany, this view of a mill dam in Nashua, New Hampshire,
demonstrates the picturesque renderings that were possible with color printing.

printing, and an expansive postal system. The popularity of postal cards in late
nineteenth-century Europe spurred interest in the United States, and souvenir
cards featuring scenes of the Chicago Columbian Exposition in 1893 are usually
considered to mark the beginning of the American picture postcard.[21] The post-
card trade grew modestly through the 1890s, but the wheels of commercial in-
novation were turning. At the end of the decade a key modification in American
postal policy laid the groundwork for major change.

On May 19, 1898, Congress authorized the use of private mailing cards
(PMCs) that could be printed by private companies, sold directly to the pub-
lic, and—after affixed with a one cent stamp—mailed anywhere in the United
States (two cents was required for international delivery). At last, the penny
postcard business was no longer chained to cards manufactured and sold by
the U.S. Postal Service. And with the government monopoly broken, penny
postcards began a new relationship with American culture (in 1901 the need to
print PMCs was dropped, but the use of PMC as a labeling device lingered for a
few years). Like government postal cards, PMCs and all cards sent prior to 1907
were required to devote one entire side to the stamp and the address; because
the address on early cards does not share space with the message, they are com-

King's River Dam at head of Peoples Ditch, near Hanford, Cal. *B. D. Frame.*

Thanks for your favor. Will exchange if you wish. Hanford, Calif.

Another subtly colored view printed in Europe. This one illustrates an irrigation dam in California's San Joaquin Valley south of Fresno. The undivided back (UDB) card was mailed from Hanford to Marlboro, New Hampshire, in April 1906.

monly referred to as undivided back (or UDB) cards. In 1907 postal regulations were changed to allow both the address and the message to appear on the same side; as a result, post-1907 cards are often called divided back (or DB) cards. With this final change in format, postcards assumed the basic appearance they would retain for the next hundred years.

The Golden Age: Marketing and Production

What has come to be known as the golden age of postcards did not immediately spring forth when PMCs were authorized in 1898. But by 1904 the craze was picking up steam, and, from then until the outbreak of the First World War in 1914, postcards held a distinctive and special status within both American and international society. The magnitude and variety of cards produced and distributed during the golden age was tremendous; many hundreds of millions of cards were printed every year, and by 1910 the number of penny postcards sent annually through the mail system approached one billion.[22] Postcards might seem ephemeral to the modern eye, but in the early twentieth century they represented a huge business that captivated the hearts (as well as the pocketbooks) of people across the social spectrum. So how did this business work?[23]

To a significant degree, the postcard craze was impelled by highly motivated customers who would avidly seek out new and different views to fill out albums and to exchange with other collectors. Of course, not everyone who purchased and sent picture postcards was a passionate collector, and demand was driven

by many people who didn't exchange cards with far-flung correspondents. But there were a great number of people who made a point of haunting local post-card establishments, and, through the numerous sales these customers generated, dealers were pushed to replenish stock and seek out new views that could satisfy the voracious desires of the collector cadre. The nature of collector behavior is well illustrated by a card inscribed by a resident of Shelbyville, Indiana, that explicates how collectors pursued new views and made plans to visit out-of-town dealers to see what their stock might offer. The DB card shows an image of Nelson's Mill Dam on the reverse side and is of German manufacture (commissioned through the Indiana News Company of Indianapolis); the unnamed correspondent—who, because it bears no address or postmark, apparently sent the card in a larger packet—notes that she or he came across it because "our dealer [in Shelbyville] has replenished his stock and I was able to find some new ones." Significantly, the correspondent was planning to use an upcoming trip to Indianapolis as an opportunity to "get some good views while there." Postcards were not a product that collectors chanced upon by happenstance. They consciously visited local dealers and also sought out new venues in distant cities, where, they hoped, fresh views would present themselves. And even if someone was not a diehard fanatic, this did not mean that the pleasures of the postcard rack held no attraction. Postcard collection was not an either-or, yes or no

By 1905 the postcard craze was in full swing with specialty postcard shops open in many cities. Of equal importance, thousands of druggists and dry goods merchants across America discovered a new source of revenue in serving the postcard trade. The general store and post office in Lanesboro, Massachusetts—shown here in a view circa 1907—was one of the many thousands of establishments where picture postcards were sold.

Nelson's Mill Dam in Shelbyville, Indiana, makes for a nice pastoral view, featuring two young women on the upper right. But the scene seems unlikely to attract much special attention.

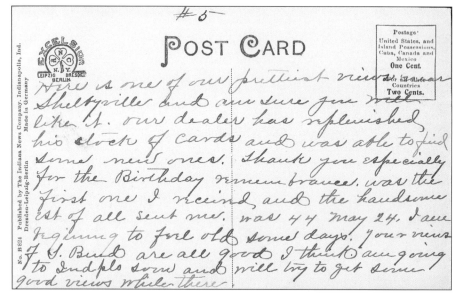

However, the inscribed message indicates that it was considered "one of our prettiest views near Shelbyville." Of more significance, the message documents how collectors would keep checking with local dealers for the latest views. And also note how the correspondent was planning a trip to Indianapolis in search of good views. Postcard collecting was not just a fad for young people, as the writer reveals that she or he had recently celebrated a birthday, turning "44 May 24."

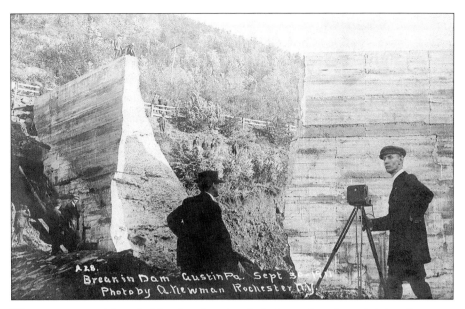

A28.
Break in Dam Austin Pa. Sept 3 - 1911
Photo by A. Newman Rochester N.Y.

The entrepreneurial zeal of local and regional photographers in sustaining the postcard industry is reflected in this view from 1911 that documents the Austin Dam failure in western Pennsylvania.

endeavor. All kinds of people purchased, sent, and appreciated cards, even if they did not obsess about when the next shipment of views might find its way to the local dealer.

As made apparent in the Shelbyville example, collectors and the general public could not drive the market for postcards if there were no places to seek out and find new views. Dealers were simply the flip side of the supply and demand equation, and people hoping to "feed their habit" were dependent upon businessmen (and perhaps some women) who had made a commercial investment in serving the postcard trade. The scale of such investments varied, ranging from a simple rack of cards near the cashier's box in a small drugstore to a large urban shop focused almost exclusively on the sale of postcards.[24] Local photographers could also participate directly in the retail market, and, along with filling orders for photographs that could be used as sources for scenic views, they could sell postcards on their own account. The entrepreneurial possibilities stimulated by the demand for postcards during the golden age were expansive. They were limited only by the resourcefulness of a prospective dealer in reading a market and in meeting the desires of collectors and the general public.

Most colorized and printed local views were manufactured at a printing plant far removed from the particular landscapes and townscapes they depicted. To illustrate how a merchant in some small town might come to possess a stock of local views, a card featuring the waterworks dam in Horton, Kansas, serves

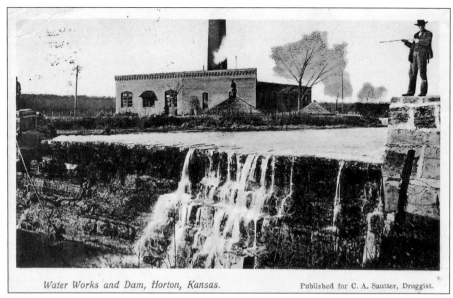

Water Works and Dam, Horton, Kansas. Published for C. A. Sautter, Druggist.

The municipal water supply dam in Horton, Kansas, circa 1907. Made for the local druggist C. A. Sautter, in Horton, Kansas, this divided back card (DB) was a product of a far-flung distribution system connecting small retail stores in the American heartland to industrial Europe.

No. 305. Publ. by The Ekstrand Drug & Book Co., Post Card Importers, Salina, Kansas. Made in Germany.

The credit line on the reverse of the Horton Dam card reveals that the Ekstrand Drug and Book Company of Salinas was the "Post Card Importer" who published the card for C. A. Sautter in Horton. Despite being published by a Salinas-based enterprise, the card was actually printed in Germany. Local-regional-national-international supply chains for local view cards were quite common.

as a good reference point. This card bears the imprint "C. A. Sautter, Druggist" on the front, while the reverse features the credit line: "Publ. By The Ekstrand Drug & Book Co., Post Card Importers, Salina, Kansas. Made in Germany." So how could a small druggist interested in selling views of the local waterworks (and presumably views of other local buildings and landscapes) get postcards manufactured in Germany?

In all likelihood a "drummer" (as in one who "drums up" business) for the Ekstrand Company was sent out from Salina to visit merchants in small towns throughout the state (and perhaps also in nearby Nebraska). This salesman met with Sautter and took an order for a selection of postcards that included the dam scene. By this point Sautter would have commissioned a local photographer to take a photo of the dam (or Sautter may have taken the photo himself if he possessed the requisite equipment). Combining this order with those from other small-town merchants, the Ekstrand Company subsequently placed a larger order with a postcard importing company. This unnamed company, probably

based in New York City, would then engage the services of a private publisher in Germany. Factory workers in Germany would take the dam photograph supplied to them, make a printing plate, and devise a color scheme deemed appropriate for the view. Upon printing and coloring, the cards were shipped back through the commercial chain until they reached Sautter and went on sale in his store. All this could take a few months or more from the time the drummer visited Horton and took Sautter's order.

Thanks to the fact that postcard companies would frequently use sample postcards as a medium for advertising prices lists, it is possible to get a direct sense of the economics of card production in the golden age. Several such cards are reproduced here; they cover an enterprise focused around the sale of high-end colorized views manufactured in Germany, a high-end American manufacturer, and mid-level American firms that sought to compete not on graphic quality but on price. Thus, around 1906 the Litho-Chrome Company of Berlin, Leipzig, and Dresden used a UDB card to publicize their willingness to supply one thousand cards of a scene for $12.00, with a minimum order of a thousand. Not exactly cheap, especially given that the buyer had to agree to purchase a thousand cards featuring a single scene. But the sheer magnitude of local view cards manufactured by companies like Litho-Chrome attests to the willingness of the American market to "bear the freight" and pay for the quality that European cards often (but not always) delivered.

In contrast to the Litho-Chrome offer, consider what the Albertype Company of Brooklyn proposed to prospective buyers in February 1908. Albertype's price per thousand "hand-colored" cards was relatively close to the Litho-Chrome quote, but the American company allowed for batches of only five hundred cards. Because of fixed costs incurred regardless of print-run size, the smaller batch was more expensive on a per card basis. But local retailers might logically calculate that five hundred cards of a particular view would satisfy market demand and that purchasing an additional five hundred cards of a scene was imprudent despite lower unit costs. Also notice how Albertype required buyers to place orders for at least five different views to get the prices quoted; the more views that were ordered, the cheaper the cost per card for all the views. Presented with the varying price and order size options, a prospective buyer had to weigh carefully what was best for them. The postcard industry was all based around entrepreneurship, and every player had an incentive to "read the market" in order to minimize slow-moving stock and maximize profits. To do otherwise was to court financial calamity.

While Albertype sought to compete on quality with other high-end manufacturers, other American companies adopted a different tack and offered significantly lower prices for products of less graphic quality. Thus the Souvenir Post Card Manufacturing Company of Rockford, Illinois, was willing to supply a thousand colorized local view cards for only $5.50. And if the buyer was will-

The premium price often placed on colorized German cards is evident in this ad, circa 1906, for the Litho-Chrome Company of New York, Leipzig, Berlin, and Dresden. "High grade colored" views could be ordered at $12.00 per "1000 of a subject."

PRICE REDUCTION.

Brooklyn, N. Y., February 1, 1908.

The Albertype Co's POST CARD
HAND-COLORED

Place Stamp Here.

Domestic 1 Ct.
Foreign 2 Cts.

This space may be used for Correspondence		This space is for the Address only		
Made to order in 4 to 5 weeks		**By 5**	**10**	**20 and more Designs**
				ordered at one time
500 Cards of a design (hand-colored)$7.00	$6.75	$6.50	
1000 " " " " "10.75	10.50	10.00	
2000 " " " " per 1000	10.25	10.00	9.50	

Terms: Net Cash Following editions at the same rates

For example taking 500 cards each of 10 designs at $6.75 (per 500) will amount to $67.50
" " 1000 " " 5 " 10.75 (" 1000) " " " 53.75
" " 2000 " " 5 " 10.25 (" 1000) " " " 102.50

When ordering **hand-colored** *post cards, please send prepaid the photographs and pencil on the margin (or on the back, if unmounted) the salient colors of the principal portions of the view, also the desired title and imprint. Do not write in ink or by typewriter on unmounted prints. The general color scheme, though, must be left to our artists. Photographs are not returnable.*

Packages of Illustrated Post Cards up to 4 lbs. can be sent by mail or express as "Printed Matter" at 8c. per pound.

Ask for edition prices of Souvenir Albums and Booklets.

THE ALBERTYPE COMPANY, 260 ADAMS STREET, BROOKLYN, N. Y.

The Albertype Company of Brooklyn, New York, was a prominent American publisher that competed with high-end German manufacturers. This ad card from early 1908 heralds a "price reduction" that compares favorably with prices quoted by the Litho-Chrome Company. Also note how customers were requested to provide "the salient colors of the principle portions of the view" with the caveat that "the general color scheme, though, must be left to our artists."

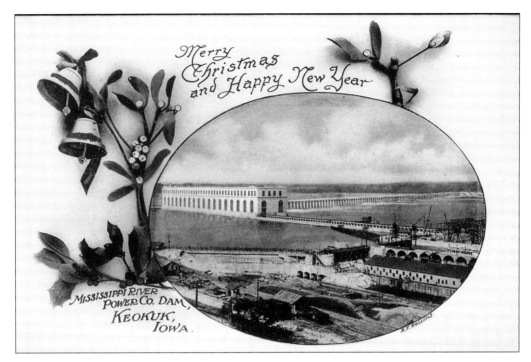

A good example of a hand-colored Albertype card.

ing to purchase five thousand cards of a single view, then the cost per thousand dropped to a mere $3.00. This was significantly less than Litho-Chrome or Albertype, but the quality was also cruder. The Quality Post Card and Novelty Company of Auburn, Indiana, further complicated the possible options by offering halftone, black-and-white "pebbled" local views for less than $5.00 per thousand, with a group order of five cards supplied at a rock bottom price of $22.50 (including an extra thousand generic greeting and comic cards thrown in for free!).

In all of this, individual merchants had to determine what best met their needs: low price or high quality, big print runs or smaller batches. And they also had to factor in delivery time, as views ordered from Europe might take months to arrive, while domestic delivery time for printed cards was generally measured in weeks. But even weeks could seem like an eternity for a merchant seeking to meet the desires of a discerning and impatient clientele. This was especially true for cards documenting local events and disasters, where interest might peak for a brief time but then rapidly fade. This brings to the fore the other big component of the local view postcard market: real photo cards.[25]

Real photo cards cost significantly more per card than printed views (see the Quality Post Card Company's price list card where real photo cards could

Local American printers saw an opportunity to compete with imports on price and delivery time, although the printing quality of domestically produced cards could prove problematic. The Souvenir Post Card Manufacturing Company of Rockford, Illinois, offered delivery times of weeks (not months) and cheap prices for relatively large orders.

Black-and-white halftone cards ("pebbled local views") were offered by the Quality Postcard & Novelty Company at less than half a cent per card. In contrast, real photo cards were available in small batches (a hundred cards) at almost three times the cost per card.

cost as much as $1.50 per hundred—the equivalent of $15.00 per thousand). But they possessed other advantages offsetting the higher price: they allowed for a relatively quick turnaround time, getting to dealers in a matter of a few weeks, if not days; and small batches of a hundred or less were often sufficient to meet market demand for a specific view. For a savvy dealer it was often far preferable to sellout a small order of more expensive cards than get stuck with hundreds of

The Beach Photo Factory of Remsen, New York, cultivated the small batch, real photo market with cards priced at "20 for $1.00." Local photographers across the nation often provided services similar to what Beach offered, facilitating production of many postcards that never would have been printed in the batch sizes of five hundred (or more) required by large manufacturers. This Beach ad was printed on a card documenting the Austin, Pennsylvania dam disaster of September 1911.

cards for scenes that had reached market saturation and were considered passé by local collectors.

Real photo cards also created a special category of views that were separated from the commercial culture of international and national postcard manufacturers. Amateur photography first began to flourish in the 1880s with the sale of Kodak box cameras. By the first decade of the twentieth century camera ownership was growing, and many people took pictures of local views on their own initiative and then had them printed on "postcard stock" photographic paper. Kodak and other photographic supply companies (going under the names Azo, Dops, Cyko, Kruxo, Velox, etc.) marketed heavy stock developing paper that was well suited for postcards.[26] All that was needed was for a local photographer to take a negative supplied to them by a customer and then print it on this heavy stock paper, and voila—a real photo postcard constituting a very particular and personal view became available to mail in a matter of days, perhaps hours.

In regard to dam postcards, real photo cards are particularly important because some of the most intriguing views are those apparently produced for an amateur and enthusiast market. This is evident in the following section on tropes and themes, where many of the images are often quite personal in the way they connect people to dams. What is also important about the vibrant market for real photo cards is the way it highlights the complex and highly diffuse character of the golden age postcard industry. Certainly there were giant firms with

Three young people having fun fishing below a mill dam. The view appears slightly out of focus, bringing into question whether it was a product of a professional photographer.

(Below) A message on the back of the fishing card reveals the picture's origin. During a visit to Aunt Bertha in Royalton (probably in Vermont), Claire, Louis, and Dell were captured for posterity after they "didn't get any fish." Amateur real photo postcards often offer intimate views connecting people and dams. As here, they were often not mailed, but nonetheless they were used to record scenes that could be shared with friends and loved ones.

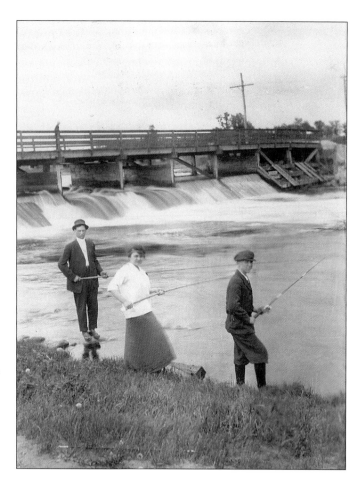

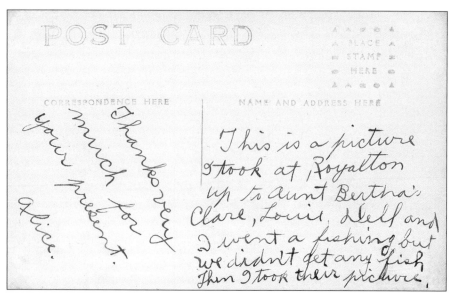

POST CARD

PLACE A
STAMP
HERE

CORRESPONDENCE HERE

NAME AND ADDRESS HERE

Thank you very much for your present. Alice.

This is a picture I took at Royalton up to Aunt Bertha's Clare, Louis, Dell and I went a fishing but we didn't get any fish Then I took their picture.

corporate tentacles stretching across continents, but there were also cards produced via a highly intimate relationship between amateur photo buffs and local camera and photography studios. And even giant companies relied upon a highly localized customer base to generate photos and place orders for the multitude of local view cards they printed. No doubt several large enterprises encouraged and commercially fed America's postcard craze, but the energy that sustained widespread interest in postcards during the golden age was not manufactured in some New York or Dresden boardroom. The energy sprang from a genuine desire by people across the United States—in cities, towns, and villages, large and small—to identify with, and share through postcards, a wide range of scenes comprising the world they lived in. Dams were simply a part of that world.

The Golden Age: Tropes and Themes

The postcard culture of dams is evident in views and personalized messages reflecting several enduring tropes and themes. Within the context of *Pastoral and Monumental*, tropes represent commonly recurring motifs (or patterns of correspondence) that both guided, and were guided by, the way that people used postcards in their everyday lives. What follows are a selection of views organized by several of the most notable themes. These categories are by no means inclusive of all the ways that dam postcards were used by the postal public, but they shine a light on the myriad ways that dam postcards intersected with the lives of people and communities.

Greetings and Standard Messages

Postcards of all sorts, whether greeting or local view, were commonly used to convey holiday wishes or information about the general well-being or health of the correspondent, a family member, or a close friend. In addition, a postcard often provided a quick way to let someone know that the sender was thinking of him or her or to give notice that a visit was in offing (e.g., "I will be coming home next week, hope to see you and Uncle Bill"). Local view cards seemed to lend a reassuring touch to such simple messages, but generic greeting cards—that is, printed postcards not tied to any specific location—could also provide a suitable format for such missives. At times, postcard manufacturers and distributors sought to combine the economic advantages of mass-produced greeting cards with the desirability of local view cards. This spawned a hybrid format that, through the application of local photos, allowed otherwise generic greeting cards to assume a local ambience.

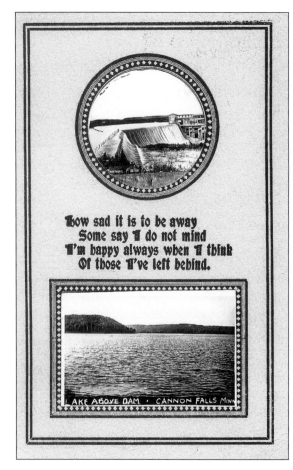

My dear friend: Corinth, N.Y.
July 6th '07
I recd. your postal & was delighted to hear from you. Will write you a "big" letter soon— This is Mr Mabie & self & a Mrs. Wakeley & our little girl, Maxine out on the big dam here.
Yours — Floy —

How sad it is to be away
Some say I do not mind
I'm happy always when I think
Of those I've left behind.

LAKE ABOVE DAM · CANNON FALLS MINN

(Above) A time-honored tradition is to use a postcard to make a promise: "Will write you a 'big' letter soon."

(Left) Photos of Minnesota's Cannon Falls Dam taken by a local photographer adorn this otherwise generic greeting card. The prepackaged poetry bordered on doggerel, but it could readily meet the needs of people who sought to convey a message but chose not to craft it themselves.

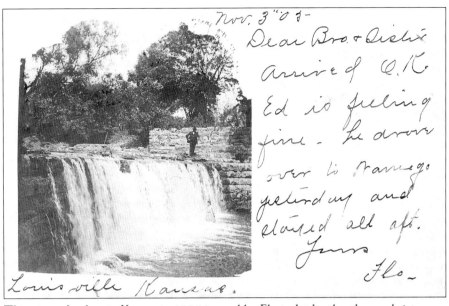

This view of a dam in Kansas in 1905 is used by Flo to let her brother and sister know that Ed (her brother or husband?) is "feeling fine." Quick updates regarding health were a staple of postcard messages from the earliest days.

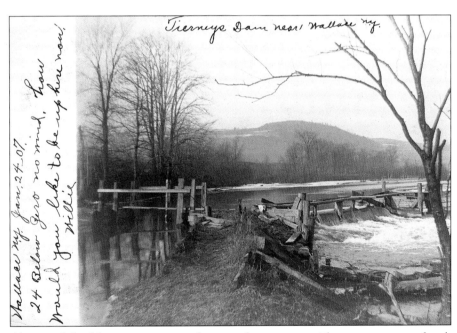

Along with health, a common use of postcards was to provide commentary on local weather conditions. This picturesque view of Tierney's Dam in the Adirondack region of New York State is used to report that temperatures in nearby Wallace had reached "24 below zero no wind" in January 1907.

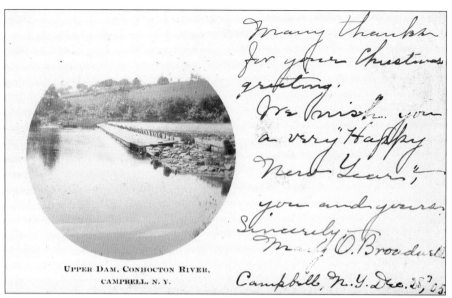

Holiday greetings were a staple of early postcards and, however improbable it might appear to a twenty-first-century observer, scenes of a local dam as ornaments for holiday cards did not seem so strange one hundred years ago. Postmarked December 28, 1905, the Upper Dam in Campbell, New York, was deemed a suitable view for wishing a "Happy New Year."

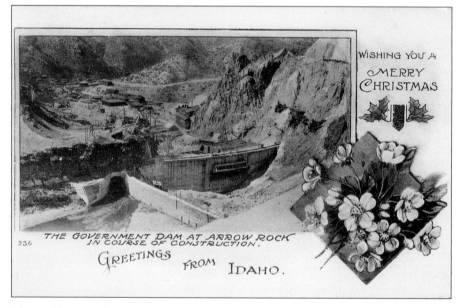

Merry Christmas from Idaho, home of the U.S. Reclamation Service's Arrowrock Dam.

By the beginning of the twentieth century, the historic Erie Canal in New York State was remembered as one of the great transportation icons of the previous century. This panorama of the canal postmarked 1907 offers a wistful refrain, since repeated many times, in many forms: "Vacation is flying past. We are all pretty well."

On Vacation and at Home

Postcards are commonly associated with travelers who send "wish you were here" messages to loved ones back home, a venerable tradition with roots tracing back to the earliest picture postcards. But cards taking note of the sender's location were by no means confined to those sent by travelers. Put another way, interest in images of dams and landscape did not spring to mind solely during trips to far-distant locales. People also liked to send cards showing scenes of their hometown and surrounding environs. In essence, local views attracted interest precisely because they depicted local and familiar landscapes. Whether at home or on the road, people found river and dam scenes to offer iconic emblems of regional terrain. And they liked to share these scenes with friends, with loved ones, and with people who they had never met except via postcards exchanged through the U.S. Postal Service.

A time-honored tradition is for travelers to personalize scenic postcards and show people back home exactly where they've been. For Beretia, the mill dam at Roscoe Falls in upstate New York marked the start of a hike "up to the top of the mountain" in September 1908. To illustrate the point, a series of Xs mark the course of the journey across the dam, along the river, and to the top of the hill in left background.

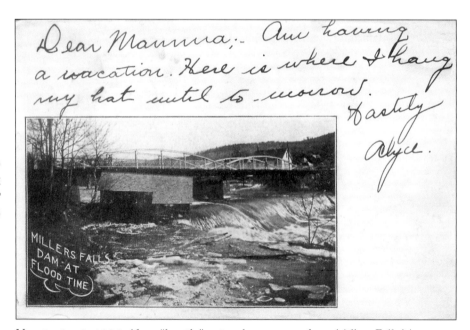

Vacationing in 1906. Alyce "hastily" writes her momma from Millers Fall, Massachusetts, just to let her know this is where she'll "hang my hat until to-morrow."

Picture postcards were well suited for commemorating a trip or vacation, but their use by no means required far-flung travel. Local views were valued precisely because they recorded the community where the sender lived. Lottie denotes this view of the dam at Black River Falls, Wisconsin, simply as "a scene up home" with her uncle silhouetted in the foreground.

A timber crib dam in the mining community of Mullen, Idaho, provides a pictur-esque setting for a group photograph taken in April 1908. According to corre-spondent May, she had entertained the party for Easter dinner; another message on the reverse reveals that "the dam falls into our back yard." For many who lived and labored in Mullen, the dam was an important part of their world.

May 15-88
Do you recognize me
on the high places?
E. C.

"Do you recognize me on the high places?" Dams were an integral part of rural life, and, in the spring of 1908, E. C. proudly posed with a friend atop the abutment (at right) of the Wamego Dam near Louisville, Kansas.

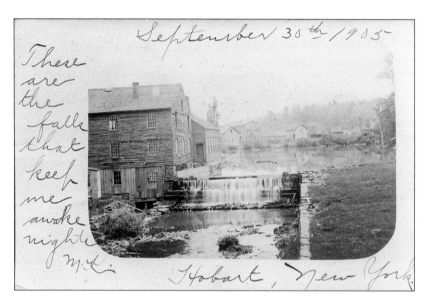

September 30th 1905

These are the falls that keep me awake nights M.K.

Hobart, New York.

In the fall of 1905, the mill dam at Hobart, New York, was a part of daily life for M. K., with the tumbling overflow keeping him awake at night.

Work Scenes

Nothing comprises more of a local view than the place where you work and earn a living. Early postcards reflected this reality and provide a record of working life. Construction views comprise a staple of the dam postcard idiom (see chapter 3), and work scenes were in large part a subset of this genre. But work scenes as a spe-

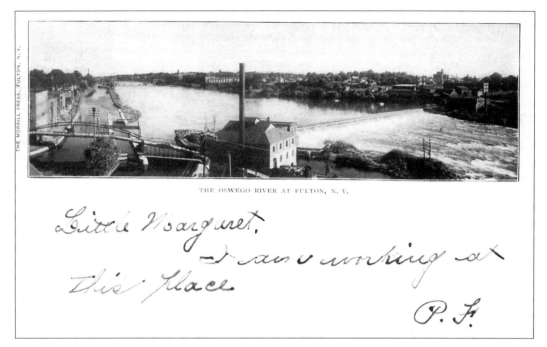

The dam, canal, and power plant in Fulton, New York, are featured on this bird's-eye view, postmarked March 3, 1906. Here, Little Margaret is assured by P. F. (her father or perhaps an older brother or sister?): "I am working at this place."

A succinct (and possessory) message accompanies this construction view of the earth embankment Piute Dam near Junction, Utah, sent in December 1907 from Henry to a friend in Kansas City, Missouri: "Me and my dam." That pretty much says it all.

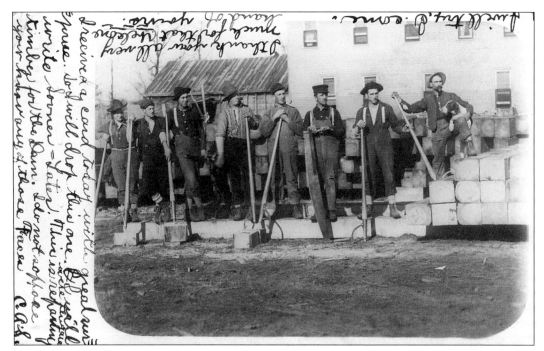

A classic posed view, postmarked 1906, of a work crew in St. Cloud, Minnesota, responsible for "repairing timber for the dam." C. A. S. was presumably a bit coy in teasing: "I do not suppose that you know any of those faces." Likely the recipient of the card knew many—if not all—of them quite well.

A proud construction crew posing at Cave Creek Dam near Phoenix, Arizona, in 1922. An arrow points down on a worker identified as Wesley (standing with pipe, third from left), who was apparently of special interest to the person who marked the unmailed card.

A beautifully framed view of the crew building the Mt. Hood Railway Power Company's Little Sandy Dam in central Oregon, photographed in 1911.

POST CARD

PLACE STAMP HERE

CORRESPONDENCE HERE

NAME AND ADDRESS HERE

This shows the men excavating and part of the forms + Runways,

All these were taken by my youngest son Clarence got his camera this past summer,

The message on the back of the Little Sandy work crew photo affirms how, by at least 1911, excellent real photo postcards could be produced by skilled amateurs. In this case, credit for the Sandy River Dam view (one of an informal series) was proudly credited to "my youngest son Clarence [who] got his camera this past summer."

Irrigation dams in the arid West were often of great personal and local import. So it was with the Throttle Dam built on the T. O. Ranch near Raton, New Mexico, circa 1910.

E. M. Benson held a close attachment to the Throttle Dam, and the detailed description written for Uncle Ben in Coon Rapids, Iowa, reads like copy for an engineering journal. Much is covered, including key dimensions and features ("has a core wall through center with a concrete base and heavy corrugated steel to within 2 ft of the top") and the amount of land to be irrigated ("about 5000 acres.")

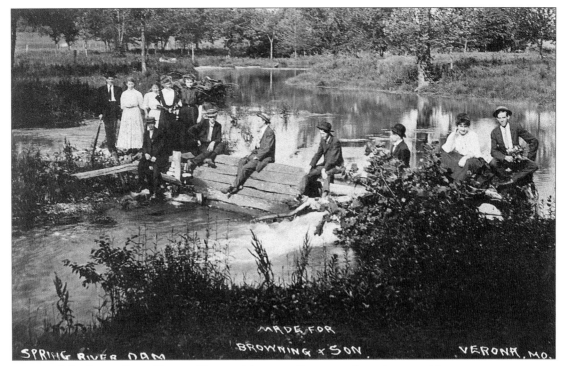

A view of the Spring River Dam in Verona, Missouri, illustrating how dams could figure into a "Landscape of Edwardian Courtship."

cific theme reflect a more personalized connection between an individual or small crew and a water-powered factory or dam construction project. Dams did not hold meaning simply as components of a larger socioeconomic construct wherein people could find employment. They also held more a more direct and visceral significance for the workers engaged in their construction or operation. Not surprisingly, postcards were commonly used as a way to share this connection and emotional tie with friends and family.

Courtship and Romance

Postcards offered an informal means of communicating thoughts of love and romantic interest. All kinds of postcards were used to convey such messages, but dams—because they often occupied publicly accessible places along picturesque streams or in local parks where young people could congregate and perhaps also find a bit of privacy—were frequently depicted on cards featuring notes of a romantic nature. Of course, postcards are a semiprivate medium, and correspondents were often careful to let their words infer much more than they actually said. But sometimes a bit of veiled prose can be all the more alluring.

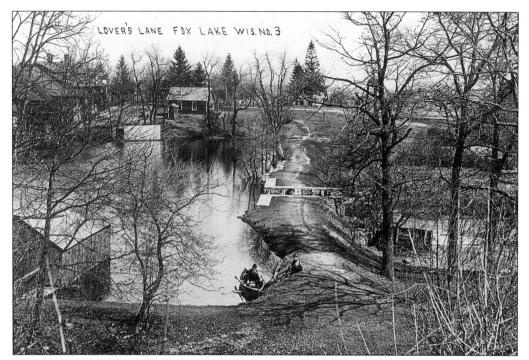

Lovers' lane in Fox Lake, Wisconsin, wending its way across the local mill dam.

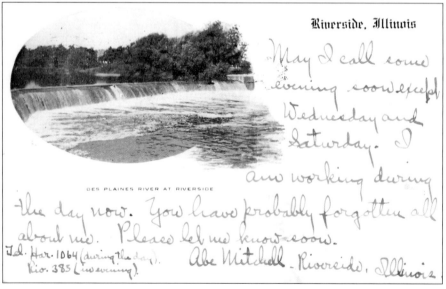

The search for love is oft filled with apprehension and anxiety. In a tentative entreaty to Miss Elvira Bronsow of Chicago, Abe Mitchell worries that "you have probably forgotten all about me." But, ever hopeful, he seeks an invitation to "call some evening soon except Wednesday or Saturday."

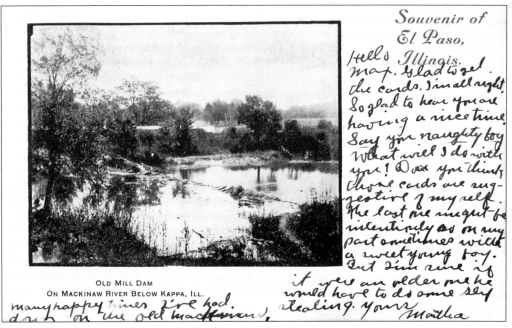

Souvenir of
El Paso,
Hells Illinois.
map. Glad to get
the cards. I'm all right.
So glad to hear you are
having a nice time.
Say you naughty boy
What will I do with
you! Do you think
those cards are sug-
gestive of myself.
The last one might be
intentionly as on my
part sometimes with
a sweet young boy.
But I'm sure if
it were an older one he
would have to do some sly
stealing. Yours
Martha

OLD MILL DAM
ON MACKINAW RIVER BELOW KAPPA, ILL.

many happy times I've had.
down on the old Mackinaw,

While it might not be a good thing to actually be "naughty," dangling the notion that you might be is something altogether different. Here, Martha makes reference to some supposedly provocative cards she recently received from Max, protesting "Say you naughty boy what will I do with you, do you think those cards are suggestive of myself." Also observe how the scene of the Old Mill Dam is underscored with the provocative: "Many happy times I've had down on the old Mackinaw!"

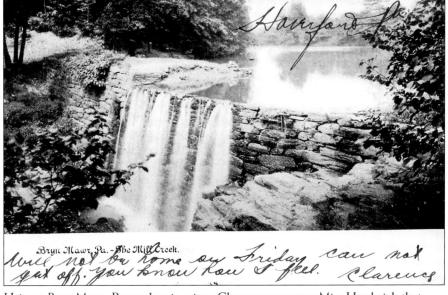

Haverford Pa.

Bryn Mawr, Pa. - The Mill Creek.

Will not be home on Friday can not
get off. you know how I feel. Clarence

Using a Byrn Mawr, Pennsylvania, view, Clarence reassures Miss Hardwick that while he "will not be home on Friday . . . you know how I feel."

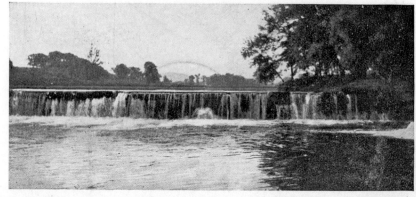

NEW MILFORD, CONN.

*Extract from N. M.
"Gazette".*

*Now what do you think
of that?*

E. H.

128C2

MARRIAGES.

AUSTIN—HUNGERFORD—At Kent, Nov.
23, by the Rev. H. K. Job, Miss Genevieve
Hungerford and Thomas Austin of Gaylords-
ville.

Housatonic River Dam.

Questions abound as to what prompted this postcard sent in early December 1905.
Hard to say what message E. H. sought to convey, but clearly a recent betrothal
had set some tongues wagging. For some reason a view of Housatonic Dam was
chosen as backdrop for the gossipy innuendo.

Community Life and Commerce

Postcards offer more than a means of personal communication. They also provide
a platform for communities, including business enterprises and social organiza-
tions, to share concerns, ideals, visions, and commercial ambitions. The audiences
for postcards might be individuals (or a collective of targeted and not so targeted
individuals), but the spur for cards reflecting community-oriented topics is some-
thing that transcends individual interest per se. Even for commercial cards that
drew upon the imagery of dams to promote a particular business interest, the iden-
tification with a local dam—and by extension a local citizenry tied to that dam—
was an important subtext of the message. While usually positive and promotional
in presentation, cards reflecting community life also could assume a darker tone,
ranging from dam disasters (illustrated in chapter 4) to tragic drownings caused by
the turbulent overflow of seemingly innocuous mill dams.

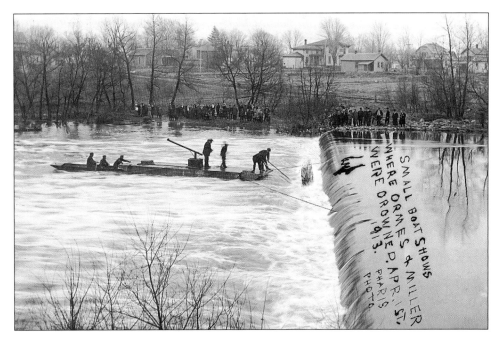

Tragedies have always galvanized communities, and this view memorializes one of the sad truths about small overflow dams—they can create dangerous eddies that even experienced kayakers fear as "drowning machines." This card remained unsent and un-postmarked so the exact location of Ormes's and Miller's death in the spring of 1913 is uncertain, but it came during a time of heavy flooding in the Ohio River Valley.

On a less morbid note, the organizers of the White County Centennial Celebration and Moose Carnival of 1914 considered the dam across the Little Wabash River to be a fitting subject in promoting the big event.

Power to the people. The Sturgis Dam and Power Plant was not particularly large, but it supplied 1,500 horsepower of electricity to a grateful city.

(Opposite, top) In October 1911 the city of Sturgis, Michigan, took time to celebrate its new municipally owned dam and hydroelectric power plant. Electricity represented modernity to twentieth-century Americans. Why should we be surprised that a local hydroelectric power plant would prompt such a gala community affair?

(Opposite, bottom) Politicians are often drawn to civic celebrations involving public works, and the Sturgis Dam celebration attracted Vice President James Sherman. Sherman was a conservative Republican (under President William Taft) and exactly why he would have helped celebrate a municipally owned utility is a bit mysterious (conservative Republicans have long championed privately financed electric power development). But what politician can pass up a parade?

209 STURGIS DAM CELEBRATION Oct. 11-12-'13

VICE-PRES SHERMAN AT STURGIS, MICH DAM CELEBRATION OCT. 11

Electric power was widely seen as a great public good, and this construction photo of the hydroelectric power dam near Judsonia, Arkansas, was projected as a harbinger of the community's (hopefully bright) future.

POST CARD

CORRESPONDENCE

ADDRESS

Judsonia, Ark., Nov. 4, 1921
We are glad you came and when you go back home think of Judsonia as the home of the Strawberry, and the home of the first hydro-electric dam in the state. We want more factories; more good men to make their homes with us.
Write the Judsonia Board of Commerce.

Their claims may have been a bit boastful, but what energized the Judsonia Board of Commerce was simple and direct: "We want more factories; more good men to make their homes with us."

Waterville, Me., _____ 1908.

Dear _____

This is where the power is generated that is used in the manufacture of **"QUIETUS."** The only preparation made that *positively kills the odor of perspiration.* Put up in sanitary tubes, retails for 25 cents. At your druggists or by mail. See other side for address.

Yours sincerely,

Advertisers were not loath to use dams in advertising, and the maker of Quietus proudly credited the dam in Waterville, Maine, as powering the manufacturing process. But exactly why the company sought to connect a deodorant with hydropower is a bit of an enigma.

The largest single water power in the world, the great Keokuk Dam across the Mississippi River and the government lock which is as long and with a higher lift than any at Panama. This great work and the city of Keokuk visited by Iowa Pharmaceutical Association Convention June 11th, 1914.

Upon its completion in 1913, local boosters hoped Keokuk Dam would attract convention business to the river town. The image of the dam lay at the heart of public and private efforts to promote community development and commerce.

WATER POWER DAM ACROSS MISSISSIPPI RIVER AT KEOKUK, IOWA, NOW UNDER CONSTRUCTION. The greatest power dam in the world. (*Compliments KKK Medicine Co.*)

DEAR SIR: I expect to have the pleasure of calling upon you within a very few days with the KKK products. May I ask you to please look over your supply to ascertain what you will require for the coming season. Thanking you for past and soliciting your future orders, Very truly,

It will do us both good if I leave you one or more bottles of KKK PECTUS BALM for Coughs and Colds. It is unequalled.

W. A. KERR, SALESMAN. MILAN, MO.

The hydroelectric power dam at Keokuk, Iowa, served as a suitable image for promoting KKK Pectus Balm as treatment for coughs and colds. The company apparently derived its name from the three Ks in Keokuk, but perhaps it also held political connotations.

Times Change . . .

In retrospect, it seems almost inevitable that the intense interest in postcards exhibited in the early years of the century would eventually fade. What was once new and exciting became not so new and familiar. After a frenzied decade, the golden age began to fade around 1915, as the economics of overproduction finally caught up with the industry. Overstock of printed cards plagued dealers and manufacturers as the market finally became saturated. People continued to send large numbers of postcards and personal real photo cards continued to attract interest, but the desire to collect and exchange more and more cards no longer enthralled a wide swath of the American public.[27] German manufacturers, so important prior to the First World War, soon disappeared from the American market after the European conflict began in August 1914. In their place domestic companies filled the void and came to dominate the industry, a position they would never relinquish. In terms of coloration and the pictorial detail of printed cards, quality generally diminished as publishers competed largely on price to serve a shrinking market. Once the First World War ended in late 1918, postcards never regained the cultural status they had held in the prewar golden age. As collecting lost its mass appeal, postcards gradually became an element of American culture that no one

The use of postcards for advertising and commerce, especially those involving automobile travel and tourism, expanded through the midcentury. This multi-view card from the early 1930s of the Vegas Camp near Hoover Dam (then under construction) also reflects how real photo cards continued to be a part of the postcard industry.

A "blue sky" applied to a halftone view that was published by the Chicago-based Curt Teich Company. This type of card sought to enhance black-and-white printing technology with an inexpensive "colorized" treatment.

THE GILLESPIE DAM, NEAR PHOENIX, ARIZONA. 104930

Among postcard collectors, the 1920s is often characterized as the "white border" era because of the proliferation of printed views (both color and black and white) framed by a white border. Sometimes the quality of white border cards could be quite good, as evident in this view of the Gillespie Dam in central Arizona. Completed in 1921 to divert water for irrigation, the dam's downstream concrete apron was used as a highway. During times of high water, the Gila River would overtop the 1,700-feet-long structure, requiring cars to ford across the apron.

thought much about because—somewhat paradoxically—it was hard to imagine a world in which they weren't present.

But just because the glory days had passed did not mean that postcards disappeared from American life. Postcards evolved and remained an essential, if not exactly high profile, component of American culture. Emporiums and shops dedicated solely to the postcard trade disappeared, but drugstores, five-and-dimes, roadside cafes, truck stops, and a host of other retail shops across the American landscape still offered local views and greeting cards to the public. The overall variety of views may have dropped, but for major landmarks and tourist destinations, postcards were readily available. In addition, the rise of auto touring and cross-country travel prompted new markets for supplying tourist camps, motels, diners, restaurants, and gas stations with ad cards. The number of postcard manufacturers gradually shrank, with a few big companies like Curt Teich in Chicago, Tichnor in Boston, Dexter Press in Nyack, New York, and E. C. Kropp in Milwaukee largely dominating the trade in colorized cards. But regional and local companies continued to thrive, with some (most notably

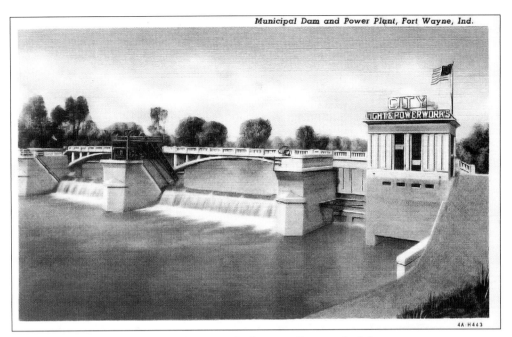

Following up on "white border" designs, which generally mimicked the appearance of cards produced prior to the First World War, "linen" cards came to prominence in the 1930s and 1940s. Printed on heavy stock, linen technology did not attempt to render fine detail. Instead, it relied upon bold swaths of color to create a new aesthetic styling. This card of Fort Wayne's municipal power dam in 1934 shows how linen cards could attractively depict concrete, water, and cloud-filled skies.

A Curt Teich price list from the mid-1930s documents how linen cards required large batch orders. For color views, customers were obligated to buy at least 3,500 cards, and they were encouraged to buy in increments of 50,000 cards or more. Simple economics encouraged a focus on major landmarks; conversely, the variety of local linen views suffered as merchants reserved their orders for cards that (they hoped) could sell in the several thousands.

A wonderful "big letter" linen card from 1942. Because linen cards needed to be manufactured in large batches, they were best suited for views capable of generating equally large sales. Thus, major structures and attractions like the Grand Coulee Dam were common subjects.

At their best, linen cards could be highly attractive. But unimaginative and indistinct renderings of scenes were also not unusual, as evident in this E. C. Kropp aerial view from the late 1940s of the dam and power plant at St. Joseph, Michigan.

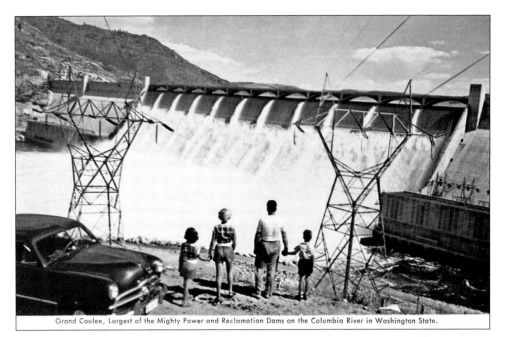
Grand Coulee, Largest of the Mighty Power and Reclamation Dams on the Columbia River in Washington State.

By the 1950s colorized and seemingly real photo postcard came into vogue. Known in the trade as chromolithographs (or simply "chromes"), in fact these were not continuous tone real photos but actually a type of halftone technique applied to color printing. As with this scene of a family posing at Grand Coulee Dam in the 1950s, chromes could offer accurate, if sometimes rather bland, renderings of a scene.

Frasher's Foto Company in Southern California and the Southwest, Eastman in Northern California, Ellis in the Pacific Northwest, L. L. Cook in the Upper Midwest, and W. M. Cline in the American South) carving out significant commercial markets oriented toward real photo views.

As chapter 6 illustrates, the coming of the New Deal in the 1930s drew public attention to many big monumental dams and the postcard industry—including both colorized and real photo companies—found a ready market to exploit. In contrast, the small-scale, pastoral dams that were commonly captured in golden age view cards attracted little attention during the New Deal.

By the mid-twentieth century postcards were an ingrained part of American life, something so elemental that, for many people, it hardly warranted attention. True, a few people purposefully collected, traded, and exchanged cards, but compared with the craze that had earlier engulfed the country, they constituted little more than a fringe group of hobbyists. Postcards had become a quick way to communicate with friends and loved ones while on the road and away from home. The notion of using local views to convey a sense of local culture or environment became passé, a remnant of a bygone time when photographs and graphic images were less common and, concomitantly, postcards depicting

local scenes were more special. In 1948 the famed photographer Walker Evans publicly mourned what had been lost. Decrying how postcards had "fallen into an aesthetic slump from which they may never recover," Evans fondly recalled the golden age (or what he termed "the trolley-car period") and the way that the "tinted surfaces" of early cards comprised "some of the truest records ever made of any period."[28] One need not share in Evans's nostalgic view of a lost past to appreciate the sentiment that spurred his lament. The postcard culture of the golden age had indeed left a remarkable legacy.

MATERIALS, DESIGN, CONSTRUCTION

An array of questions arises when someone sets out to build a dam. Some relate to location, topography, and geology, some to purpose, and many concern *what* and *how*. What materials will be used to build the dam? What will be the size and shape? And how will it be constructed? Later chapters deal with the why of dams and the way that people use them; the postcards featured here document the technology itself. Compared to detailed blueprints, contract specifications, or day-to-day sequences of construction photographs, postcards rarely offer a comprehensive record of a dam and how it came to be. Nonetheless, it is striking how much variety and technological nuance is captured in vintage postcard views.

Materials

Since ancient times, earth, rock, and wood have been used to build dams. In terms of material, the biggest development of the past 125 years has been the replacement of cut-stone masonry with concrete (in the nineteenth century concrete was often referred to as "artificial stone"). With dams, durability is a highly desirable characteristic and stone is well suited to resisting erosion. However, quarrying and transporting cut stone can be both time-consuming and expensive. In contrast, loose rock fill is simpler to use, especially if it can be readily excavated from a nearby streambed or hillside. But maintaining the shape and the structural integrity of loose rock fill—especially when frequent floods cause overtopping—can be a problem. While wood is far less durable than stone, it is often available in

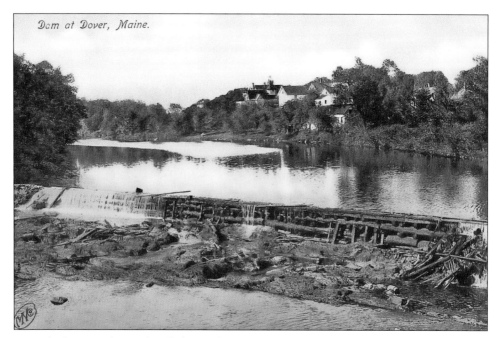

A classic timber crib mill dam in Dover, Maine, circa 1910. Maine is a heavily wooded state, and material for timber crib dams has been close at hand since colonial times. Also note how the structure rests atop a rock ledge stretching across the river bed.

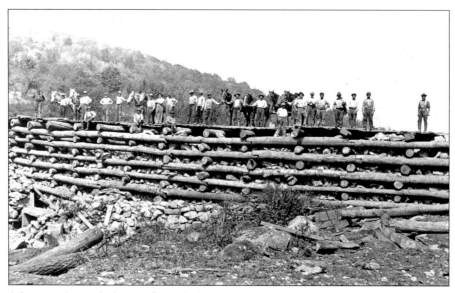

A large timber crib dam in Green Lake, New York, upon completion in 1913. By the early twentieth century concrete was in wide use, but traditional materials did not immediately vanish from America's dam-building lexicon. The choice of a specific design always reflects a wide range of influences and long-term service and permanence (which can entail considerable expense) is not always the most important factor governing design.

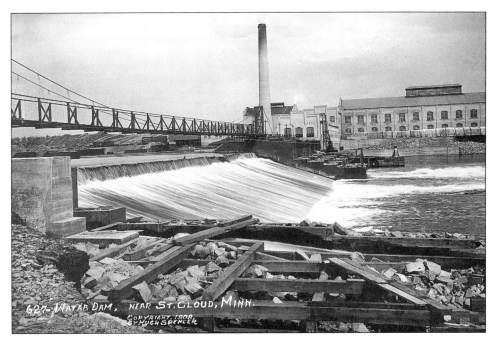

Timber crib dams could be quite large and control the flow of major rivers, as with the Watab Dam across the upper Mississippi River near St. Cloud, Minnesota.

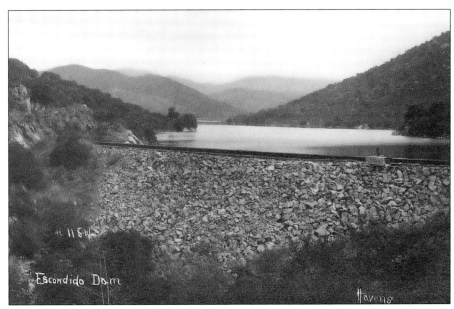

Absent timber cribbing, rock fill can also be used to create large embankment dams. This postcard, circa 1910, shows the seventy-six-feet-high Escondido Dam north of San Diego formed with more than forty thousand cubic yards of stone. To impede leakage, a double-layer of redwood planking was placed across the dam's upstream face.

large quantities near rural or village dam sites and can hold its shape for many years before deterioration or rot sets in.

From the seventeenth century through the early twentieth century Euro-Americans built a multitude of small dams using stone, wood, or a combination of the two. The most common strategy to provide stability at modest cost was to conjoin stone and timber into structures known as timber crib (or sometimes simply "crib") dams. In these, a lattice or crib of timber logs provides a basic shape for the dam; then loose rock is dumped or piled within the lattice to increase its mass and durability. To protect against the erosive power of flowing water, wooden planks were commonly placed atop the structure and the downstream face. Timber crib dams were susceptible to washout, especially if hit by heavy overflow. But they were not hard to rebuild, and often times they could be quickly repaired after suffering flood damage.

Earthen deposits are often available in large quantities near prospective dam sites and well built earth-fill dams can successfully hold back water for decades, even centuries. To insure the long-term integrity of an earth-fill dam, it is essential that the structure never be allowed to overtop—if water starts flowing over an earth embankment dam, it will quickly erode the downstream face and, in a short time, cause collapse. It is also essential that excessive water be prevented from seeping *through* the earth embankment and internally erode the structure, precipitating failure from within. It is impossible to build a completely water-tight dam (this is a basic truism of dam building), but by placing so-called core walls in the center of earth-fill dams—consisting of wooden or steel sheeting, masonry or concrete walls, or a barrier of impervious clay—infiltration can be minimized and the threat of internal erosion (sometimes called "piping") significantly reduced. Because of its propensity to erode, loose soil is not amenable for use in overflow crib dams, but if built properly (i.e., with a large spillway capable of handling heavy floods and preventing overtopping) earthen embankment dams can be used to impound very large reservoirs.

Cut-stone masonry and rock fill are comparable in terms of durability, but a mound of rock fill is by nature porous. In contrast, quarried stone can be used to build solid structures capable of both resisting seepage and withstanding overtopping. The drawback to masonry dams is largely one of cost: quarrying stone and properly setting it in a massive, watertight wall can be both time and labor intensive. Nonetheless, the great cost of large-scale masonry dams did not prevent them from being adopted for major projects. Notably, several of the greatest monumental dams of the early twentieth century—New Croton, Wachesett, Roosevelt, and Ashokan (Olive Bridge)—were masonry constructs in which large "rubble" stones were embedded in concrete in the interior of the massive structure. With this, the expense incurred by masonry construction was mitigated through a judicious use of concrete technology.

CONSTRUCTING GREAT DAM FOR WATERWORKS RESERVOIR(CAPACITY WHEN COMPLETED
75 MILLION GALLONS, ELK CITY, OKLA.

Seepage through both earthen and rock-fill embankment dams is an endemic
problem, prompting the use of interior core walls designed to limit leakage. This
construction view, circa 1910, of a small embankment dam in Oklahoma illustrates
a ceramic block core wall supported by vertical steel I beams driven into the
foundation.

UP STREAM SLOPE OF DAM, WHITINGHAM, VT.

Completed across the Deerfield River in southern Vermont in 1924, Harriman Dam
features an earth embankment design with an interior core wall formed by relatively
impermeable clay. This photo postcard was taken near the end of construction and
shows rock-fill "rip-rap" being placed atop the upstream face to counter the erosive
effects of reservoir "wave action."

Limestone is readily available in many parts of Texas, and this small curved gravity masonry dam near Gainesville makes use of quarried cut stone to create an imposing barrier across Elm Creek.

Built by the U.S. Reclamation Service and completed in 1911, the Roosevelt Dam in Arizona was one of the last large masonry dams built before concrete technology came into ascendance. At Roosevelt, concrete was used to help bind the rubble masonry into a monolithic whole. Built along a curved axis, the cross-sectional profile is thick enough to provide stability, thus making it a curved gravity dam—not a thin arch structure.

The straight-crested masonry dam under construction at Whitney, North Carolina, circa 1906. The exterior faces are formed with carefully shaped (or "dressed") stone blocks, while the structure's interior utilizes rubble construction in which rough-shaped stones are embedded in concrete. This method was typical of large masonry dams built from the late nineteenth century through about 1915.

A major shift from quarried stone masonry to concrete construction occurred from 1885 through 1915. In the 1880s, concrete comprised an anomaly in dam construction, but changes were coming. This real photo view postmarked March 12, 1914 shows a nineteenth-century stone masonry dam in Caldwell, Kansas, being repaired with concrete. The wooden planks provide support for the wet concrete as it hardens (or "sets").

Newport, Me. New Cement Dam.

The widespread availability of concrete as a building material did not only affect large-scale dam building but also figured into decisions to replace smaller mill dams. This postcard from Newport, Maine, circa 1910, reflects the pride that a small community could take in a "new cement dam." Although the term cement is used in the card's caption, it is almost certain that the dam was built using concrete—a mixture of cement, stone aggregate, and sand that is much stronger than cement alone.

Concrete was known to Roman engineers, but its use for large-scale construction projects languished for centuries before European engineers revived it in the eighteenth century. Concrete is formed by mixing cement (a pulverized material largely comprised of calcium-silicate compounds) with water, sand, and stone aggregates or gravel. The chemical reaction resulting from the interaction of cement and water (known to chemists as hydration) creates a hard, durable substance resembling stone; by mixing in sand and gravel the strength of the concrete can be increased beyond what is possible with unadulterated and relatively brittle cement. Although water is necessary to create cement, hydration represents a complex chemical reaction that, once the cement or concrete hardens (or "sets"), creates a material highly impervious to water that will not dissolve or easily erode. When iron or steel bars began to be embedded into concrete in the 1870s and 1880s—as a way to increase tensile strength and reduce susceptibility to cracking—the resulting material came to be known as reinforced concrete.

THE PINEY DAM AND SPILLWAY ON CLARION RIVER, CLARION, PA.

104758

Concrete is well suited to massive curved gravity designs such as the Clarion River Power Company's Piney (or Clarion) Dam in western Pennsylvania, completed in 1924. Although built with an upstream curve, the overflow Piney Dam is thick enough that, if straightened out, it would still be stable as a gravity dam. Thus, despite the curvature, the dam adheres to the massive tradition.

Design

Many factors influence which material and what type of design is to be used for a particular project, including geologic and topographic considerations (e.g., is it a wide valley with deep deposits of alluvial soil, or is it narrow gorge with granite canyon walls?), the remoteness/location of the site (e.g., how far is the nearest railroad heading, and how easily can supplies be transported?); cost and availability of materials (e.g., what kind and amount of earth fill or rock is near the site?); purpose and size of the proposed structure and its visual prominence (e.g., is it to be a monument attesting to the stature of a city or private company?); and—last but not least—the experience of the builders and engineers (e.g., what types of structures have they built previously and how willing are they to experiment with new designs and construction techniques?). The weighting of these factors varies from project to project, and every dam represents a particular design spawned by a distinctive mix of influences.

In contrast to Piney Dam, the concrete Salmon Creek Dam (completed in 1914 near Juneau, Alaska) is a thin arch dam adhering to the structural tradition; specifically, the cross-sectional profile is insufficient to stand as a gravity design and the upstream curvature is necessary to provide stability. Designed by Lars Jorgenson (a California-based engineer born in Denmark and educated in Germany) the 168-feet-high dam features a maximum thickness of 47.5 feet, about half the thickness necessary for a gravity dam of equal height. Salmon Creek Dam was built by the Alaska-Gastineau Mining Company and is now operated by the investor-owned Alaska Electric Light and Power Company.

No dam is ever built absent culture and precedent, and it is possible to see dam building as taking place within a context of two basic traditions: the massive and the structural. Within the massive tradition, stability is sought by using huge quantities of material of such weight (or mass) that the water pressure exerted by a pond or reservoir is insufficient to push aside or displace the dam. Timber crib, earth-fill, and rock-fill dams adhere to the massive tradition as do masonry and concrete gravity dams. In the structural tradition what is important is not the amount (or mass) of material used in a dam but rather the *shape* of the design and the way material is configured to resist water pressure. Thus, thin arch dams (i.e., curved masonry and concrete dams that are too thin to function as gravity designs) and buttress dams (with both flat-slab and multiple arch upstream faces) adhere to the structural tradition. To an on-site observer, the line separating the massive and structural traditions is generally clear, except in the case of curved masonry or concrete structures. Visually, it can be difficult to discern the difference between a massive masonry or concrete gravity dam

Buttress dams adhere to the structural tradition in that it is the shape of the design rather than the mass of concrete used that provides stability. The 125-feet-high Douglas (aka La Prele) Dam in southwestern Wyoming (completed in 1908) is the largest of the early flat-slab buttress dams built by the Ambursen Hydraulic Construction Company using Nils Ambursen's patent from 1903. This view of the downstream side shows how the dam consists of a series of buttress (spaced 18 feet apart) that support the inclined upstream face.

Upstream face of the Williamson Dam near Cisco, Texas, during construction in 1924. This view shows how the inclined flat-slab face is supported by the buttresses (visible on left).

If the space between the buttresses is filled by a series of arches—as shown here
in the Florence Lake Dam completed by the Southern California Edison Company
east of Fresno in 1926—the result is a multiple arch dam. In comparison to a
flat-slab design, the use of arches allows for a thinner upstream face and also allows
the buttresses to be spaced further apart. But the form work required for a multiple
arch design is more complicated than for a flat-slab structure.

built along a curved alignment (i.e., a curved gravity dam) and a thin arch dam
with a cross section (or profile) that is insufficient to provide stability if used for
straight-crested gravity structure.

Both the massive and structural traditions extend back to ancient times, with
the massive tradition predominating into the twentieth century. But dams in
the structural tradition offer a way to minimize the masonry and/or concrete
required for a design, and this can translate into reduced construction costs.
During the era covered by this book, massive dams were the most commonly
built. Nonetheless, thin arch and buttress dams also had their proponents
among American engineers, and the structural tradition is well represented in
dam postcards.

Spillway design represents a distinctive component of dam technology, re-
flecting both the character of the materials used in the structural design as well
as the topography and geology of a site. It also reflects the hydrologic character
of the river and the watershed above the dam site. Sometimes spillways are inte-
grated directly into the dam. And sometimes, depending upon the topography,
spillways are built at a distance from the main structure, where a gap or "saddle"

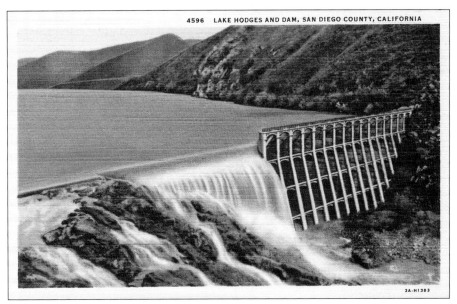

4596 LAKE HODGES AND DAM, SAN DIEGO COUNTY, CALIFORNIA

3A-H1383

Completed in 1918 to irrigate nearby Rancho Santa Fe, the 137-feet-high Lake
Hodges Dam in San Diego County is a multiple arch structure financed by the
Santa Fe Railway. The San Dieguito River is often bone dry, but when winter
storms drench the watershed the flow can be tremendous. This view from the early
1930s shows how the northern (right) side of the dam was built to a lower elevation,
thus creating a spillway that can release excess floodwater from the reservoir.

The downstream face of the Williamson Dam in Texas, showing a spillway situated
in the center of the structure.

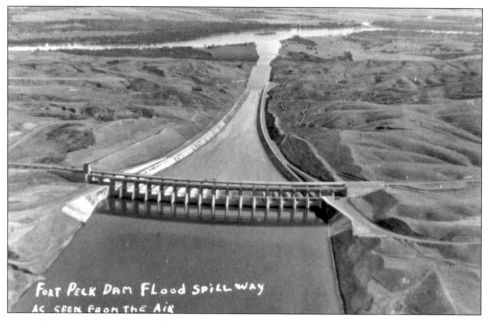

FORT PECK DAM FLood SPiLLWAY
AS SEEN FROM ThE AiR

Masonry and concrete dams are often designed to withstand overtopping, but for embankment dams care must be taken to provide specially designed spillways to safely disperse floodwater entering the reservoir. Sometime spillways are built atop or immediately adjacent to the dam. And sometimes, as with the Fort Peck Dam spillway shown here, they are placed at a considerable distance from the main structure. But the goal is the same: provide a way to safely keep the reservoir level below the top of the dam.

provides a low point and flow from a reservoir can be easily controlled. Spillways are also often fitted with movable gates that can be lifted and lowered in order to control water levels in a reservoir and maximize both water storage capacity and the ability to safely pass heavy flood flow. When fear of heavy floods is low, the gates can be dropped in order to safely increase reservoir capacity. But when the possibility of heavy flooding looms, the gates can be lifted and the capacity of the spillway increased. In determining the size and location of a spillway—as well as the scale and operational regime of spillway gates—engineers incorporate a variety of factors into the design process, with every project reflecting a different set of technical, natural, and cultural influences.

Construction

In terms of construction techniques, early American dams were generally built using human and animal power. In the latter nineteenth century, steam power was adapted at dam sites to aid in foundation excavation and in the transport and placement of timber, rock fill, masonry, and (eventually) concrete. And in the early

CASTLE ROCK DAM NEAR ADAMS, WIS. 61

Many structures, such as the Castle Rock Dam in Adams, Wisconsin, shown
here, feature movable spillways that control water releases from the reservoir. For
example, during intense spring floods, the spillway gates can be lifted to provide for
maximum flow capacity. As the spring floods diminish, the gates can be dropped;
this increases the reservoir capacity and, through the course of the year, allows
more water to pass through the hydroelectric power turbines. But if a big rainstorm
suddenly inundates the watershed, the dam operators can lift the gates and quickly
increase the spillway flow capacity. In essence, movable spillways provide for greater
reservoir storage capacity while also offering a way to safely handle heavy floods.

twentieth century, internal combustion engines and electric motors became an
ever-growing presence at dam construction sites, until by the 1930s they were an
essential component of every major project. Of course, machines never completely
replaced human labor in the dam-building process and hundreds, even thousands,
of workers were engaged in the construction of large monumental dams. Workers
could spend months, sometimes years, at remote dam sites, and the creation of
camps, commissaries, and worker housing was integral to many projects.

For earth embankment dams, technology drawn from the mining industry
was developed in the early twentieth century as a way to transport huge quanti-
ties of earth at modest cost; streams of high-pressure water were used to loosen
soil and convert it into a fluid muck (known as hydraulic fill) that could flow by
gravity to a dam site and be used to build up a large embankment. By the 1930s
large-scale earth-moving equipment (i.e., bulldozers and motorized trucks) was

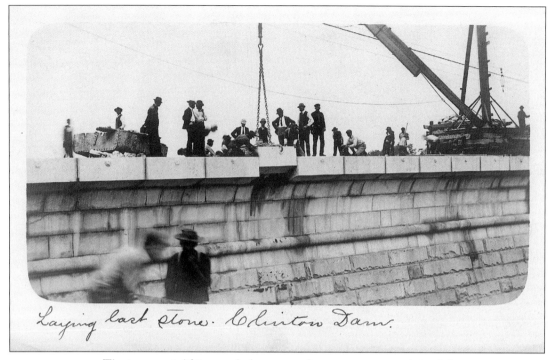

Laying last stone. Clinton Dam.

The transport, lifting, and placement of masonry stonework is a laborious process, and large masonry dams often took several years to complete. This photo postcard from 1904 celebrated the "last stone" being laid atop the Wachusett Dam in Massachusetts. A part of Boston's water supply system, this dam was started in the late 1890s and construction lasted more than five years.

in common use, and after the Second World War it dominated the construction of embankment dams. For masonry and concrete dams, one of the most important new construction techniques of the early twentieth century involved the use of aerial cableways that could transport men and material across dam sites hundreds of feet wide. But as useful as aerial cableways could be, throughout the era covered by this book they competed with large-scale trestle systems (developed out of human- and animal-powered tramways of the nineteenth century), which were also capable of efficiently transporting material across wide dam sites.

The selection of postcard views offered in this chapter cannot present a comprehensive record of how dams were constructed in the first part of the twentieth century. Nonetheless, they offer a good sense of how various materials and techniques were used to create dams in both the massive and structural traditions. They also offer evidence of how dam building reflects the topography and geology of particular sites, the availability and cost of construction materials, and the skills, experiences, and predilections of the people and organizations responsible for bringing a project to completion.

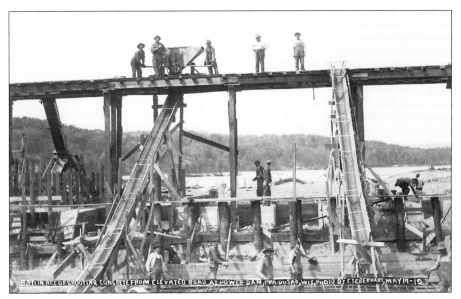

A "batch" of mixed concrete at the Prairie du Sac Dam in Wisconsin, circa 1912, being conveyed along a wooden trestle. The concrete is dumped onto wooden chutes and gravity is used to carry it into the form work.

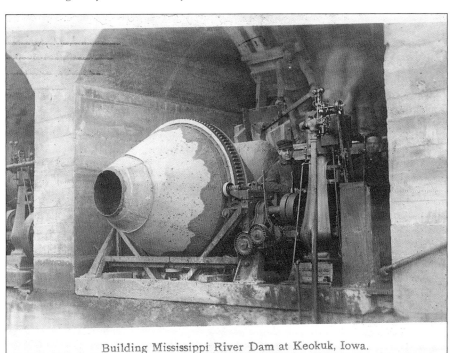

Building Mississippi River Dam at Keokuk, Iowa.

Concrete offered economic advantages over stone masonry in terms of conveying and depositing material for large dams. Wet concrete could be mixed at a central location in the dam site and then transported to various parts of the dam. This view, circa 1912, shows a concrete mixer used in building the Keokuk Dam across the Mississippi River between Iowa and Illinois.

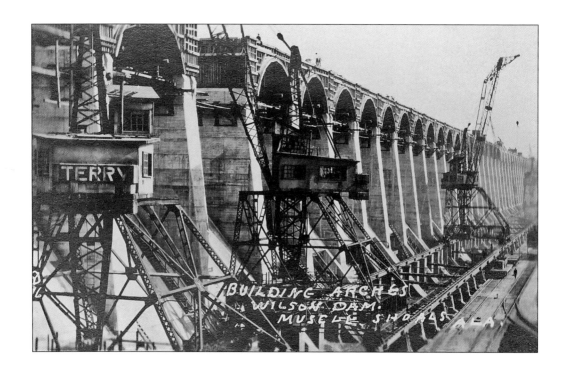

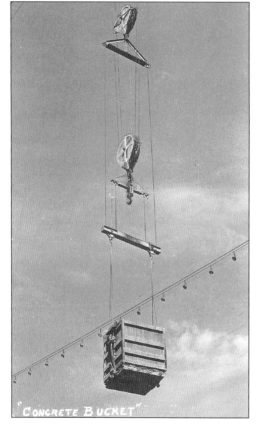

(Above) Construction of the Wilson Dam across the Tennessee River in northern Alabama, circa 1922. At Wilson Dam (originally called Muscle Shoals) the engineer Hugh Cooper built a steel trestle running the length of the structure; this trestle supported movable steel cranes that delivered buckets of concrete to various parts of the dam. The scale of the operation at Wilson Dam dwarfed that used at Prairie du Sac, but the basic principle remained the same.

(Left) The buckets used to build Shasta Dam in Northern California in the early 1940s had a capacity of eight cubic yards of concrete, twice the capacity of the aerial system used to build Hoover Dam a few years earlier.

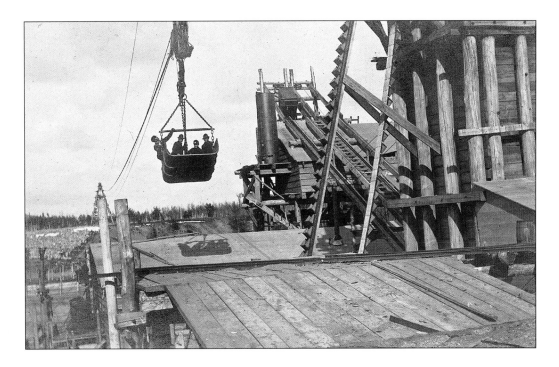

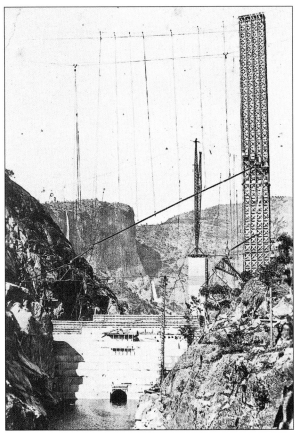

(Above) Aerial cableways provided another means of transporting construction materials. This view at Wausau, Wisconsin, circa 1912, shows a cableway in action.

(Left) Construction of O'Shaughnessy Dam at Hetch Hetchy, in the early 1920s. "Chuting" proved to be a cost effective technology, but it encouraged the use of highly fluid mixes that often suffered from excessive water content. The result: concrete with relatively low compression strength.

Freshly mixed concrete can flow like a liquid, an attribute used to advantage by engineers seeking to reduce construction costs. In the "chuting" method of construction, buckets of wet concrete are hoisted up a central tower and then, using movable chutes, delivered by gravity to various part of the dam site. In the early 1920s a tower-and-chute system was used to build the paper mill dam at Cornell, Wisconsin.

WATER—POWER DAM
SEARS ILL

In the nineteenth century, earth embankment dams were built using horse-pulled dump carts or wagons. This construction postcard, circa 1907, shows this technology being used to fill in the upstream face of a concrete diversion dam in Illinois.

Horse-pulled wagons were not terribly efficient means of conveying large quantities of earth and rock fill. A trend toward mechanization and ever-larger machines permeated the construction industry throughout the first half of the twentieth century. This view shows an excavator and large wagon in use at the earth-fill Garrison Dam in North Dakota in the late 1940s.

The movement of earth in mass quantities can also be achieved through hydraulicking. In this technology (developed by the nineteenth-century gold mining industry), pressurized water is used to transform soil in to a fluid muck that can be delivered by flumes and pipes to the dam site. As water drains out of the muck, an earth embankment is formed by the soil left behind. This view shows hydraulicking (or sluicing) underway at Big Cooke Dam in Michigan in the 1920s.

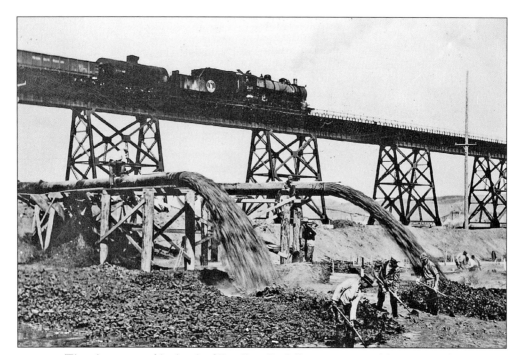

The placement of hydraulic fill in Fort Peck Dam in eastern Montana in the 1930s. The stability of a hydraulic-fill earth embankment is dependent upon effective drainage once the fill has been placed. In September 1938 Fort Peck Dam suffered from a major "slip" during construction, a near catastrophe that highlighted problems inherent with hydraulic-fill technology.

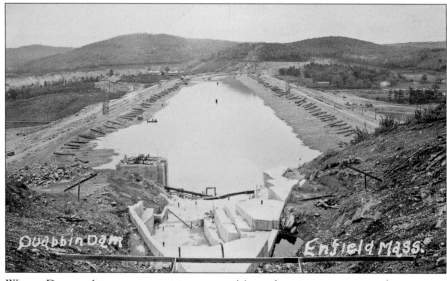

Winsor Dam under construction in western Massachusetts, circa 1938, showing the pool of water created as the hydraulic-fill structure slowly drained. This dam impounds Quabbin Reservoir, a major water component of Boston's water supply system.

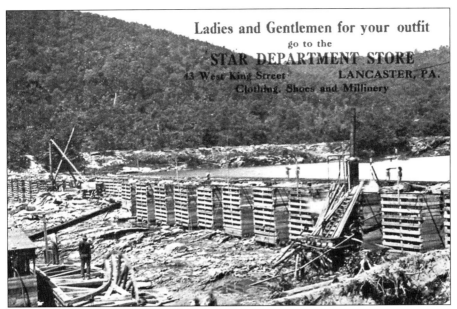

Excavation in midst of a flowing stream is a key problem faced by dam engineers because of the importance of clearing a foundation before construction proper can begin. Oftentimes such clearing is accomplished by building a temporary wooden cofferdam that blocks streamflow and allows excavation down to bedrock. This postcard, circa 1906, shows work underway at the McCall Ferry Dam (later Holtwood Dam) across the Susquehanna River in southeastern Pennsylvania. Construction of the dam was big news in the local community, and the Star Department Store in nearby Lancaster adapted the view for an advertising postcard.

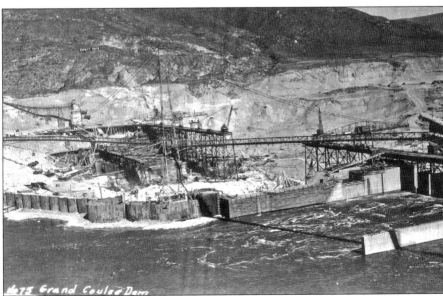

Cofferdam technology being used during construction of Grand Coulee Dam in eastern Washington in the 1930s.

In relatively narrow canyons, the clearing of foundations can only be accomplished by excavating diversion tunnels that extend around the dam site. This postcard from the early 1930s shows two of the four fifty-feet-diameter diversion tunnels excavated as part of the Hoover Dam project along the lower Colorado River.

At Fort Peck Dam in the 1930s, four large diversion tunnels were used to control flow of the Missouri River during construction. The fifty-feet-diameter tunnels were lined with concrete and later used to feed water into hydroelectric power turbines.

The construction of large dams requires hundreds, sometimes thousands, of workers. Labor camps were an essential part of many projects, and transitory housing at dam sites was frequently criticized as rather "rough." These wood frame bunkhouses at Foote Dam in Michigan, circa 1920, are hardly fancy, but they appear suitable for accommodating crews of single men.

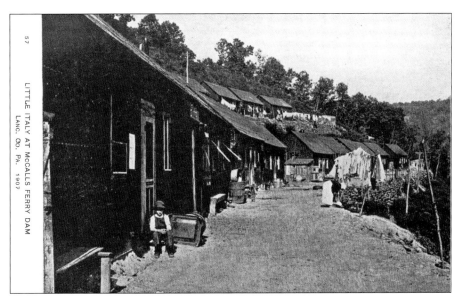

Dam projects often brought work crews into otherwise remote and rural areas. Contractors appreciated that immigrant workers would frequently accept lower wages than "native born" Americans residing near a dam site and, to keep interaction between the two groups at a minimum, often built special housing for dam laborers and their families. This view of "Little Italy" at McCall Ferry Dam in southeastern Pennsylvania in 1907 shows such an ethnically segregated encampment.

DISASTERS

Humans are fascinated by the misfortunes of others. Cars slow down at accidents so motorists can gape at gruesome wrecks. Mine shaft cave-ins captivate huge audiences across media platforms. And when a wall of water crashes through a village, or a low-lying urban district is inundated by a collapsed levee, people seek out photos to vicariously experience the devastation. This book is not the forum to explore why people are drawn to human tragedy, but it is a place to illustrate how photographs and postcards were used to visually illustrate dam disasters in the late nineteenth and early twentieth centuries.

A diversion dam washout can wreak much havoc but not necessarily cause death or widespread destruction. In contrast, if a large storage dam suddenly collapses, the devastation can be horrific. Water is a dense liquid (carry a full bucket up a flight of stairs in case you have any doubts) and possesses enormous kinetic energy when flowing in large volume. Thus, when heavy floods cascade down a river valley, the people, barns, orchards, houses, shops, mills, and bridges caught in the path can become engulfed—and quickly destroyed—in a roiling mass of water-laden debris. Large-scale dam disasters in America have been relatively rare (at least when compared to the total number of storage dams), but when they do occur they galvanize public attention, especially if there has been significant loss of life.

Dam failures have been a hazard since ancient times—the rock- and earth-fill Sadd-al-Kafara, a dam in Egypt, collapsed by overtopping soon after comple-

tion almost four thousand years ago. With the proliferation of sizable reservoirs in the nineteenth century, dams posed ever greater risks to downstream communities. In April 1802, in what the historian Norman Smith calls "the first serious dam disaster of modern times," the 164 feet-high and 925-feet-long masonry gravity Puentes Dam in southeastern Spain blew out under the pressure of an almost full reservoir. About two billion gallons of water descended upon the nearby town of Lorca, killing at least 600 people and destroying more than nine hundred homes. Britain's greatest nineteenth-century dam tragedy came in 1864 when the 95-feet-high Dale Dyke Dam (at times called the Bradfield Reservoir) failed as water seeped through the earth embankment and internally eroded the structure. Although only two hundred million gallons were released in the ensuing flood (a tenth of the Puentes disaster) the destruction was nonetheless horrific. Close to 250 people died and almost eight hundred homes were destroyed.

In the United States, small-scale washouts were hardly uncommon in the eighteenth and early nineteenth centuries, but, because the volume of water released by such failures was relatively modest, they usually were only of local interest. This changed on May 16, 1874, when a forty-three-feet-high earth embankment dam above the mill community of Williamsburg, Massachusetts, collapsed, releasing a torrent of six hundred million gallons. The earth embankment Williamsburg Dam was poorly built, and, upon completion in 1866, it soon suffered from extensive leakage. In the spring of 1874 the reservoir was allowed to fill for the first time and, under pressure of a full reservoir, failure came quickly. Passage of the flood through the mill villages of Williamsburg, Haydenville, Skinnerstown, and Leeds took less than an hour, but, as vividly recounted in Elizabeth Sharpe's book *In the Shadow of the Dam*, during that time at least 139 people perished and another 740 were left homeless. Photographers rushed to the scene, and the wreckage left by the Mill River Flood was recorded in hundreds of different stereo views soon distributed throughout the United States. American dam disasters had become tragedies that people could witness through the medium of commercial photography.

Other dam failures occurred in late nineteenth-century America, but all paled in comparison to the Johnstown Flood of May 1889. Originally constructed to supply water for the Pennsylvania Canal, in 1879 the 72-feet-high and 932-feet-long South Fork earth embankment dam was bought by a consortium of wealthy Pittsburgh businessmen operating as the South Fork Hunting and Fishing Club. Their idea was to use the capacious and newly named Lake Conemaugh as an amenity for a private mountain resort. Alterations to the original design included elimination of an outlet pipe (capable of releasing water from the reservoir during times of high water) and a scraping down of the dam's height in order to make the crest wide enough for a wagon road. In addition, the club placed nets across the spillway to keep fish from washing downstream during floods. Everything seemed fine until sustained rains hit western

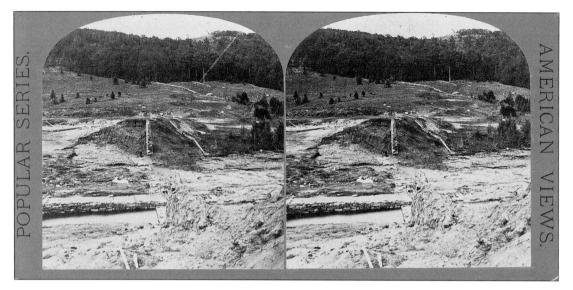

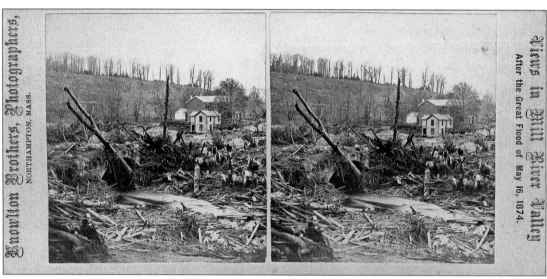

(Above) On a beautiful spring morning in May 1874, the Williamsburg Dam gave way, wreaking havoc on the Mill River Valley west of Northampton, Massachusetts. The earth-fill dam was completed in early 1866, but the reservoir was never filled to capacity until the spring of 1874. No known photograph exists of the completed dam. This post-disaster stereo view looks across the dam site, showing the triangular outline of the embankment and the remains of the masonry core wall.

(Below) Leeds lay about eight miles downstream from the Williamsburg reservoir, and the flood took about thirty minutes to reach the village. The local stone bridge was among the few structures caught in the flood path not destroyed, but much wooden debris piled up against the masonry arches. Many of the 139 victims of the flood were entrapped in debris strewn along the length of the flood zone.

The Johnstown Flood of 1889 is universally recognized as one of the greatest disasters in American history. Photographers flocked to western Pennsylvania to document the tragedy that killed more than 2,200 people. This photo is taken from a stereo view and shows the massive gap created when, during a heavy rainstorm, the 79-feet-high earth embankment South Fork Dam overtopped.

Pennsylvania in late May 1889. The rising reservoir overwhelmed the spillway (the fishnet became entangled with floating debris, reducing its already limited discharge capacity). The dam overtopped, eroding the earth embankment and precipitating a massive collapse. Almost five billion gallons of water swept down upon the unsuspecting city of Johnstown some fourteen miles downstream. Over 2,200 people died in the deluge, marking it the greatest storage dam disaster in U.S. history.

 The carnage wrought by the Johnstown Flood was extensively documented by photographers, particularly through stereo views, and the tragedy reached a worldwide audience. Ingrained in American folklore, the flood was even commemorated in a special exhibit at New York City's Coney Island that drew visitors well into the twentieth century. Although the Johnstown Flood occurred before picture postcards became a mainstay of American culture, its impact was so lasting that postcards related to the disaster were produced decades after the violent surge had passed.

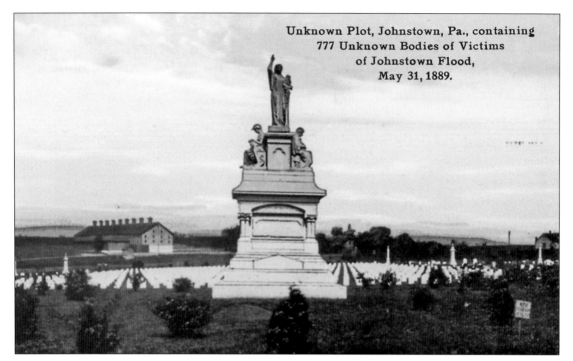

The Johnstown Flood occurred prior to the advent of the picture postcard, but memories of the disaster did not quickly fade. This postcard, circa 1910, shows the memorial built to honor the victims. It also shows the cemetery built for hundreds of unidentified bodies recovered from the disaster scene.

The Johnstown Flood resonated throughout American culture, spawning a commemorative exhibit at Coney Island in New York City.

Photo by H. R. Fitch.

4002. Sweet Water Dam, San Diego, Calif.

The disaster that never was. Completed in 1888 to support irrigation and provide a domestic water supply to National City, south of San Diego, California, the 98-feet-high Sweetwater Dam was overtopped by heavy floods in January 1895. Although not designed as an overflow structure, water poured over the top of Sweetwater Dam for forty hours. But the thin arch masonry design held firm and did not collapse under the onslaught. Produced about fifteen years after the overtopping, this popular postcard view commemorated a dramatic event that lived long in the memory of many Southern Californians.

In 1900, shortly before picture postcards achieved widespread popularity across America, the 68-feet-high and 1,091-feet-long masonry gravity dam across the Colorado River in Austin, Texas, washed out during a tremendous flood that overtopped it by 11 feet. In the years that followed, views of the devastated Austin Dam (which was not replaced for more than a decade) were often published as postcards, bearing stark testimony to the power of nature and the frailty of human constructs.

Once the postcard craze was in full swing by 1905, regional photographers frequently documented the washouts and failures of small dams in local views. Such minor disasters occurred in all parts of the nation and usually did not result in large-scale damage or loss of life. But these dam collapses could disrupt the operation of mills, power plants, and irrigation systems and were of more than passing interest to local townspeople and farmers.

Other than its name, the town of Austin, Pennsylvania, had little in common with Austin, Texas, until the afternoon of September 30, 1911, when a 70-feet-high, 535-feet-long concrete gravity dam built for the Bayless Pulp and Paper

A-1415 *The Dam just after the break, April 7th 1900, Austin, Texas*

In April 1900 heavy rains hit central Texas, causing the masonry Austin Dam to overtop by more than ten feet. This overtopping exceeded the dam's design capacity, and the center section washed away. Twenty-five people died in the resulting downstream surge. The disaster was later commemorated in postcards, including this one sent from Austin in 1907 where Marguerite somewhat cryptically writes a friend back in Newark, New Jersey: "With love and best wishes for a happy anniversary."

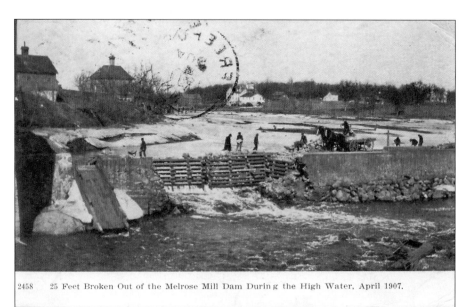

2458 25 Feet Broken Out of the Melrose Mill Dam During the High Water, April 1907.

Repairs are underway on a section of the Melrose Mill Dam in Minnesota washed out in April 1907. The dam is not particularly large, but the size of the empty millpond attests to its importance as a source of waterpower for the local mill.

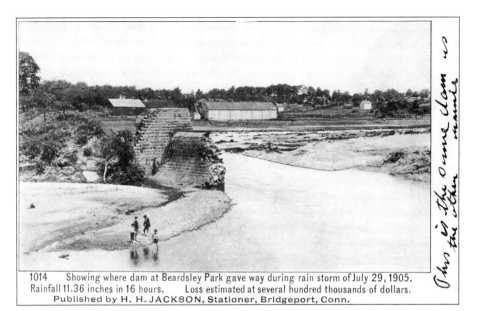

1014 Showing where dam at Beardsley Park gave way during rain storm of July 29, 1905.
Rainfall 11.36 inches in 16 hours. Loss estimated at several hundred thousands of dollars.
Published by H. H. JACKSON, Stationer, Bridgeport, Conn.

The failure of small mill dams was common in the nineteenth and early twentieth centuries, when heavy floods would wash out parts of a structure. The break in the Beardsley Park Dam near Bridgeport, Connecticut in July 1905 is a good example of this failure mode. Lives were not often lost in such disasters, but property damage could prove extensive.

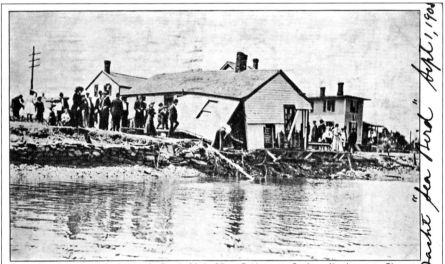

1015 This house was carried by the flood of July 29 at Bridgeport, Ct. from North ave. to River st.
over half a mile. The rainfall was 11.36 in. in 16 hours breaking the dam at Beardsley Park.
Published by H. H. JACKSON, Stationer, Bridgeport, Conn.

A view of a frame house carried half a mile by the Beardsley Park flood. Sensing a commercial opportunity, the local stationer H. H. Jackson exploited public interest in the flood with specially printed postcards.

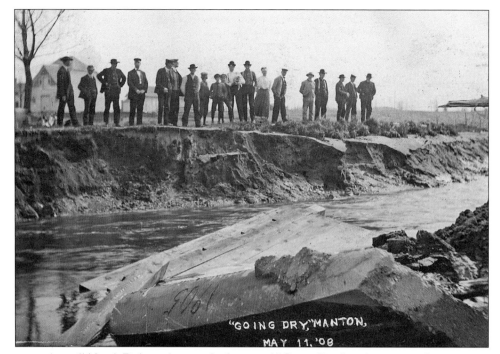

A small North Dakota dam washed out and "Going Dry" in the spring of 1908.

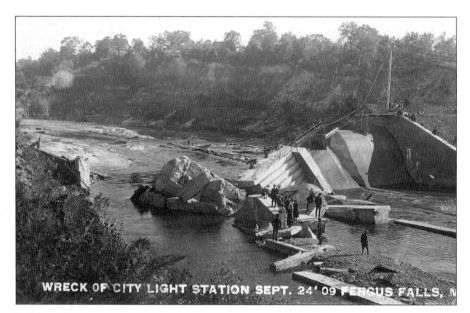

In September 1909 the hydroelectric dam in Fergus Falls, Minnesota, failed during heavy floods. A local photographer took advantage of the calamity, quickly distributing real photo postcards of the concrete wreckage.

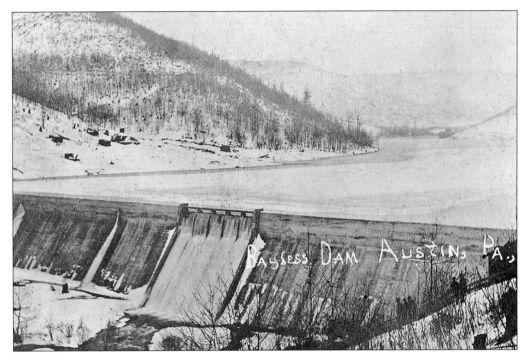

In 1909 the Bayless Pulp and Paper Company of Austin, Pennsylvania, built a
70-feet-high concrete gravity dam to supply water to their paper mill. Foundation
conditions were not good and, after parts of the dam began to "deflect" downstream
in 1910, an attempt was made to repair the structure. However, neither company
officials nor residents in the town of Austin (lying about two miles downstream)
fully appreciated what this early problem presaged.

Company slid from its foundations. The result: about five hundred million gal-
lons of water descended upon the center of town less than two miles down-
stream. At least seventy-eight people died in the destructive torrent and scores
of homes and businesses were laid to waste. The Austin, Pennsylvania, tragedy
was the first major dam disaster to occur in the postcard era, and the devastation
left by the flood was documented in a multitude of real photo views.

Dam failures did not stop after the Austin, Pennsylvania, tragedy, but for-
tunately little death accompanied the destruction brought by the overtopping
of the earth- and rock-fill Lower Otay Dam near San Diego in January 1916 or
the partial collapse of the earth-fill Calaveras Dam near San Francisco in March
1918. The author is unaware of any postcards published of these failures. In con-
trast, the collapse of the two-hundred-feet-high concrete gravity St. Francis Dam
in Southern California in March 1928 galvanized national attention. Built by the
City of Los Angeles in 1924–1926 under the direction of the famed engineer
William Mulholland, the St. Francis Dam was erected atop foundations com-
prised of less-than-ideal broken schist and sandstone conglomerate. In addition,
Mulholland (unlike many other American dam engineers) had learned little from

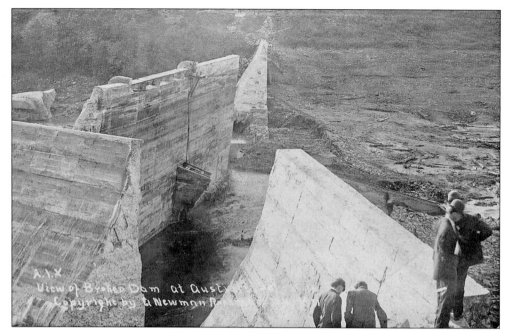

On September 30, 1911, water from a full reservoir seeped into the porous foundations of the Austin Dam. Pushing upward against the concrete base, hydrostatic forces (known as "uplift") worked to destabilize the structure and precipitate collapse. Some concrete chunks of the dam slid almost three hundred feet, impelled by the rapidly emptying reservoir. About 275 million gallons of water were released in the flood.

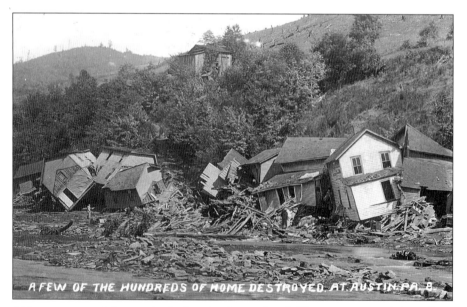

At least seventy-eight people died in the Austin flood. The center part of the valley below the dam was largely swept clear by the deluge, but along the sides of the valley cut lumber and the remains of frame houses littered the landscape.

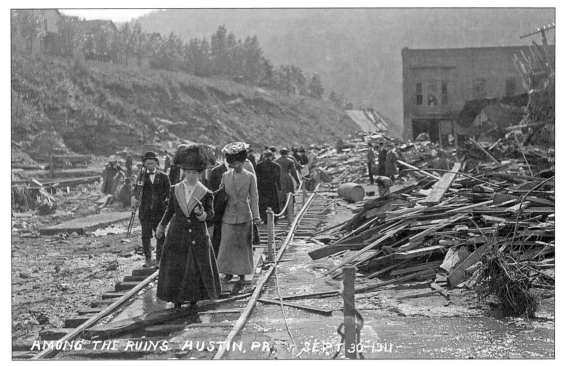

Property damage in Austin reached an estimated $6 million, and the destruction quickly became a public spectacle. This postcard captures a group of fashionably dressed women making the rounds "Among the Ruins."

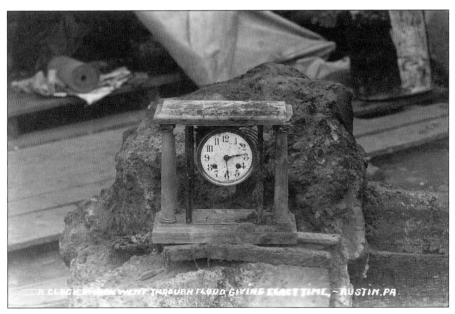

A poignant postcard registers the time the Austin flood hit: 2:29 P.M. on an otherwise peaceful Saturday afternoon.

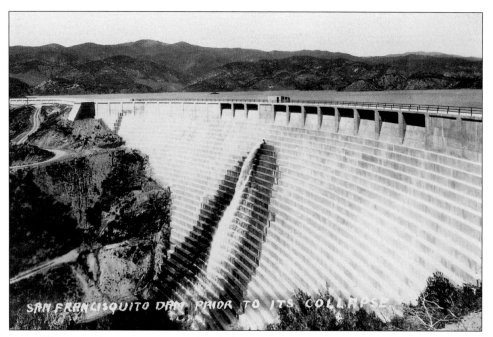

SAN FRANCISQUITO DAM PRIOR TO ITS COLLAPSE

The worst American storage dam failure of the twentieth century occurred in Southern California when, a few minutes before midnight on March 12, 1928, the St. Francis Dam gave way and twelve billion gallons of water descended upon the unsuspecting Santa Clara River Valley. The two-hundred-feet-high concrete curved gravity dam was built under the direction of William Mulholland, the chief engineer for Los Angeles' Bureau of Water Works and Supply. This photo view shows the dam as it looked shortly after completion in 1926; printed after the disaster, the photo was included in a commercial packet designed for mailing.

the Austin, Pennsylvania, dam failure, and he incorporated few features into his concrete curved gravity design that could counter the destabilizing effects of seepage and uplift. In addition, after construction was underway Mulholland decided to raise the height of his gravity dam in order to increase the reservoir capacity. But, in a tragically flawed decision, he did nothing to widen the base to compensate for the increased hydrostatic pressure of the raised reservoir.

For almost two years after the dam's completion in May 1926 the St. Francis reservoir remained partially empty. But once reservoir levels rose within three inches of the spillway crest, disaster quickly followed. A few minutes before midnight on March 12, 1928, the water-saturated broken schist underlying the dam's east abutment pushed up on the concrete structure and, within minutes, a wall of water approaching one hundred feet high began surging through San Francisquito Canyon. By the time the flood reached the Pacific Ocean five hours later, almost four hundred people lay dead, many entombed in huge piles of debris left by uprooted lemon and walnut orchards, and a wide swath of the Santa Clara Valley lay in ruin.

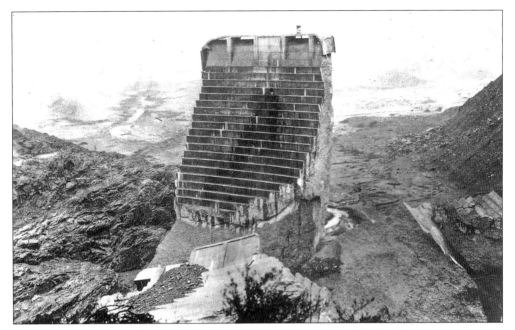

A post-collapse postcard showing the surviving center section of the St. Francis Dam on the overcast day following the flood. The St. Francis disaster attracted nationwide public attention, in part because of the dramatic character of the dam's remains but also because almost four hundred people in Los Angeles and Ventura counties died in the flood.

The power of the St. Francis flood is evident in this postcard of the washed-out Montalvo Bridge across the Santa Clara River north of Oxnard. The bridge was located about fifty miles downstream from the St. Francis reservoir and almost five hours elapsed before it was hit by the flood. But when the surge came, the force was sufficient to topple several spans of the truss bridge. Today, U.S. Route 101 crosses the Santa Clara River near this site.

Although no major city was wiped out by the St. Francis flood, many farms and rural encampments were hit hard by the disaster. At Kemp, a temporary camp for Southern California Edison employees building a transmission line, eighty-four unsuspecting workers died when their tents were engulfed at about 1:20 A.M. This snapshot shows one of many damaged automobiles left in disarray at the campsite, which lay about seventeen miles below the failed dam.

Postcards and booklets of photographs suitable for mailing documented the carnage left by the St. Francis disaster, but given the enormous scope of the tragedy, they did not appear in overwhelming numbers. For example, postcards of the Austin, Pennsylvania, disaster (as well as stereo views of the Johnstown Flood) are much easier to find today than postcards of the St. Francis disaster. This may be the result of how public access to the St. Francis flood zone was closely controlled by authorities who, ostensibly, sought to limit access on grounds of public safety. It also may reflect changes in the way that visual information was being distributed through news media after the First World War. Newspapers throughout the nation covered the disaster, often featuring photographs (printed as halftone images) supplied by wire services. By the late 1920s postcards were still an important part of America's cultural landscape, but their prominence as a visual medium had diminished since the golden age of 1905–1915.

The last major dam disaster to attract public attention prior to the 1960s came during construction of the Fort Peck Dam in eastern Montana in 1938. Built by the Army Corps of Engineers as part of a New Deal project to improve navigation on the lower Missouri River, generate hydroelectricity, and create jobs (see chapter 6), the Fort Peck Dam was a two-hundred-feet-high hydraulic-fill embankment dam. Nearing completion on September 22, 1938, the earthen structure suffered a major "slide" near the east abutment, with about five million

The St. Francis disaster prompted several engineering investigations, including an inquest by the Los Angeles County Coroner. This photo of the coroner's jury visit to the dam remains on March 23, 1928, was distributed to newspapers covering the disaster. By the late 1920s halftone images were commonly featured in newspapers, providing the American public with a major source of visual information about local, national, and world affairs.

cubic yards of water-saturated earth fill slipping upstream into the largely empty reservoir. Amazingly, the slide stopped before destroying the entire dam, but eight workers died in the structural collapse (six were never found, their bodies entombed in the rebuilt structure). Fort Peck Dam was known throughout the United States—in 1934 and 1937 President Roosevelt had visited the dam site; in 1936 a photo of the dam's spillway was featured on the cover of the first issue of *Life* magazine—and construction progress had been captured in numerous photo postcards. Not surprisingly, when the slide occurred it received extensive postcard coverage, and, as the Army Corps of Engineers undertook repairs and a massive rebuilding campaign, this too was documented in real photo views.

In focusing on examples of dam disasters that were recorded on stereo views and postcards in the late nineteenth and early twentieth centuries, it may be easy to believe that dam failures were a common fixture of American life during this time. Without doubt, small-scale washouts were common. But after the turn of the century, major collapses resulting in widespread destruction were not ordinary events. The collapse the Austin, Pennsylvania, dam in 1911 and the St.

EARTH SLIDE AT FORT PECK DAM
AERIAL VIEW LOOKING WEST AT SHAFTS
#501
COLES PHOTO
PRICE-PILOT

Dam building was a prominent part of FDR's New Deal, and the safety record of New Deal dams has proven to be quite good. But in September 1938 the Army Corps of Engineers' Fort Peck Dam across the Missouri River in eastern Montana suffered a major accident. At Fort Peck the Army engineers relied upon hydraulic-fill technology to build the massive earth embankment. As the structure neared completion, a huge section "slipped," releasing more than a million cubic yards of water-saturated earth fill into the reservoir basin.

Francis dam in 1928, with their significant death tolls, attracted widespread attention in large part because they were so unusual.

Since the slide at Fort Peck, America has not been free from dam disasters. Most have been washouts of small-scale overflow diversion dams hit by intense storm bursts or hurricane-induced floods. But some have been of greater consequence. In 1963 a section of the earth embankment holding back the Baldwin Hills Reservoir in Los Angeles gave way, killing five people and washing out 277 nearby homes. Eight years later, Los Angeles again suffered when a 6.7 magnitude earthquake partially destroyed the city's 142-feet-high Lower San Fernando Dam. Fortunately, no water was released from the reservoir and no one died, but the near collapse of the hydraulic-fill embankment (completed in 1915) bore similarity to the Fort Peck slide. Engineers took notice and became concerned that earthquakes could pose a threat to hydraulic-fill embankments, even if they been operational for many years. In June 1976 the Bureau of Reclamation's newly completed 305-feet-high earth-fill Teton Dam near Rexburg, Idaho,

DREDGE PIPES WHICH WERE CARRIED ABOUT 1,000 FEET
BY THE EARTH SLIDE AT FORT PECK DAM SEPT. 22,38.

#307
COLES STUDIO
GLASGOW

Eight people died in the Fort Peck collapse. Here, a surviving worker poses near the bottom of the slip next to a wooden flume used to transport hydraulic fill. Government officials blamed the failure on unusual foundation conditions. But it is also apparent that the inherent nature of hydraulic-fill technology—and the rapid pace of construction adopted for the New Deal project—played a significant role in the disaster. After the Fort Peck slide, hydraulic-fill technology soon faded from American dam-building practice.

gave way and unleashed more than seventy billion gallons of water (or about 234,000 acre-feet) into the upper Snake River watershed. Signs of impending collapse gave downstream towns and farming communities time to evacuate the flood zone, limiting the death toll to only eleven victims. More recently, the horrific failure of Army Corps of Engineers' levees that inundated New Orleans when Hurricane Katrina struck the Gulf Coast in 2005 has been vividly etched into America's national memory.

Like any technology, dams are subject to failure, and vintage postcards and stereo views bear witness to this reality. But while dam failures are undeniably a part of the history of America's hydraulic infrastructure, care should be taken not to exaggerate or unduly dramatize the prevalence and scope of these trage-dies. Recent disasters may have brought heartbreak to many people, nonetheless they involved but a small fraction of the thousands of dams that divert and store water across the American landscape.

USING DAMS

People build dams because they want to use water for some purpose or in some new way that natural conditions will not allow. A great many of these uses—and the transformations they brought to riverine environments—were recorded in photographs and postcards disseminated to a broad audience of Americans in the late nineteenth and twentieth centuries. What follows is a visual overview of how dams have been tapped for a multitude of purposes including milling and factory production, logging, navigation, mining, irrigation, municipal water supply, hydroelectricity, flood control, and recreation. In addition, this chapter highlights how the use of dams changed over the course of many decades. Dams do not possess an immutable relationship to human culture, and, over time, this relationship can evolve, sometimes quite dramatically.

While covering the most common reasons why people stored and diverted water, this chapter is not all-encompassing. For example, in northern parts of the United States millponds were at times used for harvesting ice, in the arid Southwest some dams were built by railroads to store water for steam locomotives, in Hawaii tidal fishponds were formed by small stone dams, and in mountain regions mining companies have often built (and still build) artificial tailing ponds to retain chemical waste and effluvia produced by ore-processing plants (large quantities of ash produced by coal-powered power plants can also be impounded behind tailing dams). None of these particular uses are covered in this book. Nonetheless, the variety shown is quite remarkable and illustrates the myriad ways that dams invigorate America's political economy.

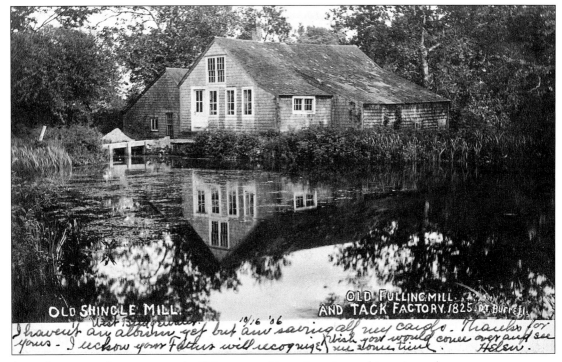

An early nineteenth-century rural mill in eastern Massachusetts used to cut wooden shingles and process wool; in a fulling mill raw wool is "beaten" in preparation for spinning and weaving. The reflection off the millpond creates a pastoral landscape par excellence.

Dams often came to serve more than one purpose—sometimes intentionally, sometimes not—and once built, a dam did not remain forever defined by the vision or desires of its original builder. Thus a dam built to foster navigation could also provide hydropower for mills; or a western dam built to store water for irrigation could later be adapted for domestic water supply as once rural citrus groves were transformed into suburban housing tracts. In the early twentieth century engineers and other people interested in expanding America's hydraulic infrastructure often spoke of "multiple-use" or "multipurpose" dams as some kind of new idea, something separating seeming haphazard development in the nineteenth century from a more rational, scientific, and reputedly modern approach. But dams have never been necessarily constrained to a single purpose. The rhetoric that called for modern multipurpose dams was in fact built upon practical precedents extending back many decades, if not centuries.

Mills

Broadly conceived, waterpower is a manifestation of solar energy. Water in oceans and lakes is heated by the sun, evaporating into the atmosphere and coalescing as clouds. Upon cooling, atmospheric moisture falls to the earth's surface as rain

A wooden gristmill in New York's Hudson River Valley, reputedly built by Revolutionary War soldiers in the eighteenth century.

A nineteenth-century rural gristmill in Indian Springs, Georgia, powered by a vertical overshot waterwheel. Water diverted by a dam is carried to the mill via an open wooden flume; the weight of the water captured by the buckets turns the waterwheel, and power is brought into the mill by a rotating shaft connected to the wheel's axis. Water splashing over the wheel may appear picturesque, but it represents an energy (and economic) loss because only water retained in the buckets can power the turning wheel.

The Kings Grist Mill on the Cumberland River near Williamsburg, Kentucky, illustrates how simple dams could provide a productive interface between human ingenuity and the rural environment.

or snow (or perhaps sleet or hail). Some of this precipitation seeps into the soil and becomes subsurface groundwater. But much remains on the surface and gathers into rivulets and creeks that conjoin to form rivers. And these rivers, under the inexorable pull of gravity, descend toward the sea or into landlocked desert lakes. The purpose of mill dams is to control and direct the flow of surface water so that the kinetic energy in the stream—ultimately derived from the solar heat that evaporated the water into the atmosphere—can be converted to mechanical power. By controlling water so that it turns a waterwheel, mill builders sought to capture the energy of a stream as it drops to a lower elevation. The power developed by rotating waterwheels could then be transmitted mechanically via gears and drive shafts to equipment within a mill or factory. Thus, dams do not *create* waterpower, they simply provide a means of *capturing* the power inherent in flowing streams.

The waterpower available at any given site depends on two factors: the volume of flow (often expressed as cubic feet per second or cfs) and how rapidly the streambed drops (often expressed as feet per mile). Thus, if two streams carry equal flow while Mill Creek descends at a rate of fifty feet per mile and Factory Brook drops a hundred feet per mile, then Factory Brook has the potential to

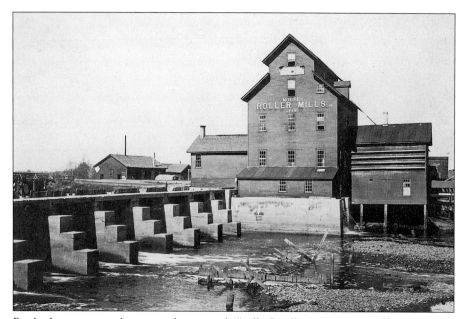

By the late nineteenth century larger-scale "roller" mills proved more efficient in processing grain, and they began to replace traditional grist mills. The Model Roller Mills in Nedecah, Wisconsin, built in 1884, represent a good example of this new generation of mill technology. The concrete dam shown in this view, circa 1910, was likely built to replace an earlier wooden crib dam.

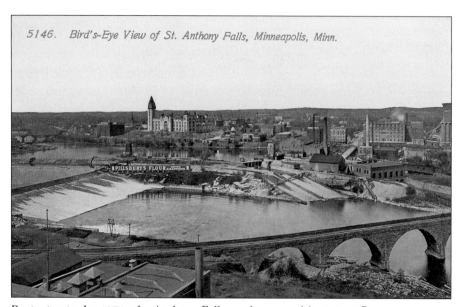

Beginning in the 1870s the Anthony Falls on the upper Mississippi River were developed as a major power source for roller mills controlled by the Pillsbury Flour Company. Use of this waterpower proved vital to the growth of Minneapolis, Minnesota.

Old Slater Mill and River Dam,
First Cotton Mill in America,
Pawtucket, R. I.

Steam engines are frequently linked to the origins of the Industrial Revolution, but waterpower was equally as important, especially in the development of America's early textile mills. Samuel Slater's water-powered mill in Pawtucket, Rhode Island, started production in 1793 and is celebrated as the first cotton mill in the United States.

generate twice as much power. Similarly, if the two streams descend at the same slope but Mill Creek carries three times more flow, then factories built along Mill Creek will have the potential to develop three times more power than those astride Factory Brook. Simply stated, waterpower is a function of both *flow* and *drop*. Increasing flow or capturing a greater elevation drop will create more powerful hydropower systems.

Clearly, large rivers with greater average flow possess more waterpower potential than smaller streams. But larger rivers are harder to control and require more effort to dam and develop as a power source. Conversely, while small streams may, in absolute terms, possess less power potential, they are easier to harness through construction of small dams. Thus, the history of mill dams in America generally followed a pattern where small streams in a region were developed first. Only later, when economic conditions justified a greater investment (in terms of labor, capital, or a combination of the two), were dams and water control systems built to exploit the power of larger rivers.

For centuries humans utilized waterpower as an outgrowth of agricultural production, grinding grain in local grist mills, sawing wood, and beating raw

A 6938 Boston Mfg. Co, Cotton Mill, Waltham, Mass.

British textile production reigned supreme during the nineteenth century, but with the help of tariff protection, the American textile industry competed for the domestic market. In 1814 Boston-based investors (operating as the Boston Associates) financed the first integrated textile mill in the United States. Drawing waterpower from the upper Charles River, the Boston Manufacturing Company's mill in Waltham, Massachusetts, integrated cleaning, spinning, and weaving into one large factory. In other words, the integrated mill took in raw cotton and shipped out woven cloth.

wool in fulling mills. Significantly, by the early nineteenth century waterpower was also being used to operate large textile mills, an event of great importance in the early Industrial Revolution. As Euro-American settlements dispersed westward across the North American landscape, water-powered mills—serving a range of industrial purposes—proved integral to economic development. Through time, larger rivers were harnessed to power larger factories. It was not until the adoption of large fossil fuel power plants and the proliferation of hydroelectric power technology in the twentieth century that traditional water-powered mills began to fade in significance. But the legacy of waterpower on the industrial landscape endures, as factories and industrial compounds often remain clustered along rivers and streams. In addition, many sites originally developed for mechanical power transmission were later adapted for the generation of hydroelectricity.

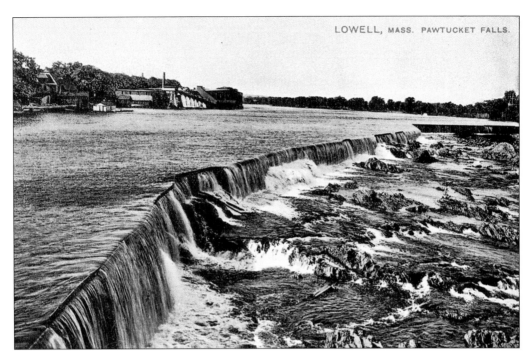

Looking beyond Waltham, the Boston Associates sought to expand their business model at a site with larger waterpower potential. A large bend in the Merrimack River, where the water drops over thirty feet in the space of a mile, offered an opportunity to capture more than forty thousand horsepower. Starting in the 1820s, the mills of Lowell, Massachusetts, became icons of economic and technological progress. Water diverted by the Pawtucket Falls Dam proved capable of powering almost thirty mills comparable in size to the earlier Waltham mill.

Stereo view of the Boott Mill in Lowell, circa 1870, one of many major textile factories in the city that depended upon the Merrimack River for power.

Hopedale Cotton Mills,
Burlington, N. C.

As labor costs rose in New England, manufacturers sought to build textile mills in the American South where organized labor held less influence. There were also an abundance of rivers in the region that could be tapped for power. This postcard, circa 1907, shows a cotton mill in Burlington, North Carolina, modeled on New England factories.

INTERIOR IVANHOE COTTON MILL, NO. 2,
SMITHFIELD, N. C.

Interior of a North Carolina textile mill, circa 1907, with technology adhering to the template pioneered in New England.

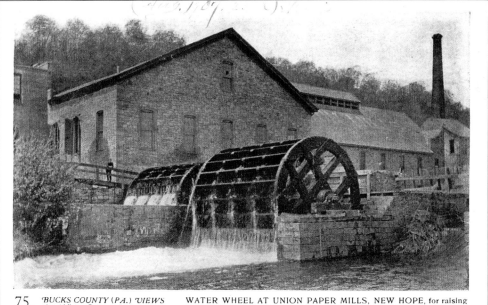

75. *'BUCKS COUNTY (P.A.) VIEWS* WATER WHEEL AT UNION PAPER MILLS, NEW HOPE, for raising
Arnold Bros., Printers, Rushland, Pa. water from the river into the canal. It has been in operation many years.

Undershot breast wheels could be very efficient in transforming the kinetic energy
of flowing water into mechanical energy. But the practical diameter of large-scale
breast wheels was limited to about fifteen to eighteen feet (beyond this they became
too cumbersome to build and operate). This view of a paper mill operation along
the Delaware River at New Hope, Pennsylvania, shows a waterwheel approaching
the maximum viable size.

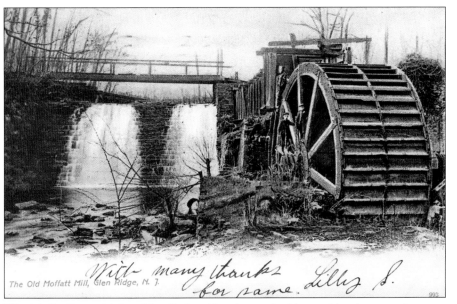

The Old Moffatt Mill, Glen Ridge, N. J.

The Moffet Paper Mill in Glen Ridge, New Jersey, had burned by the time this
postcard was made around 1905, but the imposing breast wheel survived.

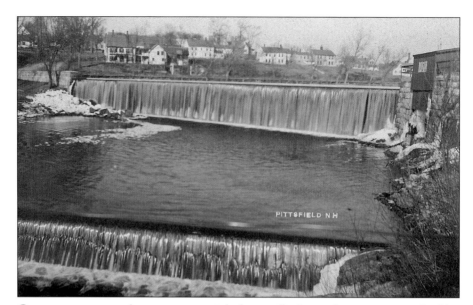

One way to capture the power potential of a rapidly descending stream is to build a series of modestly sized dams, each feeding a separate mill and waterwheel. That's what was done at Pittsfield, New Hampshire. But this method is inefficient for major rivers, and nineteenth-century hydraulic engineers sought other ways to develop large waterpower sites.

The solution to the size limitations posed by waterwheels came with "water turbines," a new technology that could efficiently transform water pressure into rotating mechanical power. Beginning in the 1840s, the Lowell-based hydraulic engineer James B. Francis pioneered the development of water turbines, and the technology was quickly adopted by other entrepreneurs. This illustration is taken from a manufacturer's late nineteenth-century catalog of turbines available for purchase.

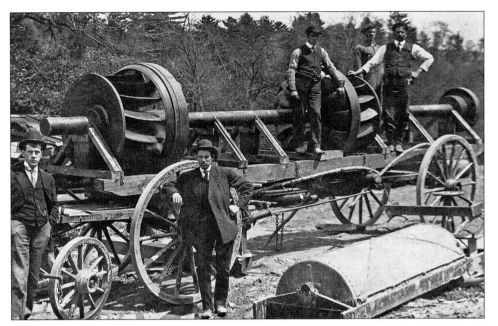

A view of turbine runners, circa 1907, in transit to a hydroelectric power plant under construction in New York State. The "double-runner" drive shaft shown here will be powered by two adjacent turbines.

Water turbines are often immersed in water and obscured from view. Close examination of this unidentified mill shows the vertical drive shaft extending up from the submerged turbine. Although efficient in terms of power development, turbines are much less visually expressive—not to mention less picturesque—than traditional waterwheel technology.

A small grist mill in Forestville, Iowa, powered by a submerged water turbine. It is possible that this mill was originally powered by a traditional waterwheel and later upgraded with a more efficient turbine.

Another way that mills could increase power efficiency was to adopt pressurized penstocks in place of open flumes or headraces. Penstocks allow for a turbine to capture more of a site's power by reducing both spillage and "head loss" from open channels. In this view, circa 1905, of the Old Mill Dam in Housatonic, Massachusetts, the enclosed penstock is on the left.

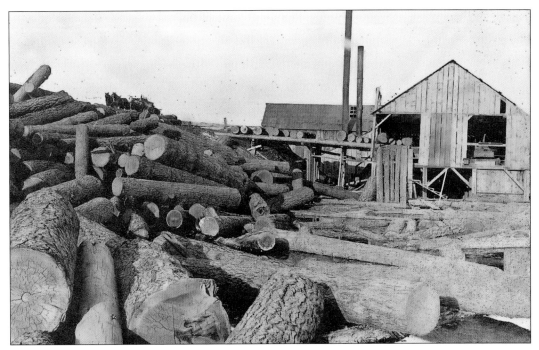

Sawmills often used dams both to provide waterpower and to create ponds where logs could be temporarily stored. This undated, unidentified real photo postcard shows logs floating in a millpond prior to cutting.

Logging

When Euro-Americans began settling the eastern coast of North America in the seventeenth century, the environment was dominated by vast expanses of ancient forest. American Indians made use of the wooded terrain and transformed it through fires and agriculture, but in precolonial times they had no access to iron hatchets or saws. As a result, their impact on the landscape was limited, at least in comparison to what Europeans accomplished in clearing forests and using timber for fuel, for building barns, houses, and ships, and for fabricating furniture and commercial goods. At first, logging was primarily a local enterprise. But by the nineteenth century it had become a major industry of regional and national scope as cities grew and timber frame structures proliferated across the landscape.

Water was tied to the exploitation of timber resources in two key ways: through water-powered saw mills and through the use of dams and rivers to store logs and float them to downstream mills. Often, large logs cut during the fall and winter were held behind "splash dams" and later, during spring floods and freshets, released in a watery rush to waiting downstream mills. Such a regime was pioneered in the wooded expanses of New England and later adopted in the Great Lakes region, the South, and the Pacific Coast. In some places,

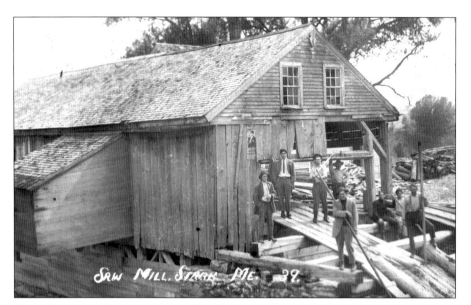

Sawmills were a ubiquitous part of the American landscape from the arrival of the first Euro-American colonists through the early twentieth century. This view of the sawmill in Stark, Maine, postmarked 1916, illustrates how uncut logs could be drawn in from an adjacent logging pond.

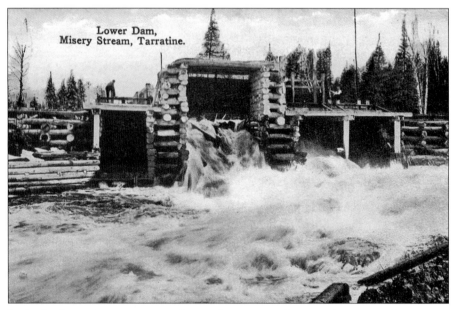

In the lumber industry, water is also used to connect logging districts to downstream mills. To help insure strong stream flow, logging outfits frequently built storage dams to help sustain river levels for longer than the usual spring flood season would allow. This view, circa 1910, shows a timber crib dam in Tarratine, Maine, with a central gate that can be raised to pass lumber downstream.

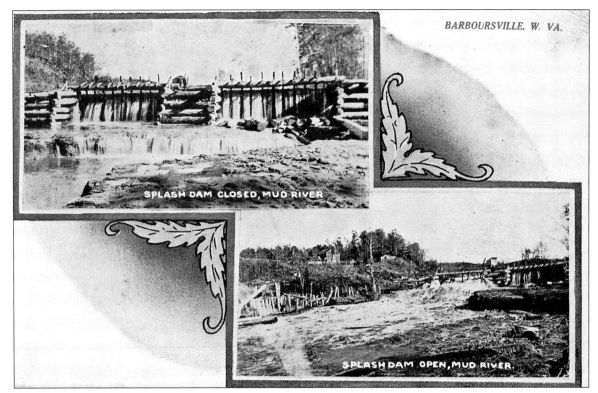

SPLASH DAM CLOSED, MUD RIVER

SPLASH DAM OPEN, MUD RIVER

A "splash dam" in the logging region of Barboursville, West Virginia. Water is stored during the winter and early spring and then quickly released so that logs can be carried downstream in the flood surge. The normal, undammed flow of the stream was deemed insufficient to transport cut logs without risk of being stranded in the shallow streambed.

most notably the High Sierra of central California, dams were used to supply water to lengthy flumes (the longest stretched for more than fifty miles), which allowed timber to float from remote mountain saw mills to railheads in the Central Valley.

With the tremendous growth of the pulp and paper industry in the late nineteenth century—a phenomenon closely tied to increased newspaper distribution and magazine publishing—paper mills expanded upon precedents set by earlier logging operations. Paper mills could take advantage of river transportation as a source of logs for pulp; paper mills could also use waterpower in processing pulp and making paper. In the twentieth century, paper mills often evolved into hydroelectric power plants where mechanical power transmission was replaced by electric power technology.

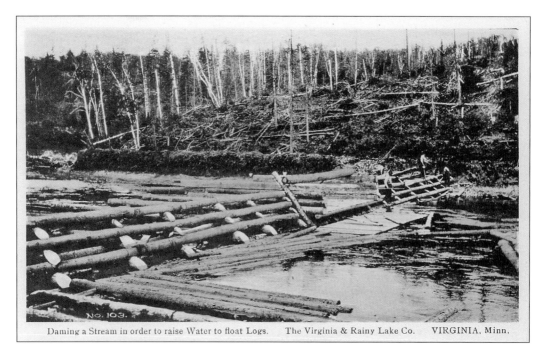

No. 103.

Daming a Stream in order to raise Water to float Logs. The Virginia & Rainy Lake Co. VIRGINIA, Minn.

In the nineteenth century the upper Midwest and Great Lakes region became a major source of timber. The logging techniques used here were largely transferred from practices pioneered in the eastern United States. This view, circa 1910, shows a logging dam in Virginia, Minnesota, designed to impound "a Stream in order to raise Water and float Logs."

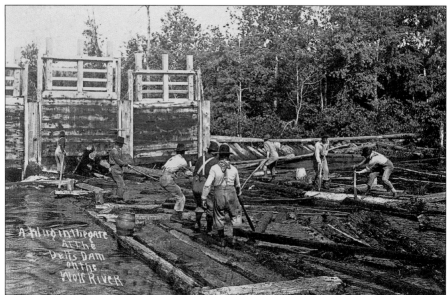

A plug in the gate
At the
Dells Dam
on the
Wolf River

Logging operations along the Wolf River in Wisconsin, highlighting the dangerous work of passing logs through the gate in the Dells Dam. This real photo postcard, circa 1907, describes the team of loggers as unblocking a "plug in the gate."

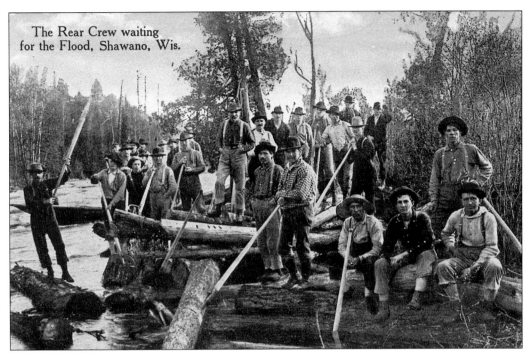

The Rear Crew waiting for the Flood, Shawano, Wis.

A "Rear Crew" near Shawano, Wisconsin, awaiting logs from an upstream splash dam.

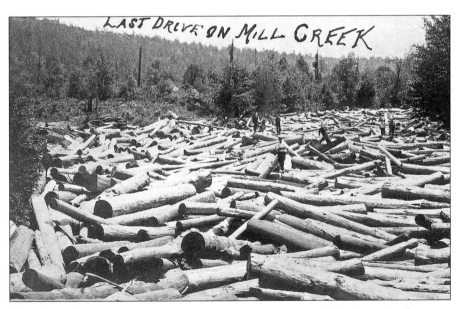

LAST DRIVE ON MILL CREEK

The phrase "log jam" derives from a very real phenomenon that plagued early logging operations. Too little water—or too many logs—created conditions where transportation became impossible until a large storm surge would, quite literally, break the log jam. This postcard from 1908 vividly illustrates the jam created by the "last drive on Mill Creek" near Ridgeway, Pennsylvania.

Logs and cut timber can also be carried in flumes supplied with water from logging ponds. This view shows a sawmill and flume in southern Oregon in operation around 1910.

At the turn of the century, giant sequoia and sugar pine logging operations made use of lengthy flumes to carry timber out of California's High Sierra. Completed in 1909, the Hume Lake Dam fed a fifty-mile-long flume that carried cut timber down to the railhead in Sanger, California. The company later sold its holdings to the U.S. Forest Service, and Hume Lake was adapted for recreational use. This real photo view, circa 1940, makes the lake appear as a natural feature of the mountain landscape, but it was decidedly industrial in origin.

A postcard from around 1910 showing the Sanger flume as it neared its terminus adjacent to San Joaquin Valley Railroad (a spur line of the Southern Pacific).

Built by the Grande Ronde Lumber Company in western Oregon, the Perry Dam makes good use of local materials. The company's log flume is visible in the right foreground.

Lumber Mill and Dam filled with saw logs. McCloud River, California.

In the early twentieth century lumber mills developed into large-scale industrial enterprises. This sawmill and logging pond along the McCloud River in Northern California highlights how the technology was expanding at the turn of the century.

Paper mills were a vital part of the logging industry and often relied upon water-power for plant operations. This postcard from the 1940s shows the integration of a dam and hydroelectric power plant at the Sterling Paper Mill in Eau Claire, Wisconsin.

Old Water Works at Fairmount Dam and Canal, Philadelphia, Pa.

One of America's most important early canal routes ascended the Schuylkill River westward from Philadelphia to the anthracite coal fields surrounding Port Carbon. This view, postmarked April 1913, shows the Schuylkill Navigation Company's Fairmount Dam with the canal in the foreground. The city's municipal waterworks (which made use of the dam after it was constructed by the canal company) appear in the right background.

Navigation

Floating down a river or sailing across a lake requires minimal energy, at least when compared to other means of long-distance transport. The wetted surface of a ship, boat, or barge, may offer resistance (or "drag") as it passes through the water. But, matched against a horse-pulled wagon moving along a rutted road, waterborne transportation is amazingly efficient. Even today, in an age of motorized trucks and diesel-powered trains, waterborne commerce maintains an essential role in national and international transportation systems.

In colonial America, rivers offered an effective medium for conveying goods and heavy cargo. However, difficulties arose when stream flow dropped and channel depths became too low to allow easy passage of boats and barges. Also, rocky stretches of streambed—often called rapids, falls, or shoals—could form significant barriers for river travel no matter how heavy the current. Mindful of successful navigation projects in eighteenth-century Britain, leaders in early America saw canals as a way to overcome difficulties presented by low water and

The Chesapeake and Ohio Canal was intended to connect the Potomac River watershed with the Ohio River Valley on the western slope of the Appalachian Mountains. But by the time the 184-mile-long canal reached Cumberland, Maryland, in 1848, railroad technology had rendered the interregional system obsolete. The canal operated commercially within the Potomac watershed until the 1920s, connecting Georgetown with the Maryland, Virginia, and West Virginia hinterlands. It is now maintained by the National Park Service as the Chesapeake and Ohio Canal National Historical Park.

rocky streambeds. Some of the earliest canals in America (such as the Potowmack Canal at Great Falls on the Potomac River near Washington, D.C., or the Pawtucket Canal along the lower Merrimack River in Massachusetts) were not lengthy constructs. Instead, they consisted of a few locks built to circumnavigate a particularly troublesome stretch of the river; once a boat passed through these locks, it would reenter the stream and continue along the natural waterway.

Seeking to induce long-distance trade and develop ways to carry large quantities of bulky cargo, regional boosters in the early nineteenth century envisioned much more expansive canal systems. Two of the earliest such projects were the Schuylkill Navigation Company's system connecting tidewater Philadelphia to coal fields in central Pennsylvania and the famous Erie Canal connecting the Hudson River to Lake Erie (a distance of more than 250 miles). Work on the Erie Canal started in 1817 and, upon completion in 1825, played a key role in the ascent of New York City as America's premier commercial center. The success of the Erie Canal soon spurred "feeder canals" covering the terrain of upstate New York as well as canals to the west in the Ohio River Val-

A pair of canal boats on the Erie Canal in upper New York State at the beginning of the twentieth century. In the far left background, you can see the team of mules used to pull the boats at a slow, steady pace of about three miles per hour.

Stone Bridge and Dam, Kent, Ohio.

Upon completion in 1825, the Erie Canal provided a navigable waterway connecting the Hudson River to Lake Erie and the Great West lying beyond the Appalachian Mountains. In the 1830s boosters in Ohio worked to connect Lake Erie with the Ohio River and with western Pennsylvania. This dam at Kent, Ohio, was built in the 1830s as part of the Pennsylvania and Ohio Canal.

In western Ohio, the Miami and Erie Canal was built between 1825 and 1845 to connect Lake Erie with the Ohio via the Miami River Valley. This real photo postcard, circa 1910, shows a new concrete dam built at the Grand Rapids canal locks. The Miami and Erie Canal gradually lost economic relevance in the face of competition from railroads; the heavy floods of March 1913 spelled the end of full-scale operation, although some sections are still used for local recreation and tourism.

When the Erie Canal was replaced by the larger New York State Barge Canal, the new system required much greater quantities of water to maintain operability. The Hinckley Dam was completed in 1915 to provide water for the new navigation system. Presently, the reservoir is also used by the City of Utica as a source of municipal water supply.

A "white border" postcard from the 1920s showing Lock No. 24 on the New York State Barge Canal. The size and scale of nineteenth-century canals proved incapable of economically competing with railroads, but large-scale barge traffic could move bulk cargo at competitive rates.

Had a delightful drive yesterday. Lena.

April 30/06

Since the early nineteenth century, navigation along the Mississippi and Ohio Rivers has been a vital part of America's transportation system. The U.S. Supreme Court ruling in *Gibbon v. Ogden* (1824) established federal jurisdiction over navigable rivers and the Army Corps of Engineers (with authorization from Congress) subsequently assumed responsibility for improving and maintaining shipping along major rivers. This real photo postcard postmarked 1906 shows a steamboat passing through the Army Corps of Engineers' lock at Marietta, Ohio.

In the 1930s, development of a nine-feet-deep river channel for the upper Mississippi River required construction of large dams like the facility at Genoa, Wisconsin, completed in 1937. As with many other navigation dams built by the Army Corps of Engineers, it is "movable" in that the cylindrical "rollers" between the concrete piers can move up and down to better control river flow during times of both low water and heavy floods. The lock in the foreground is built to accommodate large barges that can compete with truck and railroad commerce. Note also how the design provides for the construction of a second lock.

ley. In 1820–1850 a multitude of canals were proposed and often times built. But the rapid expansion of railroads at midcentury quickly brought an end to the boom in canal building. For example, by 1850 the Chesapeake and Ohio Canal had made its way up the Potomac River to Cumberland, Maryland, but there it stopped, never coming close to reaching the Ohio River watershed.

Canals certainly did not disappear from the American landscape in the latter nineteenth century, but their economic importance steadily waned as the decades passed and railroad systems grew. In the early twentieth century a resurgence of interest in waterborne transportation fostered the expansion of "inland waterways" along major rivers such as the Ohio and Mississippi. During this time, the original Erie Canal was replaced by the larger (but far less poetic) New York State Barge Canal. Support for inland navigation remained a priority for the Army Corps of Engineers, and a series of federal dams built along the Mississippi and Ohio Rivers during the New Deal were designed to support increased barge traffic within the nation's heartland. Today, nineteenth-century canals survive largely as "heritage trails" or within park preserves; in contrast, many of

6A-H2318

As captured in this linen postcard of 1936, the sleek design for the Tennessee Valley Authority's concrete navigation lock at Pickwick Dam in Central Tennessee marks it as a component of America's modern inland waterway system.

the navigation systems planned and implemented in the early and mid-twentieth century remain a vital part of America's transportation infrastructure

Dams can facilitate navigation in two ways: one is by impounding water in slack-water pools that inundate rocky stretches of the streambed and provide a sufficient depth of water so that canal boats and barges do not run aground—at the upper reaches of a slack-water pool another dam and lock need to be built, allowing boats and barges to continue their journey—and the other is by storing and feeding water into a canal system in order to keep the canal prism filled. This is important because the operation of locks will steadily draw water down through a canal system; as a result, great importance was often placed on developing reliable water sources (i.e., reservoirs impounded by dams) capable of filling locks at high elevations in the system.

As an example of a slack-water system, the series of dams built upstream from Philadelphia by the Schuykill Navigation Company in the 1820s and 1830s were fitted with traditional canal locks to provide a 108-mile-long navigation channel. Slack-water systems are also evident in navigation improvements built by the U.S. Army Corps of Engineers along the Ohio and upper Mississippi Rivers in the late nineteenth and early twentieth centuries. In contrast, the South Fork Dam (which eventually collapsed and caused the horrific Johnstown

Flood in 1889) was an example of a storage dam designed to supply water for a canal. (Note that the doomed dam was originally built as part of the Pennsylvania Canal, but, after the Pennsylvania Railroad rendered the canal obsolete, it was sold to the South Fork Hunting and Fishing Club. This privately controlled club owned the dam and reservoir at the time of failure). The relationship of water supply dams to navigation is not merely a matter of historical interest. For example, successful operation of the New York State Barge Canal relies upon water supplied by the Delta Dam located near the "summit" of the canal in the middle of the state. Similarly, water releases from Army Corps of Engineer dams across the upper Missouri River (such as the Fort Peck Dam discussed in chapter 6) help maintain water levels in the lower Missouri River sufficient to support large-scale barge traffic as far north as Sioux Falls, Iowa.

Mining

Water is closely tied to both the discovery of gold in California in 1848 (gold flecks were first spotted during excavation of a tailrace for the Sutter's Fort sawmill) and to commonly used methods of gold separation. Panning, the classic technique used by individual gold miners, used water as an essential medium in washing away debris (i.e., rocks, pebbles, and dirt) and leaving behind heavy gold flecks and nuggets in the metal pan's bottom. Panning technology in the California gold fields quickly evolved through development of large-scale sluice boxes, long toms, and "rockers," all the while increasing the economic value of a steady, reliable water supply. Early on in the gold rush diversion dams were also built to dewater streambeds and provide access to deep crevices where gold, washed from the mountains during eons of rainstorms and snowmelt, had collected during centuries past. By the early 1850s numerous diversion dams and far-flung ditches had been erected to control water supplies in the Sierra Nevada. Significantly, water law in California and other parts of the West was strongly influenced by the Doctrine of Appropriation practiced in the early gold fields, a protocol in which water rights derive from diversion and beneficial use and not simply from ownership of riparian land adjacent to a stream.

Mining in the gold rush era is frequently perceived as an effort undertaken by thousands of self-sufficient miners, each working a small claim individually or in the company of a few colleagues. In truth, large-scale corporate mining came quickly, driven by a desire to control and transport water in large quantities. As part of this, some of the earliest large storage dams in the United States were built high in the northern Sierra to capture flood water and maximize its use in gold extraction. Closely following increased water supplies came the development of hydraulicking as a gold mining technique. In this practice, a high-pressure stream of water is directed against earthen hillsides containing gold flecks and (with luck) small nuggets of the precious metal. The pressurized water

Stereo view, circa 1878, taken by the famous California photographer Carleton Watkins, of the 131-feet-high English Dam in the northern Sierra Nevada. First built in 1856 and raised in 1876, this huge timber crib and rock-fill structure impounded a reservoir with a storage capacity of over 4.8 billion gallons (about 15,000 acre-feet), one of the largest in mid-nineteenth-century America. The size of the dam and reservoir reflects the great value of water to the hydraulic gold mining industry.

The focus of this postcard, circa 1910, may be the dramatic railroad bridge crossing the Bear River in Nevada County, California. But in the foreground lies a diversion dam built to support the region's once flourishing gold mining industry.

Placer Mining.

Early twentieth-century postcard of placer (hydraulic) mining in Washington state. This view illustrates how high-pressure streams of water were used to erode gold-bearing soil, creating a fluid muck that could be directed into flumes and transported by gravity to downstream processing plants.

Placer Mining and Mount of the Holy Cross, South Park Div. C & S. Colorado

Another postcard view of high-pressure placer mining, this one high in the Rocky Mountains along the line of the Colorado and Southern Railway. The technology was a centerpiece of gold mining in nineteenth-century California, later diffusing throughout the West.

Englebright Dam across the Yuba River in Northern California. Completed in 1941 by the Army Corps of Engineers, this concrete arch dam holds back mining debris in the Yuba basin; it also supplies water to hydropower plants operated by the Yuba County Water Authority.

A-104—Badin Dam and Power House, Badin, N. C.

Aluminum processing plants consume huge amounts of electricity to transform bauxite ore into usable metal. This color postcard, circa 1930, shows the hydropower dam serving the aluminum plant in Badin, North Carolina. The development along the Yadkin River was initiated in 1912 by the French company L'Aluminium Français, but, after the outbreak of the First World War in Europe, the plant was sold to Pittsburgh-based ALCOA prior to completion in 1917.

Cheoah Dam-Tapoco, N.C. I-J-13

ALCOA perceived the southern Appalachian Mountains as a good source of hydroelectric power and continued to build dams in the region through the 1920s. In 1913 the company bought several small power companies in western North Carolina and eastern Tennessee, including the Tallassee Power Company. Condensing the latter company's name down to Tapoco, in 1919 ALCOA completed the Cheoah Dam in Tapoco, North Carolina, as part of a four-dam system on the Cheoah and Little Tennessee Rivers. After the Tennessee Valley Authority was authorized in the 1930s ALCOA transferred rights covering other dam sites to the new federal agency.

erodes the gold-bearing soil and the resulting fluid muck (commonly referred to as hydraulic fill) is carried through flumes to downstream processing plants, where the gold is separated from the mud and rocky debris.

By the end of the nineteenth century hydraulic mining had brought so much rock and earthen debris into the Sacramento River Valley that one of the first legislative efforts to protect the environment and reduce the effects of floods focused on controlling the hydraulic mining industry. Starting in 1893, the federally authorized California Debris Commission took on this regulatory task in concert with the Army Corps of Engineers. The commission did not bring an end to hydraulic mining, but it could—and did—require the construction of special "debris dams" designed to hold back the residue of hydraulicking within reservoirs and thus protect lower valleys from further clogging and flooding.

The pinnacle of hydraulic mining in California came before widespread use of picture postcards, and some of the most revealing images of the industry were captured on stereo views taken in the 1870s and 1880s. But hydraulic mining diffused through the west in the late nineteenth and early twentieth centuries, and more than a few postcards record this technological transfer. In addition,

hydraulic-fill technology was used to build earth embankment dams in the early twentieth century, further evidence of the impact of mining on dam building.

In the twentieth century mines of all sorts grew in size and oftentimes came to require huge amounts of electric power to maintain productivity. As a result, many hydroelectric power dams were built specifically to energize mining operations. Most importantly, the aluminum industry depended upon huge quantities of electricity to "reduce" bauxite ore into the lightweight metal that, prior to the twentieth century, had largely been a laboratory curiosity rather than an essential element of modern industry. The role played by aluminum interests in spurring construction of hydroelectric dams proved to be particularly important in the American South, where the Aluminum Company of America (ALCOA) pioneered in developing the hydropower potential of the southern Appalachian Mountains. Later, giant hydropower dams of the Pacific Northwest—most notably Grand Coulee and Bonneville dams—energized huge government-subsidized aluminum plants built during the Second World War.

Irrigation

In humid regions, crops flourish because of rainfall. On desert tracts, natural precipitation is insufficient to sustain harvests, but irrigation offers a way to cultivate otherwise dry fields. The evolution from hunter-gatherer modes of subsistence to sedentary agriculture was closely tied to water, and irrigation played an im-

SUGAR BEETS ON IRRIGATED TRACTS NEAR REDMOND, OREGON.

Irrigation comprised a social crusade of sorts, but it was also a business, one in which promoters sought to distinguish their holdings from all the other irrigated tracts in the West. Often times boosterism flourished more than actual crops, but isn't that the American way? Here, the Deschutes Irrigation and Power Company boasts of their irrigated sugar beet fields.

1503 — IRRIGATING A CALIFORNIA ORANGE GROVE.

"Irrigating a California Orange Grove," as depicted by the San Francisco-based publisher Edward H. Mitchell, one of the most prolific postcard manufacturers in the western United States. This view, circa 1910, was not linked to any specific town or irrigation project and was widely marketed as a seeming "local" view.

2785. IRIGATIUM SCENE. PHOENIX, ARIZ.

R. L. BALKE. U. S. Licensed Indian Trader, Phoenix Ariz.

Orange groves are not easy to find in modern day Phoenix, Arizona, but the history of the Valley of the Sun is inextricably tied to irrigated agriculture. Hundreds of years ago the Hohokam Indians built irrigation canals in the Salt River Valley and in the late nineteenth century, Anglo-American settlers re-excavated these long-abandoned ditches. The phrase "Irigatium Scene" may simply be a typographical error. Or it may reflect a desire to associate Phoenix with the accomplishments of ancient civilizations.

Flume Check on Irrigation Canal,
Imperial Valley, Calif.

Water flowing through irrigation canals needs to be carefully controlled to ac-
commodate changes in elevation. If canals are too steep, erosion can cause serious
"breaks" that will interrupt flow and—unless quickly repaired—destroy adjacent
crops. This view features a "flume check" in Southern California's Imperial Valley
that protects canals against erosive damage.

portant role in the hydraulic civilization of early Mesopotamia. Other socially
complex cultures in early China, Mayan Mexico, and the Indus River Valley of
modern-day Pakistan also manipulated scarce water resources to create distinctive
modes of agricultural production. Irrigation is tied to some of the most important
cultural developments in human history, and, in a modern-day counterpoint, irri-
gation proved of vital import to the social, political, and economic development
of the American West. In the arid western United States—an expanse that the
nineteenth-century explorer and scientist John Wesley Powell famously defined
as lying west of the hundredth meridian—the ecological transformation of the
Great American Desert relied upon dams and water control technology to "make
the desert bloom."

The basic concepts underlying irrigation have changed little since ancient
times. Divert water out of a river or stream (or pump it from underground aqui-
fers), transport it to otherwise arid land, and then distribute it over a field or or-
chard so moisture can seep down and nourish roots. Different crops, soils, and
climates can require different quantities of water (and different watering sched-
ules) to maximize productivity. But the essential tenets of irrigation technology
largely transcend specific cultural or environmental factors.

Over time irrigators came to appreciate that much of a river's cumulative
flow comes during brief, intense floods, often in spring or early summer. For

Spanish settlers were the first to bring European-style irrigation to the Americas, erecting several diversion dams in what later became the southwestern United States. This real photo postcard, circa 1910, documents the remains of the late eighteenth-century masonry dam built to divert water to the San Diego Mission in Southern California.

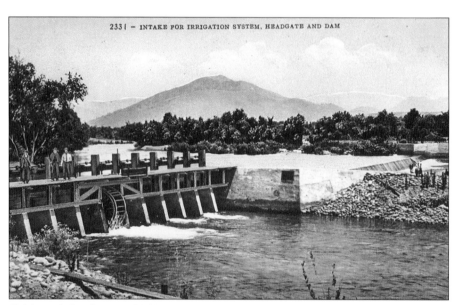

California's San Joaquin Valley is one of the world's most productive agricultural regions. This postcard illustrates a diversion dam and canal intake along the Kings River south of Fresno. The elaborate headgate is designed to prevent floodwaters from entering—and damaging—the canal. This early twentieth-century scene evokes a pastoral, almost garden-like quality where irrigation fits easily into the natural environment.

systems dependent upon small diversion dams, these seasonal floods cannot be used for irrigation because they pass over the dams as they surge toward the ocean or a low-lying desert lake. Storage dams offer a means of altering this dynamic. By capturing seasonal floods and allowing otherwise lost water to be used later in the growing season, storage dams make possible the cultivation of land that otherwise could not be brought "under the ditch."

Irrigation thus relies on two basic dam types: diversion and storage. Diversion dams are usually smaller and less expensive to construct, so they were usually the first to be built when a river or stream was developed for irrigation. Thus, the earliest dams built at eighteenth-century Spanish settlements such as San Antonio and San Diego were diversion structures. And when Mormon settlers began colonizing Utah in the late 1840s, they relied upon small-scale dams to divert creeks flowing west out of the Wasatch Mountains. Although the size of the individual dams built by nineteenth-century Mormon colonists was small, their cumulative impact was great. Scores of settlements spread across Utah and into Idaho, Nevada, and Arizona. After the Civil War, non-Mormon irrigation colonies and settlements soon sprang up in Colorado, California's Central Valley, and the Salt River Valley in central Arizona.

By the 1890s irrigation was widely practiced throughout the West, spurring interest in the construction of storage dams to capture floods and allow cropping of yet more arid land. In the late 1880s John Wesley Powell led a federally sponsored irrigation survey to identify reservoir sites in the headwaters of major rivers. Because of rising political fears that private property rights in the West might suffer from federal intrusion, Powell's survey lasted only a few years. But Powell brought into public consciousness the idea that government could play a role in the "reclamation" of the American West. Impetus for federally supported irrigation and reclamation projects grew during the 1890s as many (but certainly not all) initiatives financed by private capital foundered in the wake of the Depression of 1893. Western states also saw large federal expenditures going into navigation improvements in the Ohio and Mississippi River valleys and into harbor dredging along the East Coast and the Great Lakes. The West wanted its share of the federal largess, but with assurances that control over water rights and private property would remain in Western hands.

Pieces of the reclamation puzzle were coming together at the turn of the twentieth century. Nonetheless, creation of the U.S. Reclamation Service in 1902 almost certainly would not have occurred if William McKinley had not been assassinated in September 1901, an event catapulting Teddy Roosevelt into the presidency. In contrast to McKinley, Roosevelt held an activist vision of government and he soon advocated direct federal financing of dams and irrigation works. Local farmers served by these projects were, upon their completion, to

Completed in the early 1880s, the Platte Canyon Canal was built using private capital to irrigate tens of thousands of acres in the greater Denver region.

6739. IRRIGATION FLUME, PLATTE CANYON, COLORADO.

a truly trip. and our crazy crew enjoying every thmed to the.

a. E.

repay construction costs over a period of ten years. Then these payments to the federal treasury could be used to support yet more projects in the West. And so forth ad infinitum. Or at least that was the idea.

Roosevelt signed the National Reclamation Act on June 17, 1902, with Frederick H. Newell taking charge of the newly created U.S. Reclamation Service. Over the next several years the agency oversaw construction of some of the largest dams in the United States, including the 280-feet-high Roosevelt Dam near Phoenix, Arizona, the 309-feet-high Shoshone (later renamed Buffalo Bill)

Dam in Wyoming, and the 350-feet-high Arrowrock Dam near Boise, Idaho. The service also built smaller-scale diversion dams and canal works but received most acclaim for its monumental storage dams.

Newell had trumpeted the economic efficiencies that would accompany the construction of his agency's dams (something he faulted private irrigation projects for). So it proved to be no small embarrassment when the cost of almost all the Reclamation Service's projects dramatically exceeded original estimates. Political pressure fed by cost overruns eventually forced Newell's resignation in 1914. And political pressure also brought about significant restructuring of project repayment schedules. Ten-year repayment schedules stretched to twenty years (with no interest charges), and these revised terms were often revised yet again. As an example, the project that included construction of Roosevelt Dam (which under the original terms should have been reimbursed to the federal government by 1921) was not officially paid out by Phoenix area landowners until 1956. The tail had come to wag the dog, as local interests in the West eventually found a means of using federal support for irrigation in ways unanticipated when Powell's irrigation survey was forced to disband in the early 1890s.

In strictly technological terms, Reclamation Service dams could be judged a success. But they were expensive and, if held to the standards of private capital markets, often constituted economic failures. By the early 1920s, the financial problems of the service were widely recognized and more than a few people clamored to abolish the agency. In fact, adoption of the name Bureau of Reclamation in 1923 came in an effort to counter such sentiment and forestall the agency's closure. Although bureau projects continued to be authorized in the 1920s, it was the proposed Boulder Canyon Project (eventually spawning the Boulder Dam, later named the Hoover Dam, featured in chapter 6) that largely provided the political impetus to keep the agency alive.

Thanks to publicity and promotion, many people believe that the federal government was responsible for all of the big dams and irrigation projects built in the twentieth-century American West. In fact, by 1920 a mere 7 percent of irrigated land in the West bore any relation to the federal government. By the end of the twentieth century this figure had increased to about 25 percent, but even today most irrigation in the region remains under the control of local water companies, irrigation districts, or water conservation authorities. Their dams may not be on the scale of a Roosevelt or Arrowrock, but nonetheless they can be quite substantial. Yes, it is impossible to imagine the creation of the modern West without the involvement of the federal government. But it is equally impossible to comprehend Western water history without recognizing the significance of private capital and private initiative.

Soon after Congress authorized the U.S. Reclamation Service in 1902, the agency developed plans for an irrigation project on the lower Colorado River near the Mexican border. Appropriating land from the Yuma Indian Reservation, the Yuma Reclamation Project used the Laguna Dam to divert water to tracts in both California and Arizona.

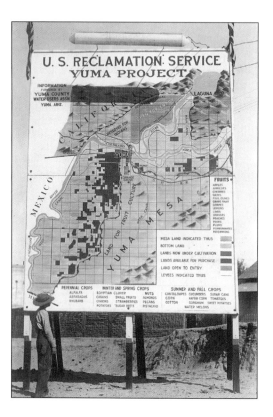

A large billboard of the Yuma Reclamation Project as depicted on a postcard, circa 1915. The Reclamation Service did much to publicize its projects, but the agency suffered significant logistical and financial problems. Like many other early Reclamation Service projects, the Yuma Project farmers struggled to survive; repayment of the construction debt needed to be stretched out for decades beyond the original terms.

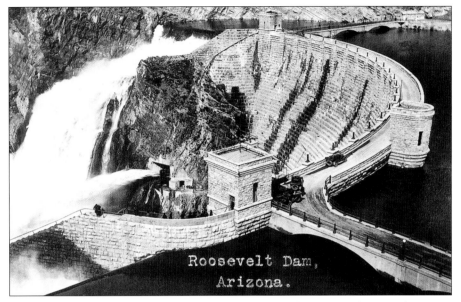

Roosevelt Dam,
Arizona.

Roosevelt Dam lies about sixty miles east of Phoenix, Arizona, and was perhaps the most famous of the Reclamation Service's early monumental projects. Official completion came on March 18, 1911, with former president Theodore Roosevelt (the dam's namesake) travelling to speak at the dedication ceremony. Frederick Newell, the director of the Reclamation Service, did not attend, largely because of political problems fomented by construction delays and cost overruns.

Completed in 1910, Shoshone Dam (now called Buffalo Bill Dam) is a 309-feet-high concrete thin arch structure that helps irrigate thousands of acres in north central Wyoming. Although the Reclamation Service (later Bureau of Reclamation) is well known for massive gravity designs, it has also built major thin arch dams. In this instance, the narrow gorge forming the Shoshone site proved to be ideally suited for a thin arch design.

Many people believe that the federal government is responsible for all irrigation in the West, but in truth most irrigated land in the region is controlled by private owners or local authorities. This real photo postcard, distributed by the local photographer F. C. Chapman, shows construction of the earth embankment Sevier River Dam near Nephi, Utah, circa 1910. The horse-drawn wagons and the camp lying below the dam reflect the agrarian heritage of Mormon farmers who first settled the area in the 1850s and set an example in "making the desert bloom."

(Opposite, top) The Reclamation Service's Boise Project was dependent upon storage provided by the 348-feet-high concrete curved gravity Arrowrock Dam. Considered the highest dam in the world when completed in 1915, Arrowrock Dam served a multitude of farmers in the bench lands surrounding Boise, Idaho.

(Opposite, bottom) Massive embankment dams were also a part of Bureau of Reclamation irrigation projects. A good example is the Tieton Dam in central Washington State completed in 1924.

Completed in 1895, the 135-feet-high masonry curved gravity Hemet Dam was privately financed by the Lake Hemet Water Company. Built to irrigate land in the San Jacinto Valley about seventy miles southeast of Los Angeles, the reservoir lies more than 4,300 feet above sea level. Hemet Dam was one of the largest irrigation dams built in the nineteenth-century American West.

Located in the Sierra Nevada foothills of central California, the 328-feet-high concrete curved gravity Exchequer Dam was built between 1924 and 1926 by the Merced Irrigation District. Close in size to the Bureau of Reclamation's biggest dams, Exchequer was an imposing structure that served one of the state's most agriculturally productive regions. Construction financing came from the sale of bonds in the private investment market.

J. W. Lough's Irrigating Machinery
White Woman Creek Leoti Kans.

Irrigation dams store and divert surface water, but this is not the only source of the precious liquid available in arid regions. Pumping from underground aquifers also became common in the West during early twentieth century. This postcard advertises how J. W. Lough's Irrigating Machinery (powered by a tractor engine) could supply water for the otherwise dry plains surrounding Leoti, Kansas. At first, the region's Ogallala Aquifer lay a mere few dozen feet below the surface; today, pumps need to lift water several hundred feet, raising fears that the once bountiful subsurface reserve will someday be drained dry.

Municipal Supply

When population densities are low, there is little reason to build collective water supply systems. On farms and in small villages, individual families in the premodern era could dig their own wells or carry water from a nearby stream. This was the state of affairs in much of colonial America. But as urban populations of Philadelphia, New York, Boston, and other cities began growing in the early republic, water quantity and quality surfaced as a major civic issue.

People in the early nineteenth century did not possess a modern understanding of germ theory (that only came at the end of the century). But they did appreciate that the prevalence of "bad water" as defined by smell, color, and turbidity often correlated with disease outbreaks. Deadly yellow fever outbreaks in Philadelphia in the 1790s gave impetus to a municipal waterworks—replete with a steam pump, a centralized water tank, and wooden distribution pipes— that could deliver water from the Schuylkill River to residents throughout the central city. By the 1820s the steam pump had been replaced by waterwheels

New York City's original Croton Dam in Westchester County, forty miles north of Manhattan. To the modern eye, it may appear to be of rather modest proportions. But, as shown in a stereo view circa 1870, it stood as the tallest dam in the United States when completed in 1842. This structure remained in operation until the early twentieth century, when it was submerged under the reservoir created by the city's New Croton Dam.

14. High Bridge, New York.

A postcard from 1904 of the High Bridge that carried the original Croton Aqueduct across the East River into Manhattan. The Roman Empire comes to America! Note how the card was sent with the directive "Put this in your book." Sixty years after completion, the structure still held power as a civic monument.

Storage on a monumental scale. By the beginning of the twentieth century, New York City was working to replace the original Croton Dam with the 297-feet-high New Croton Dam. Completed in 1907, the massive masonry structure featured a huge overflow spillway at the north abutment.

drawing water from the Schuylkill Navigation Company's dam at Fairmount. With this, the famed Fairmount Waterworks (illustrated in chapter 2) began an illustrious ninety-year history.

As Philadelphia grew so did Manhattan, with interest in a municipal water supply system for New York City surfacing as early as the 1770s. By the early 1830s conditions on the rocky island had become intolerable; health concerns and a lack of reliable water streams for fighting fires drove efforts to tap into a rural water supply. Completed in 1842, New York City's Croton Aqueduct carried copious quantities of water more than forty miles from the Croton River in Westchester County down to Manhattan. As part of this system, a fifty-feet-high masonry dam provided storage and ultimately allowed for a flow of ninety million gallons of water a day to slake the thirst of city residents. A massive masonry aqueduct carried the system's water conduit across the East River to distribution reservoirs in Manhattan, a practical symbol of achievement that evoked the glories of ancient Rome. Water and civilization: a potent pairing taking root in North America through construction of a major dam and aqueduct.

From the 1850s on, municipal water supply grew as a civic concern for politicians, boosters, businessmen, public health advocates, and citizens who heralded safe, reliable water supply as a foundation of modern American society.

Clinton, Mass. - Wachusett Reservoir

Storage on a monumental scale redux. Starting in the 1890s Boston began building a 205-feet-high dam across the upper Nashua River. Completed in 1904, the Wachusett Dam provided a storage capacity of sixty-five billion gallons (about 175,000 acre-feet). Eventually the city would tap into the Connecticut River watershed in western Massachusetts, but first it developed water sources closer to home.

SPRING VALLEY DAM.

BASKETTE DRUG CO. PUBLISHERS. PHOTO. BY NAISAT

Long before San Francisco developed Yosemite National Park's Hetch Hetchy Valley as a source of water supply, the privately owned Spring Valley Water Company built the concrete curved gravity San Mateo Dam to serve the city. Completed in 1886, the San Mateo Dam (also known as Crystal Springs Dam) is now operated as part of the city's municipally owned system.

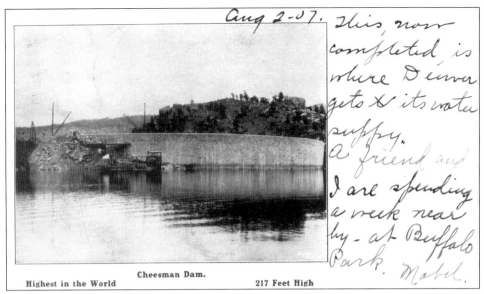

Cheesman Dam.
Highest in the World 217 Feet High

Aug 2–07. This, now completed, is where Denver gets of its water supply. A friend and I are spending a week near by — at Buffalo Park. Mabel.

Monumentality in the West. Completed in 1904, the 217-feet-high Cheesman Dam provided Denver with a reliable, high-quality mountain water supply.

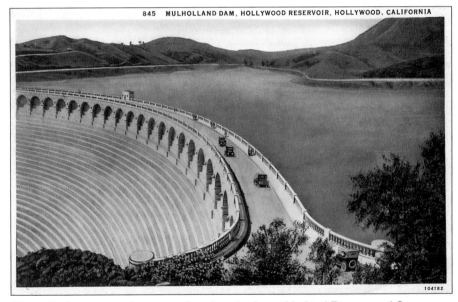

845 MULHOLLAND DAM, HOLLYWOOD RESERVOIR, HOLLYWOOD, CALIFORNIA

Through the nineteenth century, Los Angeles lagged behind Denver and San Francisco in terms of population and civic stature. But when Los Angeles completed a 233-mile-long aqueduct to deliver water from the Owens River, it began its rise as a major metropole. In the early 1920s, Los Angeles built dams to store Owens River near the city. For the reservoir site lying in the Hollywood Hills, the city's chief engineer William Mulholland devised a monumental concrete gravity design. After the failure of Mulholland's St. Francis Dam , the downstream face of his earlier dam above Hollywood was covered with earth fill and the spillway lowered to reduce hydrostatic pressure.

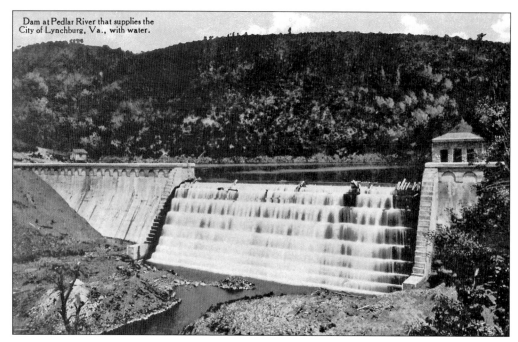

Dam at Pedlar River that supplies the
City of Lynchburg, Va., with water.

Monumentality in the early twentieth-century South. Completed to a height of
seventy-three feet in 1907, the Pedlar Dam is a concrete gravity structure across
the Pedlar River, a tributary of the James River in west central Virginia. The dam
supplies the City of Lynchburg with water via a twenty-one-mile-long aqueduct.

The search for pure water came in many ways, as every community existed
within both a unique physical environment and a distinctive political milieu.
In order to limit the effects of both human and industrial pollution, a rural or
"mountain water supply" was often sought. However, for many cities this proved
an impracticable goal. Instead, diverting or pumping supplies from nearby rivers
and running the flow through settling and filtration basins became a mainstay
of numerous systems, including those serving Philadelphia, Washington, D.C.,
Lawrence, Massachusetts, Cincinnati, Ohio, and Omaha, Nebraska.

In a political context, it is of more than passing interest that municipal supply
systems often drew water from distant rivers within their own state but rarely
relied on aqueducts that crossed state lines. For example, prior to construc-
tion of the Ashokan Dam (illustrated in chapter 1) and the associated Catskill
Aqueduct—which required a lengthy pressurized tunnel extending under the
Hudson River—New York City sought to dam the Housatonic River in west-
ern Connecticut at a site only about a mile east of the state border. Absent the
political boundary separating the two states, there is little question that the
Housatonic offered a far preferable source of water for New York City if viewed
strictly in engineering terms. But the state boundary could not be ignored, and
Connecticut lawmakers were loath to accommodate the interests of New York
City. Thus, city officials abandoned hopes of tapping the Housatonic, instead

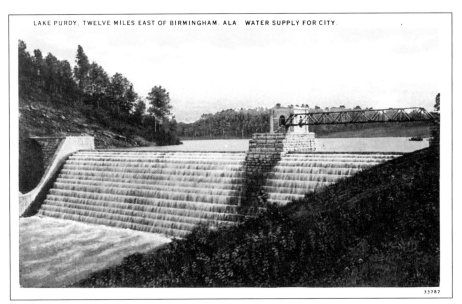

Birmingham, Alabama, is well remembered for civil rights protests in the 1960s, but it was also a major Southern industrial center. Purdy Dam is a concrete gravity overflow structure built in 1929 across the upper Cahaba River. Originally constructed by a private water company, it was purchased in 1951 by the publicly owned Birmingham Water Works Commission.

Massive concrete gravity technology may have dominated water storage for municipal systems, but some cities opted for more innovative designs. Among the most notable of these was Salt Lake City, Utah, which, starting in 1917, constructed a 150-feet-high multiple arch structure in the foothills south of the city. Designed by the California engineer John S. Eastwood, the Mountain Dell Dam was his only municipal water supply dam.

In the 1850s a major aqueduct was designed by Major Montgomery C. Meigs of the Army Corps of Engineers to carry Potomac River water into Washington, D.C. The system did not employ a major storage dam across the Potomac, relying instead on a lengthy diversion dam that directed flow into the intake canal (barely visible at the dam's far end). Although expanded and upgraded in succeeding years, the system's basic design remains intact.

focusing on the Catskills and a difficult to build crossing of the Hudson River as a new source of water. The Housatonic/Catskills situation is among the more extreme examples of how politics interfaced with technology in the development of municipal water supply. But politics has always played a role in the allocation of regional water resources, often pitting urban and rural interests against one another.

Through the twentieth century, cities and towns across North America perceived water supply as an essential component of civic livelihood. In these systems, storage dams often provided invaluable service as they cushioned the effects of drought. Of almost equal importance, storage dams assumed symbolic significance as monuments of civic accomplishment, structures that stood as testimony to the power of urban government to improve the lives of average citizens. Twenty-first-century Americans largely take for granted the tremendous infrastructure that provides copious quantities of hygienic water at the touch of a tap. But in the nineteenth and early twentieth centuries safe and reliable water supplies were something to be valued, even cherished, by a citizenry that was all too aware of the alternative.

A small dam used to impound water for the New Brunswick, New Jersey, water-works at the beginning of the twentieth century. The building in the right background is a steam-powered pumping plant that drew water from behind the dam and fed it into the municipal distribution system.

Hutchison, Kansas, would not be called a big city (the Census of 1920 recorded about twenty-three thousand residents) but the local community nonetheless valued its waterworks and dam.

Upper Settling Basins, Minne-Lusa Station, Omaha Water Works System.

Omaha's water supply is pumped from the silt-laden Missouri River. Before being deemed fit for domestic consumption, the water is retained in "settling basins" where sediment can be removed. The embankment at the early Minne-Lusa Station that created such a basin was not tall, but it nonetheless served as a key component of the system. Minne Lusa is reportedly derived from an American Indian word denoting "clear water."

Hydroelectricity

In colonial America, waterpower was largely used to grind grain, beat raw wool, and energize shingle and saw mills; during the nineteenth century mill dams were tapped to spin cotton and to operate power looms in large textile mills. In this early practice, the kinetic energy of falling water was transformed into mechanical power by connecting waterwheels—and later turbines—to rotating shafts. Through gears and belts these shafts could physically distribute power to machines and equipment on various shop floors. Mills and factories that relied upon mechanical transmission of waterpower needed to be built in close proximity to a flowing stream or river. In addition, the proliferation of waterpower technology was usually constrained to easily accessible sites. Remote, mountainous sectors of the landscape were often times left undeveloped, despite the presence of fast-rushing streams possessing great power potential.

Dramatic change came with the development of electric power technology. Because electricity—and hence electric power—could be transmitted great distances using thin copper wires, the need to place mills, factories, or other sites of energy consumption adjacent to flowing rivers disappeared. Simply by attach-

After commercial electric power became viable in the 1880s, local entrepreneurs soon realized that existing water-powered mills could be used to generate electricity. All that need be done was to connect a dynamo or generator to the rotating shaft of a waterwheel or turbine. This early hydroelectric power plant in Bethel, Vermont, could easily be mistaken for a rural wood-working mill.

An interior view of a small powerhouse, circa 1905, likely part of an older mill. It may have been unusual for electric power technology to be so "domesticated" in terms of an office environment, but this scene highlights the compatibility of electricity and traditional forms of waterpower.

The advent of electric power allowed textile companies to remove belt-and-pulley systems and replace them with electric motors. The Weave Room in Cotton Mill No. 4 in Pelzer, South Carolina, illustrates how electric power technology brought major changes to shop floors throughout America.

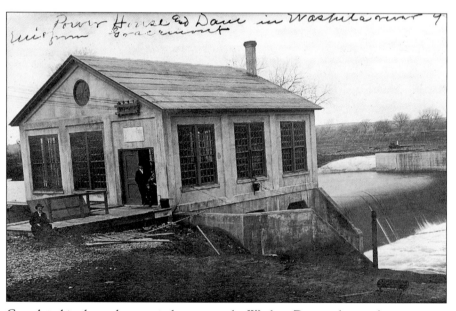

Completed in the early twentieth century, the Washita Dam and powerhouse in Anadarko, Oklahoma, provided electricity to the surrounding Cherokee community. As became ever more prevalent across the United States, this reinforced concrete plant was newly built for electric power generation.

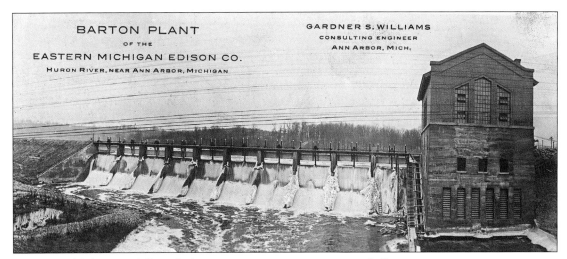

The upper Midwest and Great Lakes region contains numerous swift-flowing streams well suited for power development. Completed in 1912, the Barton Dam and Powerhouse was designed by Gardner Williams for a private utility company in central Michigan. Williams taught civil engineering at the University of Michigan while simultaneously serving as a consulting engineer for the electric power industry. He was also the engineer responsible for the municipally owned dam and powerhouse in Sturgis, Michigan.

ing the rotating power shaft of a waterwheel or turbine to an electric generator, the energy captured from falling water could be distributed to a multitude of far-distant users (or "load centers" as utility managers might phrase it). Beginning in the late nineteenth century electric power technology radically transformed the world's industrial infrastructure and, by making power widely available in new and unprecedented ways, redefined modern life.

The Scientific Revolution of the seventeenth and eighteenth centuries focused great attention on electricity and magnetism, but, at first, the knowledge gained did not prove particularly practical. The key discovery underlying electric power technology came in 1820 when the Danish physicist Hans Orsted observed how the needle of a magnetic compass deflects when placed near an electrically charged wire. The essential relationship between magnetism and electricity (i.e., electromagnetism) suddenly became clear. A year later, the British scientist William Faraday exploited Orsted's insight and constructed a small rotating motor powered by electric current.

As Orsted discovered, when a conductor (typically a copper wire) is moved so that it passes through a magnetic field, a current is induced in the wire. Thus, by attaching a magnet to a rotating shaft and then placing copper wires close to the magnet, it is possible to generate a steady electrical current. So long as the shaft keeps turning, electricity will keep flowing. In this way, mechanical energy in the form of a rotating shaft can be readily transformed into electrical energy.

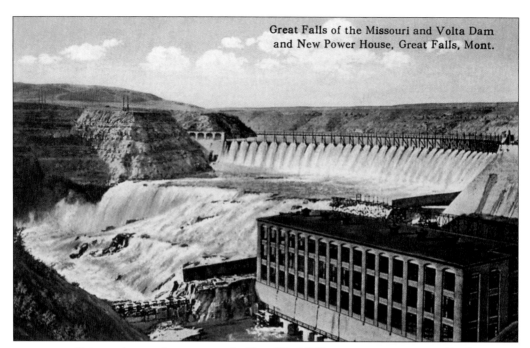

Great Falls of the Missouri and Volta Dam and New Power House, Great Falls, Mont.

Prior to America's entry into the First World War an imposing series of hydro-electric power plants were built along the upper Missouri River by the Montana Power Company. Often times in mountainous regions mining and hydroelectric power are closely intertwined; the Montana Power Company was a subsidiary of the Anaconda Company, Montana's largest copper producer. Completed in 1915, the dam and power plant at Great Falls was later renamed in honor of John D. Ryan, first president of the Montana Power Company.

And, as Faraday demonstrated, an electric current can then be used to power motors.

The earliest commercial use of electricity came in the 1840s with the electric telegraph, and by the 1870s electric power was used for large-scale "arc-lighting" systems. But the key breakthrough came in 1882 when Thomas Edison brought his first "central station," direct current (DC) system on-line in New York City. While many of Edison's early systems used coal-fired steam engines to turn the generators (also called dynamos), it was a simple step to connect electric power generators to waterwheels (or turbines) and thus create *hydro*electric power. The first hydroelectric power generation in the United States is usually credited to a small facility in Appleton, Wisconsin, where in 1882 an existing mill was fitted with a small Edison dynamo and electricity transmitted to a few nearby build-ings. From this humble beginning, hydroelectric power rapidly spread across the American landscape.

Edison's DC power systems were considered "universal" in that they could be used both for illumination and for powering motors. But as a technology, DC's great limitation was that it could not be efficiently transmitted more than

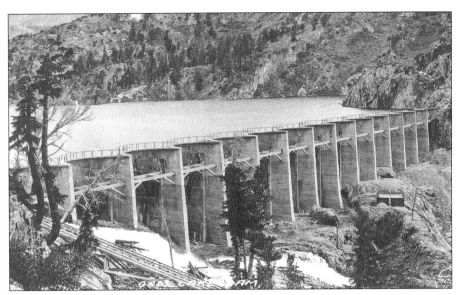

In California, hydroelectric power systems often took on a distinctive style, one in which a relatively small flow feeds turbines lying several hundred feet or more below the storage reservoirs. The Nevada-California Power Company's Gem Lake Dam (completed in 1917) stores water at 9,000 feet above sea level and supplies water to the Rush Creek Power Plant under a head of 1,810 feet.

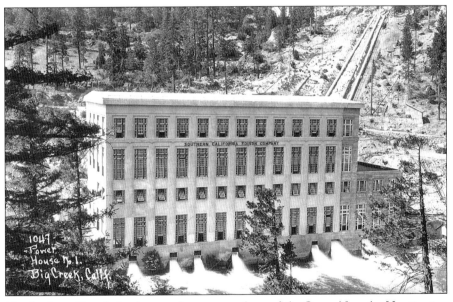

Not far from Gem Lake, but on the western slope of the Sierra Nevada, Huntington Lake and the Big Creek system developed into one of America's largest hydroelectric power facilities. This postcard, circa 1913, shows the newly completed Big Creek powerhouse no.1 that operated under a head of 2,131 feet and featured a generating capacity of over 60,000 kilowatts. The high-head penstocks leading to the plant are visible in the right background.

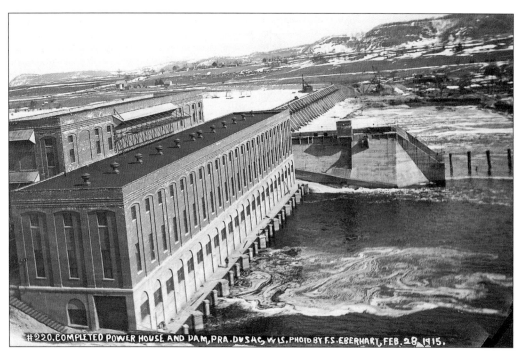

#220. COMPLETED POWER HOUSE AND DAM, PRA. DU SAC, WIS. PHOTO BY F.S. EBERHART, FEB. 28, 1915.

In the midwestern United States large-scale hydroelectric power plants were relatively "low-head" (especially when compared to systems in the mountainous West) and relied upon high rates of water flow to maximize power production. Completed in 1914, the Prairie du Sac plant near Sauk, Wisconsin, operates under a head of about forty feet but, because of high flow, has a generating capacity of twenty-nine thousand kilowatts.

SWITCHBOARD
AT THE DAM

The control room at Prairie du Sac. This view shows how rapidly hydroelectric power technology evolved prior to the First World War.

A real photo view, circa 1914, of the horizontal turbines and generators in the
Prairie du Sac plant.

For large-scale power production, the horizontal turbines and generators used at
Prairie du Sac were soon displaced by vertical units. As shown here, the generators
installed at the Keokuk Dam across the upper Mississippi in 1912–1913 represent
an early deployment of this important hydraulic technology. Vertical turbines and
generators soon became the standard for large hydropower plants.

The engineer Hugh Cooper was in charge of constructing the Keokuk Dam for private investors, and his next big project was the federal government's Muscle Shoals Dam across the Tennessee River in northern Alabama. Authorized in 1916 for the manufacture of nitrate explosives, the dam was not completed until 1924 (renamed Wilson Dam, during the New Deal it was subsumed into the Tennessee Valley Authority).

a few miles. For longer transmission, DC "line losses" quickly accumulated to the point that they consumed all the power being transmitted. In other words, the economic viability of DC systems rapidly diminished as power lines lengthened. Alternating current (AC) technology appeared in the late 1880s as a potent competitor to DC because it allowed for the long-distance transmission of electricity. However, while a single AC circuit was well suited to lighting, it could not easily power motors. Grappling with this problem, the visionary inventor Nikola Tesla perceived that if more than one AC circuit was run along a transmission line, the resulting polyphase AC system could be used for *both* lighting and power. In the 1880s Edison's DC systems had established the commercial viability of electric power generation and distribution. In the 1890s, polyphase AC rapidly supplanted DC because of its suitability for long-distance power transmission. Throughout the twentieth and into the twenty-first century, three-phase AC power technology comprised the standard for America's electric power networks.

In the 1890s electric power entrepreneurs began anew to investigate water-power sites throughout the United States. The goal was to calculate whether the hydroelectric power potential could justify the investment required to build

THE ONLY COUNTY OWNED HYDRO-ELECTRIC PLANT IN AMERICA

THE CHEAPEST CURRENT SOLD. LET US MAKE YOU PRICES, CORDELE, GA. 4006-23

Prior to the New Deal the Muscles Shoals Dam represented the only major hydroelectric project funded by the federal government. While privately financed initiatives dominated electric power development in the 1920s, locally and municipally owned dams found a place in regional power grids. For example, the county-operated dam near Cordele, Georgia, was trumpeted as providing "the cheapest current sold. Let us make you an offer."

the dam, penstocks, turbines and generators, and power transmission lines necessary to bring the power to a viable commercial market. Of course, interest in adapting older hydraulic power systems also constituted part of the move to hydroelectric power. But because three-phase AC technology allowed for long-distance power transmission, it proved especially important in encouraging the development of hydropower sites previously considered too remote to be profitably developed.

The growth in America's hydroelectric power industry in the early twentieth century largely coincided with the arrival of picture postcards, and the technology was frequently featured in local views. From small-scale (almost pastoral) plants through large-scale facilities with generating capacities exceeding a hundred thousand kilowatts, hydroelectricity became a vital part of the national power grid during the first three decades of the century. The vast majority of this development relied upon financing from the private sector, creating what are known today as investor-owned utilities. As documented in chapter 6, government support for hydroelectric power became a hallmark of the New Deal under President Franklin Delano Roosevelt. But the hydroelectric power projects of the 1930s were only possible because of extensive innovations underwritten—and implemented—by private industry in the 1890s through 1930.

(Left) In the 1920s, America's most ambitious municipally owned hydroelectric power system was Seattle City Light in Washington State. The city's two-hundred-feet-high concrete arch Diablo Dam in the Cascade Mountains neared completion in 1930.

(Below) Private capital financed the vast majority of power development in the 1920s, and investor-owned utilities proudly extolled their contributions to local economies. This local chamber of commerce sign celebrated construction of Oakdale Dam near Delphi, Indiana, a two million dollar facility to be owned and operated by the Indiana-Hydro Electric Power Company.

OAKDALE DAM INFORMATION
LOCATION CARROLL COUNTY-COUNTY SEAT DELPHI BEST SMALL CITY IN STATE
CONTRACTORS L. E. MYERS CO. CHICAGO
OWNERS INDIANA-HYDRO ELECTRIC POWER CO.
TIPPECANOE RIVER - ESTIMATED COST TWO MILLION DOLLARS
LENGTH 1640 FEET-HEIGHT 42 FEET - GENERATES 13000 HORSE POWER
HEIGHT STEEL TOWER FROM FOUNDATION 195 FEET-FROM RIVER BED 265 FEET
'LAKE DELPHI' WILL BE ABOUT 12 MILES LONG
WORK BEGUN JULY 25 1924-EXPECT TO COMPLETE JUNE 1 1925
GREATEST WIDTH OF DAM AT BASE 315 FEET - TOP 30 FEET
2000 CAR LOADS EQUIPMENT AND MATERIAL REQUIRED TO COMPLETE
DELPHI IS A CLEAN PROGRESSIVE CITY. WE WANT TO MEET YOU. WE WANT
YOUR TRADE. WE INVITE YOU TO DELPHI
'SHE'S BEAUTIFUL
LOOK HER OVER'
CHAMBER OF COMMERCE

WOLEVER PHOTO
DELPHI IND

The Boston-based engineering firm Stone & Webster was arguably the most important designer, builder, and financier of hydroelectric power projects in the pre–New Deal era. They championed massive concrete gravity dams, as exemplified by the Philadelphia Electric Company's Conowingo Dam across the Susquehanna River in northern Maryland completed in 1931. In terms of technology, the power plants built during the New Deal did not represent anything revolutionary compared to what had been developed by private industry in the 1920s. This color postcard from the mid-1930s was made from a painting of the dam commissioned by the power company.

Flood Control

Rivers are dynamic, constantly changing in response to rain storms, snowmelt, and parching drought. Many rivers experience significant flooding in the spring, rising above their normal banks and inundating low-lying riparian lands abutting the river. This land is often referred to as a floodplain, with people understanding that in times of high water it may likely become a temporary lake. Such intermittent flooding can be seen as beneficial in creating fertile bottomlands well suited to high-yield crop cultivation. But flooding can also devastate farms, villages, and cities built aside a cresting river or stream.

In the nineteenth century, the vagaries of weather and the havoc wrought by rising rivers were facts of life for people throughout North America. Floods were acknowledged as a part of the natural order but, as investment in mills, factories, transportation systems, and urban centers increased, a widespread desire to reduce the financial costs of persistent flooding began to grow. But how best to accomplish this daunting task?

At the beginning of the twentieth century flooding was a common experience throughout America. Many towns and cities suffered because of a river that would rise with the perennial coming of spring floods. The exact location of this postcard view, circa 1910, is unknown—the handwritten caption refers only to the "[illegible] park end of the steel bridge." But clearly the inundation was not welcomed by the many people forced from their homes and businesses.

In the nineteenth century the U.S. Army Corps of Engineers took the lead in promoting levees as the most appropriate way to control floods on major streams. Levees are essentially low-earth embankments built parallel to the banks of a river that are designed to block rising waters from spilling out over the floodplain. Up to a point, levees can provide reliable flood protection to riparian lands, but in confining the flow they also prevent sediment carried by a river from being deposited atop the floodplain. Over time, this results in the elevation of the river bottom rising as sediment accumulates. And as the river bottom rises so too does the height reached by periodic floods. As a result, levees must be constantly maintained and elevated if they are to remain effective in controlling floods.

Despite disinterest—if not outright hostility—on the part of the Army Corps of Engineers, a different approach to flood control began to develop in the early twentieth century. In such systems, large flood control dams are placed across the headwaters of major streams and rivers. When heavy rains and/or snowmelt increase flow to flood levels, gates in the dams are closed and water rises in the reservoirs. Subsequently, as precipitation and runoff in the water-

A town did not need to be on a large river to suffer the ravages of flooding. For example, in August 1906 the small town of Orangeville, Illinois, was inundated by Richland Creek. Interestingly, this postcard is postmarked 1910, suggesting that memories of the flood did not soon subside.

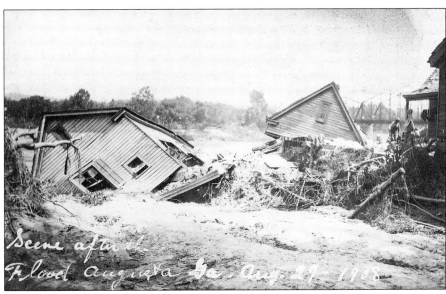

Floods were not confined to any particular region, they occurred across America. This postcard from 1908 shows the devastation wrought by the Savannah River on low-lying areas in Augusta, Georgia.

Local photographers were drawn to the spectacle of raging rivers, and mill dams were often a focus of flood postcards. Here, the Beatrice Flour Mills in southeastern Nebraska weathers the rising waters of the Big Blue River in June 1908. The water is so high that the submerged dam is barely evident.

shed drops, water held in the reservoirs can be gradually released over a period of days or weeks. With specially designed flood control dams, extreme river levels can be held in check and the harmful effects of high water reduced if not eliminated.

Of course, every storage dam built to support irrigation, municipal water supply, or hydroelectric power is at heart a flood control dam. That is, they are all designed to capture floods so water will not flow out into the ocean or a desert lake before being put to some human use. So the idea of using dams specifically to prevent the flooding of low-lying areas was not something that occurred without practical precedent. But flood control structures located in the upper reaches of a watershed did represent a challenge to the Army Corps of Engineers' orthodoxy that levees placed along low-lying rivers comprised the best, and only, way to properly attack the nation's flood control problem.

Flooding was a common occurrence in low-lying areas of America throughout the nineteenth century, something that people tolerated so long as they believed it constituted an inevitable and unavoidable act of nature. But with the coming of the twentieth century and the ascendance of progressive ideas

5820. THE LEVEE AT CHALMETTE. NEW ORLEANS. LA.

Sent in 1909, this postcard shows the levee at Chalmette near New Orleans. The low-lying land to the right is entirely dependent upon the levee to hold back the Mississippi River. A plaintive message on the back of the card refers to the scene and reflects the anxiety that such levees could impel: "One of the reasons I would not like to live here." Ever since the tragic collapse of levees during Hurricane Katrina in 2005, and more recently the chaos wreaked by Hurricane Sandy's surge in October 2012, Americans have become acutely aware that flood control is not something to be taken lightly.

projecting that nature could be tamed through acts of technological will, the seeming inevitability of floods faded in the face of an overarching question: In a modern, technologically advanced society, why can't flooding be controlled if not stopped altogether?

A catalyst to such thought came in the early spring of 1913 when intense flooding ravaged the Ohio River Valley, wreaking havoc on cities such as Dayton and Columbus and a multitude of other communities. Much of the worst devastation came within the Miami River watershed, and soon a political movement arose to create a special state-authorized Miami Conservancy District to provide for regional flood protection. Under the leadership of the engineer Arthur Morgan, the district abandoned reliance upon levees (Morgan rejected ideas promulgated by the Army Corps of Engineers) and set out to build single-purpose flood control dams in the upper reaches of the watershed. During normal times no water would be stored behind these dams, thus insuring that their

1/24/'08.

This is the way we keep the water out. Yo. J. B.

5287 Levee Front 6th Street, Cairo. Ill.

Levees were—and are—an essential part of life along the Mississippi and Ohio Rivers. Cairo, Illinois, lies at the confluence of the two rivers, and residents have long recognized the importance of their protective embankments. This view, postmarked 1908, shows what Cairo's levee looked like from the riverboat landing during times of low water. As the correspondent succinctly observed: "This is the way we keep the water out."

full capacity could be called upon when heavy rains and/or snowmelt threatened to turn quiet rivers into raging torrents.

In concert with the Miami Conservancy District, other regional flood control initiatives sprang forth in the 1910s and early 1920s, including Los Angeles County in Southern California, greater Phoenix in central Arizona, and San Antonio, Texas. It remained a time when, except for the lower Mississippi River and the Sacramento River basin in Northern California, the federal government shied away from involvement in flood control projects. As a result, many early flood control dams were entirely funded at the local and state level.

In 1927 the efficacy of the Army Corps of Engineers and its policies came under intense questioning as major floods hit the lower Mississippi River Valley. Levees collapsed, leaving hundreds of square miles of land under water for weeks on end. And municipal leaders in New Orleans purposely blew up a downstream levee to insure that rural Louisiana farmers would be inundated and not their fair city. Later that same year, Vermont was also hit by devastating

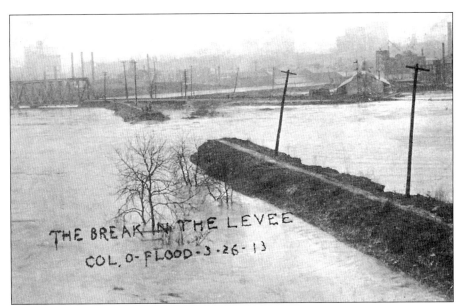

Massive floods hit the Ohio River watershed in March 1913, causing millions of dollars in damage and taking hundreds of lives. Floods may have been a part of American life since colonial times, but the destruction brought by this massive inundation struck a chord with the American public. Postcard views, such as this scene of a major levee break along the Scioto River in Columbus, Ohio, helped bring national attention to the disaster.

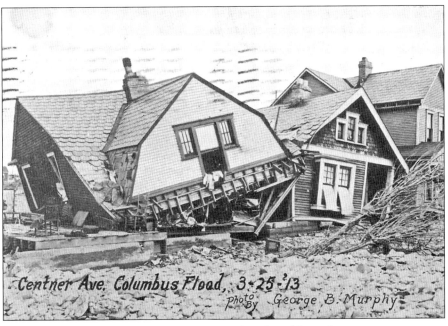

As the levees failed, Columbus, Ohio, was left vulnerable to the rising waters. These wooden frame homes along Center Avenue were among hundreds of buildings damaged in the flood.

The Sensation of the Zone
at the
Panama-Pacific International Exposition

Henry Ellsworth's Dayton Flood.

(Left) In ways reminiscent of Coney Island's Johnstown Flood exhibit, an exhibit heralding the Dayton Flood was included in San Francisco's Panama-Pacific International Exposition in 1915 and publicized on color postcards. The floods of 1913—which killed more than 350 people—impelled civic leaders to seek protection by constructing flood control dams in the Miami River watershed.

(Below) Cleaning up along Dayton's North Jefferson Street, March 28, 1913. In parts of the city the flood reached depths of more than ten feet, ruining the inventory of many an unfortunate business.

Englewood Dam

The Miami Conservancy District represented one of America's first public agencies that, while separate from direct state control, also transcended local town, city, and county authority. The district operated as a regional agency charged with providing flood control for the Miami Valley as a whole and not just for a single city or county. Levees were deemed passé, and the district's focus was on large dams, including the 125-feet-high Englewood Dam completed in 1920. Financed through local property tax assessments, the district's embankment dams were not to be used for any purpose other than flood control.

floods. With this one-two punch, the stage was set for a rethinking of the "levees only" policy and for political changes in how future flood control projects would be financed. While massive federal investment in dams and multipurpose flood control initiatives would not come until the rise of the New Deal in the 1930s, by the late 1920s a new sense of how humankind could—and should—control raging rivers had taken root across America.

The large storage dams subsequently proposed for flood control were often touted as multipurpose in that they were designed to serve a variety of uses; for example, Hoover Dam was built to provide water for irrigation, municipal water supply, hydroelectric power, and flood control. But this raised an important problem, emanating from the fact that it is impossible to control water levels so that *all* the various uses can be met with maximum efficiency. For example, irrigators might logically want to use all the water in a reservoir during the summer growing season and they have little interest in storing water for use during the

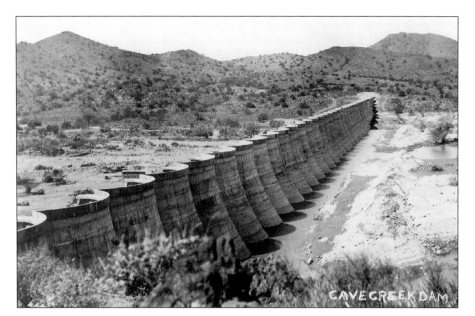

Seeking protection from flash floods along Cave Creek, in the early 1920s the City of Phoenix and Maricopa County joined with the Salt River Valley Water Users' Association, the Santa Fe Railway, the Union Oil Company, and other private entities to finance a multiple arch flood control dam. After the 1930s, communities frequently looked for federal support when seeking to build flood control dams. But this was not the norm in the 1920s. Completed in 1923, Cave Creek Dam stored no water other than floods held back during heavy storm bursts.

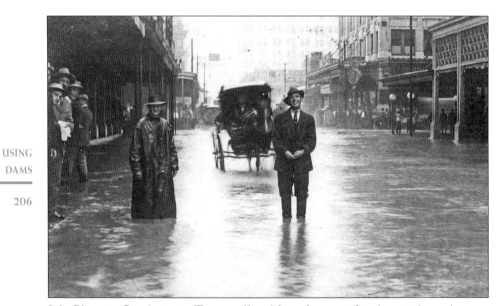

Like Phoenix, San Antonio, Texas, suffered from frequent flooding in the early twentieth century. This view shows a downtown street during the high water of September 1921.

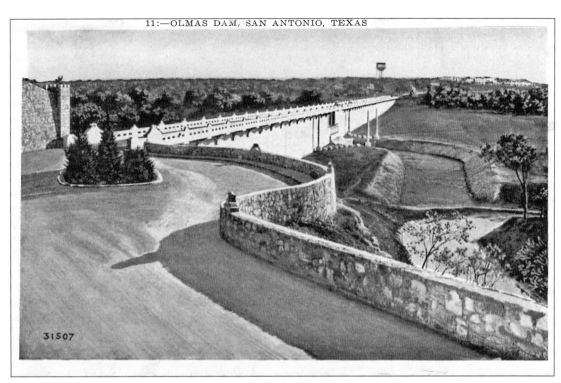

31507

To protect the commercial downtown, San Antonio authorities constructed Olmos Dam in the mid-1920s. The reservoir area is left dry and utilized as part of a park that can be evacuated when storms threaten. As the historian Char Miller has pointed out, the three million dollars expended on Olmos Dam and related work did nothing to protect poorer parts of the city. Further evidence, should there be any doubt, that flood control and politics are closely intertwined.

fall and winter. Conversely, hydropower power plants serve year-round markets as do municipal water supply agencies. And for a dam to provide for maximum protection as a flood control structure it need be kept empty so that its maximum storage capacity will be available whenever a heavy storm might hit. This latter requirement might seem a simple one to meet, but it stands in direct opposition to a public interest in keeping local reservoirs full, or at least not empty, so that they can facilitate swimming, boating, fishing, and other recreational diversions. Dams offered a way to ameliorate the effects of floods on the American landscape, but exactly how they were to accomplish this task involved a politically complex interplay among a variety of public and private interests. And make no mistake, flood control policy in the twenty-first century is no easier to plan and implement than it was decades ago.

USING
DAMS

207

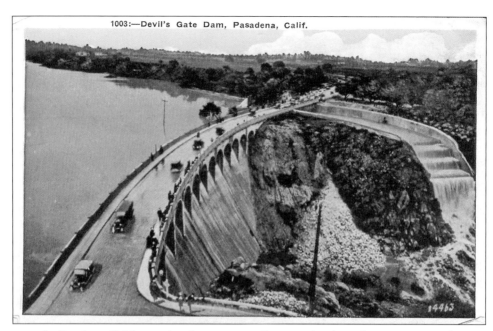

1003:—Devil's Gate Dam, Pasadena, Calif.

In Southern California the climate is usually quite dry, but when rains come they can come hard. In 1915 the Los Angeles County Flood Control District was formed to help protect parts of Los Angeles, Pasadena, and communities in the foothills of the San Gabriel Mountains from floods. Completed in 1920, Devils Gate Dam across the Arroyo Seco near Pasadena was the district's first major dam. As with the Miami Conservancy District, financing derived from local property taxes.

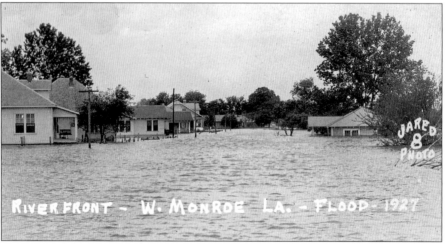

RIVERFRONT — W. MONROE LA. — FLOOD — 1927

Heavy floods hit the lower Mississippi River Valley in the spring of 1927 and did not recede for months. The collapse of levees along the river and the extensive destruction brought by the high water forced the Army Corp of Engineers to rethink its "levees only" policy of flood control. The tragedy also fostered increased political interest in federal funding for flood control projects. This real photo postcard shows the inundated riverfront of West Monroe, Louisiana, in April 1927.

In the fall of 1927 floods ravaged interior New England, with Vermont being particularly hard hit. Huge tracts of farmland were inundated, as shown in this view of the Missisquoi River Valley in Richford. The only Vermont floods to rival 1927 came in 2011, when Hurricane Irene devastated the state.

In the 1930s floods continued to inflict hardship across the American landscape, prompting new federal flood control legislation. This postcard shows the havoc brought to Apollo, Pennsylvania, in March 1936 when the Kiskiminetas River (a tributary of the Allegheny River) inundated the downtown commercial district. Every stranded person in this photo represented a likely voter. And they all had good reasons to embrace government-sponsored flood control.

OHIO RIVER STAGE 52.6 FEET
U. S. LOCK No. 10
MARCH 19, 1936

HIGH WATER MARK

HARTMAN SERVICE MAIN ST. AT FERRY ROAD HOLLIDAYS COVE, W. VA.
JUNCTION U. S. 22 AND W. VA. 2

The spring floods of 1936 affected a wide swath of the upper Ohio River water-
shed. Hollidays Cove near Weirton, West Virginia, lies about eighty miles down-
stream from Apollo, Pennsylvania, but it too suffered from extreme high water. The
flood stage reached on March 19 is vividly depicted on this postcard of Hartsman's
Esso service station.

Recreation

Recreation is rarely invoked as a primary reason for building a dam. Hydropower,
irrigation, municipal supply, and flood control are at the forefront when people
seek to justify a dam project; recreation looms in the background, seemingly
tacked on as yet another use to help justify a reservoir impoundment. The vast
majority of dams were not built with recreation as a primary goal; nonetheless, the
value of artificial ponds and reservoirs in fostering nonpractical, aesthetic ameni-
ties has long been recognized. For example, Emperor Nero constructed one of the
largest dams of the Roman era to create a lake at his villa in Subiaco. Similarly, in
the 1880s the reservoir created by the ill-fated South Fork Dam above Johnstown,
Pennsylvania, was adapted by the South Fork Fishing and Hunting Club as the
centerpiece of a bucolic mountain retreat catering to Pittsburgh's business elites.
And in the 1890s, a sizable dam and pond was built at the private Blairsden estate
in central New Jersey primarily for its aesthetic value.

105—Grist Mill Pond, Gilbertsville, N. Y.

A pastoral summer scene in western New York State, circa 1910. The postcard
maker and the public knew that this serene pond was created to serve a downstream
grist mill. Yet the expanse of water—made accessible by a rowboat tied to a small
wooden pier—offered more to the Gilbertsville community than a prosaic source
of power. It also presented an attractive environment that invited fishing, swimming,
and passive reflection.

As reflected in historic postcards, recreational use of artificial ponds and res-
ervoirs usually revolved around fishing and swimming. In the former category,
fishing could be enhanced both in the reservoir itself and in the waters directly
below the dam. Of course, fish populations that flourish in artificial reservoirs
are usually not species native to the no longer free-flowing river. The prolif-
eration of exotic (or nuisance) species as facilitated by dams is an ongoing is-
sue that bedevils environmentalists concerned about the degradation of river
ecologies. But dams do provide for recreational fishing opportunities, even if it
involves nonnative species. Swimming is also common at rural dams, although,
for health reasons, it is frequently banned in reservoirs used for municipal water
supply. Sailing is also possible on reservoirs, and, following in this tradition, by
the 1930s motorized watercraft and water-skiers began to proliferate atop the
waterscape created by large dams.

In more general terms, small ponds and lakes formed by dams have often

The Dam at Blairsden, Peapack, N. J.

The New York City investment banker C. Leyard Blair began building a country villa in the Somerset Hills of New Jersey in 1898. To enhance his opulent retreat (the main mansion contained thirty-eight rooms and twenty-five fireplaces), he constructed a large masonry dam to create Ravine Lake. Impounding the headwaters of the Raritan River, this reservoir served no purpose other than to provide an aquatic element to the fifty-acre estate.

become so integrated into communities that people lose sense that they are actually artifacts of human creation. They are perceived not as interventions into but simply as attributes of the local environment. The recreational amenities afforded by such artificial lakes do not have to involve an active use such as swimming or water-skiing. They can constitute more passive appreciations of an expanse of water surrounded by familiar trees, buildings, and cottages—a pastoral environment in which dams are not intruders but components of a cherished local landscape.

Copyright 1905 by the Rotograph Co. 4/7/07

A 1858a Doan Brook, Cleveland, O.

Have my eyes full of dope, so can't write a letter now. Am having a great time. See you soon. Et. (Scene near us.)

A group of young boys sailing a toy sailboat along Cleveland's Doan Brook. The masonry arch dam offers an ideal launching site for the small craft. And note how the message reflects the correspondent's medical condition and mental state.

BOAT HOUSE AND LOWER BASIN, DELLWOOD PARK.

A real photo view postmarked 1908 of the boathouse, dam, and pond in Lockport, Illinois. Dellwood Park offered a place to socialize, meet friends (old and new), and perhaps go boating with a prospective sweetheart. A community asset indeed!

Dams can impede migration and otherwise disrupt the environs of many native fish species. But they can also create aquatic environs where recreational opportunities for would-be anglers abound. The pool below this timber crib dam in Garfield, New York, was apparently a favorite for trout fishermen, "Where Lurk the Speckled Beauties."

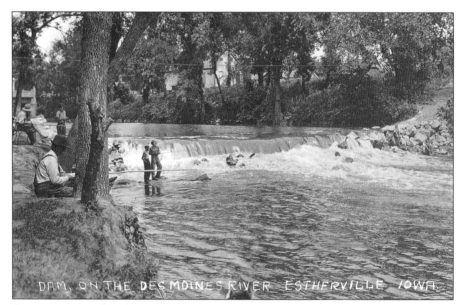

A quiet summer day along the Des Moines River near Esterville, Iowa. A small dam offers a good spot for a coterie of fishermen to practice an ancient pastime. Maybe a fish dinner or two is in the offing.

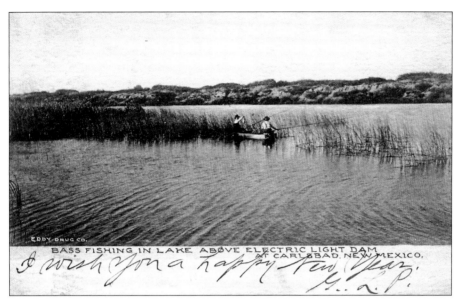

As dams grew larger, capacious reservoirs beckoned adventuresome anglers. Although the fish species that thrived in artificial lakes were not the same as those native to the undammed stream, in the twentieth century reservoir fishing became a beloved pastime of millions of Americans. The lake featured in this postcard mailed in 1906 was created to provide Carlsbad, New Mexico, with hydroelectric power, but it quickly spawned a cadre of local fishermen drawn to the lake bass.

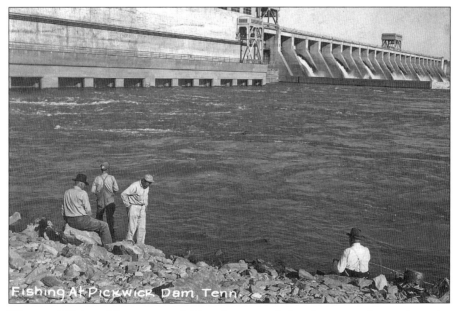

The possibilities of downstream fishing also expanded as dams grew larger through the course of the twentieth century. The roiling waters below the power plant at Pickwick Dam along the lower Tennessee River (completed in 1938) provide a group of African American fishermen with a favorable setting to ply their craft.

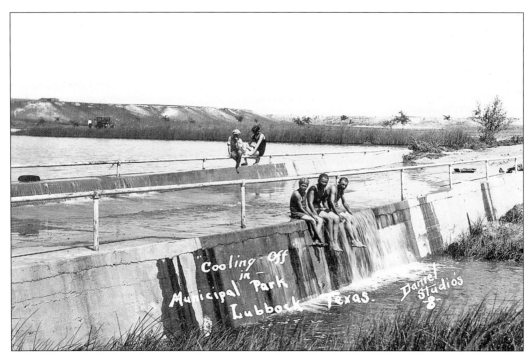

An informal portrait of swimmers cooling off in Lubbock's municipal park. West Texas can get hot in the summer, and any "swimming hole" offering a bit of relief was something to cherish and enjoy.

The location of this real photo postcard, circa 1920, is unknown but likely lies in Northern California. The small dam forms a nice place to cool off for man, woman, and beast; in the background a strolling trio wander across the adjacent meadow. The recreational amenities afforded by the dam and pond appear to be well appreciated.

Youthful divers make the most of the Reedsburg Dam amid the vacation and tourist community of Houghton Lake, Michigan. The dam adjoins the deepest part of the reservoir and offers a relatively safe place for diving. Oh, to be young again.

The joys of swimming and cooling off in a reservoir have never abated, but by midcentury they were supplemented by motorized water sports. The high-pitched whine of an outboard engine may do little to foster quiet reflection, but the thrills of water-skiing proved impossible for many Americans to resist. Even at low water, the Sardis Lake reservoir in northern Mississippi (built by the Army Corps of Engineers and completed in 1940) has a surface area of at least thirty thousand acres, more than enough for a multitude of water skiers to find satisfaction.

THE NEW DEAL

The market crash of 1929 and the Great Depression of the 1930s brought dam building into the public consciousness in new and significant ways. The changes were not always immediate, and they often involved projects planned prior to economic hard times. Nonetheless, the coming of the New Deal represented a major shift in the funding of water resource projects and in how they were promoted as public works. Above all, the political reorientation of the 1930s brought the federal government to the forefront as an essential financier of dams throughout the nation. Of course, the U.S. Reclamation Service (renamed the Bureau of Reclamation in 1923) had been building large dams in western America for more than twenty years while the Army Corps of Engineers had been operating navigation dams in the Ohio and Mississippi watershed since the nineteenth century. But the idea of looking to the federal government as the primary builder and financer of the nation's dams arose only in the 1930s with the election of President Franklin Delano Roosevelt (FDR) and the ascendance of his New Deal economic initiatives.

New Deal dams were built to provide for hydroelectric power, irrigation, flood control, municipal water supply, navigation, as well as recreation. In addition, they offered jobs to a chronically underemployed workforce and brought construction contracts to businessmen wracked by the Depression. Of equal import, New Deal dams assumed great symbolic significance, offering evidence that the American spirit had not been broken and that, in the face of adversity,

Work relief comprised an early focus of FDR's New Deal, and small-scale projects, such as the Civilian Conservation Corps (CCC) "check dam" shown in this snapshot view, circa 1935, were well suited to put people to work. But small-scale dam projects of this sort were rarely documented on postcards during the 1930s. Instead, large monumental dams dominated public consciousness during the New Deal.

the United States and its citizenry could accomplish wondrous things. Monumentality became a driving force underlying the construction and celebration of the massive dams that, for many people, gave physical definition to the New Deal. Certainly there were federal programs such as the Civilian Conservation Corps (CCC) that sponsored the work of small-scale dam building in the service of soil conservation and local flood control. But such projects of modest scope rarely attracted national attention, and their construction was rarely featured on postcards. In contrast, large-scale dam and water control projects fostered a tremendous surge in the distribution of postcards documenting their construction.

There was one notable facet of New Deal dam building that did consciously evoke a sense of pastoralism: the housing facilities erected for some early projects—particularly the Tennessee Valley Authority's (TVA) Norris Dam—were designed to promote feelings of a community, a place not simply to board transient workers for a few months but a settlement of permanence where families could presumably take root and flourish. In such communities, image may have trumped reality as the work of dam building remained a tough job and often

attracted a transient, hardscrabble workforce. Nonetheless, image was of great importance to the New Deal, and big dam projects provided a way to meld monumental accomplishment with a pastoral notion of community and social cohesion.

New Deal dams extended across the United States, but many of the largest and best known were built in the arid West and the American South. Hoover Dam lay astride the Colorado River on the Nevada-Arizona border and stands as the best known of all American dams. While closely associated with the New Deal, Hoover Dam was under construction long before FDR became president, and in this sense it is an anomaly relative to other New Deal dams. But the origins of Hoover Dam reflect dynamics that conform to the history of the big dams that followed. Hoover Dam was tied to specific boosters and advocates emanating from the Imperial Valley and Los Angeles, while other projects were energized by their own set of regional interests. The particulars may have differed, but New Deal dam projects as a whole shared a common heritage in the way they connected to the political economy of specific regions or watersheds.

The federal government, acting through the Bureau of Reclamation, the Army Corps of Engineers, and New Deal agencies such as the Public Works Administration (PWA), was an essential factor in the construction of Hoover and other New Deal dams. But federal activism took shape only through a prism of regional interest and advocacy involving local politicians and lobbyists. Prior to the 1930s this activism took the form of watershed planning, often undertaken by the Army Corps of Engineers in response to congressional directives. Most commonly, these studies derived from the House of Representatives' House Document No. 308, which, in 1926, called for studies of navigable rivers to ascertain their power possibilities. The so-called 308 Reports that were completed by the Army Corps of Engineers in the late 1920s and early 1930s did not specify exactly how the construction of various projects might proceed (financing was a political decision left to Congress, the president, and private sector interests). Wary of large budget deficits, Herbert Hoover was not inclined to act upon 308 Reports developed during his presidency. But FDR held a different view of public works development, and 308 Reports allowed him to move quickly on major New Deal projects such as Fort Peck, Bonneville, and Grand Coulee Dams, and the TVA's Norris Dam in northeastern Tennessee. The New Deal created a distinctive political economy, but the water projects that FDR reveled in celebrating often derived from plans that were many years in the making.

What is offered here is not a comprehensive history of New Deal dam building. Rather, the focus is on delineating the core economic and political factors that spawned several major projects and on illustrating their physical form and the way that construction was documented in picture postcards. These dams vary in their particular histories, but collectively they achieved great promi-

Authorized long before the onset of the Great Depression, Hoover Dam neverthe-
less served as a precedent and model for later New Deal projects. Rising 726 feet
from deepest foundations, it was the tallest dam in the world upon completion in
1935. Its reservoir (Lake Mead) can impound over 28 million acre-feet of water (an
acre-foot is about 326,000 gallons), the equivalent of about 9 trillion gallons. For
many people, Hoover Dam is the paragon of monumentality.

nence in national life. For many Americans across the socioeconomic spectrum,
these monumental structures came to symbolically define the New Deal.

Hoover Dam

With an annual flow of close to sixteen million acre-feet per year, the Colorado
River is the largest river in the American Southwest. The challenge confronting
anyone seeking to tap the Colorado's flow is that for much of its length the river-
bed lies far below the adjacent terrain. But the lower stretch of the river is amena-
ble to diversion, and irrigation entrepreneurs in Southern California were the first
to make major use of the stream's vast flow. Out of a privately financed initiative
to irrigate the Imperial Valley, the seeds of the Hoover Dam (originally Boulder
Dam) first germinated.

In 1900 the California Development Company began diverting water from
the Colorado to nourish the Imperial Valley. The company's canal—which
started in U.S. territory but then passed through Mexico for about fifty miles
before reentering California—proved troublesome because of persistent silt ac-
cumulation. Hoping to correct the problem, in 1904 the company excavated a

In September 1930 a crowd of southern Nevadans flocked to ceremonies celebrating completion of a spur line connecting the Union Pacific mainline to the Colorado River dam site. At the ceremony, Secretary of the Interior Ray Lyman Wilbur unexpectedly proclaimed that the structure would be henceforth be called Hoover Dam, in honor of his boss, President Herbert Hoover. Throughout the legislative battles of the 1920s it had been known as Boulder Dam or Boulder Canyon Dam.

new canal opening a few miles south in Mexico. To the company's misfortune, in 1905 heavy storms washed away the new head gates and the entire flow of the river began pouring into the valley. The uncontrolled flooding continued for two years, until a massive engineering effort led by the Southern Pacific Railroad finally closed the breach. In the disaster's aftermath the irrigation company collapsed and, in 1916, their assets were transferred to the publicly administered Imperial Irrigation District. Agricultural production had resumed once the flooding stopped, but fear lingered that a devastating "break" might recur. Soon the district began clamoring for federally supported flood protection and for a new All-American Canal that would preclude their water from passing through Mexico.

Federal officials refrained from fighting the floods of 1905–1907, but the lower Colorado River had not been ignored by the early Reclamation Service. By the end of the First World War the service was seeking new venues for its dam-building skills, and, at the urging of the Imperial Irrigation District, Congress authorized the agency to develop plans for a Colorado River storage and

In March 1931 Six Companies Incorporated's $48 million bid won the contract to build Hoover Dam. The Bureau of Reclamation eventually built decent living quarters for the thousands of workers that clamored to the site, but Six Companies pushed ahead and did not wait for government-sponsored housing. This snapshot shows Ragtown, the impromptu worker camp located about a mile upstream from the dam site (the encampment was later flooded out by Lake Mead)

Boulder City soon after completion in late 1931. The houses in the foreground are for high-ranking Bureau of Reclamation officials and leaders of Six Companies. In the far background are the barracks built for rank-and-file workers. Tightly controlled by the federal government, Boulder City had an appointed "mayor" who was not elected by residents or workers.

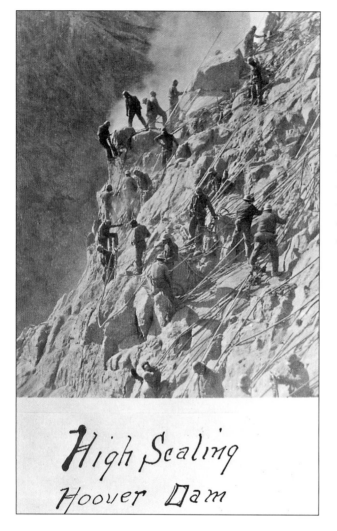

High Scaling
Hoover Dam

To help insure a tight bond with the dam's concrete, "high scalers" took on the dangerous work of clearing loose and fissured rock from the canyon walls. More than one hundred workers—many of them high scalers—died during four years of construction.

flood control dam. In ensuing studies, Arthur P. Davis, the Reclamation Service director, recognized that irrigation revenues could never bear the cost of a major dam; as an alternative, hydroelectric power offered the only viable means of financing the project. A dam over five hundred feet high and impounding more than twenty million acre-feet of water could generate many millions of kilowatt hours per year. But where to market all this power?

Between the time the Boulder Canyon Project Act was first introduced in Congress in 1922 and its passage in December 1928, the City of Los Angeles and other Southern California communities came to dominate advocacy of the project. Most importantly, in 1924 Los Angeles filed a claim for 1,500 cubic feet per second of Colorado River flow. With this, the city served as the catalyst for the Colorado River Aqueduct and for what evolved into the Metropolitan Water District of Southern California (MWD). The most practical way of getting Colorado River water to consumers in greater Los Angeles involved pumping water

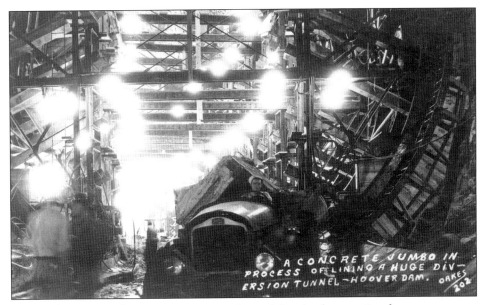

For Six Companies, the most important early work involved excavating four fifty-feet-diameter tunnels through the canyon walls around the dam site. These tunnels were needed to divert river flow and allow unhindered excavation of the foundation. Exhaust from gasoline-powered trucks in the confined tunnels created dangerous work conditions, later leading to worker lawsuits.

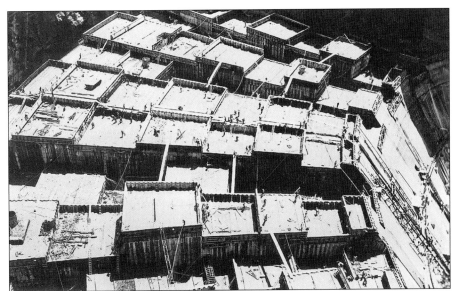

The initial diversion of the Colorado River occurred in November 1932. The first concrete was cast in June 1933, not long after Roosevelt's Secretary of the Interior Harold Ickes had banished the name Hoover in favor of Boulder Dam. This post-card from 1934 highlights the massive proportions of the Hoover-Boulder design. With a maximum thickness of 660 feet, the structure is almost as thick as it is tall. More than three million cubic yards of concrete were needed to complete the dam.

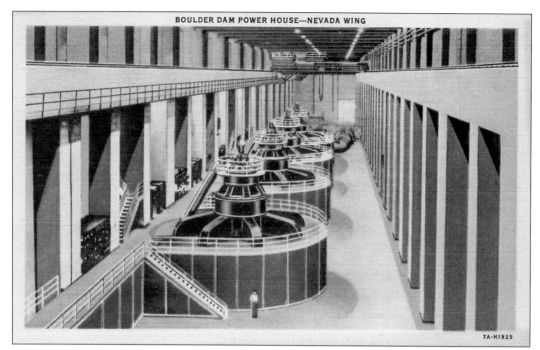

BOULDER DAM POWER HOUSE—NEVADA WING

7A-H1925

Hydroelectric power was an essential component of the Boulder Canyon Project, and the generating capacity of the two powerhouses (one in Nevada, one in Arizona) exceeded one million horsepower. Among the key benefactors of Hoover Dam were Los Angeles and other cities that joined the Metropolitan Water District of Southern California (MWD).

EAGLE MT. LIFT Colorado River Aqueduct 41806 Houck Cor

Much of the hydroelectric power generated at Hoover is used to pump water for the MWD's two-hundred-mile-long Colorado Aqueduct. This real photo postcard shows the MWD's 438-feet-high Eagle Mountain Lift shortly after completion in 1939.

Farmers in Southern California's Imperial Valley comprised the dam's other major beneficiary. The Boulder Canyon Project Act provided funding for a major canal to serve the valley that would not need to pass through Mexican territory, hence the name "All-American Canal."

The successful topping out of the dam represented a major political opportunity for FDR. This postcard commemorates FDR's visit to Boulder Dam on September 30, 1935, a trip made in the run-up to his reelection campaign of 1936. Two years after FDR's death in 1945, a Republican-controlled Congress voted to revert the name back to Hoover Dam. It has remained so ever since.

A popular "big letter" card from 1937 highlighting the dam, Lake Mead, Boulder City, and the electric power system. The scene depicted in the R shows a tour group being escorted through a tunnel deep within the dam. The Bureau of Reclamation has long welcomed tourists, many of whom celebrate the dam as a grand symbol of American accomplishment.

more than two hundred miles across the imposing escarpment of the Mohave Desert. To effect this pumping, the MWD's Colorado Aqueduct would absorb more than a third of the power generated at Hoover Dam, thus providing a financial foundation for the Boulder Canyon Project. Conversely, the federal government (and wary taxpayers) could be assured that power contracts with the MWD would be honored because of the district's authority to assess property taxes within its service area.

The Boulder Canyon Project was born out of the flooding of the Imperial Valley, but its long-term viability depended upon the ability of an urbanized Los Angeles to fund its enormous cost. And be assured, the political influence of Los Angeles was essential because of opposition to the dam on the part of both Arizona (who feared that California would monopolize use of the lower Colorado) and America's private power industry. The antagonistic posturing of private power lobbyists was particularly troubling to Herbert Hoover, who, as secretary of commerce in the Harding and Coolidge administrations, promoted development of the Colorado River. But Hoover was also a Republican enamored with the primacy of private initiative; he considered electric power to be best handled by investor-owned utilities. Thus the Boulder Canyon Project posed

COVE CREEK DAM AS IT WILL LOOK WHEN COMPLETED

COVE CREEK DAM SITE, EASTERN TENNESSEE 3A317

A white border postcard from the early 1930s illustrating the Army Corps of Engineers' proposed Cove Creek Dam at the site where Norris Dam was later built. The inset image depicts a barge lift to the left of the power plant. The Norris design excised the barge lift, as TVA officials considered it a needless expense.

a problem for him because of how it inserted the federal government into the business of power generation. In the end, President Hoover and his Secretary of the Interior Ray Lyman Wilbur found a middle ground where the project's power plant would be built and owned by the federal government but *operation* (at least for the first fifty years) would be controlled by the City of Los Angeles and the Southern California Edison Company.

When President Calvin Coolidge signed the Boulder Canyon Project Act into law in December 1928, the onset of the Great Depression was almost a year away. Job creation played no role in arguments justifying the dam's construction. But by the time work commenced in the fall of 1930, construction jobs were a big part of what drove public interest in the project. And by the time the main dam contract was let in 1931, jobs of any kind had become a national obsession. In this light, Hoover Dam served as a major precursor for the big New Deal dams that followed, both in terms of creating jobs and in reconfiguring the landscape of the nation's electric power network. The Boulder Canyon Project set in motion a public works initiative that the New Deal soon embraced and, through a multitude of other dams, extended across the American landscape.

A note of clarification: Both Boulder Canyon and Black Canyon (lying about

Legislation authorizing the TVA was signed by FDR on May 18, 1933; work on Norris Dam started the following October. Thousands of people were put to work both on the dam and in clearing more than 150,000 acres of land for the reservoir. TVA officials engaged the Bureau of Reclamation to develop final plans (not the Army Corps of Engineers!), and bureau engineers eliminated the barge lift. This multi-view card highlights the both the power plant and the recreational opportunities offered by the reservoir.

twenty miles further downstream) feature dramatic, narrow gorges with steep hard rock walls. Initial investigations for building a large dam across the Colorado focused on Boulder Canyon, but by 1923 Reclamation Service engineers recognized that Black Canyon offered a preferable site. Black Canyon is where the dam was built, but the name of the dam and project remained Boulder or Boulder Canyon throughout the 1920s.

Norris Dam and the TVA

The federally owned Wilson Dam (see chapter 5) was authorized in 1916 to manufacture nitrate-based explosives, but when completed in 1924, the need for government-subsidized nitrates had passed. Political debate soon swirled around the following question: Should the dam (originally called Muscle Shoals) be transferred to private utilities under a long-term lease or should it become part of a larger government project focused on developing Appalachia and the Tennessee

789 SPRING-TIME SCENE, IN MODEL TOWN OF NORRIS, TENN.

5A-H1920

Beyond dam building, the TVA was promoted as a catalyst for social and economic change in a region perceived as one of the poorest in the United States. As part of this, the settlement at Norris Dam famously included a "model town." By importing a physical vision of middle-class civility, TVA Chairman Arthur Morgan hoped that the "backwoods" of Appalachia could be raised to the norms of an ever-modernizing America. Homes like those depicted in this picturesque linen postcard from 1935 were for TVA managers and supervisors, not for the average worker.

Bathers-Norris Lake, Tenn.

A "modern" scene of sunbathers on the edge of Norris Lake. Electric power, progress, prosperity, and the ability to lounge in the sun. What more could anyone want from the New Deal? Of course, many rural families were flooded out and lost their homes because of Norris Dam, but that sad reality was justified by a greater regional good.

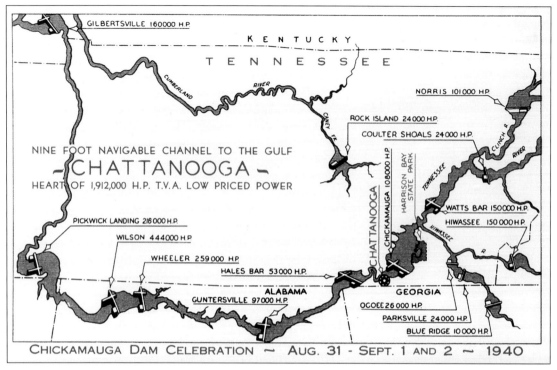

GILBERTSVILLE 160000 H.P.

K E N T U C K Y

T E N N E S S E E

CUMBERLAND

RIVER

CANEY FK.

NORRIS 101000 H.P.

ROCK ISLAND 24000 H.P.

COULTER SHOALS 24000 H.P.

CLINCH R.

RIVER

NINE FOOT NAVIGABLE CHANNEL TO THE GULF

~CHATTANOOGA~

HEART OF 1,912,000 H.P. T.V.A. LOW PRICED POWER

CHICKAMAUGA 108000 H.P.

HARRISON BAY STATE PARK

TENNESSEE

WATTS BAR 150000 H.P.

HIWASSEE 150000 H.P.

PICKWICK LANDING 216000 H.P.

WILSON 444000 H.P.

WHEELER 259000 H.P.

HALES BAR 53000 H.P.

CHATTANOOGA

HIWASSEE

R.

ALABAMA

GUNTERSVILLE 97000 H.P.

GEORGIA

OCOEE 26000 H.P.

PARKSVILLE 24000 H.P.

BLUE RIDGE 10000 H.P.

CHICKAMAUGA DAM CELEBRATION ~ AUG. 31 - SEPT. 1 AND 2 ~ 1940

Norris Dam represented just the beginning of a comprehensive effort to transform the Tennessee Valley through dam construction. A postcard heralding the TVA's Chickamauga Dam Celebration in 1940 underscores the tremendous amount of electricity (almost two million horsepower) now available in the valley. It also highlights the Tennessee River's "nine foot navigable channel," connecting Chattanooga to New Orleans and the Gulf of Mexico.

River Valley? Republican presidents Coolidge and Hoover had no interest in promoting federal power projects in the region, but they lacked the power to force the transfer of Wilson Dam to the private power companies or to entrepreneurs like Henry Ford (who proposed to operate the plant under a hundred-year lease). In Congress, progressive Senator George Norris of Nebraska led a national fight for public power, seeing in Wilson Dam an opportunity to bring public power to an economically impoverished region. In the midst of the ongoing Muscle Shoals controversy Congress directed the Army Corps of Engineers to study the entire Tennessee Valley and prepare a comprehensive development plan involving power, navigation, and flood control. A key part of the Army Corps of Engineers' resulting 308 Report recommended that a large storage dam be built across the Clinch River (a tributary of the Tennessee River) at a site designated Cove Creek. The proposed Cove Creek Dam was to be a multipurpose structure providing flood control, hydroelectric power, and recreation. In accord with the Army Corps of Engineers' longstanding mission to foster navigation, it also included a huge lift that could transport barges over the 260-feet-high structure.

Straight-crested concrete gravity dams were a TVA trademark in the 1930s and 1940s. Although technologically conservative, TVA's dams sported a distinctive moderne style (usually credited to architect Roland Wank) that captured the public's imagination. Completed in 1944, the 480-feet-high Fontana Dam in western North Carolina is widely considered to be TVA's most visually compelling project.

During Herbert Hoover's presidency there was no interest in using federal funds to build the Cove Creek Dam or pursue other aspects of the 308 Report. Hoover saw investor-owned utilities as the heart of America's electric power industry, and if private capital declined to finance construction, then there was no reason to push for implementing the project. Even as the Great Depression deepened and unemployment soared to over 20 percent, Hoover stuck to his guns and resisted authorizing large public works like the Cove Creek Dam.

In contrast to Hoover, FDR endorsed public power development during the presidential campaign of 1932 and, once elected, made use of the existing Wilson Dam and the Army Corps of Engineers' 308 Report on the Tennessee River Valley to spur creation of a new agency: the TVA. The TVA was to be "owned by the people of the United States of America" and operated as an independent entity within the federal government. The TVA's leadership reconfigured the dam at Cove Creek, engaged the Bureau of Reclamation to develop a final design, and, in honor of public power proponent George Norris, gave it a new name: Norris Dam. The region would never be the same again.

Cottages At Fontana Village-Fontana Dam, N.C.

Fontana Dam featured a village for workers, but, compared to the "model town" of Norris, it looked more like a well-maintained trailer park. The TVA was originally touted as a program that would fundamentally restructure the social and political economy of the Tennessee Valley. After Arthur Morgan's dismissal as TVA chairman in 1938, the agency's social agenda faded from prominence. In its place, the generation of electricity ascended as the TVA's central and enduring mission.

Interior of Power House, Showing the Giant Generators

T.V.A.'s $115,000,000 Kentucky Dam is Located in Western Kentucky OC-H382

The TVA's Kentucky Dam powerhouse with sleekly stylized generators. Electricity symbolized the modern world, and the agency eagerly embraced the imagery of progress. New Deal dam projects were often driven by a political desire to bring the benefits of "public power" to citizens who, prior to the 1930s, had been ignored or underserved by investor-owned utilities.

Columbia River Dams: Bonneville and Grand Coulee Dams

Other than the lower Mississippi, the Columbia River carries more water than any river in the United States—five times more than the annual flow of the Colorado. Draining the high mountains of Idaho, Montana, and British Columbia, as well as parts of Wyoming, Oregon, and Washington, the power potential of the Columbia is commensurate with its huge flow. The lower stretches of the river also cut through the Cascade Mountain Range, providing a passage way for migrating fish seeking upstream spawning grounds or, in more recent times, for steamboats and diesel-powered barges serving inland ports.

For centuries, American Indians found sustenance within the Columbia River watershed, relying upon its huge fish runs to support a large and complex tribal society. When Euro-Americans arrived in the Pacific Northwest they too began exploiting the river's fisheries, using mechanized technologies that far surpassed the capacity of traditional American Indian practices. And by the end of the nineteenth century, the Army Corps of Engineers had built locks and short canals to transport boats around rocky shoals that impeded navigation. The Columbia River lay at the heart of a burgeoning regional economy, but in the early twentieth century the power potential of the stream still remained untapped. Many people understood the tremendous hydropower potential of the Columbia—the problem lay in how to develop a viable commercial market that could absorb huge quantities of electricity.

Two major New Deal dams were built to harness the Columbia River and

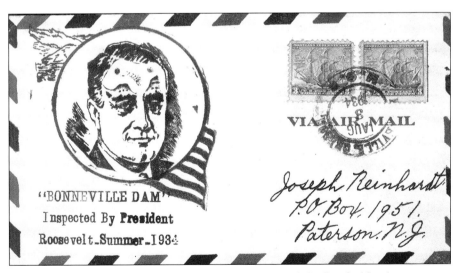

During the presidential campaign of 1932, FDR visited the Pacific Northwest and advocated public development of Columbia River hydropower. This postal "cover"—sent across country to New Jersey—celebrates FDR's return visit in 1934, when he toured the site of Bonneville Dam near Portland, Oregon.

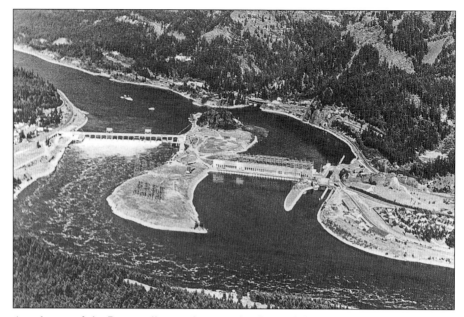

Aerial view of the Bonneville site showing the dam at left, Bradford Island in the center, and the powerhouse and navigation lock at right.

generate electricity. The end product of these two projects may have been the same, but the political and economic forces that spurred their construction were quite different. The Bonneville site (at times called Warrendale) lay only about forty miles east of Portland, Oregon, and occupied terrain familiar to the Army Corps of Engineers because of its earlier work in navigation improvement. When the Army Corps of Engineers undertook a 308 Report of the Columbia in the late 1920s, they were interested in hydroelectric power possibilities and in improving the navigability of the lower reach of the river. The site selected for Bonneville straddled Bradford Island, using the southern channel for both a navigation lock and as forebay for the powerhouse. The northern channel would be blocked by the dam proper and feature a spillway design that could accommodate the passage of heavy floods. The dam would also include major fish ladders (see chapter 7) designed to allow passage for salmon and other migrating species.

Grand Coulee Dam lies 450 miles upstream from Bonneville, and its origins reflected very different regional interests. In the early twentieth century boosters in Spokane began pushing for a one-hundred-mile-long irrigation canal designed to carry water by gravity flow from the Pend Oreille River (a tributary of the Columbia) to the Columbia Basin, a huge tract of dry but arable land west of the city. After the First World War, competing boosters in the town of Wenatchee (led by the local newspaper editor Rufus Woods) began advocating a different approach to irrigating the basin. Their idea was to build

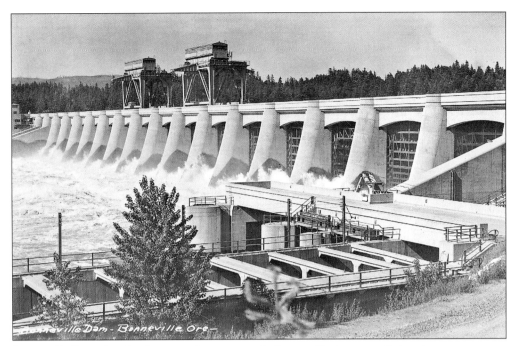

Bonneville Dam shortly after completion in 1937. Bonneville is not a tall dam (at maximum, water at the upstream face rises fifty-nine feet above the river below). Specially designed fish ladders (shown in the foreground) were integrated into the original design to facilitate upstream passage of salmon and other spawning fish.

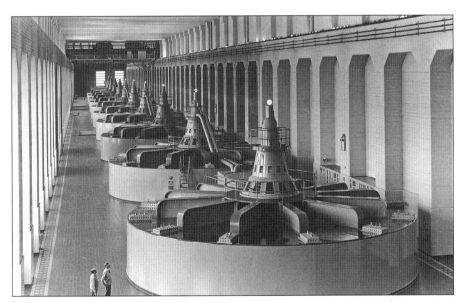

Interior of the Bonneville powerhouse. The ten turbine-generator units have a combined generating capacity of over five hundred thousand kilowatts. In the 1980s, a second powerhouse (located on the Washington State side of the dam) came online with an additional half a million kilowatts of capacity.

The Georgie Burton of Portland steaming up Lake Bonneville shortly after completion of Bonneville Dam. Almost fifty miles long, the slack-water reservoir created by the dam allows boats to pass unimpeded over the once formidable Cascade Rapids.

As commemorated on a postcard folder, FDR followed up his visit to Bonneville in 1934 with a trip to Grand Coulee Dam in eastern Washington State. He visited again in 1937, and his association with the project led to the Grand Coulee reservoir being named in his honor: Franklin D. Roosevelt Lake.

MASON CITY - THE CONTRACTORS TOWNE - GRAND COULEE DAM - WASH.

As with Norris and Boulder City, the Grand Coulee project hoped to highlight the uplifting effect of the New Deal on workers' lives. This view shows part of the housing built by the contracting consortium Mason-Walsh-Atkinson-Kier (MWAK) below the dam site. Known as Mason City, it stood as a sanitary—if rather stark—complex of barracks and homes. In 1938, more than five thousand workers drew a paycheck from the project.

a large hydropower dam at Grand Coulee and pump irrigation water up to the Columbia Basin. As a bonus, excess power generated at the dam could be used to electrify and transform Wenatchee into a center of industry. The power from a five-hundred-feet-high dam promised to be tremendous; projected to reach two million kilowatts, it would be the largest hydropower facility in the world. The battle pitting the gravity canal versus the dam and pumping plan dragged on into the 1930s. But after the Army Corps of Engineer's 308 Report endorsed development of Grand Coulee Dam as a hydroelectric plant the canal scheme soon passed into the dustbin of history.

Under President Hoover no effort was made to use the resources of the federal government to build either Bonneville or Grand Coulee. As a presidential candidate, FDR held a different view of developing the Columbia's power potential, and upon taking office, he took action: the U.S. Army Corps of Engineers would take charge at Bonneville and the Bureau of Reclamation at Grand Coulee. FDR's bravado in pursuing both projects simultaneously constituted no small political risk because little immediate demand existed for electric power

In contrast to Hoover, Grand Coulee did not rely upon an aerial cableway to transport concrete. Instead, a trestle and tramway system conveyed buckets of concrete to the cranes. The buckets were then lifted and positioned above the site of the "pour." This artful view shows the mixing plant (far left), steel trestle, and movable gantry cranes.

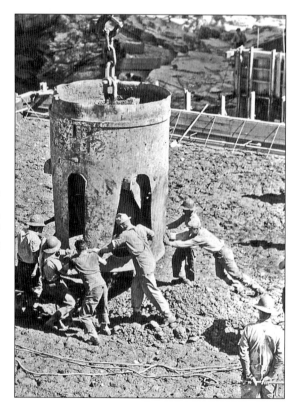

The first bucket of concrete for Grand Coulee Dam was cast on December 6, 1935. Each bucket held four cubic yards, which—you can do the math—required the scene shown here to be repeated more than two and a half million times. The 502-feet-high, 4,000-feet-long design required more than ten million cubic yards of concrete, three times the volume of Hoover Dam.

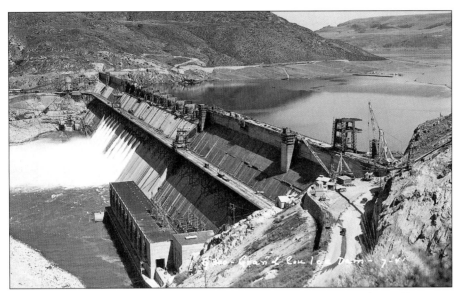

Construction nears completion, July 1941. When full, the reservoir formed by
the dam (Franklin D. Roosevelt Lake) stretches two hundred miles north to the
U.S.–Canadian border. At the time this photo was taken, the powerhouse in the left
foreground was already generating electricity. When all the generators came online
in the early 1950s, Grand Coulee had a generating capacity of almost two million
kilowatts—the largest in the world.

Upon completion in early 1942 the dam was widely touted as the "eighth wonder"
of the world. It also stood as a monument to the efficacy of the federal government,
celebrated at a "Free View Point" where—at no charge!—tourists could garner
salient facts from the Government Information Service. For example: Grand Coulee
Dam was the first man-made structure to use more masonry than the largest
pyramid of ancient Egypt.

in the Pacific Northwest—or at least this demand paled in comparison to the capacity offered by the two dams. True, the projects included navigation improvement (for Bonneville) and irrigation (for Grand Coulee) as justifications but—rhetoric aside—hydroelectric power constituted the key and essential feature of both endeavors. As it turned out, lingering fears that the two dams might prove to be ill-advised white elephants (a common complaint from Republican congressmen who despised the New Deal) evaporated at the end of the decade when the coming of the Second World War transformed industry in the Pacific Northwest. In particular, aluminum smelters—producing the vital lightweight metal used in airplane manufacture—drew huge amounts of electricity from Bonneville and Grand Coulee throughout the war. But when FDR acted to approve the two projects in 1933, it represented an act of faith that somehow, someway a market for the power could be found.

The Central Valley Project: Shasta and Friant Dams

California is America's most agriculturally productive state with the irrigated fields of the Central Valley constituting a wellspring of this bounty. Stretching from Redding in the north to Bakersfield in the south, the four-hundred-mile long Central Valley is drained by two major rivers: the Sacramento (to the north) and the San Joaquin (to the south). The two rivers join at the delta that feeds San Francisco Bay and from there flows into the Pacific Ocean. On a map, the Sacramento and San Joaquin might appear similar, but in terms of hydrology they are very different. The Sacramento is fed by runoff from the northern Sierra Nevada and carries *more* water than can be profitably used to irrigate the northern Central Valley (also called the Sacramento Valley); conversely, the San Joaquin River carries *less* water than can be used to profitably irrigate the arable lands of the southern Central Valley (or San Joaquin Valley). The great purpose of the Central Valley Project—and its key dams at Shasta and Friant—was to address this hydrologic imbalance and find a way to efficiently transfer Sacramento River water to the more arid south.

In the 1870s irrigation enthusiasts, politicians, and large landowners in the San Joaquin Valley first explored ways to access water supplies from the north. The political, economic, and technological challenges posed by such schemes were formidable, and decades passed with little accomplished. In the 1920s plans for a state-sponsored project gained momentum, as politicians plotted to reconcile a range of competing interests in order to "Move the Rain." As worked out by the early1930s, the plan involved building a large storage structure (originally called Kennett Dam, later renamed Shasta) across the upper Sacramento River that would hold back seasonal floods; the dam would also generate large quantities of hydroelectric power. Water released from the Shasta reservoir would flow through the Sacramento Valley and, after farmers and irrigation districts had appropriated their legal share, excess flow made available by flood storage would pass into the delta. Here, a pumping plant—connected to the Shasta

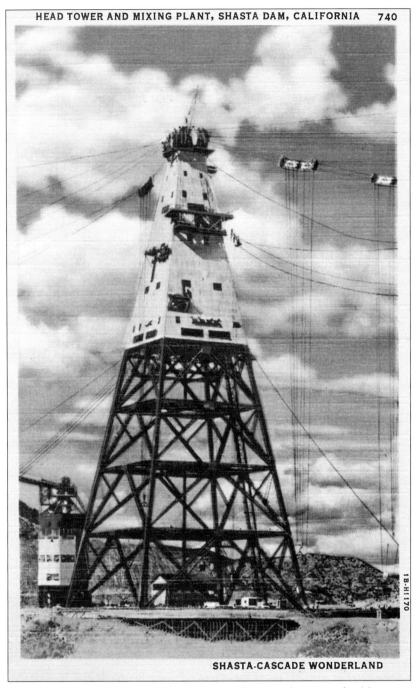

1B-H1170

SHASTA-CASCADE WONDERLAND

Shasta Dam's construction relied upon a sophisticated system of cableways to transport concrete across the expansive dam site. This photo shows the four-hundred-feet-high head tower that loomed above the concrete mixer and supported an array of seven distinct cableways.

The curved gravity design for Shasta taking shape with the main tower for the cableway visible at the top center-left. As at Hoover and Grand Coulee, the concrete was placed in discrete "blocks" in order to control cracking as the concrete cooled.

power plant by a 150-mile-long transmission line—would lift the water up into a 120-mile-long canal running south into the San Joaquin Valley. Water from this canal would be released to farmers in the lower San Joaquin Valley, allowing the water that they had previously drawn from the San Joaquin River to be deployed further south. To affect this diversion, Friant Dam would be built across the upper San Joaquin River near Fresno, and water from its reservoir (Lake Millerton) would be carried south in a 100-mile-long canal to irrigate land in Kern County near Bakersfield.

In essence, the floodwaters stored behind Shasta would be used to open up new irrigated tracts in the arid south, but only through an imaginative "water swap" made possible by storage and hydropower generation in the upper Sacramento Valley. The idea was to "Move the Rain" so that limited hydrologic resources could be more evenly dispersed across the Central Valley landscape. A simple concept perhaps, but one involving a huge infrastructure investment.

As originally conceived, the ambitious project was to be undertaken entirely with state monies and resources. The switch from a California-based initiative to New Deal federal project came in the 1930s when it became apparent to cash-strapped state authorities that, without financing from the federal government, it would languish for years, perhaps decades. At first it appeared that the Army Corps of Engineers might adopt the project, but soon the Bureau of Reclamation entered the picture and, with authority from Congress and FDR, took charge of constructing and operating the system. With the bureau in control,

Shasta was built using 8-cubic-yard "buckets" transported via the aerial cableways. Roughly 5.4 million cubic yards of concrete—requiring more than 650,000 bucket dumps—were needed to complete the 602-feet-high curved gravity structure.

Workers frequently used construction postcards as a way to communicate about life on the job. In this message, an unnamed correspondent expresses pride in being associated with the "wonderful Shasta Dam" ("she's a big one"), but also notes "it was three men killed there last week but that's not all by a long way." The card was never postmarked, so it's hard to know how (or whether) the message reached the intended recipient.

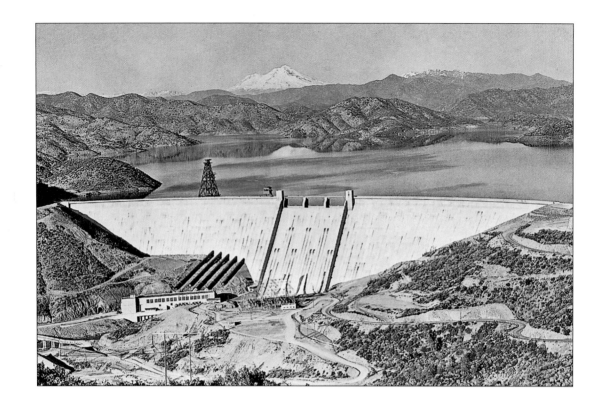

Aerial view of the Bonneville site showing the dam at left, Bradford Island in the center, and the powerhouse and navigation lock at right.

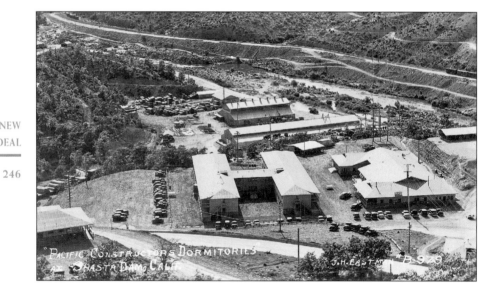

During the presidential campaign of 1932, FDR visited the Pacific Northwest and advocated public development of Columbia River hydropower. This postal "cover"—sent across country to New Jersey—celebrates FDR's return visit in 1934, when he toured the site of Bonneville Dam near Portland, Oregon.

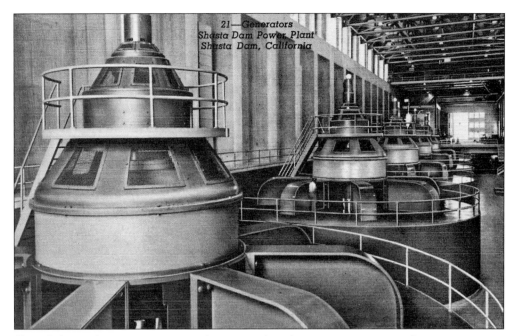

Shasta's five turbine-generator units have a combined generating capacity of 584,000 kilowatts.

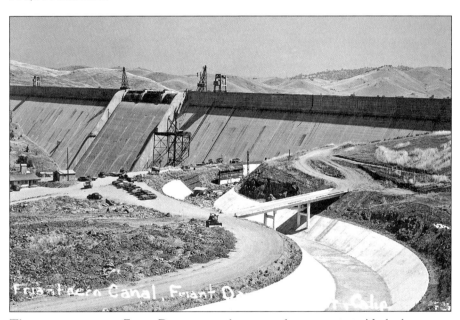

The concrete gravity Friant Dam approaching completion in 1942. No hydro-electricity is generated at Friant because so little water passes into the lower San Joaquin River. Instead, most water is diverted into the Friant-Kern Canal, flowing south for almost a hundred miles. The only reason that landowners in the lower San Joaquin River Valley allow the water diversions at Friant is because of the "replace-ment" water pumped to them from the Sacramento River using power generated at Shasta. Moving the rain indeed.

A postcard of the Kansas City riverfront in 1914. Steamboat and barge traffic held a significant place in the political economy of the twentieth-century Missouri River Valley. Navigation interests pushed for a large dam in the upper watershed that could regulate flow and insure increased channel depths. After FDR became president in 1933, Fort Peck became the site of a multipurpose dam that would both generate hydroelectric power and aid river navigation in the lower valley.

the renaming of Shasta Dam symbolized the transformation from state to federal project. Started in the late 1930s—when many other New Deals dams were already reaching completion—both Friant and Shasta did not "top out" until after America's entry into the Second World War in 1941.

Fort Peck Dam

The opening of Montana's goldfields in the 1860s brought steamboat travel far up the Missouri River. Even after the arrival of railroads in the 1870s and 1880s, commercial riverboats continued to ply the upper river, connecting St. Louis and Kansas City to the agricultural bounty of the northern Great Plains. In the lower Missouri Valley, navigation interests sought more reliable river flow that would allow for larger cargo shipments, reduce the possibility that boats and barges might run aground, and in general counter the effect of debilitating droughts. Seeking to eliminate the problem of low water, twentieth-century politicians and businessmen in the region pushed for a large upstream reservoir that could capture spring floods and, through controlled releases, insure steady, year-round stream flow in the lower valley.

In developing a 308 Report for the Missouri River Valley during the 1920s, the Army Corps of Engineers identified Fort Peck in eastern Montana as a good site for a multipurpose dam. But Army officers recognized that it was difficult to

At Fort Peck, the Army Corps of Engineers devised a 265-feet-high hydraulic-fill design. This multi-view real photo postcard shows the dredge used to excavate the mud slurry (top left and right); the pipeline ("floating dredge line") used to transport the slurry about two miles downstream to the dam site (bottom left); and the deposition of the fill (bottom right). During the course of construction more than a hundred million cubic yards of dredged fill were placed in the 21,000-feet-long dam.

justify the high construction cost given the relatively modest economic benefits that would result in terms of hydropower generation and improved navigation. When the report was completed in 1932, engineers refrained from recommending the construction of Fort Peck Dam. In the eyes of the Army Corps of Engineers, the economic benefits of improved navigation were modest at best, and even if a sizable amount of power could be produced at the dam there appeared to be little demand for electricity in the scantly populated northern Great Plains.

Following FDR's election, the cost-benefit equation of the Fort Peck Dam quickly changed, essentially because of the importance that New Deal administrators placed on job creation. The upper Great Plains had been hard hit by the Great Depression, and the value of jobs in the regional economy came to trump any fears that the project might become a financial white elephant. Thus, a key justification for Fort Peck Dam was simply to put people to work; in this, the project proved a great success: by 1936 over ten thousand people were drawing a paycheck at Fort Peck. Jobs, power, and navigation: a potent combination that, in the fall of 1933, sparked the PWA's approval of what for a time would be the world's largest earth embankment dam.

New Deal Townsite

Compared to the TVA's "model town" of Norris, or the Bureau of Reclamation's Boulder City, Fort Peck had a much less wholesome reputation. A story published in the first issue of *Life* magazine (November 23, 1936) gave national exposure to the rough-and-tumble character of camps at Fort Peck that were outside the Army Corps of Engineers' control. This view of the "New Deal Townsite" shows one of several such worker communities.

Other Dams of the New Deal Era

The big dams featured above attracted the most attention during the New Deal, but a multitude of other structures also drew regional interest throughout the 1930s. With early support from programs like the PWA and later support from a series of federal Flood Control Acts beginning in 1936, major dams flourished in watersheds across the American landscape. Despite the celebratory rhetoric that accompanied the creation of the TVA, many politicians in other river basins were wary of yielding to the federal government too much control over their region's projects. And, while the Army Corps of Engineers and the Bureau of Reclamation became bitter bureaucratic rivals competing for projects, they shared a common loathing for other possible regional authorities based on the TVA model. Of course, state and local authorities welcomed the federal dollars that came with dam projects, but they resisted giving over any more power to the federal government

FORT PECK DAM FLOOD SPILLWAY
LOCATED ABOUT 3 MILES EAST OF THE DAM. DESIGNED TO HANDLE 255,000 CUBIC FEET OF WATER PER SECOND, ALMOST TWICE AS MUCH AS THE GREATEST FLOOD ON THE MISSOURI RIVER

Although the *Life* story on Fort Peck focused on camp life, the famous cover by the photographer Margaret Bourke-White featured a dramatic construction view of the concrete spillway gates. This postcard view may lack the artistry of the *Life* cover, nonetheless it conveys the spillway's visually powerful form.

The message on a postcard view of the spillway (postmarked August 1937) affirms that the symbolism attached to big New Deal dams did indeed resonate with the American public. Noting that "[we] were impressed with the big way our administration spends money in the big west," the correspondent connects the monumentality of Fort Peck Dam to the architecture of ancient empires: "We thought there was something grand in the imposing rhythm of these structures at the Fort Peck Dam. Something reminiscent of the pictures in history books of the rows of Collossi at Karnak."

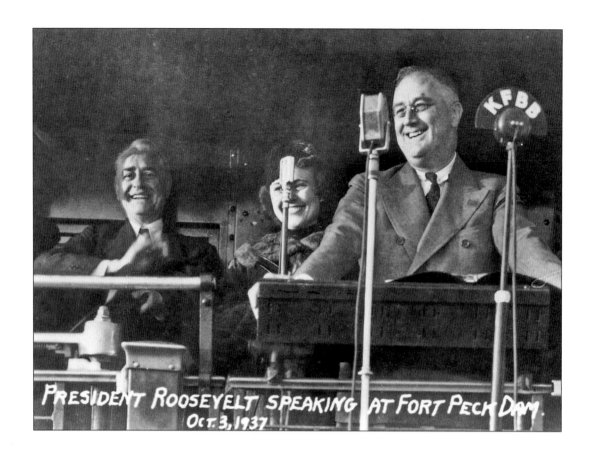

PRESIDENT ROOSEVELT SPEAKING AT FORT PECK DAM.
OCT. 3, 1937

(*Opposite, top*) FDR's New Deal did not work immediate economic miracles and it is often forgotten that America suffered a major recession in 1937–1938. Hoping to reinvigorate the economy, FDR—in concert with congressional Democrats seeking federal largess for their home districts—came to support more government funding for major dam projects; he also sought to further identify himself with "big dams" and the benefits they offered in terms of jobs and business contracts. Here, FDR visits Fort Peck Dam in the hinterlands of eastern Montana, giving a radio address in October 1937. A few days before, he had visited both Bonneville and Grand Coulee.

(*Opposite, bottom*) In September 1938, just as the dam neared completion, a huge section of earth fill "slipped" in a muddy mess, killing eight workers. But fortunately for project boosters, the slide did not destroy the entire structure. Using more conventional methods of earth construction (i.e., giant trucks and bulldozers), the Army Corps of Engineers completed the huge embankment in 1940.

(*Above*) Water exiting the diversion tunnels with powerhouse no. 1 shown in the right background. The first Fort Peck powerhouse came online in 1943 with a generating capacity of 105,000 kilowatts (a second powerhouse was completed in 1961); energy from the dam is distributed to power companies and rural electric cooperatives in eastern Montana and nearby North Dakota.

Dover Dam on Tuscarawas River, between Canton, Dover, and New Philadelphia, Ohio 8A-H2552

In alliance with the Muskingham Conservancy District, the Army Corps of Engineers built the Dover Dam in southeastern Ohio solely as a flood control project. Completed in 1936, its spillway only infrequently discharges water. The overflow depicted in this linen postcard from 1940 was created by an illustrator who worked for the Curt Teich postcard company.

(Opposite, top) The Conchas Dam impounds the Canadian River in northeastern New Mexico, providing for irrigation, flood control, and recreation. FDR approved the project in July 1935 and the Works Progress Administration, the Public Works Administration, and the Civilian Conservation Corps, financed construction and helped bring jobs to a destitute region. The Army Corps of Engineers completed the two-hundred-feet-high concrete gravity dam in 1939.

(Opposite, bottom) A postcard message from a Conchas Dam worker in January 1938 reinforces how New Deal dams connected with the men who built them. Don Miller updates his friend Ray: "I went to work here 8 days after I left Fort Peck. Guy and Lewis didn't get on so they went to Redding [i.e., Shasta Dam]. I'm back on graveyard. I get $1.00 per hr.—48 hours a week." If nothing else, this postcard confirms that workers perceived big dam projects as prime employment opportunities, traveling great distances to "get on" a job.

CONCHAS DAM
UNDER CONSTRUCTION

Box 1875 – Conchas Dam, N. M.

POST CARD

CORRESPONDENCE

ADDRESS

Dear Ray,
I went to work here
8 days after I left Fort Peck.
Guy & Lewis didn't get on
so they went to Redding.
I'm back on graveyard. I
get $1.00 per hr. – 48 hrs. a week.
Weather is sure swell. Warm
& no snow. Write and let me
know how you are.
Don R. Miller

Mr. Ray Kueffler
Box 177
Williston
N. Dak.

Scenic View of Norfork Dam and Norfork Lake
In the Beautiful Ozarks

PHOTO BY U. S. ENGINEER CORPS, LITTLE ROCK, ARK.

Authorized by Congress in the Flood Control Act of 1938, work on the 244-feet-high Norfork Dam across the North Fork River in Arkansas started in 1941. The Army Corps of Engineers' original plan did not provide for hydroelectric power, but pressure from Baxter County officials soon convinced Congress to authorize a power plant. The dam was completed by the corps in 1944, its eighty-thousand-kilowatt power plant became fully operational five years later.

KINGSLEY DAM
OGALLALA, NEBR

In Nebraska, the big New Deal dam was a huge hydraulic-fill embankment stretching across the North Platte River near Ogallah. Financed by the Public Works Administration, the 165-feet-high Kingsley Dam was built for irrigation and, at least initially, did not include a hydroelectric power plant (one was added in the 1980s). Today, the Central Nebraska Public Power and Irrigation District exercises jurisdiction over Kingsley Dam.

The Grand River Dam Authority, a state-authorized agency, received substantial support from the Public Works Administration to build the Grand River (or Pensacola) Dam in northeastern Oklahoma. Completed in 1940, the dam is a 150-feet-high, 4,000-feet-long concrete multiple arch structure with a generating capacity of 120,000 kilowatts. Impounding the 43,500 acre Grand Lake O' the Cherokees, the dam quickly became a major tourist destination.

FORT RANDALL DAM
PICKSTOWN, SO. DAK.

Navigation and irrigation may have been part of the "multipurpose" justification for the Army Corps of Engineers' big Missouri River Dams, but hydroelectricity quickly reigned supreme. Completed in 1956, the Fort Randall Dam in South Dakota has a generating capacity of 320,000 kilowatts.

than absolutely necessary. Significantly, no other river basin in America ever adopted in toto the TVA model of federally controlled regional water development.

Legacies

New Deal dams represented the ascendance of the monumental dam on the American landscape. At times, objections were raised as to the desirability of a particular dam. But overall the 1930s constituted a time when large-scale water projects were championed—by both politicians and the public—as great accomplishments affirming the resilience of the national spirit. A great host of purposes and agendas attended the advocacy of New Deal dams, but the importance of hydroelectric power generation held meaning across the nation's political landscape. During the New Deal electricity was transformed from a desired feature of modern life into a birthright of national citizenship. New Deal dams provided a means of bringing the federal government into the business of electric power, and, although the nation's investor-owned utility industry never lost its place in the larger political economy, the role of the state in energy policy has remained strong ever since.

While New Deal dam building—and FDR's economic initiatives as a whole—may have ameliorated the devastation wrought by the Great Depression, it failed to fully reignite the economy. Only with the coming of the Second World War and huge defense expenditures did the American economy approach the vitality of the 1920s. The Second World War also rendered moot critiques lobbed by anti-Roosevelt politicians that FDR's dams would become white elephants possessing limited long-term value. This proved especially true for the hydroelectric power development at Grand Coulee and Bonneville and with the TVA dams, all of which served a variety of vital military missions, including aluminum smelting, ship and airplane manufacture, and support for the Manhattan Project.

New Deal dams may not have won the Second World War, but after hostilities ended in 1945, many Americans took it as axiomatic that big dams served a great patriotic purpose. Big dams had powered the "arsenal of democracy," insured bountiful crop harvests, and protected cities and war industries from floods. Out of this sprang a great legacy of New Deal dams, one that spurred a flurry of projects in the postwar era. The damming of big rivers—and completing the visions laid out in many Army Corps of Engineers' 308 Reports and by Bureau of Reclamation planners—was not something to be questioned. Or at least it was not questioned by the crowd of politicians and boosters who saw dams and water projects as ideal vehicles for injecting federal dollars into their states, communities, and congressional districts. Nay-saying fiscal conservatives might deride such projects as mere "pork barrel," but they were hardly devoid of value, especially for a society hell-bent on consuming ever more electric power. The postwar era has been described as the "Go-Go years" of American dam building, and the intensity of this development can be tied to the success of New

Big projects like Hoover and Grand Coulee were the centerpieces of the Bureau of Reclamation's work during the New Deal. But smaller projects were also valued by farmers and politicians in less noticed parts of the West. The Humboldt River is hardly a major river in terms of stream flow, but it is vital to the life and economy of northern Nevada. The Rye Patch Dam lies about twenty-two miles upstream from the farming community of Lovelock; completed by the Bureau in 1936, the earth embankment structure helps irrigate more than forty thousand acres.

Deal dams in supporting the war against Japan and Germany. As the Cold War against communism gained speed, the need to maintain economic supremacy continued apace. In this, dams were promoted as an essential part of the nation's expanding industrial infrastructure.

But despite the patriotic ardor that many people attached to dam construction, a counternarrative was gestating in the postwar era, one less enamored of the changes that dams brought to river valleys and riverine ecologies. As large dams proliferated through midcentury, the environmental costs they exacted engendered increasing criticism. As explored in chapter 7, an unmitigated sense of universal good that came with humankind "conquering nature" proved illusory, or at least unsustainable, as the years passed and more free-flowing rivers were transformed into slack-water reservoirs. The legacy of New Deal dams and their impact on the American landscape is undeniable, but this legacy proved more complicated than the triumphant narrative that reigned when the dams were first built and celebrated amid the economic crisis of the Great Depression and war against the Axis powers.

In the postwar era, New Deal projects continued their hold on the American imagination. Perhaps nowhere was this more evident than at Grand Coulee, where the tremendous dam was celebrated as an American spectacle. Here, contestants vying to be Miss Washington State 1948 pose with the spillway as backdrop. How to interpret this scene? At the very least the dam had transcended its utilitarian purpose, becoming an artifact of Americana writ large and a place to celebrate mass culture. Why not a beauty pageant?

(Opposite, top) Completed in 1951, the two-hundred-feet-high Davis Dam was built by the Bureau of Reclamation to help maximize hydroelectric power generation on the lower Colorado River. Named after Arthur Powell Davis, director of the U.S. Reclamation Service between 1915 and 1923 and an early advocate of Hoover Dam, it has a generating capacity of more than 255,000 kilowatts.

(Opposite, bottom) The political benefits of big dam building resonated for years after FDR's death in 1945, and even Republican President Dwight Eisenhower participated in ceremonies for new Army Corps of Engineers and Bureau of Reclamation dams. But, Eisenhower also endorsed the Idaho Power Company's plans to build the Hells Canyon hydropower dams along the Snake River below Boise. The Oxbow Dam shown here (completed in 1961) is a 175-feet-high earth embankment structure built by Morrison-Knudsen, a firm that had helped build Hoover, Norfork, and many other federally financed dams.

Lurking beneath the seeming accessibility of New Deal dams lay a technological mystery, a world appreciated in terms of cheap, abundant electricity but often little understood. This view of visitors gazing at a Grand Coulee turbine-generator shaft, circa 1947, symbolizes both the awe and bewilderment that beset the average citizen when confronted with the technology that defined (their) modern society. Engineers and politicians told them that dams were good and necessary. And who could disagree? The New Deal championed a vision of dams that incurred little cost beyond an expenditure of money. But dams transformed the environment and altered the landscape in ways that not all citizens appreciated or valued. Eventually, these concerns would find a voice.

FISH AND ENVIRONMENT

By the start of the twenty-first century dams were widely viewed as having a negative impact on the environment. Such perceptions did not spring out of the ether but had roots extending back more than two hundred years, to a time when dams were first blamed for blocking seasonal fish runs. As early as the eighteenth century, New England farmers, who had come to rely on fishing as a component of their rural lifestyle, sought the removal of mill dams through legal action (and sometimes by vigilante force) to protect their use of river resources. The clash of "fish versus power" first brought to the foreground in colonial New England was later played out in many parts of the United States and remains a centerpiece of environmental conflict, especially in the Pacific Northwest. It should not be surprising that evidence of this conflict—or at least of efforts made to ameliorate the effect of dams on fish survival—can be found in stereo views and vintage postcards. The presence of fish ladders (or fishways) captured in many views documents the efforts of dam builders to find a way to balance the socio-economic values of waterpower against those of regional fisheries. Athough the effectiveness of fish ladders in protecting fish runs has never been particularly high, the persistence of the technology—extending from the nineteenth-century dam across the Merrimack River at Lowell, Massachusetts, through major structures such as the Bonneville Dam on the Colombia River near Portland Oregon—speaks to long-standing awareness of the environmental effect of waterpower development.

263

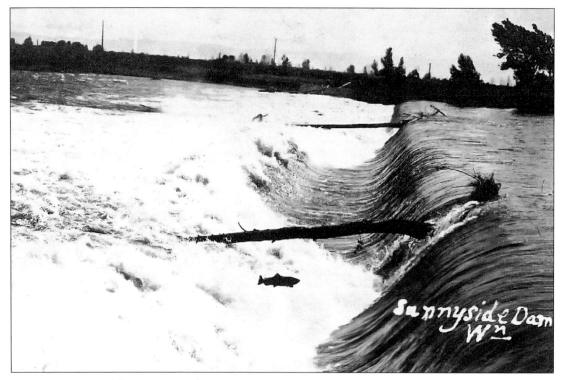

The spectacle of spawning fish making their way upstream was (and is) a source of fascination to the American public. This real photo card postmarked 1918 nicely silhouettes a salmon seeking passage up the Yakima River in central Washington State.

While early dams could interfere with fish migration and swamp out upstream meadows and bottomlands, thus provoking the economic ire of riparian landowners, the environmental impact of millponds could also be perceived in an agreeable light. As noted in chapter 5, millponds often created scenes of pastoral tranquility, quiet stretches of water akin to natural lakes that became a familiar part of local landscapes. It was not until the latter nineteenth century and the advent of large storage dams—that is, structures inundating several hundred (eventually many thousand) acres—that anti-dam opposition took on new political energy.

The contemporary origins of this brand of anti-dam activism can be traced to England in the 1870s, when the City of Manchester proposed a bold initiative to increase its municipal water supply. The plan was to enlarge Lake Thirlmere with a sixty-four-feet-high dam and tap into it with a ninety-five-mile-long aqueduct for the benefit of a growing urban population. Lake Thirlmere was a picturesque feature of northeast England's Lake District, and many Brits feared that by converting the (relatively) pristine natural lake into an artificially enlarged

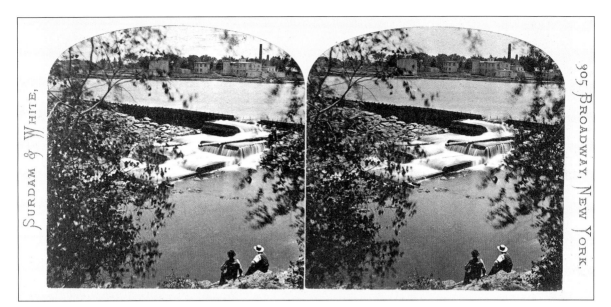

Fishways to the rescue? Artificial means of providing upstream passage appeared in the nineteenth century, as shown in this stereo view, circa 1870, of the Pawtucket Falls Dam at Lowell, Massachusetts. By lowering a section of the dam so that water could spill down a series of "steps," spawning fish were offered a possible path for upstream migration. But any water passing through the fishway was water that could not be used to power the Lowell textile mills. In this lies the enduring conflict of "fish versus power."

Waupaca's "Electric Light Dam" and fish ladder, circa 1908.

Power Dam on Clackamas River, at Cazadero, Oregon.

Spawning fish are a vital part of the culture and environment of the Pacific Northwest. But rushing rivers are also a major source of waterpower. Seeking a balance, this early hydroelectric power dam across the Clackamas River in Oregon featured a small fish ladder to mitigate the impact on seasonal fish runs.

Arguably the site of the most famous fish ladders in the United States, the facilities at Bonneville Dam near Portland, Oregon, were deemed particularly important because almost the entire watershed of the Columbia River lies upstream from the fifty-nine-feet-high structure.

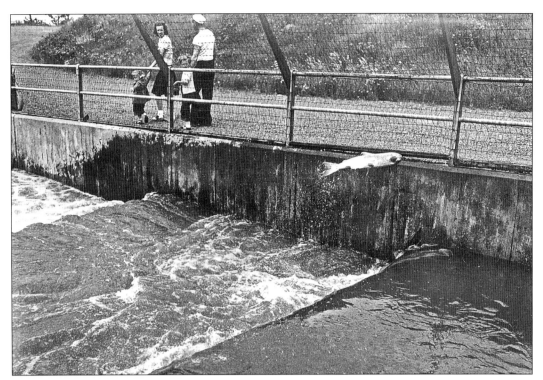

A Bonneville fish ladder in action, circa 1950. Salmon and other migrating species could ascend the dam via a series of relatively short leaps. Bonneville's fish ladders were designed on a large scale, but the basic concept had been used since at least the nineteenth century.

reservoir the country's beloved cultural landscape would be forever marred. The Lake Thirlmere project eventually went forward with Parliament's approval and a royal assent from Queen Victoria. But the Thirlmere controversy attracted international attention, highlighting the damage that dam construction might wreak on environmentally sensitive landscapes.

The greatest dam controversy in American history came when San Francisco looked to expand its municipal water supply into the remote reaches of California's High Sierra. Proposals to transform mountain valleys into storage reservoirs were not unusual at the beginning of the twentieth century, but what distinguished San Francisco's initiative—and made it so controversial—was that the valley it sought to dam, Hetch Hetchy, lay within the boundaries of Yosemite National Park.

The battle over the high mountain valley extended from 1901 (when federal law allowed for the possibility of creating reservoirs in Yosemite National Park) through 1913 (when Congress passed the Raker Act and authorized San Francisco to build what became O'Shaughnessy Dam). The famous naturalist John Muir fought vigorously against the dam on grounds that it would defile one of

As fish ascended the Bonneville system, fish counts were taken to keep track of annual runs for different species. Unfortunately, as the years have passed and more upstream dams have been built, fish populations within the Columbia watershed have dropped dramatically.

(Opposite, top) Fishing along the Columbia River was a vital component of Indian culture predating the arrival of Euro-Americans. Traditional techniques were used at Celilo Falls through the 1950s, when completion of the Dalles Dam drowned the falls under a massive reservoir. Yes, the dam featured a fish ladder system like that used at Bonneville, but this did nothing to preserve the ancient fishing grounds at Celilo Falls. And what was the primary benefit offered by the dam? A hydroelectric power plant with a capacity of almost 1.8 million kilowatts. In the political environment of post–Second World War America, American Indian fishing advocates held little influence in the face of a burgeoning electric power juggernaut.

(Opposite, bottom) The "dam removal" campaigns of the late twentieth century could draw inspiration from some earlier initiatives. For example, the Sunbeam Dam in western Idaho had been built to power local mining operations. But after the mines closed, a hole was blown in the concrete structure in the 1930s, opening up spawning grounds in the (aptly named) Salmon River watershed.

Indians Fishing at Celilo Falls, Oregon # 93

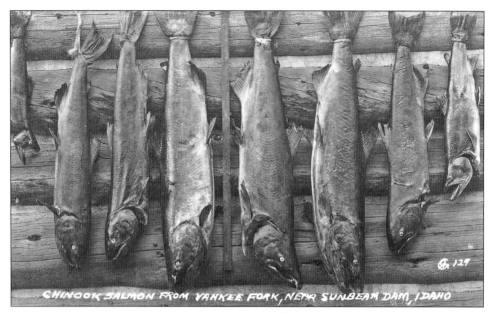

A postcard from the 1940s featuring prized Chinook salmon taken from the waters of Yankee Fork near the breached Sunbeam Dam.

the greatest wonders bestowed by the creator on the natural world. In a memorable quotation, Muir made poignant reference to the loss that would be suffered should San Francisco's commercial interests have their way in flooding the valley: "These temple destroyers, devotees of ravaging commercialism, seem to have a perfect contempt for Nature, and, instead of lifting their eyes to the God of the mountains, lift them to the Almighty Dollar. Dam Hetch Hetchy! As well dam for water-tanks the people's cathedrals and churches, for no holier temple has ever been consecrated by the heart of man."[1]

In contrast, advocates for the dam saw it as a great conservation project, one that would provide the city with abundant quantities of both pure mountain water and hydroelectric power. As the battle ebbed and flowed over the course of a decade, the arguments of both sides took on unexpected nuances, with preservationists proposing a hotel be built in the midst of Hetch Hetchy Valley in order to better accommodate recreational development. Pro-dam enthusiasts took a different tack in terms of scenic values, proclaiming that the reservoir would in fact increase the beauty of the valley by imbuing the water surface with wondrous reflections, making the surrounding cliffs and waterfalls appear all the more amazing.

In the end, the economic value of the reservoir to the city held sway—most San Francisco residents, including more than a few members of the Sierra Club that Muir cofounded in the 1890s, supported the dam and aqueduct project— and anti-dam forces endured a bitter defeat. While the history and resolution of

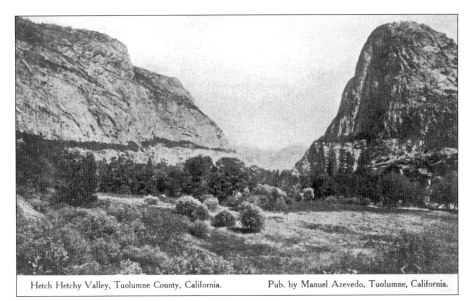

Hetch Hetchy Valley, Tuolumne County, California. Pub. by Manuel Azevedo, Tuolumne, California.

America's first great cultural battle over dam building came at Hetch Hetchy Valley in Yosemite National Park. This pre-dam postcard depicts the valley floor that anti-dam activists sought to protect from inundation. Broadly speaking, they saw their work as an effort to preserve "wilderness" so that it could be enjoyed by urban vacationers seeking respite from modern life. In contrast, San Francisco officials viewed Hetch Hetchy Valley as an ideal site for a municipal reservoir, one that would supply fresh water for decades to come.

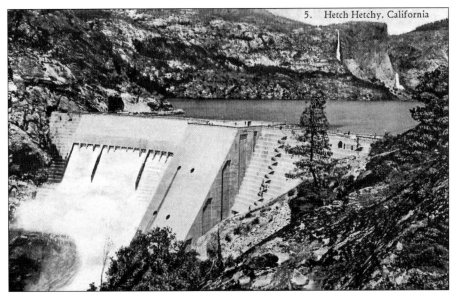

5. Hetch Hetchy, California

The battle over Hetch Hetchy lasted more than a decade. Finally, in 1913 San Francisco won authority to build a four-hundred-feet-high dam across the lower end of the valley. This view shows the partially completed dam in 1923 with the reservoir and waterfalls visible in the background.

The naturalist and Sierra Club cofounder John Muir is known for many things, but none more so than his passionate defense of Hetch Hetchy. Later in the twentieth century, anti-dam crusaders saw in Muir an inspirational guide, someone to emulate in their fight against dams and water projects. The author is unaware of any photograph of Muir visiting Hetch Hetchy, but this real photo postcard dating to the 1920s shows him in Yosemite's Mariposa Grove a few years before his death in 1914.

the Hetch Hetchy controversy holds much of interest to environmental historians, two points bear emphasis. First, the defeat imbued Muir with an air of martyrdom, made all the more poignant by his death a year after the dam's approval by Congress and President Woodrow Wilson. A reverence for Muir helped instill in later environmentalists the conviction that dams presented an especially egregious threat to wilderness and wild terrain. And this reverence also impelled the environmental community to take special interest in protecting national parks from future dam incursions. Second, the arguments against the Hetch Hetchy Dam were not grounded in a sense of ecology. Rather, like so much early interest in preserving sites of natural wonder, they focused on scenic values and on how the visual character of the valley would be debilitated by the dam and reservoir. A sense of how dams interfered with natural systems and ecological balance was not a part of the Hetch Hetchy controversy. Such concerns would only arise with the anti-dam initiatives of the latter twentieth century.

In the 1920s and 1930s no major dam controversies enveloped the nation

As dams and reservoirs expanded across the American landscape in the 1920s, rural communities became aware that local river valleys were vulnerable to expropriation. The Deerfield River Valley in southern Vermont did not represent a natural wonder worthy of National Park protection, but as this real photo postcard, circa 1910, illustrates, it held much rural charm, if not pastoral beauty.

After completion of the New England Power Company's Harriman Dam in 1924, much of the Deerfield River Valley was obliterated by a reservoir covering a large part of Whitingham, Vermont. The reservoir provided for power generation along with swimming and lake fishing. The power company also paid local property taxes that helped pay for a new town hall. But something was lost within the 130-year-old town, something that could not be replaced by the amenities of the modern world.

The following is handwritten/typed on the cover image:

Airmail

LOYSTON, TENNES[SEE]
Submerged beneath the waters of
NORRIS DAM
MAR 14 1936
Last Day of Mail Service
Satre N. Turner
Satre N. Turner, Postmistress

Mr. Paul Peters,
101 West 88 St.
New York, N. Y.

The inundation of rural communities became a part of American culture as dam building proliferated. The TVA's Norris Dam was heralded as a great New Deal boon to the people of the Tennessee Valley, but hundreds of people lost their homes to make way for the dam's reservoir. This philatelic "cover" commemorates the last day—March 14, 1936—you could mail a letter from the Loyston, Tennessee, post office. The letter reflects an understanding that life in the Clinch River Valley was changing forever thanks to Norris Dam, whether one liked it or not.

(certainly nothing approached the notoriety of Hetch Hetchy) but the propagation of expansive reservoirs continued to incite local awareness that dam building came with a price. Rural communities were displaced by impending dam projects and longtime residents forced to relocate, all to make way for the forces of progress. As cemeteries were exhumed and the graves of loved ones removed from reservoir take zones, a sense of exploitation by the disenfranchised gestated. Usually nothing dramatic transpired, or at least nothing that could significantly challenge the celebratory narrative of New Deal dams triumphing over nature. But seeds of discontent were sown every time families were forced against their will to abandon a hard-won homestead or village-based business in the name of someone else's progress. Notably, the towns obliterated by the Quabbin Reservoir in western Massachusetts (completed in 1939 to provide greater Boston with a remarkable supply of uncontaminated water) are still angrily recalled by local residents resentful of the "water grab" made decades ago by powerful urban interests to the east. American Indian tribes, with reservation lands occupying river valley bottomlands, came to bear significant burdens as dam engineers and politicians targeted their lands for major reservoirs.

A civic monument at eight thousand feet above sea level. Eleven Mile Dam was built high in the Rocky Mountains in 1930–1932 to increase Denver's municipal water supply and sustain urban growth. The thin arch concrete structure impounds the upper South Platte River above Cheesman Dam and creates one of the state's largest reservoirs.

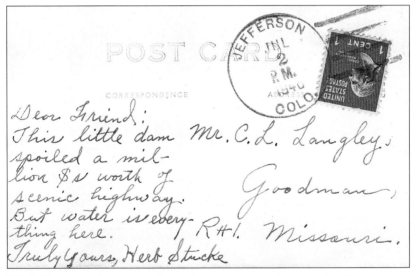

While Denver politicians and civic boosters certainly appreciated the storage provided by the Eleven Mile Dam, the message adorning this real photo view, postmarked 1940, reflects public awareness of a cultural price exacted by the project: "This little dam spoiled a $1 million worth of scenic highway. But water is everything here."

Echo Park Dam

...Man and Nature Cooperate

An artist's rendering of the proposed Echo Park Dam, circa 1950. The Bureau of Reclamation may have promoted the dam as a beneficial melding of man and nature, but many Americans considered the dam to be a baneful intrusion into Dinosaur National Monument. In contrast to Hetch Hetchy, preservationists were successful in protecting Echo Park. Although dam building continued at many other sites, Echo Park flashed as a beacon to the nascent anti-dam movement, a demonstration of what was politically possible.

After the Second World War dam building kept up the pace of the New Deal but, in the midst of this frenzy, resistance to a large dam project achieved national force. Echo Park Dam was proposed by the Bureau of Reclamation as a means of developing the Green River (a major tributary of the Colorado River) for hydroelectric power. Nothing was remarkable about that. But the Echo Park site lay within the boundaries of Dinosaur National Monument in eastern Utah, and as a national monument, it was accorded status comparable to that of a national park. Although the paleontological relics comprising the monument's raison d'etre were not to be disturbed by the proposed dam, the project nonetheless represented a park invasion akin to the tragic expropriation of Hetch Hetchy. Or at least that it is how many conservationists, growing ever more anxious as dam building proliferated across the American landscape, perceived the threat posed by Echo Park Dam. A national campaign railing against the Echo Park project gained momentum, and congressional hearings in the 1950s brought forth a successful questioning of the assumptions and projections used by bureau engineers to justify the dam.

In 1956 Echo Park Dam was dropped from the Colorado River Storage Project Act, thereby establishing an important precedent that dams could be blocked if enough political pressure was brought to bear. But the same legislation authorized construction of Glen Canyon Dam in southern Utah, a 602-feet-high concrete arch structure with a storage capacity equal to Hoover Dam; the reservoir formed by Glen Canyon Dam (Lake Powell) would extend almost 200 miles up the Colorado River and inundate more than 250 square miles of canyon wilderness.

By the early 1960s, a time in which Rachel Carson's landmark *Silent Spring* served as a vanguard for the modern environmental movement, a reinvigorated Sierra Club perceived Glen Canyon Dam as a horrible travesty, comparable in scale to the Hetch Hetchy disaster. Efforts to block completion of Glen Canyon Dam proved futile, but the Sierra Club soon had another project to fight, this one involving construction of a hydroelectric power dam that would back up water into the lower reaches of Grand Canyon National Park. The so-called damming of Grand Canyon quickly became a cause célèbre for environmentally conscious citizens across the United States. In the end, the lower Grand Canyon project lost congressional support in the late 1960s, but more because of political opposition emanating from the Pacific Northwest than from environmental activism (the plan in toto included transferring water from the upper Snake River to the Colorado watershed). Regardless of exactly why the project lost political support, an important point had been reinforced within the environmental community: dam building was not something that need be suffered without a fight. By the 1970s, the popular perception of dams was undergoing a dra-

RECREATIONAL AREA
GARRISON DAM
RIVERDALE, NO. DAK.

The proliferation of huge reservoirs after the Second World War did not come without opposition, especially from people who were to be displaced from ancestral homelands. The Garrison Dam was the first big Army Corps of Engineers' project along the Missouri River after the completion of Fort Peck Dam in 1940. Many people supported Garrison because of what it promised in terms of power generation and flood control. But the American Indians of the Three Affiliated Tribes (Mandan, Hidatsa, and Arikara) were forced to give up their reservations in the Missouri River bottomlands to make way for Lake Sacajawea. Euro-American Midwesterners made use of the new reservoir—water sports in the midst of North Dakota ignited a widespread recreational passion—and many gave little thought to what the American Indians lost. But the Three Affiliated Tribes had brought their case to Congress and, though failing to block the dam, helped foster a growing political awareness that dams incurred great social costs.

matic transformation. No longer was the cultural narrative of dams dominated by a positivistic telling. Just as environmental concerns of all types found favor among many—but certainly not all—Americans, dams began to be broadly questioned in ways seemingly unthinkable a few years earlier. But the roots of this questioning could be traced to a long-standing concern for migrating fish populations and, as at Hetch Hetchy and Echo Park, for a heartfelt appreciation of what could be lost beneath rising reservoirs.

BRIDGE CANYON DAMSITE

Echo Park Dam may have been stymied, but in the early 1960s Bureau of
Reclamation officials and boosters in the Southwest sought to further develop
hydropower along the lower Colorado River. The plan: to build a huge dam at
Bridge Canyon, a site (shown here in a postcard circa 1950) that would back up
water into the lower reaches of Grand Canyon National Park. The Sierra Club
fought the so-called Grand Canyon Dam at Bridge Canyon with a nationwide
public relations campaign. By 1968 the project was politically dead, thanks
largely to opposition from political interests in the Pacific Northwest. Anti-dam
environmentalists were nonetheless emboldened by their seeming success in
blocking the project; the Sierra Club soon focused its organizational energy
on dams as the progenitors of great environmental hardship.

SNAPSHOT CULTURE

At midcentury picture postcards were entrenched as essential components of American culture, but their status had changed dramatically since the golden age of 1905–1915. Postcard collectors and postcard clubs survived, but more as a hobbyist niche and not as a broad-based movement engaging people across the sociocultural landscape. The diversity of local views was in decline, and, from the perspective of the renowned photographer Walker Evans, the graphic quality of postcards had also eroded since the golden age. In an essay published in *Fortune* in 1948, Evans waxed nostalgic about how "main street" views—a genre that he had collected for many years—were in decline.[1] But it wasn't just changes in postcards and the views they recorded that Evans lamented, it also involved the changing character of life in the postwar America.

Postcards now largely served as a means of quick communication and as a marker of travels made and prominent places seen. Views of massive, monumental dams like Hoover and Shasta and Norris continued to proliferate in the late 1940s and 1950s, but, carrying on a trend from the New Deal era, small-scale dams attracted scant attention from postcard manufacturers. Local drugstores were still festooned with racks of cards but, in contrast to the golden age, the variety of views was severely diminished. "Comic cards" or landscape scenes tied to no particular town were widely distributed, a consequence of mass production and the reduced manufacturing costs that such generic views entailed. The

Snapshot culture circa 1925. A group visits the La Grange Dam in the foothills near Modesto, California. Completed in the mid-1890s, this masonry overflow dam diverts water from the lower Toulumne River for the Turlock and Modesto Irrigation Districts.

Camping astride the reservoir above the Littlerock Dam in northern Los Angeles County, circa 1930. This candid snapshot was probably taken in the late fall or early winter, after the reservoir had been drawn down by the demands of pear farmers served by the Littlerock Creek and Palmdale Irrigation Districts.

St Francis dam
26/23 Sunday
Took this picture
when on my vacation
wasn't that a terrible
disaster. I took a whole
dozen up there. Effie
and us went on a
picnic. This is all
that is left of the
dam.

(Above) Before they
were demolished with
explosives in May 1929,
the remains of the St.
Francis Dam became a
tourist destination for
day trippers out of Los
Angeles, many armed
with a camera.

(Left) An intriguing
inscription on a snapshot
of the St. Francis Dam
ruins, documenting how
it was one of a dozen
taken while "on my
vacation." The photog-
rapher acknowledges the
"terrible disaster," but
his visit also included a
picnic with Effie.

A young woman appears less than excited by a stop at Coolidge Dam in central Arizona. Completed in 1930 to store water for American Indian tribes in the lower Gila River Valley, this multiple dome dam (a variant on multiple arch design) was located about ten miles south of U.S. Route 70 (and about eighty miles east of Phoenix). Transcontinental travelers frequently visited the imposing structure named in honor of President Calvin Coolidge.

specific—which spawned such a tremendous range of local views in the golden age—gave way to the general. To Evans's chagrin, few people seemed to mind.

This transformation of postcard culture did not mean that Americans had lost interest in visual images or photography—far from it. The evolution of postcards in American life had not occurred in a vacuum but coincided with myriad social transformations revolving around the ascendance of motion pictures, the permeation of radio and television into the nation's living rooms, and the explosive growth in image-based tabloids and magazines like *Life* and *Look*. Changes in postcard culture also reflected increased reliance on telephones as a means of personal communication. But perhaps most importantly, the change correlated with an expansion of personal, amateur photography. From the 1920s on, inexpensive, easy to use cameras became a staple of the American family. As a consequence, snapshot photography boomed on a scale that approached, and likely exceeded, the manufacture of picture postcards at the high mark of the golden age. While personal photography had played a role in early postcard

Whether called Boulder or Hoover, the huge concrete dam across the Colorado River near Las Vegas became a tourist attraction even before its official completion in 1935. In this snapshot from 1938 taken atop the dam, a sharp-dressed man is himself caught taking a photo. Snapshot culture in action!

The car behind this stylish young woman sports an Ohio license plate from 1950, reflecting how Hoover Dam attracted visitors from across the United States long after the New Deal had passed into history.

Prior to the terrorist attacks of September 11, 2001, visitors to Hoover Dam were welcome to take an elevator down to the base of the dam and experience the structure from the bottom up. Here a fashionable woman of the early 1960s strikes a pose before the looming downstream face.

Another Hoover Dam view from the early 1960s, this one featuring a jovial trio of women with Lake Mead in the background. At the time the photo was snapped the reservoir was quite low (note the white "bathtub ring" residue that shows how high the reservoir can reach when filled). Since the 1990s, precipitation in the Colorado River watershed has proven insufficient to bring the reservoir level anywhere near full capacity; many hydrologists fear that future climate conditions will exacerbate this trend in the decades ahead.

Americans of all ethnic and cultural backgrounds have come to see Hoover Dam as a national landmark. Here, an African American woman visits the dam in 1971.

A young woman at Bonneville Dam near Portland, Oregon, circa 1940. Hoover Dam might be America's most popular "dam as destination" but other projects certainly experience their share of visitors.

Two women at the Norris Dam overlook, circa 1960. The plaque between them highlights the TVA slogan "Built for the People of the United States of America" —a helpful reminder that the dam was not built by a privately owned utility.

Jack and Mary at the Norris Lake marina in 1946 (Norris Dam is visible in the background). It's easy to imagine a Hank Williams tune softly wafting from a nearby radio.

Ozark Dam Forsythe, Mo
June 1942

(Above) A man
visits the hydroelectric
power dam at Forsythe,
Missouri, during the
late spring floods of
June 1942.

(Left) A boy and a
dam: Shasta Dam in
Northern California,
circa 1955.

At an elevation almost seven thousand feet above sea level, two women pose atop Big Bear Dam in Southern California, circa 1950. The dam was built in 1910–1911 about eighty miles east of Los Angeles in the San Bernardino Mountains, but it was not until completion of the Rim of the World Highway in the mid-1920s that Big Bear Lake became a major tourist destination.

history (witness the great numbers of small-batch, real photo cards featured in this book), its subsequent growth from the 1920s on assumed a trajectory that extended well beyond the realm of postcards.

Dams are well represented in this snapshot culture. As captured in a multitude of personal photographs, people visited, posed in front of, and relaxed at dams and reservoirs throughout the United States. From the 1920s on, the settings for such snapshots came to be dominated by monumental structures. Perhaps most notably, tourists visiting Hoover Dam in the midst of a cross-country trek documented their journey with an almost ritualistic "we were here and this photograph proves it" snapshot or color slide. But Hoover was hardly an anomaly, and other major dams also attracted a welter of amateur shutterbugs. At these structures tourists also sent postcards to friends and loved ones. But such postcards supplemented (they did not supplant) a desire to render a more personal connection to a site or vista. Snapshot culture had the ability to put people—usually friends or loved ones—front and center in a scene and, as this selection of snapshots highlights, the dam often served as backdrop for a personal portrait.

Postcard culture did not end in cataclysmic collapse. It slowly shrank as a distinctive feature of modern life, ceding ground to mass media as well as to am-

A summer day and an inviting expanse of clipped grass: relaxing in the shadow of the Wachusett Dam in northeast Massachusetts, circa 1960.

Something special is in the air as three women take time for a quick snapshot at Baltimore's Loch Raven Dam, circa 1960. A cotillion perhaps? Or maybe it's prom night.

In the early 1960s dams held great political potency, especially in California. This snapshot photo catches President John F. Kennedy shaking hands with Governor Edmond "Pat" Brown after JFK helicoptered in to dedicate the Bureau of Reclamation's Whiskeytown Dam on September 28, 1963. Within a decade, the environmental impact of dam building would acquire significant standing within America's political discourse. But in the weeks before his assassination in Dallas, JFK could still unequivocally celebrate Whiskeytown Dam for its contribution to natural resource conservation.

ateur photography, slide projectors, and Super 8 home movie footage. With the ascent of personal video cameras and recorders in the late 1970s, the creation and consumption of images became ever more integrated into America's social fabric. Digital technology of the twenty-first century, with every cell phone and PDA serving as a camera, has only further entrenched images into the social media that connect people through a flourishing Internet. A century ago there was no Internet. Instead, a burgeoning mail system provided a mechanism for the sharing of visual imagery on a scale that someone at the beginning of the nineteenth century—before the invention of photography—would have found astonishing, if not beyond belief. Picture postcards of the early twentieth century represented an amazing cultural construct, one involving a tremendous range of participants and devotees. But American society is far from static as it constantly evolves in response to technological and cultural forces. Picture postcards are embedded in this evolution and, no matter what the future may bring, their place in the history of America's cultural landscape is forever assured.

POSTSCRIPT

At midcentury monumental dams were but one among many landmarks and structures that people experienced and consumed through postcards, snapshots, and a welter of mass media. By the 1960s dams were still being built and expansive water control and supply systems remained an integral part of America's urbanizing culture. But in many ways large dams had done their job too well. They had become normalized. The cultural excitement attached to major New Deal projects held fast in the public imagination, but such excitement proved elusive for the next generation of dams. Scenic river valleys, white water rapids, towns, family farms, and American Indian homelands continued to disappear under rising reservoirs, making the idea of dams as wellsprings of unmitigated good ever harder to sustain. Citizens from many walks of life were coming to see that there was no free lunch—that for all the good they brought in terms of flood control, hydroelectric power, irrigated agriculture, and municipal water supply, dams took an undeniable toll on riparian landscapes and riverine environments. A question loomed ever larger as the decades passed: Were the benefits worth the cost?

Analysis of the anti-dam and dam removal movements of the latter twentieth century lies beyond the scope of this book. But it is clear that a protest culture fomented by the Vietnam War, in combination with the skeptical questioning of government incited by the Watergate scandal of the early 1970s, provided powerful impetus to environmentalists who saw in dams a malevolent threat to the natural order of the world. Opposition to dams certainly drew upon earlier precedents as dwindling populations of spawning fish provided an enduring flashpoint. But an ecological awareness that had largely been absent in the first half of the century came into ascendance. Now dams were to be

In the 1930s no one expressed concern that this stretch of the Colorado River
above Hoover Dam would be inundated by Lake Mead. After all, it holds seemingly
little scenic value when compared to the dramatic landscapes of the Grand Canyon
or the High Sierra. But riparian sandbars are actually of great import in propagating
native fish species such as the humpback chub. By the 1990s, the river environment
captured in this postcard from the 1920s closely matched the type of riverscape
that biologists were seeking to restore to the Grand Canyon.

decried not simply because of their assault on scenic vistas but also because
of how they disrupt the balance of nature. Native fish species of little value to
the commercial and sport fishing communities assumed a significance unimag-
inable only a few years before. The diminutive snail darter almost stopped
construction of the Tellico Dam in eastern Tennessee, and the previously un-
heralded humpback chub of the Colorado River brought renewed attention to
the effect of upstream dams upon the sandbars and fragile ecologies of Grand
Canyon National Park.

For the small-scale pastoral dams that were so much a part of rural and small
town life at the beginning of the twentieth century, much had changed as the
decades passed. Power from small mill dams meant little once the mills them-
selves had closed (perhaps to be demolished or, if lucky, transformed into retire-
ment homes, apartment lofts, or discount outlet malls). By the latter part of the

In recent years, the most common catalyst for dam removal has been a desire to reopen a stream to fish migration. And the most common impediment to reaching this goal is electric power generation. The age-old trade-off of fish versus power was resolved in favor of alewife, Atlantic salmon, and American shad in a historic decision by the Federal Energy Regulatory Commission (FERC), which authorized the removal of the Edwards Dam across the lower reach of the Kennebec River in Augusta, Maine. This stereo view, circa 1885, shows Edwards Dam when it was used to power local textile mills. Later it was adapted to generate about three thousand kilowatts of hydroelectric power. In its ruling that allowed for the dam's removal in 1999, the FERC determined that the public good of opening up the lower Kennebec River to fish migration outweighed the economic value of the dam's power generating capacity.

century, fossil fuel and nuclear power plants were built on a scale of hundreds of thousands kilowatts (sometimes more); the few hundred horsepower offered by many old mill dams represented scant more than a rounding error. Some communities still held an attachment to a relic mill dam in their midst, but the cultural ties spurred by work and economic sustenance disappeared. Often times any sense of why a dam had been built was lost as small towns and rural fields gave way to suburban tracts and satellite bedroom communities. Pastoral dams of a bygone era became stigmatized as "orphan dams," structures separated from history and community life.

In many ways, a sense of the pastoral migrated from once useful dams to a riparian environment replete with free-flowing streams, native fish stocks, and biodiverse wetlands. The catch phrase became "in-stream use," and structures designed to alter and control water flow became anathema to this ideal. In large part this new pastoral landscape—in which the "fish versus power" conflicts of the eighteenth century have been brought full circle—evokes a world that ex-

Among the most widely reported dam removal efforts involves the Elwha Dam, a
hydroelectric plant in Washington State's Olympia Peninsula completed in 1913.
In 1992 a federal law gave authority to the federal government to remove the dam.
But the question of how to handle sediment collected behind the structure delayed
action for almost twenty years. Specifically, scientists and engineers have needed to
devise a breaching scheme that will not release sediment in such a way that harm will
come to the very fish populations that the project seeks to protect. Breaching dams
might seem to be a simple proposition, but to do it properly can be quite complex

isted before humans set out to make use of it. But of course, left unstated in such
a narrative is that the building blocks of American civilization have simply been
outsourced to some other river valley (perhaps flooded out for a major municipal
water supply reservoir) or to a fossil fuel power plant spewing out carbon diox-
ide in someone else's backyard. There is no free lunch. Somewhere an account-
ing will be made.

Much changed in the tumultuous decades between the 1950s and the 1990s,
and dams, including their public perception, were affected by this cultural trans-
formation. One thing lost in recent years has been an appreciation of how, not so
long ago, dams were commonly perceived as markers—if not monuments—of a
civilizing culture, a culture focused on transforming nature's bounty to a larger
social purpose. Now, Americans take for granted a copious supply of hygienic

In the 1930s and 1940s dam building assumed the air of a promising future, something that could readily engage youthful energies and youthful interest. In this snapshot from the mid-1940s, a group of young adults in Northern California finds it perfectly natural to collect around a sign heralding Shasta Dam and its rising reservoir.

water at the kitchen tap and the ability to summon huge quantities of electricity at the flip of a switch. The source of this bounty largely remains obscured to the public, hidden by bureaucratic veils that only a public policy wonk might enjoy piercing. But make no mistake, the hydraulic infrastructure supporting American life in the twenty-first century maintains a scope and reach that has diminished only slightly, if at all, over the past fifty years. What has changed is a broad-based understanding of how ingrained this infrastructure is within the fabric of America's culture and political economy.

All this is not to say that dams are always good and that contemporary dam removal initiatives are necessarily ill-advised. Far from it. But we should remain aware of the extent that modern life in many cities and regions depends upon dams and the water control systems they sustain. So it was a hundred years ago when picture postcards swept across America's cultural landscape, and so it re-mains today.

By the late 1960s dam building had lost its panache, and, at least to many in a generation coming of age after the Great Depression had faded into history textbooks, it no longer seemed so new or exciting. Championed by Governor Edmund "Pat" Brown and approved by the California electorate in 1960, the California Water Project brought water development on a scale comparable with the greatest New Deal works. But with environmentalists bringing ever greater attention to the costs associated with dams, the cultural and symbolic appeal of the California Water Project as it approached completion in the late 1960s held little allure among young people. This prosaic snapshot of a not so young woman visiting the 735-feet-high Oroville Dam construction site stands in striking contrast to the foursome gathered around the Shasta Dam sign two decades before. From the 1960s on, dams occupied a far different place in America's cultural landscape than they held in the century's first fifty years.

NOTES

Chapter 1. Pastoral and Monumental

1. For one example among many, see Richard Gerstell, *American Shad in the Susquehanna River Basin: A Three-Hundred-Year History* (University Park: Pennsylvania University Press, 1998), 47–54. In Massachusetts, the *Fifty-Third Annual Report of the Commissioners of Fisheries and Game for the Year Ending November 30, 1918* (Boston: Wright and Potter, 1919), 173–78, included significant discussion of fishways in the state. Much attention was given to the lower Merrimack River and an 1865 photograph of the fishway at Lawrence Dam appears opposite page 168.

2. For more on the Hetch Hetchy controversy, see Holway R. Jones, *John Muir and the Sierra Club: The Battle for Yosemite* (San Francisco: Sierra Club, 1965); Kendrick A. Clements, "Politics and the Park: San Francisco's Fight for Hetch Hetchy, 1908–1913," *Pacific Historical Review* 48 (1979): 185–215; and Robert Richter, *The Battle over Hetch Hetchy: America's Most Controversial Dam and the Birth of Modern Environmentalism* (New York: Oxford University Press, 2005).

3. George Miller and Dorothy Miller, *Picture Postcards in the United States, 1893–1918* (New York: Clarkson N. Potter, 1976), 22, 26.

4. Norman D. Stevens, ed., *Postcards in the Library: Invaluable Visual Resources* (New York: Haworth Press, 1995), frontispiece. The quotation is from Professor Bill Katz, School of Information Science and Policy, State University of New York/Albany.

5. Norman D. Stevens, "Welcome to the World of Postcards," in *Postcards in the Library*, ed. Norman D. Stevens (New York: Haworth Press, 1995), 3.

6. Examples of generally descriptive postcard books include Gary L. Doster, *From Abbeville to Zebulon: Early Post Card Views of Georgia* (Athens: University of Georgia Press, 1991); Mary Norton Kratt and Mary Manning Boyer, *Remembering Charlotte: Postcards from a New South City, 1905–1950* (Chapel Hill: University of North Carolina Press, 2000); Luc Van Malderen, *American Architecture: A Vintage Postcard Collection* (New York: Images Publishing, 2000). For a book focused on postcards produced by one company, see J. L. Lowe and B. Papell, *Detroit Publishing Company Collector's Guide* (Newton Square, PA: Deltiologists of America, 1975).

7. An example of such a theme-based postcard book is Roger Grant's *Railroad Postcards in the Age of Steam* (Iowa City: University of Iowa Press, 1994).

8. For example, see Christraud M. Geary and Virginia-Lee Webb, *Delivering Views: Distant Cultures in Early Postcards* (Washington, D.C.: Smithsonian Institution Press, 1998); James R. Ryan, *Picturing Empire: Photography and Visualization of the British Empire* (Chicago: University of Chicago Press, 1997); Joanna C. Scherer, "The Photographic Document: Photographs as Primary Data in Anthropological Enquiry," in *Anthropology and Photography, 1860–1920*, ed. Elizabeth Edwards (New Haven: Yale University Press, 1992), 32–41; Joanna C. Scherer, "You Can't Believe Your Eyes: Inaccuracies in Photographs of North American Indians," *Studies in the Anthropology of Visual Communication* 2 (1975): 67–79. A similar type of analysis of images appearing within the popular journal *National Geographic* is available in Catherine A. Lutz and Jane L. Collins,

Reading National Geographic (Chicago: University of Chicago Press, 1993). Japanese colonial rule over Taiwan, and the way that postcards reflect the interests of the Japanese colonial regime, is analyzed in Paul D. Barclay, "Peddling Postcards and Selling Empire: Image-Making in Taiwan under Japanese Colonial Rule," *Japanese Studies* 30 (May 2010): 81–110.

9. Some readers might suspect that the very act of making postcards of dams was controlled by a few manufacturers possessed of an agenda to manipulate public opinion and perceptions, an agenda that (for some reason) sought to promote an acceptance of dam technology otherwise foreign to an unaware and gullible public. In response to such a possible critique, the author simply asks readers to consider evidence presented in chapter 2, which illustrates the diffused process of postcard production and the way distribution relied upon a wide range of participants from the retail level up. In this sense, the "postcard craze" of the early twentieth century represented the attributes of a popular culture in which the impetus for growth and expansion germinated within a broad-based sector of the American population. In contrast, it did not represent a mass-culture phenomena in which the actions (and reactions) of the public were largely guided and directed by a few institutions or corporations. As the years passed by, the novelty of postcards waned and their cultural import as a medium of communication evolved. And by the mid-twentieth century, postcard production had certainly become more centrally controlled, with a few large manufacturers playing a major role in the industry. But even at midcentury, many regional manufacturers flourished and cards were largely produced in response to orders placed by local businesses and distributors. Dam postcards remained a part of the "mix" of local views produced by postcard companies, and, although the rich diversity of views available during the golden age of postcards (1905–1915) gradually diminished in succeeding decades, postcards retained attributes of a popular (as opposed to mass) culture phenomena through midcentury. Should someone wish to construct a cultural narrative based upon a reading of dam postcards that differs from the one presented in this book, the author says "go to it." More, not less, discussion of dams and their place in American society is to be encouraged. Note: All images in this book were digitally scanned by the author. Adjustments were made in terms of brightness and contrast and at times the images were cropped to enhance readability; in addition, digital techniques were used on occasion to reduce printing imperfections and limit the visual impact of surface damage suffered by the images over the past one hundred years.

10. Lest there be any question, no claims are made that the particular images in this book are somehow special in the context of American history or American art. At times, books about photographs take pains to stress the unique character of the images they analyze in justifying why particular photographs deserve historical study. A good example of this is Alan Tractenburg's *Reading American Photographs: Images as History, Matthew Brady to Walker Evans* (New York: Hill and Wang, 1989), where the reader is advised that, only because the "American photographs" presented are so special, is it possible for them bear the weight of Tractenburg's musings about their relationship to (and revelations about) American culture. In contrast, *Pastoral and Monumental* projects no notion that the images presented are of unique artistic or historical merit. The power and meaning of this book derives more from the fact that the images it analyzes are *not* special and are actually interesting because they are so ordinary and—at least in comparison to images created by artist-photographers such as Mathew Brady or Walker Evans—seemingly unremarkable. In essence, it is their ordinariness that makes them special.

11. Susan Sontag, *On Photography* (New York: Dell Publishing Company, 1977), 22–23.

12. Errol Morris, *Believing Is Seeing: Observations on the Mysteries of Photography* (New York: Penguin, 2011), xxii. Morris is perhaps best known for his documentary film *The Thin Blue Line* in 1988 and his Academy Award–winning *The Fog of War: Eleven Lessons from the Life of Robert S. McNamara*, released in 2003.

13. The tenuous nature of our ability to know the past is provocatively and instructively explored in Murray G. Murphey, *Truth and History* (Albany: State University of New York Press, 2009).

14. Roy Flukinger interview in Morris, *Believing Is Seeing*, 70.

15. Leo Marx, *The Machine in the Garden: Technology and the Pastoral Ideal* (New York: Oxford University Press, 1964), 3, 23. Pastoralism is also prominently treated in a literary context by Henry Nash Smith in *Virgin Land: The American West as Symbol and Myth* (Cambridge: Harvard University Press, 1950). For a recent exploration into pastoralism and the ways that it is has been used to serve a variety of commercial, economic, and social interests in the late nineteenth and twentieth centuries see Torben Huus Larsen, *Enduring Pastoral: Recycling the Middle Landscape Ideal in the Middle Tennessee Valley* (New York: Rodophi Press, 2011).

16. Frederick H. Newell, "Irrigation: An Informal Discussion," *Transactions of the American Society of Civil Engineers* 62 (1909): 13.

17. The terror that can accompany public fascination with large-scale engineering works is discussed in David Nye, *American Technological Sublime* (Cambridge: MIT Press, 1994). Interestingly, while Nye directs some attention to dams, water control technology comprises a relatively minor focus of his analysis.

18. See John R. Freeman to A. P. Davis, September 26, 1912, quoted in Donald C. Jackson, *Building the Ultimate Dam: John S. Eastwood and the Control of Water in the American West* (Norman: Oklahoma University Press, 2005), 124.

19. Freeman's career is described in his profession obituary "John Ripley Freeman," *Transactions of the American Society of Civil Engineers* 98 (1933): 1471–76. He graduated from the Massachusetts Institute of Technology in 1876 and for more than forty years served as a member of the MIT board of trustees (formally known as the MIT Corporation). Freeman played a major role in the expansion of New York City's water supply and served as consulting engineer for the city's Catskill aqueduct system from 1905 until his death in 1932.

20. The ecological importance of beaver dams in creating biodiverse wetlands is nicely synopsized in Alice Outwater, *Water: A Natural History* (New York: Basic Books, 1997), 3–34.

21. For example, the Heavy Construction Engineering Association is publicly known as the Beavers and features www.thebeavers.org as its website. Membership in the association, founded in 1955, is oriented toward "corporations, companies, partnerships and individuals who have been or are engaged in the dam and/or heavy engineering construction industry in the United States, and who have actively participated in important heavy engineering or major dam construction." Over two thousand people attended the Beavers Fifty-fifth Annual Awards Dinner in Los Angeles in January 2010.

22. Edward Wegmann, *The Design and Construction of Dams* (New York: John Wiley, 1911), 498–500; Wegmann quotes drawn from Enos Mills, "The Little Conservationists," *Saturday Evening Post*, September 24, 1910.

23. Quotation taken from *Huntington Lake* pamphlet published by the San Joaquin and Eastern Railroad Company, circa 1925; pamphlet in author's collection. This railway had been built in 1912 to deliver supplies (cement, penstocks, turbines, and so on) during the first phase of construction at Big Creek. For a good overview history of the Big Creek system, see David Redinger, *The Story of Big Creek* (Los Angeles: Angeles Press, 1949). Also see Jackson, *Building the Ultimate Dam*.

24. Carol Sheriff, *The Artificial River: The Erie Canal and the Paradox of Progress, 1817–1862* (New York: Hill and Wang, 1996), especially chapter two, "The Triumph of Art Over Nature," 27–51.

25. William Cronon, *Nature's Metropolis: Chicago and the Great West* (New York: W. W. Norton, 1991), 56–62, 263–69.

26. See David McCullough, *The Johnstown Flood* (New York: Simon and Schuster, 1968); Carl Degan and Paula Degan, *The Johnstown Flood of 1889: The Tragedy of the Conemaugh* (Fort Washington, PA: Eastern National, 1984); and Michael McGough, *The 1889 Flood in Johnstown, Pennsylvania* (Gettysburg, PA: Thomas Publications, 2002), for good overviews of the collapse of the South Fork Dam. For an especially interesting and well-illustrated treatment of the disaster in a socioeconomic context, see Michael McGough, *The Club and the 1889 Flood in Johnstown, Pennsylvania* (Fort Washington, PA: Eastern National, 2006).

Chapter 2. Postcard Culture

1. David M. Henkin, *The Postal Age: The Emergence of Modern Communications in Nineteenth Century America* (Chicago: University of Chicago Press, 2006), 5.

2. The overland delivery of written messages dates to ancient times with, most famously, the Roman Empire making use of roads to administratively bind together far-flung provinces. As the Roman Empire declined so too did its postal system, but, by at least the fifteenth century, political and commercial demands in Europe had fostered both state-sponsored mail systems and private mail initiatives. Out of this environment, the basic structure of the British postal system evolved through the seventeenth and eighteenth centuries. British society endorsed the public policy that government (perhaps in concert with some private contractors) should operate an expansive mail system, and it was this concept that British colonists brought to North America. The term *postal* derives from the Roman *posts* established along major roads to support messenger travel. *Mail* derives from the use of chain metal bags in late medieval Europe to protect messages from illicit access during overland travel. See Wayne E. Fuller, *The American Mail: Enlarger of the Common Life* (Chicago: University of Chicago Press, 1972), 1–11. British use of postmarking is noted in Carl H. Scheele, *A Short History of the Mail Service* (Washington, D.C.: Smithsonian Institution Press, 1970), 70.

3. Fuller, *American Mail*, 49. The early U.S. Post Service is also well described in Richard J. John, *Spreading the News: The American Postal System from Franklin to Morse* (Cambridge: Harvard University Press, 1998).

4. For example, a single sheet letter sent less than thirty miles in 1820 would require a postage of six cents. But if sent, say, from New York City to New Orleans (or to any destination more than four hundred miles away) it would cost twenty-five cents. See Scheele, *A Short History of the Mail Service*, 66; Fuller, *The American Mail*, 43. Shipping rates for all kinds of goods dropped significantly with the advent of canals, steamboats, and railroads, and it appeared patently unfair that, in the early 1840s, a barrel of flour could be sent from New York City to Troy, New York for twelve and a half cents while postage for a single sheet letter between the two cities came to eighteen and a half cents (Fuller, *The American Mail*, 61).

5. Under the rate structure of 1851, letters sent more than three thousand miles (e.g., from New York to California) required ten cents postage, and this remained in effect until 1863; if letters sent less than three thousand miles were not prepaid then postage was five cents. For over two decades after 1853 flat-rate postage for all domestic letters held at three cents; the rate dropped to two cents in 1885 and (except for a brief period during the First World War) remained there until raised to three cents in the 1930s. For a good overview of postage stamp and postage rate evolution see Scheele, *A Short History of the Mail Service*, 73–77, 91, 105–6, 184.

6. The social and cultural importance of the shift to a "flat-rate" postage regime is stressed in John, *Spreading the News*. In his landmark history of the California Gold Rush, J. S. Holliday makes eloquent use of letters sent to and from California by both "argonauts" and their loved ones back east. Perhaps most remarkably, letters sent from the East Coast with no more than the recipient's name and the address "Sutters Fort California" were often successfully delivered to remote Sierra Nevada mining camps. See J. S. Holliday, *The World Rushed In: The California Gold Rush Experience* (New York: Simon and Schuster, 1981).

7. The number of letters passing through the U.S. Postal Service experienced explosive growth, from about 27 million in 1840 to over 160 million twenty years later. See Henkin, *The Postal Age*, 3, 5.

8. Quote from ibid., 3.

9. The relationship of the postal system to the Civil War is discussed in ibid., 137–47; and in Scheele, *A Short History of the Mail Service*, 86–90.

10. Mail cars were utilized between Philadelphia and Washington, D.C., as early as 1837; formal establishment of RPOs came in 1864; see Scheele, *A Short History of the Mail Service*, 92–97.

11. Richard R. John, *Network Nation: Inventing American Telecommunications* (Cambridge: Belknap Press of Harvard University Press, 2010). John observes that "the telegraph had not been

designed to accommodate the entire population. . . . Prior to 1910 the telegraph had, with a few minor exceptions, remained a specialty service for an exclusive clientele of merchants, lawmakers, and journalists" (6).

12. The evolution of free delivery, both urban and rural, is described in Fuller, *The American Mail*, 71–78; and Scheele, *A Short History of the Mail Service*, 66, 91–92, 114–18.

13. Lipman's Postal Card is discussed in Howard Woody, "International Postcards: Their History, Production, and Distribution (Circa 1895 to 1915)" in *Delivering Views: Distant Cultures in Early Postcards*, ed. Christraud M. Geary and Virginia-Lee Webb (Washington, D.C.: Smithsonian Institution Press, 1998), 14.

14. Scheele, *A Short History of the Mail Service*, 97.

15. John Wood, ed., *America and the Daguerreotype* (Iowa City: University of Iowa Press, 1991).

16. Fox Talbot's calotype technology overcame limitations of daguerreotypes and tintypes by creating thin paper negatives that could be used produce multiple prints of a specific view. Although early calotypes suffered from a lack of clarity (one of the reasons that daguerreotypes achieved early dominance), the technology pointed toward a photographic future in which specific images could be reproduced in large quantities. Through the 1840s and early 1850s, experimenters and practitioners advanced the art of photography through a multitude of processes and techniques. The most important of these was Scott Archer's wet plate collodion process that allowed photographers to record a negative image on a clear glass plate; glass plate negatives subsequently allowed for many clear, precise copies to be printed on photo-sensitized paper. In addition, the collodion process required exposure times of only a few seconds (give or take), rather than the few to several minutes necessary for early calotypes and daguerreotypes. A plethora of books detail the early history of photography, including Alma Davenport, *History of Photography: An Overview* (Boston: Focal Press, 1991); Michael Frizot, *A New History of Photography* (New York: Koneman, 1998); Beaumont Newhall, *The History of Photography: From 1839 to the Present*, 5th ed. (New York: Museum of Modern Art, 1982); Reese V. Jenkins, *Images and Enterprise: Technology and the American Photographic Industry* (Baltimore: Johns Hopkins University Press, 1975); and Laurent Roosens and Luc Salu, *History of Photography: A Bibliography of Books* (London: Mansell, 1987); tintype technology and practice is described in Steven Kasher, *America and the Tintype* (New York: ICP/Steidl, 2008).

17. The cartes de visite and cabinet view trade is described and illustrated in William C. Darrah, *Cartes de Visite in Nineteenth Century Photography* (Gettysburg: by the author, 1981).

18. The origin and evolution of the stereo view industry is described and illustrated in William C. Darrah, *The World of Stereographs*, 2nd ed. (New York: Land Yacht Press, 1998).

19. For discussion of stereo views after 1900, see Darrah, *World of Stereographs*, 47–52.

20. Barry Shank, *A Token of My Affection: Greeting Cards and American Business Culture* (New York: Columbia University Press, 2004).

21. George and Dorothy Miller, *Picture Postcards in the United States, 1893–1918* (New York: Clarkson N. Potter, 1976), 1–14. Geary and Webb, *Delivering Views*, 2, affirms that the postcard industry "grew out of a fortuitous intersection of several technological innovations and social advancements. . . . Nineteenth-century postal regulations changed to accommodate the mailing of a non-letter format . . . [, and] the development of the picture postcard also depended upon two major inventions, photography and printing processes such as collotype, color lithographs, and the use of halftones."

22. Miller and Miller, *Picture Postcards in the United States*, 22, 26, reports that "official United States Post Office figures for the year ending June 30, 1908 cite 667,777,798 postcards mailed in this country. By 1913 the total in the country had increased to over 968,000,000, and by this date the craze was reportedly on the decline. . . . More than a million postcards passed through the Baltimore post office during the Christmas 1909 season."

23. Scores of domestic printers and postcard companies served the American market. Some of the most prominent include Hugh C. Leighton of Portland, Maine; Eastern Illustrating and Publishing Company of Belfast, Maine; Tichnor Company of Boston; Rotograph

Company of New York City; Albertype Company of Brooklyn; H. Beach of Remson, New York; Elizabeth Novelty Company, Elizabeth, New Jersey; Curt Teich Company of Chicago; Auburn Postcard Compnay of Auburn, Indiana; Detroit Publishing Company of Detroit, Michigan; E. C. Kropp of Milwaukee, Wisconsin; W. Cline of Tennessee; Pacific Novelty Company of Portland, Oregon; E. Mitchell Company of San Francisco; Frasher's Foto Company of Pomona, California; and Eastman Company of California. Although based in the United States, many American firms (including those listed above) contracted with German printing companies prior to the start of the First World War. Hundreds of local photographers also printed cards for local distribution and for individual customers. The website for the Metropolitan Postcard Club of New York City provides a remarkably detailed listing of postcard printers and publishers active during the golden age and later. Scholars will particularly appreciate how postcard views are used to illustrate the individual entries. See www.metropostcard.com/metropcpublishers.html.

24. The website www.pdxhistory.com provides a history of postcards in the Pacific Northwest and includes an interior view of Patton's Post Card Hall in Salem, Oregon, circa 1908, showing what a store specifically oriented to the postcard trade looked like (see www.pdxhistory.com /html/post_card_history.html).

25. For a good overview of the real photo postcard trade, see Robert Bogdan and Todd Weseloh, *Real Photo Postcard Guide: The People's Photography* (Syracuse: Syracuse University Press, 2006). See also Rosamond B. Vaule, *As We Were: American Photographic Postcards, 1905–1930* (Boston: David R. Godine, 2004); and Hal Morgan and Andreas Brow, *Prairie Fires and Paper Moons: The American Photographic Postcard* (Boston: David R. Godine, 1981).

26. Bogden and Wesolah, *Real Photo Postcard Guide*, 218, reports that Kodak, operating under the brands Velox, Azo, Solio Artura, Aristo, and Kodak, controlled 69 percent of the market for real photo postcard stock in 1908. Competing brands included Defender, Kruxo, and Cyko. An excellent online reference to the many companies involved in manufacturing real photo cardstock is available through the website of Playle's Online Auction (http://www.playle.com/realphoto/). This site includes scans illustrating the variety of ways that each company printed their identifying logo on the back of cards. Specific features of these identifying logos changed over the years, offering historians a guide to when a particular card might have been printed.

27. Miller and Miller, *Picture Postcards in the United States*, 27–32 demarks 1909 as "the turning point in the postcard craze" and also points to increased tariffs of German cards as an impetus for a gradual slowing of the fad. But while the postcard craze may have faded in intensity by 1915, the place of postcards in American life had become firmly entrenched as a means of social and commercial communication. Shank, *A Token of My Affection*, 181–82, 282, notes the impact of the tariff and also credits a saturated market as a factor in the demise of a broadbased postcard industry.

28. Walker Evans, "Main Street Looking North From Courthouse Square," *Fortune* 37 (May 1948): 102–6.

Chapter 7. Fish and Environment

1. John Muir, *The Yosemite* (New York: Century Company, 1912), 261–62.

Chapter 8. Snapshot Culture

1. Walker Evans, "Main Street Looking North From Courthouse Square," *Fortune* 37 (May 1948): 102–6.

SELECTED BIBLIOGRAPHY

This book coalesced over more than three decades of reading about, ruminating upon, and looking at dams and vintage postcards. The essential sources underlying this book are the actual postcards and graphic images reproduced as illustrations. But these images (along with thousands of their kin that could not make it into the book) can only go so far in explicating the ways that dams and postcards are intertwined with American life and culture. For readers wishing to embark on their own forays into this history, the following sources, organized on a chapter-by-chapter basis, provide a good starting point. Annotated notes and a select bibliography are provided for the first two chapters. For the other chapters, a select bibliography of instructive books and articles documents the topic covered. These groupings of sources are not comprehensive or encyclopedic, but they do include many engaging books and articles—generally accessible through a good library associated with the Interlibrary Loan service or online databases—that can enhance a reader's understanding of dam and postcard history.

Some of the references focus on specific designs, structures, or events and are drawn from historic source material (such as a book on dam engineering from the 1910s, an article on the impact of dam construction on migrating fish published in a 1940s sportsman magazine, or a historical treatise on a tragic dam disaster). Some of the references are to recent academic books on environmental history or on the relationship of photography to the social sciences and to how seemingly objective knowledge is socially constructed. Others are scholarly treatises detailing how various dam technologies have evolved over time. Despite the varied subject matter—and the wide range of approaches taken by various authors—these multifaceted sources offer insights into how dams interface with society and how Americans have come to appreciate both the value of and the costs incurred by water control technologies.

Chapter 1. Pastoral and Monumental

Allen, James, ed. *Without Sanctuary: Lynching Photography in America*. New York: Twin Palms Publishing, 2000.

Barrett, Rosa, and Stacy McCarroll Cutshaw. *In the Vernacular: Photography of the Everyday*. Seattle: University of Washington Press, 2008.

Batchen, Geoffrey. "Vernacular Photographies." *History of Photography* 24 (Autumn 2000): 262–71.

Bryson, Norman, et al., eds. *Visual Culture: Images and Interpretations.* Hanover: Wesleyan University Press and the University Press of New England, 1994.

Cartwright, Lisa, and Marita Sturken. *Practices of Looking: An Introduction to Visual Culture.* New York: Oxford University Press, 2001.

Ciarlo, David. *Advertising Empire: Race and Visual Culture in Imperial Germany.* Cambridge: Harvard University Press, 2011.

Flinn, Alfred D. "Architecture of Kensico Dam." *Engineering News* 74 (September 2, 1913): 433–36.

Ford, Colin, ed. *The Story of Popular Photography.* Pomfret, VT: Trafalgar Square Publishing, 1889.

Goldberg, Geoffrey H., with E. Ashley Rooney, ed. *Bridges: A Postcard History.* Atglen, PA.: Schiffer Publishing Ltd., 2011.

Hirsch, Marianne. *Family Frames: Photography, Narrative, and Postmemory.* Cambridge: Harvard University Press, 1997.

Johnson, Robert Flynn. *Anonymous Enigmatic Images from Unknown Photographers.* New York: Thames and Hudson, 2004.

Katz, William. "Frontispiece." In Stevens, *Postcards in the Library.*

Kasson, John F. *Civilizing the Machine: Technology and Republican Values in America, 1776–1900.* New York: Penguin Books, 1976.

Kelsey, Robin, and Blake Stimson. *The Meaning of Photography.* Williamstown: Sterling and Francine Art Museum, 2008.

Lemagney, Jean-Claude, and Abdre Rouille, eds. *A History of Photography: Social and Cultural Perspectives.* New York: Cambridge University Press, 1987.

Marien, Mary Warner. *Photography: A Cultural History.* New York: Harry S. Abrams Inc., 2002.

Marx, Leo. *The Machine in the Garden: Technology and the Pastoral Ideal in America.* New York: Oxford University Press, 1964.

Newell, Frederick H. "Irrigation: An Informal Discussion." *Transactions of the American Society of Civil Engineers* 62 (1909): 13.

Nye, David E. *American Technological Sublime.* Cambridge: MIT Press, 1994.

———. *Image Worlds.* Cambridge: MIT Press, 1985.

———. *Narratives and Spaces: Technology and the Construction of American Culture.* New York: Columbia University Press, 1997.

McCullough, David G. *The Johnstown Flood.* New York: Simon and Schuster, 1968.

Miller, George, and Dorothy Miller. *Picture Postcards in the United States 1893–1918.* New York: Clarkson N. Potter, 1976.

Mills, Enos. *In Beaver World.* New York: Houghton Mifflin, 1913.

Mirzeoff, Nicholas, ed. *The Visual Culture Reader.* New York: Routledge Press, 1998.

Mitchell, W. J. T. *What Do Pictures Want: The Lives and Loves of Images.* Chicago: University of Chicago Press, 2005.

Morris, Errol. *Believing Is Seeing: Observations on the Mysteries of Photography.* New York: Penguin, 2011.

Rickards, Maurice. *The Encyclopedia of Ephemera: A Guide to the Fragmentary Documents of Everyday Life for the Collector, Curator, and Historian.* New York: Routledge, 2000.

Ruby, Jay. "Images of Rural America: View Photographs and Picture Postcards." *History of Photography* 12 (October–December 1988): 327–43.

Schonauer, David. "Triumph of Vernacular." *American Photo* 11 (September–October 2000): 20.

Smith, Henry Nash. *Virgin Land: The American West as Symbol and Myth.* Cambridge: Harvard University Press, 1952.

Sontag, Susan. *On Photography.* New York: Dell Publishing, 1973.

Stevens, Norman, ed. *Postcards in the Library: Invaluable Visual Resources.* New York: Haworth Press, 1995.

———. "Welcome to the World of Postcards." In Stevens, *Postcards in the Library*, 1–4.

Swartz, Joan M., and James Ryan. *Picturing Place: Photography and the Geographical Imagination.* New York: I. B. Tauris, 2003.

Upton, John. *The Photograph as Artifice.* New York: Independent Curators Inc., 1979.

Wegmann, Edward. *The Design and Construction of Dams.* 6th ed. New York: John Wiley and Sons, 1911.

White, Hayden. *The Content of Form: Narrative Discourse and Historical Representative.* Balitmore: Johns Hopkins University Press, 1987.

Chapter 2. Postcard Culture

Batchen, Geoffrey. *Forget Me Not: Photography and Remembrance.* New York: Princeton Architectural Press, 2004.

Bogdan, Robert. *Exposing the Wilderness: Early Twentieth-Century Adirondack Postcard Photographers.* Syracuse: Syracuse University Press, 1999.

Bogdan, Robert, and Todd Weseloh. *Real Photo Postcard Guide: The People's Photography.* Syracuse: Syracuse University Press, 2006.

Chien, David. *About 85 Years Ago: Photo Postcards from America, 1907–1920.* Niwot, CO: Roberts Rinehart Publishing, 1997.

Darrah, William C. *Cartes de Visite in Nineteenth Century Photography.* Gettysburg: By the author, 1981.

———. *The World of Stereographs.* 2nd ed. New York: Land Yacht Press, 1998.

Davenport, Alma. *History of Photography: An Overview.* Boston: Focal Press, 1991.

Davis, Allen F. *Postcards from Vermont: A Social History, 1905–1945.* Hanover: University Press of New England, 2002.

Doster, Gary L. *From Abbeville to Zebulon: Early Post Card Views of Georgia.* Athens: University of Georgia Press, 1991.

Dotterer, Steven, and Galen Cranz. "The Picture Postcard: Its Development and Role in American Urbanization." *Journal of American Culture* 5 (1982): 44–50.

Edwards, Elizabeth, ed. *Anthropology and Photography, 1860–1920.* New Haven: Yale University Press, 1992.

Brown, Elspeth H. *The Corporate Eye: Photography and the Rationalization of American Commercial Culture, 1884–1929.* Baltimore: Johns Hopkins University Press, 2005.

Evans, Eric J., and Jeffrey Richards. *Social History of Britain in Postcards, 1870–1930.* London: Longman, 1980.

Fuller, Wayne E. *The American Mail: Enlarger of the Common Life.* Chicago: University of Chicago Press, 1972.

Frizot, Michael. *A New History of Photography.* New York: Koneman, 1998.

Geary, Christraud M., and Virginia-Lee Webb. *Delivering Views: Distant Cultures in Early Postcards.* Washington, D.C.: Smithsonian Institution Press, 1998.

Grant, Roger. *Railroad Postcards in the Age of Steam.* Iowa City: University of Iowa Press, 1994.

Gross, Larry, ed. *Studying Visual Communication.* Philadelphia: University of Pennsylvania Press. 1975.

Henkin, David M. *The Postal Age: The Emergence of Modern Communications in Nineteenth-Century America.* Chicago: University of Chicago Press, 2006.

Jackson, Donald C. "The Pastoral, The Monumental, and What Lies In-Between: Images of Dams and the Riparian Landscape, 1900–1960." In *Water in History: The World of Water,* edited by Terje Tvedt and Terje Oestigard, 323–48. London: I. B. Tauris, 2006.

Jenkins, Reese V. *Images and Enterprise: Technology and the American Photographic Industry.* Baltimore: Johns Hopkins University Press, 1975.

John, Richard J. *Spreading the News: The American Postal System from Franklin to Morse.* Cambridge: Harvard University Press, 1995.

Kasher, Steven. *America and the Tintype.* New York: ICP/Steidl, 2008.

Krat, Mary, and Mary Manning Boyer. *Remembering Charlotte: Postcards from a New South City, 1905–1950.* Chapel Hill: University of North Carolina Press, 2000.

Lowe, J. L., and B. Papell. *Detroit Publishing Company Collector's Guide.* Newton Square, PA: Deltiologists of America, 1975.

Lutz, Catherine A., and Jane L. Collins. *Reading National Geographic.* Chicago: University of Chicago Press, 1993.

Mace, Henry O. *Collector's Guide to Early Photographs.* 2nd ed. New York: Krause, 1999.

Meikle, Jeffrey. "A Paper Atlantis: Postcards, Mass Art, and the American Scene." *Journal of Design History* 13 (2000): 267–86.

Morgan, Hal, and Andreas Brown. *Prairie Fires and Paper Moons: The American Photographic Postcard.* Boston: David R. Godine, 1981.

Newhall, Beaumont. *The History of Photography: From 1839 to the Present.* 5th ed. New York: Museum of Modern Art, 1982.

Phillips, Tom. *The Postcard Century: 2000 Cards and Their Messages.* New York: Thames and Hudson, 2000.

Rickards, Maurice. *Collecting Printed Ephemera.* Oxford: Phaidon/Christie's, 1988.

Roosens, Laurent, and Luc Salu. *History of Photography: A Bibliography of Books.* London: Mansell, 1987.

Ryan, James R. *Picturing Empire: Photography and Visualization of the British Empire.* Chicago: University of Chicago Press, 1997.

Ryan, D. B. *Picture Postcards in the United States, 1893–1918.* New York: C. N. Potter, 1982.

Scheele, Carl H. *A Short History of the Mail Service.* Washington, D.C.: Smithsonian Institution Press, 1970.

Scherer, Joanna C. "The Photographic Document: Photographs as Primary Data in Anthropological Enquiry." In Edwards, *Anthropology and Photography, 1860–1920,* 32–41.

———. "You Can't Believe Your Eyes: Inaccuracies in Photographs of North American Indians." *Studies in the Anthropology of Visual Communication* 2 (1975): 67–79.

Shank, Barry. *A Token of My Affection: Greeting Cards and American Business Culture.* New York: Columbia University Press, 2006.

Stewart, Susan. *On Longing: Narratives of the Miniature, the Gigantic, the Souvenir, the Collection.* Baltimore: Johns Hopkins University Press, 1984.

Van Malderen, Luc. *American Architecture: A Vintage Postcard Collection.* New York: Images Publishing, 2000.

Taureg, Martin, and Jay Ruby, eds. *Visual Explorations of the World.* Aachen: Herodot, 1987.

Tractenberg, Alan. *Reading American Photographs.* New York: Hill and Wang, 1989.

Vaule, Rosamond P. *As We Were: American Photographic Postcards, 1905–1930.* Boston: David R. Godine, 2004.

Wolfe, Laettia. *Real Photo Postcards: Unbelievable Images from the Collection Harvey Tulcensky.* New York: Princeton Architectural Press, 2005.

Williams, Gardiner, and Lewis Ayres. "A Municipal Hydroelectric Plant." *Engineering Record* 65 (March 2, 1912): 230–31.

Wood, John, ed. *America and the Daguerreotype.* Iowa City: University of Iowa Press, 1991.

Staff, Frank. *The Picture Postcard and Its Origins.* New York: Praeger, 1966.

Woody, Howard. "International Postcards: Their History, Production, and Distribution (Circa 1895 to 1915)." In Geary and Webb, *Delivering Views,* 13–46.

Wright, Terence. "Photography: Theories of Realism and Convention." In Edwards, *Anthropology and Photography, 1860–1920,* 18–31.

Chapter 3. Materials, Design, and Construction

Bassell, Burr. *Earth Dams: A Study*. 2nd ed. New York: Engineering News, 1907.

Binnie, Geoffrey M. *Early Victorian Water Engineers*. London: Telford, 1981.

Courtney, C. F. *Masonry Dams from Inception to Completion*. London: Crosby Lockwood and Son, 1897.

Creager, William. *Engineering for Masonry Dams*. New York: John Wiley and Sons, 1917.

"Dam Building at 7 Cents a Yard." *Engineering Record* 70 (July 11, 1914): 46.

Garcia-Diego, J. A. "Old Dams in Extramadura." *History of Technology* 2 (1977): 95–124.

Harrison, Charles L. "Provision for Uplift and Ice Pressure in Designing Masonry Dams." *Transactions of the American Society of Civil Engineers* 65 (1912): 142–225.

Jackson, Donald C. *Building the Ultimate Dam: John S. Eastwood and the Control of Water in the American West*. Lawrence: University Press of Kansas, 1995.

Jackson, Donald C., ed. *Dams: Studies in the History of Civil Engineering*. Aldershot, England: Ashgate/Variorum Press, 1997.

———. "Structural Art: John S. Eastwood and the Multiple Arch Dam." *Engineering History and Heritage Journal, Proceedings of the Institution of Civil Engineers* 162 (August 2009): 137–46.

Jacob, Arthur. *The Designing and Construction of Storage Reservoirs*. New York: D. Van Nostrand, 1904.

Jakobsen, B. F. "Volume Relation of Constant Angle Arch Dams and Gravity Dams." *Engineering and Contracting* 65 (December 8, 1920): 554–57.

Jorgensen, Lars. "The Constant-Angle Arch Dam." *Transactions of the American Society of Civil Engineers* 78 (1915): 685–733.

Justin, Joel. *Earth Dam Projects*. New York: John Wiley, 1932.

Kollgaard, Eric B., and Wallace L. Chadwick, eds. *Development of Dam Engineering in the United States*. New York: Pergamon Press, 1988.

"The La Prele Dam: A 130-Ft Hollow Reinforced Concrete Dam Near Douglas, Wyoming." *Engineering News* 64 (November 10, 1910): 499–501.

Leffel, James. *Leffel's Construction of Mill Dams*. Springfield, Ohio: by the author, 1881. Reprint, Park Ridge, NJ: Noyes Press, 1972.

Lesley, Robert W. *History of the Portland Cement Industry in the United States*. Chicago: International Trade Press, 1924.

Macy, Christine. *Dams*. New York: W. W. Norton, 2009.

Molloy, Peter. "Nineteenth Century Hydropower: Design and Construction of Lawrence Dam, 1845–1848." *Winterthur Portfolio* 15 (Winter 1980): 315–43.

Moore, George Holmes. "Neglected First Principles of Masonry Dam Design." *Engineering News* 70 (September 4, 1913): 442–45.

Newlon, Howard, ed. *A Selection of Historic American Papers on Concrete, 1876–1976*. Detroit: American Concrete Institute, 1976.

"Opposition to Concrete Chutes." *Engineering News* 74 (September 2, 1915): 468.

Schnitter, Nicholas J. *A History of Dams: The Useful Pyramids*. Rotterdam, Netherlands: A. A. Balkemas, 1994.

———. "The Evolution of the Arch Dam." *Water Power and Dam Construction* 19 (October–November 1976): 19–21, 34–40.

———. "The Evolution of Buttress Dams." *Water Power and Dam Construction* 26 (June–July 1984).

Schuyler, James D. "Recent Practice in Hydraulic-Fill Dam Construction." *Transactions of the American Society of Civil Engineers* 57 (1907): 196–277.

———. *Reservoirs for Irrigation, Water Power, and Domestic Water Supply*. 2nd ed. New York: John Wiley and Sons, 1909.

Sherard, James L., et al. *Earth and Earth-Rock Dams.* New York: John Wiley, 1963.

Smith, Courtland L. *Construction of Masonry Dams.* New York: McGraw-Hill, 1915.

Smith, Norman. *A History of Dams.* Secaucus, NJ: Citadel Press, 1972.

———. *Man and Water: A History of Hydro-Technology.* New York: Charles Scribner's Sons, 1975.

"Rock-Fill Dams in California." *Engineering News.* 40 (July 28, 1898): 62–64.

Turpin, Trevor. *Dam.* London: Reaktion Books, 2008.

Wegmann, Edward, and Fred Noetzli. *The Design and Construction of Dams.* 8th ed. New York: John Wiley and Sons, 1927.

Chapter 4. Disasters

Baker, Charles Whiting. "Otay Rock-Fill Dam Failure." *Engineering News* 75 (February 3, 1916): 236–39.

Bennett, Ralph. "More Proof of Need for Supervision of Dams." *Engineering Record* 74 (September 16, 1916): 357.

Binnie, Geoffrey M. *Early Victorian Water Engineers.* London: Telford, 1981.

"The Desirability of State Supervision of Design, Construction, and Operation of Dams and Reservoirs." *Engineering and Contracting* 38 (October 23, 1912): 450–52.

"The Failure of a Concrete Dam at Austin, Pa., on Sept. 30, 1911." *Engineering News* 66 (October 5, 1911): 419–22.

Freeman, John R. "Some Thoughts Suggested by the Austin Dam Failures in Regarding Text Books on Hydraulic Engineering and Dam Design in General." *Engineering News* 66 (October 19, 1911): 462–63.

Hill, William R. "A Classified Review of Dam and Reservoir Failures in the United States." *Engineering News* 47 (June 19, 1902): 506–7.

Hyde, Henry M. "The Menace of the Dam." *Technical World Magazine* 16 (January 1912): 505–11.

Jackson, Donald C., and Norris Hundley Jr. "Privilege and Responsibility: William Mulholland and the St. Francis Dam Disaster." *California History* 82 (Fall 2004): 8–47, 72–78.

Jorgensen, Lars. "The Record of 100 Dam Failures." *Journal of Electricity* 44 (March 15, 1920): 274–76; continued in *Journal of Electricity* 44 (April 1, 1920): 320–21.

Kleinschmidt, H. S. "Defiance of Statute and Engineering Law Wrecked Mammoth Dam." *Engineering News-Record* 78 (July 12, 1917): 52–56.

Markwart, A. H., and M. C. Hinderlider. "Public Supervision of Dams." *Transactions of the American Society of Civil Engineers* 98 (1933): 828–87.

McMillan, Franklin. "The Failure of the Fergus Falls, Minn., City Dam." *Engineering News* 62 (October 14, 1909): 303–5.

Montgomery, M. R. *Saying Goodbye: A Memoir of Two Fathers.* New York: Alfred Knopf, 1989.

"Mulholland Dam Backed by Earthfill Against Downstream Face." *Engineering News-Record* 112 (May 3, 1934): 558–60.

Nuschke, Marie Kathern. *The Dam That Could Not Break: An Eye-witness Account of the 1911 Austin Flood.* Coudersport, PA: Potter Enterprise, 1960.

Outland, Charles F. *Man-Made Disaster: The Story of the St. Francis Dam.* Glendale, CA: Arthur H. Clark, 1963.

Saxena, K. R., and V. M. Sharma. *Dams: Incidents and Accidents.* Rotterdam, Netherlands: A. A. Balkemas, 2005.

Sharpe, Elizabeth. *In the Shadow of the Dam: The Aftermath of the Mill River Flood of 1874.* New York: Free Press, 2004.

Smith, Norman. *A History of Dams.* Secaucus, New Jersey: The Citadel Press, 1972.

Taylor, T. U. "The Austin Dam." *Bulletin of the University of Texas,* no. 164. Austin: University of Texas, 1910.

Chapter 5. Using Dams

MILLS

Evans, Oliver. *The Young Mill-Wright and Miller's Guide*. Philadelphia: Blanchard and Lea, 1795.

Ferguson, Eugene S. *Oliver Evans: Inventor Genius of the American Industrial Revolution*. Greenville, DE: Hagley Museum, 1980.

Howell, Charles. "Colonial Watermills of the Wooden Age." In *America's Wooden Age: Aspects of Its Early Technology*, edited by Brooke Hindle, 120–59. Tarrytown, NY: Sleepy Hollow Restorations, 1975.

Hunter, Louis. *A History of Industrial Power in the United States, 1780–1930: Vol. 1, Water Power*. Charlottesville: University Press of Virginia, 1979.

Hyde, Charles K. *An Inventory of Historic Engineering and Industrial Sites in Lower Michigan*. Washington, D.C.: Government Printing Office, 1977.

Kulik, Gary, and Julia C. Bonham. *Rhode Island: An Inventory of Historic Engineering Sites*. Washington, D.C.: Government Printing Office, 1980.

Kulik, Gary, Roger Parks, and Theodore Z. Penn, eds. *The New England Mill Village*. Cambridge: MIT Press, 1982.

Lucas, Adam Robert. "Industrial Milling in the Ancient and Medieval Worlds: A Survey of the Evidence for an Industrial Revolution in Medieval Europe." *Technology and Culture* 46 (January 2005): 1–30.

Macauley, David. *Mill*. New York: Houghton-Mifflin, 1983.

Malone, Patrick M. *Water Power in Lowell: Engineering and Industry in Nineteenth-Century America*. Baltimore: Johns Hopkins University Press, 2009.

Malone, Patrick, and Robert B. Gordon. *The Texture of Industry: An Archeological View of the Industrialization of North America*. New York: Oxford University Press, 1994.

Reynolds, Terry. *Stronger than a Hundred Men: A History of the Vertical Water Wheel*. Baltimore: Johns Hopkins University Press, 1983.

Roth, Matthew. *Connecticut: An Inventory of Historic Engineering and Industrial Sites*. Washington, D.C.: Society for Industrial Archeology, 1981.

Steinberg, Theodore. *Nature Incorporated: Industrialization and the Waters of New England*. Amherst: University of Massachusetts Press, 1991.

Zimiles, Martha, and Murray Zimiles. *Early American Mills*. New York: Potter, 1973.

NAVIGATION

Bernstein, Peter J. *Wedding of the Waters: The Erie Canal and the Making of a Great Nation*. New York: W. W. Norton, 2006.

Blair, John. *Waterways and Canal-Building in Medieval England*. London: Oxford University Press, 2007.

Hunter, Louis. *Steamboats on the Western Rivers: An Economic and Technological History*. Cambridge: Harvard University Press, 1949.

Johnson, Leland R. *The Davis Island Lock and Dam, 1870–1922*. Pittsburgh: U.S. Army Engineer District, 1985.

———. *Engineers on the Twin Rivers: A History of the Nashville District, Corps of Engineers, United States Army*. Nashville: U.S Army Engineer District, 1978.

———. *The Ohio River Division, U.S. Army Corps of Engineers*. Cincinnati: U.S. Army District, 1992.

Kapsch, Robert J. *Canals*. New York: W. W. Norton, 2004.

———. *Historic Canals and Waterways of South Carolina*. Columbia: University of South Carolina Press, 2010.

Larkin, F. Daniel. *New York State Canals: A Short History*. Fleischmanns, NY: Purple Mountain Press, 1990.

Leggett, Robert F. "The Jones Falls Dam on the Rideau Canal." *Transactions of the Newcomen Society* 31 (1957–59): 205–18.

McFee, Michele A. *Long Haul: Story of New York State Barge Canal.* Fleischmanns, NY: Purple Mountain Press, 2002.

O'Brien, William Patrick, Mary Yeath Rathbun, and Patrick O'Bannon. *Gateways to Commerce: The U. S. Army Corps of Engineers 9-Foot Channel Project on the Upper Mississippi River.* Denver: National Park Service, 1992.

Shallat, Todd. *Structures in the Stream: Water, Science, and the Rise of the U.S. Army Corps of Engineers.* Austin: University of Texas Press, 1994.

Shank, Thomas. *Towpaths to Tugboats: A History of American Canal Engineering.* York, PA.: American Canal and Transportation Center, 1995.

Shaw, Ronald E. *Canals for a Nation: The Canal Era in the United States, 1790–1860.* Lexington: University of Kentucky Press, 1993.

Sheriff, Carol. *The Artificial River: The Erie Canal and the Paradox of Progress, 1817–1862.* New York: Hill and Wang, 1996.

Thomas, B. F., and D. A. Watt. *The Improvement of Rivers.* New York: John Wiley and Sons, 1909.

Willingham, William F. *Army Engineers and the Development of Oregon: A History of the Portland District, U.S. Army Corps of Engineers.* Washington, D.C.: Government Printing Office, 1983.

Zimmerman, Albright G. *A Canal Bibliography: With a Primary Emphasis on the United States and Canada.* Easton, PA: Canal History and Technology Press, 2002.

LOGGING

"A California Flume for Transporting Lumber." *Engineering News* 25 (April 11, 1891): 356.

Carroll, Charles F. *The Timber Economy of Puritan New England.* Providence: Brown University Press, 1973.

Chaney, Michael P. *White Pine on the Saco River: An Oral History of River Driving in Southern Maine.* Orono: Maine Folklife Center, 1993.

Carranco, Lynwood. *Redwood Logging Industry.* San Marino, CA: Golden West, 1982.

Cronan, William. *Nature's Metropolis: Chicago and the Great West.* New York: W. W. Norton, 1991.

Fries, Robert F. *Empire in Pine: The Story of Lumbering in Wisconsin, 1830–1900.* Madison: State Historical Society of Wisconsin, 1951.

Hindle, Brooke. "Introduction: The Span of the Wooden Age." In *America's Wooden Age: Aspects of Its Early Technology,* edited by Brooke Hindle. Tarrytown, NY: Sleepy Hollow Restorations, 1975.

Johnston, Hank. *They Felled the Redwoods.* Los Angeles: Trans-Anglo Books, 1966.

———. *Thunder in the Mountains: The Life and Times of Madera Sugar Pine.* Los Angeles: Trans-Anglo Books, 1968.

Judd, Richard W. *Aroostook: A Century of Logging in Northern Maine.* Orono: University of Maine Press, 1989.

Martin, J. P. "The Design of Log Flumes." *Engineering News* 68 (November 14, 1912): 908–13.

Penn, Theodore Z., and Roger Parks. "The Nichols-Colby Sawmill in Bow, New Hampshire." *IA: Journal of the Society for Industrial Archeology* 1 (1975): 1–12.

Peterson, Charles S. "Early Lumber Mills: A Pictorial Essay." In Hindle, *America's Wooden* Age, 63–83.

Rector, William Gerald. *Log Transportation in the Lake States Lumber Industry.* Glendale, CA: Arthur H. Clark, 1953.

Stranahan, Susan Q. *Susquehanna: River of Dreams.* Baltimore: Johns Hopkins University Press, 1993.

Wilson, John S. "Upper Factory Brook Sawmill." *IA: Journal of the Society for Industrial Archeology* 3 (1977): 43–52.

Wood, Richard G. *A History of Lumbering in Maine, 1820–1861.* Orono: University of Maine Press, 1935.

MINING

Pisani, Donald J. "The Origins of Western Water Law: Case Studies from Two California Mining Districts." *Water, Land, and Law in the West: The Limits of Public Policy, 1850–1920.* Lawrence: University Press of Kansas, 1996.

Bowie, A. J. *A Practical Treatise on Mining in California.* New York: D. Van Nostrand, 1905.

Eddy, Lewis H. "The Argonaut Mine, Calif." *Engineering and Mining Journal* 102 (August 5, 1916): 265–67.

Greever, William S. *The Bonanza West: The Story of the Western Mining Rushes.* Norman: University of Oklahoma Press, 1963.

Hagwood, Joseph J. *The California Debris Commission.* Sacramento: U.S. Army Corps of Engineers, 1981.

Holliday, J. S. *Rush for Riches: Gold Fever and the Making of California.* Berkeley: University of California Press, 1999.

———. *The World Rushed In: The California Gold Rush Experience.* New York: Simon and Schuster, 1981.

Johnson, Drew Heath, and Marcia Eymann. *Silver and Gold: Cased Images of the California Gold Rush.* Iowa City: University of Iowa Press, 1998.

Kelley, Robert L. *Gold vs. Grain: The Hydraulic Mining Controversy in California's Sacramento Valley, A Chapter in the Decline of Laissez-Faire.* Glendale, CA: Arthur H. Clark, 1959.

Lingenfelter, Richard E., ed. *The Mining West: A Bibliography and Guide to the History and Literature of Mining the American and Canadian West.* London: Scarecrow Press, 2003.

Littlefield, Douglas R. "Water Rights during the California Gold Rush: Conflicts over Economic Points of View." *Western Historical Quarterly* 14 (1983): 415–34.

Paul, Rodman W. *Mining Frontiers of the Far West, 1848–1880.* Albuquerque: University of New Mexico Press, 1963.

Rohe, Randall E. "Hydraulicking in the American West: The Development and Diffusion of a Mining Technique." *Montana, the Magazine of Western History* (Spring 1985): 18–35.

"Walnut Grove Dam Failure." *Engineering News* 22 (April 26, 1888): 389–90.

Wilson, Eugene B. *Hydraulic and Placer Mining.* New York: John Wiley and Sons, 1904.

IRRIGATION

Arrington, Leonard J., and Thomas C. Anderson. "The 'First' Irrigation Reservoir in the United States: The Newton, Utah Project." *Utah Historical Quarterly* 39 (Summer 1971): 207–23.

Ashworth, William. *Ogallala Blue: Water and Life on the Great Plains.* New York: W. W. Norton, 2006.

Boyd, David. *Greeley and the Union Colony.* Greeley, CO: Tribune Press, 1890.

Brough, Charles H. *Irrigation in Utah.* Baltimore: Johns Hopkins University Press, 1898.

Churchill, Beryl Gail. *Challenging the Canyon: A Family Man Builds a Dam.* Cody, WY: WordsWorth, 2001.

Davis, Arthur Powell. *Irrigation Works Constructed by the United States Government.* New York: John Wiley and Sons, 1917.

Davison, Stanley. *The Leadership of the Reclamation Movement, 1875–1902.* New York: Arno Press, 1979.

Etcheverry, B. A. *Irrigation Practice and Engineering: Volume III, Irrigation Structures and Distribution Systems.* McGraw-Hill, 1916.

Fiege, Mark. *Irrigated Eden: The Making of an Agricultural Landscape in the American West.* Seattle: University of Washington Press, 1999.

Gates, Paul Wallace. *History of Public Land Law Development.* Washington, D.C.: Government Printing Office, 1968.

Howard, Randall R. "Irrigation Frauds in Ten States." *Technical World Magazine* 17 (July 1912): 504–14.

Hurt, Douglas. *Indian Agriculture in America: Prehistory to the Present.* Lawrence: University Press of Kansas, 1987.

Igler, David. *Industrial Cowboys: Miller and Lux and the Transformation of the American West.* Berkeley: University of California Press, 2001.

Institute for Government Research. *The U.S. Reclamation Service: Its History, Activities and Organization.* New York: D. Appleton, 1919.

Introcaso, David M. "The Politics of Technology: The 'Unpleasant Truth About Pleasant Dam.'" *Western Historical Quarterly* 26 (Autumn 1995): 333–52.

Jackson, Donald C. "Engineering in the Progressive Era: A New Look at Frederick Haynes Newell and the U.S. Reclamation Service." *Technology and Culture* 34 (July 1993): 539–74.

Jackson, W. Turrentine, Rand F. Herbert, and Stephen R. Wee, eds. *Engineers and Irrigation: Report of the Board of Commissioners on the Irrigation of the San Joaquin, Tulare, and Sacramento Valleys of the State of California, 1873.* Washington, D.C.: Government Printing Office, 1990.

Lee, Lawrence. *Reclaiming the American West: A Historiography and Guide.* Santa Barbara: ABC-Clio, 1980.

Mead, Elwood. *Irrigation Institutions: A Discussion of the Economic and Legal Questions Created by the Growth of Irrigated Agriculture in the West.* New York: MacMillan, 1903.

Miller, M. Catherine. *Flooding the Courtrooms: Law and Water in the Far West.* Lincoln: University of Nebraska Press, 1993.

———. "Riparian Rights and the Control of Water in California, 1879–1928: The Relationship between an Agricultural Enterprise and Legal Change." *Agricultural History* 59 (1985): 1–24.

Newell, Frederick Haynes. *Irrigation in the United States.* Revised ed. New York: Thomas Y. Crowell, 1906.

Pisani, Donald J. *From the Family Farm to Agribusiness: The Irrigation Crusade in California and the West, 1850–1931.* Berkeley: University of California Press, 1984.

———. *To Reclaim a Divided West: Water, Law, and Public Policy, 1848–1902.* Albuquerque: University of New Mexico Press, 1992.

———. *Water and American Government: The Reclamation Bureau, National Water Policy, and the West, 1902–1935.* Berkeley: University of California Press, 2002.

Porter, Charles R. *Spanish Water, Anglo Water: Early Development in San Antonio.* College Station: Texas A&M University Press, 2009.

Powell, John Wesley. *Report on the Lands of the Arid Region.* Washington, D.C.: Government Printing Office, 1879.

Sauder, Robert A. *The Yuma Reclamation Project: Irrigation, Indian Allotment, and Settlement along the Lower Colorado River.* Reno: University of Nevada Press, 2009.

Sherow, James Earl. *Watering the Valley: Development along the High Plains Arkansas River, 1870–1950.* Lawrence: University Press of Kansas, 1990.

Smith, Karen. *The Magnificent Experiment: Building the Salt River Project, 1870–1917.* Tucson: University of Arizona Press, 1986.

Smythe, William Ellsworth. *The Conquest of Arid America.* New York: MacMillan, 1900.

———. "The Struggle for Water in the West." *Atlantic Monthly* 86 (1900): 646–54.

Thomas, George. *The Development of Institutions under Irrigation with Special Reference to Early Utah.* New York: MacMillan, 1920.

Worster, Donald. *John Wesley Powell.* New York: Oxford, 2000.

MUNICIPAL WATER SUPPLY

Abbot, Carl. *The Metropolitan Frontier: Cities in the Modern American West*. Tucson: University of Arizona Press, 1998.

Adams, Henry A. *The Story of Water in San Diego and What the Southern California Mountain Water Company Has Done to Solve the Problem*. Chula Vista, CA: Denrich Press, 1916.

Albert, Richard T. *Damming the Delaware: The Rise and Fall of Tocks Island Dam*. 2nd ed. University Park: Penn State University Press, 2009.

Bissell, Charles A., ed. *The Metropolitan Water District of Southern California: History and First Annual Report*. Los Angeles: Metropolitan Water District, 1939.

Blake, Nelson M. *Water for the Cities: A History of the Urban Water Supply Problem in the United States*. Syracuse: Syracuse University Press, 1956.

Bone, Kevin, and Gina Pollara, eds. *Water-Works: The Architecture and Engineering of the New York City Water Supply*. New York: Monticelli, 2006.

Burr, William E., Rudolf Hering, and John R. Freeman. *Report of the Commission on Additional Water Supply for the City of New York*. New York: Martin B. Brown, 1904.

Catskill Water Supply: A General Description and Brief History. New York: Board of Water Supply, 1917.

Cooper, Erwin. *Aqueduct Empire: A Guide to Water in California, Its Turbulent History and Its Management Today*. Glendale, CA: Arthur H. Clark, 1968.

Dickinson, William C., Dean A. Herrinn, and Donald R. Kennon. *Montgomery C. Meigs and the Building of the Nation's Capital*. Columbus: Ohio University Press, 2001.

Elkind, S. Sara. *Bay Cities and Water Politics: The Battle for Resources in Boston and Oakland*. Lawrence: University Press of Kansas, 1998.

Freeman, John R. *Report on New York's Water Supply*. New York: Martin B. Brown, 1900.

Gottlieb, Robert, and Margaret Fitzsimmons. *Thirst for Growth: Water Agencies as Hidden Government in California*. Tucson: University of Arizona Press, 1991.

Goubert, Jean Pierre. *The Conquest of Water: The Advent of Health in the Industrial Age*. Princeton: Princeton University Press, 1986.

Hagaman, Edward Hall. *The Catskill Aqueduct and Earlier Water Supplies of the City of New York*. New York: Mayor's Catskill Aqueduct Celebration Committee, 1917.

Hanson, Warren D. *Water and Power: A History of the Municipal Water Department and Hetch Hetchy System*. San Francisco: City and County of San Francisco, 1994

Hoffman, Abraham. *Vision or Villany: Origins of the Owens Valley-Los Angeles Water Controversy*. College Station: Texas A&M University Press, 1981.

Hundley, Norris. *The Great Thirst: Californians and Water—A History*. Rev. ed. Berkeley: University of California Press, 2002.

Kahrl, William L. *Water and Power: The Conflict over Los Angeles' Water Supply in the Owens Valley*. Berkeley: University of California Press, 1982.

Koepple, Gerard T. *Water for Gotham: A History*. Princeton: Princeton University Press, 2001.

Magnusson, Roberta J. *Water Technology in the Middle Ages: Cities, Monasteries, and Waterworks after the Roman Empire*. Baltimore: Johns Hopkins University Press, 2001.

Melosi, Martin V. *Precious Commodity: Providing Water for American Cities*. Pittsburgh: University of Pittsburgh Press, 2011.

Mulholland, Catherine. *William Mulholland and the Rise of Los Angeles*. Berkeley: University of California Press, 2000.

Nesson, Fern L. *Great Waters: A History of Boston's Water Supply*. Hanover, NH: University Press of New England, 1983.

Ostrom, Vincent. *Water and Politics: A Study of Water Policies and Administration in the Development of Los Angeles*. Los Angeles: Haynes Foundation, 1953.

Steuding, Bob. *The Last of the Handmade Dams: The Story of the Ashokan Reservoir*. Fleischmanns, NY: Purple Mountain Press, 1989.

Stradling, David. *Making Mountains: New York City and the Catskills*. Seattle: University of Washington Press, 2007.

Taylor, Ray W. *Hetch Hetchy: The Story of San Francisco's Struggle to Provide a Water Supply for Her Future Needs*. San Francisco: Richard I. Orozco, 1926.

Weidner, Charles H. *Water for a City: A History of New York City's Water Supply from the Beginning to the Delaware River System*. New Brunswick: Rutgers University Press, 1974.

Wurm, Ted. *Hetch Hetchy and Its Dam Railroad*. Glendale, CA: Trans-Anglo Books, 1973.

HYDROELECTRICITY

Adams, John A. *Damming the Colorado: The Rise of the Lower Colorado River Authority, 1933–1939*. College Station: Texas A&M University Press, 1990

Brigham, Jay. *Empowering the West: Electrical Politics before the New Deal*. Lawrence: University Press of Kansas, 1998.

Conover, Milton. *The Federal Power Commission: Its History, Activities and Organization*. Baltimore: Johns Hopkins University Press, 1923.

Cooper, Hugh L. "The Water Power Development of the Mississippi River Power Company at Keokuk Iowa." *Journal of the Western Society of Engineers* 17 (January 1912): 213–18.

"The First Three-Phase Transmission Plant in the United States." *Electrical Review* 23 (November 29, 1893): 179.

Fitzsimons, Gray. "Uncivil Engineers: The Struggle for Control of Seattle's Early Water and Electric Utilities, 1890–1910." *IA: Journal of the Society for Industrial Archeology* 22 (1996): 11–34.

Fowler, Frederick Hall. *Hydroelectric Power Systems of California and Their Extensions into Oregon and Nevada*. Washington, D.C.: Government Printing Office, 1923.

Goldmark, Henry. "The Power Plant, Pipe Line and Dam of the Pioneer Electric Power Company of Ogden, Utah." *Transactions of the American Society of Civil Engineers* 38 (1897): 246–314.

Hirt, Paul. *The Wired Northwest: The History of Electric Power, 1870s–1970s*. Lawrence: University Press of Kansas, 2012.

Hubbard, Preston J. *Origin of the TVA: The Muscle Shoals Controversy, 1920–1932*. Nashville: Vanderbilt University Press, 1961.

Hughes, Thomas P. *Networks of Power: The Electrification of Western Society, 1880–1930*. Baltimore: Johns Hopkins University Press, 1984.

Hunter, Louis, and Lynwood Bryant. *A History of Industrial Power in the United States, 1780–1930: Vol. 3, The Transmission of Power*. Cambridge: The MIT Press, 1991.

Jackson, Harvey H., III. *Putting Loafing Streams to Work: The Building of Lay, Mitchell, Martin, and Jordan Dams, 1910–1929*. Tuscaloosa: University of Alabama Press, 1997.

Johnston, Hank. *The Railroad That Lighted Southern California*. Glendale, CA: Trans-Anglo Books, 1966.

LaRue, E. C. *Colorado River and Its Utilization*. Washington, D.C.: Government Printing Office, 1916.

Mannikko, Nancy Farm. "Seattle City Light's Constant Angle Arch Dam at Diablo Canyon." *IA: The Journal of the Society for Industrial Archeology* 17 (1991): 17–31.

Myers, William A. *Iron Men and Copper Wires: A Centennial History of the Southern California Edison Company*. Los Angeles: Trans-Anglo Books, 1984.

Nye, David E. *Electrifying America: Social Meanings of a New Technology*. Cambridge: MIT Press, 1990.

"The Pioneer Electric Power Transmission." *Journal of Electricity* 5 (March 1898): 109–13.

Pitzer, Paul C. *Building the Skagit: A Century of Upper Skagit Valley History*. Portland, OR: Galley Press, 1978.

Redinger, David H. *The Story of Big Creek.* Los Angeles: Angeles Press, 1949. Revised ed., edited by Edith I. Redinger and William A. Myers. Glendale, CA: Trans-Anglo Books, 1986.

Reynolds, Terry S. "Dams and Hydroelectric Technology in the American West: A Different Model." *IA: Journal of the Society for Industrial Archeology* 22 (1996): 5–10.

von Schon, H. A. E. C. *Hydro-Electric Practice.* Philadelphia: J. B. Lippincott, 1908.

FLOOD CONTROL

Arnold, Joseph, L. *The Evolution of the 1936 Flood Control Act.* Fort Belvoir, VA: Office of History, U.S. Army Corps of Engineers, 1988.

Barry, John M. *Rising Tide: The Great Mississippi Flood of 1927 and How It Changed America.* New York: Simon and Schuster, 1998.

Jackson, Donald C. "Private Initiative—Public Works: Ed Fletcher, the Santa Fe Railway and the Cave Creek Flood Control Dam." In *Fluid Arguments: Water Development in the American Southwest,* edited by Char Miller, 251–75. Tucson: University of Arizona Press, 2001.

Kelley, Robert. *Battling the Inland Sea: American Political Culture, Public Policy and the Sacramento Valley.* Berkeley: University of California Press, 1989.

Leuchtenburg, William Edward. *Flood Control Politics: The Connecticut River Valley Problem, 1927–1950.* Cambridge: Harvard University Press, 1953.

Morgan, Arthur E. *The Miami Conservancy District.* New York: McGraw-Hill, 1951.

O'Neill, Karen M. *Rivers by Design: State Power and the Origins of U.S. Flood Control.* Durham: Duke University Press, 2006.

Orsi, Jared. *Hazardous Metropolis: Flooding and Urban Ecology in Los Angeles.* Berkeley: University of California Press, 2004.

Peterson, W. H. "Cave Creek Flood Control Dam Multiple Arch Structure Built Along New Lines." *Southwest Builder and Contractor* 62 (February 16, 1923): 30–33.

Reuss, Martin. "Andrew A. Humphreys and the Development of Hydraulic Engineering: Politics and Technology in the Army Corps of Engineers, 1850–1950." *Technology and Culture* 26 (January 1985): 1–33.

Rosen, Howard, and Martin Ruess, eds. *The Flood Control Challenge: Past, Present, and Future.* Chicago: Public Works Historical Society, 1988.

Tibbetts, Fred. "Sacramento River Flood Control." *Engineering and Contracting* 39 (April 9, 1913): 404–12

Van Heerden, Ivor. *The Storm: What Went Wrong and Why During Hurricane Katrina—the Inside Story from One Louisiana Scientist.* New York: Penguin, 2007.

RECREATION

Adams, Nicholas. "Architecture for Fish: The Siennese Dam on the Bruna River—Structure and Designs, 1468–ca. 1530." *Technology and Culture* 25 (October 1984): 768–97.

Grubb, Herbert W., and James T. Goodwin. "Economic Evaluation of Water-Oriented Recreation in the Preliminary Texas Water Plan." *Texas Water Development Board Report No. 84,* September 1968.

Higginbottom, James Arnold. "Artificial Fishponds in Roman Italy during the Late Republic and Early Empire." PhD dissertation, University of Michigan, 1991.

Smith, Norman. "The Roman Dams of Subiaco." *Technology and Culture* 11 (1970): 58–68.

Walsh, R. G, et al. "Measuring Benefits and the Economic Value of Water in Recreation on High Country Reservoirs." *Colorado Water Resources Research Institute, Colorado State University Competition Report No. 102,* September 1980.

Chapter 6. The New Deal

Billington, David P., and Donald C. Jackson. *Big Dams of the New Deal Era: A Confluence of Engineering and Politics.* Norman: University of Oklahoma Press, 2006.

Bureau of Reclamation. *Boulder Canyon Project Final Reports: General History and Description of the Project.* Boulder City, NV: Bureau of Reclamation, 1948.

———. *Dams and Control Works.* Washington, D.C.: Government Printing Office, 1938.

Cannon, Brian Q. "'We Are Now Entering a New Era': Federal Reclamation and the Fact Finding Commission of 1923–24." *Pacific Historical Review* 66 (May 1997): 185–211.

Caro, Robert A. *The Path to Power.* New York: Simon and Schuster, 1982.

Condit, Carl. *American Building Art: The Twentieth Century.* New York: Oxford University Press, 1961.

Clapp, Gordon R. *The TVA: An Approach to the Development of a Region.* Chicago: University of Chicago Press, 1955.

Design of TVA Projects. Technical Report No. 24, volume 1, *Civil and Structural Design.* Washington, D.C.: Government Printing Office, 1952.

Downey, Sheridan. *They Would Rule the Valley.* San Francisco: by the author, 1947.

The Fontana Project: A Comprehensive Report on the Planning, Design, Construction and Initial Operations of the Fontana Project. Technical Report No. 12. Washington, D.C.: Government Printing Office, 1949.

Hayes, Samuel P. *Conservation and the Gospel of Efficiency: The Progressive Conservation Movement, 1890–1920.* Cambridge: Harvard University Press, 1959.

Holway, W. R. *A History of the Grand River Dam Authority, 1935–1968.* Tulsa, OK: Tulsa County Historical Society, 1968.

Hundley, Norris. *Water and the West: The Colorado Compact and the Politics of Water in the American West.* Berkeley: University Press, 1966.

King, Judson. *The Conservation Fight: From Theodore Roosevelt to the Tennessee Valley Authority.* Washington, D.C.: Public Affairs Press, 1959.

Kleinsorge, Paul L. *The Boulder Canyon Project: Historical and Economic Aspects.* Stanford: Stanford University Press, 1941.

Lee, Lawrence B. "California Water Politics: Depression Genesis of the Central Valley Project, 1933–1944." *Journal of the West* 24 (1985): 63–81.

Liel, Abbie B., and David P. Billington. "Engineering Innovation at Bonneville Dam." *Technology and Culture* 49 (July 2008): 727–51.

Maass, Arthur. *Muddy Waters: The Army Engineers and the Nation's Rivers.* Cambridge: Harvard University Press, 1951.

Moeller, Beverly. *Phil Swing and Boulder Dam.* Berkeley: University Press of California, 1971.

Moffett, Marian, and Lawrence Wodehouse. "Noble Structures Set in Handsome Parks: Public Architecture of the TVA." *Modulus* 17 (1984): 75–83.

The Norris Project: A Comprehensive Report on the Planning, Design, Construction, and Initial Operations of The Tennessee Valley Authority's First Water Control Project. Technical Report No. 1. Washington, D.C.: Government Printing Office, 1940.

O'Daniel, Patrick. *Memphis and the Superflood of 1937.* Charleston, SC: History Press, 2010.

Pacific Constructors, Inc. *Shasta Dam and Its Builders.* San Francisco: Schwabacher-Frey Company, 1945.

Person, H. S. *Little Waters: Their Use and Relations to the Land.* Washington, D.C.: Government Printing Office, 1936.

Pitzer, Paul C. *Grand Coulee: Harnessing a Dream.* Pullman: Washington State University Press, 1994.

Rhodes, Benjamin D. "From Cookesville to Chungking: The Dam Designing Career of John L. Savage." *Wisconsin Magazine of History* 72 (Summer 1989): 243–72.

Richardson, Elmo. *Dams, Parks and Politics: Resource Development and Preservation in the Truman-Eisenhower Era.* Lexington: University Press of Kentucky, 1973.

Stevens, Joseph. *Hoover Dam: An American Adventure.* Norman: University of Oklahoma Press, 1988.

Stevenson, Mark Allen. *Tennessee Valley Authority in Vintage Postcards*. Charleston, SC: Arcadia Publishing, 2005.

Swain, Donald. "The Bureau of Reclamation and the New Deal, 1933–1940." *Pacific Northwest Quarterly* 61 (July 1970): 137–46.

———. *Federal Conservation Policy, 1921–1933*. Berkeley: University of California Press, 1963.

"10,000 Montana Relief Workers Make Whoopee on Saturday Night." *Life* 1 (November 23, 1936).

Warne, William E. *The Bureau of Reclamation*. New York: Praeger Publishers, 1973.

Welky, David. *The Thousand Year Flood: The Ohio-Mississippi Disaster of 1937*. Chicago: University of Chicago Press, 2011.

Welsh, Michael. *A Mission in the Desert: Albuquerque District, 1935–1985*. Washington, D.C.: Government Printing Office, 1985.

Willingham, William F. *Water Power in the "Wilderness": The History of Bonneville Lock and Dam*. Portland: U.S. Army Corps of Engineers, 1988.

Wilson, Richard Guy. "Dams: Photographs from the Depression." *Modulus* 17 (1984): 35–43.

———. "Machine-Age Iconography in the American West: The Design of Hoover Dam." *Pacific Historical Review* 54 (1985): 463–93.

Wolf, Donald E. *Big Dams and Other Dreams: The Story of Six Companies Inc.* Norman: University Press of Oklahoma, 1996.

Chapter 7. Fish and Environment

Anfinson, John O. *The River We Have Wrought: A History of the Upper Mississippi*. Minneapolis: University of Minnesota Press, 2003.

"Are We Completely Dammed?" *Outdoor America* 6 (May–June 1941): 3–4.

Bilharz, Joy A. *The Allegany Senecas and Kinzua Dam: Forced Relocation through Two Generations*. Lincoln: University of Nebraska Press, 1998.

Boyer, Diane E., and Robert Q. Webb. *Damming Grand Canyon: The 1923 USGS Colorado River Expedition*. Logan: Utah State University Press, 2007.

Clements, Kendrick A. "Politics and the Park: San Francisco's Fight for Hetch Hetchy." *Pacific Historical Review* 48 (May 1979): 185–215.

Coker, Robert E. *Keokuk Dam and the Fisheries of the Upper Mississippi River*. Bureau of Fisheries Document No. 1063. Washington, D.C.: Government Printing Office, 1929.

Cumbler, John. "The Early Making of an Environmental Consciousness: Fish, Fisheries Commissions, and the Connecticut River." *Environmental History Review* 15 (1991): 73–92.

"Dams and Wild Rivers: Looking Beyond the Pork Barrel." *Science* 158 (October 13, 1967).

Donahue, Brian. "Damned at Both Ends and Cursed in the Middle: The 'Flowage' of the Concord River Meadows." *Environmental Review* 13 (1989): 47–68.

Finley, William L. "Salmon or Kilowatts: Columbia River Dams Threaten Great Natural Resource." *Nature Magazine* 26 (August, 1935).

Fox, Stephen. *The American Conservation Movement: John Muir and His Legacy*. Madison: University of Wisconsin Press, 1981.

Harvey, Mark. *A Symbol of Wilderness: Echo Park and the American Conservation Movement*. Albuquerque: University of New Mexico Press, 1994.

Hogan, C. C. "The Rush Creek Controversy." *Journal of Electricity Power and Gas* 37 (November 25, 1916): 407–9.

Hoag, Heather J., and May-Britt Ohman. "Turning Water into Power: Debates over the Development of Tanzania's Rufiji River Basin, 1945–1985." *Technology and Culture* 49 (July 2008): 624–51.

Howe, Donald W. *Quabbin: The Lost Valley*. Ware, MA: Quabbin Book House, 1951.

Igler, David B. "When Is a River Not a River? Reclaiming Nature's Disorder." *Environmental History* 1 (April 1996): 52–69.

Jones, Holway. *John Muir and the Sierra Club: The Battle for Yosemite.* San Francisco: Sierra Club, 1965.

Kulik, Gary. "Dams, Fish and Farmers: Defense of Public Rights in Eighteenth Century New England." In *The New England Working Class and the New Labor History,* edited by Herbert G. Gutman and Donald H. Bell, 187–213. Urbana: University of Chicago Press.

Lawson, Michael L. *Dammed Indians: The Pick-Sloan Plan and the Missouri River Sioux, 1944–1980.* Norman: University of Oklahoma Press, 1994.

Leopold, Aldo. *A Sand County Almanac.* New York: Oxford University Press, 1949.

Leopold, Luna B., and Thomas Maddock Jr. *The Flood Control Controversy: Big Dams, Little Dams, and Land Management.* New York: Ronald Press, 1954.

Lincoln, Robert Page. "The Dams Situation in the West." *Fur-Fish-Game* 98 (January 1948): 9–11, 45–47.

Maass, Arthur. *Muddy Waters: The Army Engineers and the Nation's Rivers.* Cambridge: Harvard University Press, 1951.

McDonald, Michael J., and John Muldowny. *TVA and the Dispossessed: The Resettlement of Population in the Norris Dam Area.* Knoxville: University of Tennessee Press, 1981.

Morgan, Arthur. *Dams and Other Disasters: A Century of the Army Corps of Engineers in Civil Works.* Boston: Porter Sargent, 1971.

Peterson, Elmer T. *Big Dam Foolishness: The Problem of Modern Flood Control and Water Storage.* New York: Devin-Adair, 1954.

Pearson, Byron E. "Salvation for Grand Canyon: Congress, the Sierra Club and the Dam Controversy, 1963–68." *Journal of the Southwest* 26 (Summer 1998): 159–75.

———. *Still a River Runs Through It: Congress, the Sierra Club, and the Fight to Save Grand Canyon.* Tucson: University of Arizona Press, 2002.

Reisner, Marc. *Cadillac Desert: The American West and Its Disappearing Water.* New York: Viking Press, 1986.

Righter, Robert W. *The Battle over Hetch Hetchy: America's Most Controversial Dam and the Birth of Modern Environmentalism.* New York: Oxford University Press, 2006.

Schneider, Robert Kelly. *Unruly River: Two Centuries of Change along the Missouri.* Lawrence: University Press of Kansas, 1999.

Taylor, Joseph E., III. *Making Salmon: An Environmental History of the Northwest Fisheries Crisis.* Seattle: University of Washington Press, 1999.

Van Dyk, Jere. "Long Journey of the Pacific Salmon." *National Geographic* 178 (July 1991): 3–37.

White, Richard. *The Organic Machine.* New York: Hill and Wang, 1995.

Worster, Donald. *Rivers of Empire: Water, Aridity, and the Growth of the American West.* New York: Pantheon, 1985.

———. *Under Western Skies: Nature and History in the American West.* New York: Oxford University Press, 1992.

Chapter 8. Snapshot Culture

Czech, Kenneth P. *Snapshot: America Discovers the Camera.* Minneapolis: Lerner Publications, 1996.

Greenough, Sarah, et al., eds. *The Art of the American Snapshot, 1888–1978.* Princeton: Princeton University Press, 2007.

Naef, Weston. "The Snapshot as Social Memory." *American Art Review* 16 (November–December 2004): 144–47.

Olivier, Marc. "George Eastman's Modern Stone-Age Family: Snapshot Photography and the Brownie" *Technology and Culture* 48 (January 2007): 1–19.

Skrein, Christain. *Snapshots: The Eye of the Century.* Stuttgart: Hatje Cantz, 2004.

Tufte, Virginia, and Barbara Myerhoff. *Changing Images of the American Family.* New Haven: Yale University Press, 1979.

Postscript

Farmer, Jared. *Glen Canyon Dammed: Inventing Lake Powell and the Canyon Country.* Tucson: University of Arizona Press, 1999.

Goldsmith, Edward, and Nicholas Hild Yard. *The Social and Environmental Effects of Large Dams.* San Francisco: Sierra Club, 1984,

Hagland, Karl. *Inventing the Charles River.* Cambridge: MIT Press, 2002.

Hawley, Steven. *Recovering a Lost River: Removing Dams, Rewilding Salmon, Revitalizing Communities.* Boston: Beacon Press, 2011.

Hunt, Constance Elizabeth, and Verne Huser. *Down by the River: The Impact of Federal Water Projects and Policies on Biological Diversity.* Washington, D.C.: Island Press, 1988.

Leslie, Jacques. *Deep Water: The Epic Struggle over Dams, Displaced People, and the Environment.* New York: Farrar, Straus and Giroux, 2005.

McCully, Patrick. *Silenced Rivers: The Ecology and Politics of Large Dams: Enlarged and Updated Edition.* London: Picador, 2001.

McPhee, John. "Farewell to the Nineteenth Century." *New Yorker* (September 27, 1999).

Nurcott, Susan, et al. "The Big Dam Debate: The Yangtze River Three Gorges Dam Project." *Civil Engineering Practice* 12 (Spring–Summer 1997): 3–104.

Outland, Alice. *Water: A Natural History.* New York: Basic, 1996.

Palmer, Tim. *Endangered Rivers and the Conservation Movement.* Berkeley: University of California Press, 1986.

———. *Stanislaus: The Struggle for the Soul of a River.* Berkeley: University of California Press, 1982.

Peterson, Keith C. *River of Life, Channel of Death: Fish and Dams on the Lower Snake.* Lewiston, ID: Confluence Press, 1995.

Porter, Eliot. *The Place No One Knew: Glen Canyon on the Colorado.* San Francisco: Sierra Club, 1963.

Roberge, Earl. *Those Snake River Dams.* Walla Walla: Grey Fox Press, 2001.

Rose, Gene. *The San Joaquin: A River Betrayed.* Fresno, CA: Linrose Publishing Company, 1992.

Russell, Martin. *Glen Canyon and the Struggle for the Soul of the American West.* New York: Henry Holt, 1989.

Soloman, Steven. *Water: The Epic Struggle for Wealth, Power, and Civilization.* New York: HarperCollins, 2010.

Thompson, Jim, and Cynthia Brooks. *Tellico Dam and the Snail Darter.* Tellico Plains, TN: Tellico Publications, 1991.

INDEX

Note: Page numbers in italic type indicate illustrations.

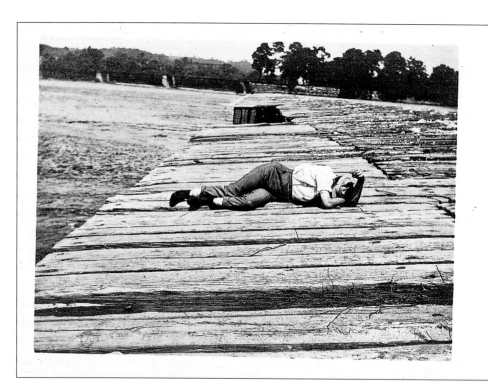